Kandinsky
A Life in Letters
1889–1944

Kandinsky

A Life in Letters
1889–1944

Edited by
JELENA HAHL-FONTAINE

in collaboration with
KATE KANGASLAHTI

HIRMER

Contents

7 Preface

14 Notes on the edition

15 The Letters 1889–1944

255 Supplementary Documents (chronological)

281 Biographies (chronological)

301 Literature

306 Acknowledgements

309 Index

Preface

"Artists, even if they don't speak very cleverly about art, generally say living things. Writers, on the contrary, speak of things that have already crystallized, i.e., they don't see them in motion, but in a state of inertia, of 'death.'" Wassily Kandinsky penned these words to his French colleague Robert Delaunay in 1911. As he often directed similar or even more critical remarks toward art historians, here we will let him speak for himself, without comment and with only the most necessary explanations.

Recognized today as a founding father of abstract art, an enormous body of literature has been devoted to Kandinsky's career and work. But are not the letters from his own hand as important as the interpretations of historians, or rather even more so? Surprisingly, many of his letters have remained unpublished, including those written to his lifelong best friend, the composer Thomas de Hartmann. His correspondence with Gabriele Münter, Alexei Jawlensky, Nikolai Kulbin, Galka Scheyer, and others is either not available in its entirety or is printed only in German, Russian, or French. More than a third of the letters chosen for this collection, itself the culmination of many years of research, are published here for the first time, and each has been translated from one of those three languages. They reflect not only the decades I have spent studying Kandinsky's art and translating his Russian writings into German, but also the privilege I have had of working with a number of his contemporaries—Vladimir Bekhteev, Olga de Hartman, Lette Valeska (heir of Galka Scheyer), Felix Klee, Rudolf Ortner, and Fritz Tschaschnig—as well as with his widow

Nina Kandinsky for twelve years. Over time, several archives have further entrusted me with copies of his letters, with the hope of one day seeing these precious primary sources published. At long last, this undertaking has become possible.

Until now, only a select portion of some 1,000 handwritten pages to Gabriele Münter—highly personal, openhearted, and lively letters to his former student and life partner, written between 1903 and 1914—has been published. Here, in Kandinsky's excited daily reports from Odessa, we discover his enthusiasm for the Revolution of 1905 and the struggle for a more liberal and democratic Russia—and soon after, his horror when it became a pogrom and a massacre. Known in general to be extremely discreet about private matters and often reluctant to "explain himself" to others, with Münter he shared not only his intimate sufferings, but also his doubts and progress in art. His letters to her offer precious insights into the mind of this radical innovator. As early as 1904, for example, he confirmed that he saw the goal before him quite clearly: to open the way for a new type of painting with wonderful and infinite possibilities. We also learn about his important contacts with the Russian art scene: in a 1912 letter from Moscow, he states that his task is "to sow freedom among artists here, and to strengthen the bond between Russia and Germany."

Kandinsky's correspondence with Arnold Schoenberg from early 1911 is of enormous historical importance, written at a time when the artist was on the cusp of painting his first abstract work and the Austrian composer was about to invent atonality; both were experimenting with stage plays and writing their first theoretical treatises. I have previously published these letters in their entirety, with commentary and much additional material. Since the English translation of 1984 is still available, we have limited the number of quotations reproduced here.

In his letters to Galka Scheyer, his representative in the United States who had undertaken the mission of introducing his work to the

American public, Kandinsky was often instructive. It was vital to his own interests to see her well informed, even if that sometimes meant, as he himself admitted, boasting about his successes. The same holds true for his New York dealer, Israel Ber Neumann. Today we benefit from this frank exchange of information. We learn, for example, that having been expelled from Germany after the start of World War I, the artist did not have the opportunity to produce any oil paintings in 1915, and painted only seven in 1921 (although others sometimes appear on the art market today).

A complete edition of all of his letters would be ideal, but given that Kandinsky was a prolific correspondent in spite of his many activities, such a work would amount to more than twenty large volumes. Further documents of interest and a list of all previous publications devoted to his correspondence appear at the end of this book, along with references to his complete theoretical writings and the monumental catalogues raisonnés of his paintings. For this reason, we have limited the illustrations here to those works Kandinsky mentions by name. Our more compact selection concentrates on the least known, but most important and characteristic letters, with the wish and expectation of encouraging further scholarly engagement with the artist. He writes not only about art, of course, but also about his everyday life, politics, and art politics, as well as love affairs and their complications. We have included examples of as many aspects of his life and career as possible and have not shied away even from the artist's sometimes problematic statements, leaving readers free to arrive at their own conclusions. I can personally confirm that I have not encountered a single mean-spirited letter, and his occasional criticism of other artists has often proved justified over time. Altogether, my work on this edition and my collaboration with Kate Kangaslahti have been a pure joy for me.

But not everything is discussed here. Two tragic events remained secret during Kandinsky's and Nina's lifetimes. Only recently has a document come to light in the Munich municipal archives stating

that in November 1897, a son was born to Kandinsky's first wife and cousin, Anna (Anya). The child survived but a single day. And only after the death of his second wife, Nina, did it become known that their son Vsevolod had died at the age of three in Moscow in 1920.

Although hardly confidential, another topic Kandinsky never mentioned outright was his own wealthy background and the lofty cultural status and education of his family: his relatives included professors, jurists, the founder of Russian psychiatry Viktor Kandinsky (1849–1889), industrialists who were also publishers and patrons of the arts, and so on. His uncle Ivan Sabashnikov, who visited the Russian writer Alexander Herzen during his exile in London, belonged to the same nineteenth-century liberal elite as his parents. Theater and museum visits and concerts were par for the course, as both of his parents played musical instruments and he himself studied cello and piano from the age of eight. His best grades in high school were for Russian and "Logics"; he read ancient Greek, Latin, French, and German (one grandmother was Baltic nobility), and his doctoral thesis indicates that he even had a basic knowledge of English. Accustomed to a life of affluence, he could afford ten years of university studies interrupted by visits to Paris, the Crimea, and a honeymoon trip that extended over six months (!) and half of Europe. He was furious when his professors denied his request to spend an additional year and a half in Western Europe during his studies.

While largely silent on the subject of this early privilege, he tried to familiarize Gabriele Münter, who never accompanied him to Russia, with his extended family. Here we have not dwelt on his exuberant praise for his warmhearted Russian friends and relatives and his countless pet names—"a whole dictionary!" as Kandinsky put it—for all the family members and their children, whom he loved dearly. We have also omitted the considerable number of "garden letters" he wrote to Münter in the summer of 1911, but suffice it to say he was very happy to keep himself busy in their country home in Murnau. Some things

that may strike the modern-day reader as strange have historical explanations: references to weak nerves or "neurasthenia" around 1900, often treated with cold water (or Kneipp) cures, correspond to today's notion of "burnout." In the early Russian letters, in particular, we encounter the style and manners of a century ago. The perfectly accepted custom of brotherly kisses among men is found to some extent even today in eastern and southern Europe. As we have usually dispensed with salutations and the standard forms of address, we should note that Kandinsky always sent greetings to the wives of his friends, and in his Russian letters never referred to them as "your wife," but politely used both the woman's first name and her father's name: never "Nina" without "Nikolaevna." No letters to his second wife exist, for they were never separated for a single day during their marriage. And because Paul Klee lived on the same street in Munich and later was Kandinsky's neighbor when they taught together at the Bauhaus, there is little correspondence between them; rather than letters, they exchanged paintings, which is well documented.

Given the turbulent period in which he lived, it comes as no surprise that not all of his letters have survived (it is perhaps more remarkable that so many have been preserved). His friend Benedikta (Bena) Bogayevskaya destroyed "a whole box of letters" before her suicide in 1930, according to her daughter. As a member of the famous Lv'ov nobility, Bena's fate under Stalin would at the very least have been Siberia. She had played an important part in Kandinsky's life since 1894, when he was best man at the wedding of his friend, Petr Bogayevsky. Yet Bena often lived apart from her husband, and when she gave birth to a daughter in 1911, she chose Kandinsky as godfather ("because you are religious"). There are suspicions, though no proof, that he may have been the father. He persuaded Bena, who worked as a French teacher, to translate Signac's manifesto of 1898 into Russian (though it was never published), and in 1910 she helped him organize his own Russian translation of *Concerning the Spiritual in Art*, because, as he

wrote to Münter, she was able to decipher his almost "abstract" handwriting "quite well." In her letters to Kandinsky, Bena complained that he wrote too little, and there is mention of a difficult farewell in Munich in 1909 as well as a meeting in Italy; in 1913, she updated him on the construction of his new six-story tenement house in Moscow. One sketch, three woodcuts, and a copy of his book *Concerning the Spiritual in Art* with a dedication to Bena's husband remain in the family's possession.

Kandinsky wrote few letters between 1915 and 1921: during these years in Moscow, he seldom had time even to paint. Instead, he dedicated himself to cultural-political activities, initially with great enthusiasm and high hopes. From late 1919 until March 1921, he presided over the state commission tasked with distributing artworks from all eras to provincial museums, not merely those in Moscow and Petrograd. Meanwhile, his private life was rife with drama—his separation from Münter and the final, difficult end to their relationship, his marriage to the beautiful, young (and pregnant) Nina, the birth and death of their son Vsevolod. During the same period he faced increasing hostility from younger, more radical artists.

There is far more literature on his Moscow and Bauhaus periods. One aspect of his time at the Bauhaus, however, remains neglected today, and Kandinsky's letters do not show it either, though it was well known by everyone within the school. There he enjoyed the status of an "elder statesman"—not only because he was the oldest person, but also in recognition of his sense of justice, intelligence, and noble demeanor. His word carried uncontested authority, whether in relation to internal quarrels or when he was sent by the director Walter Gropius to settle numerous difficulties with the German authorities in Weimar and Dessau. Only at the end did Kandinsky fail, when he tried to convince the National Socialists to accept abstract art.

Kandinsky expressed himself unreservedly in his private communications; it probably never occurred to him that his letters would become public, so he had no reason to be cautious. We are fortunate

to discover surprising aspects of his personality: in the liveliness of his correspondence we find humor and a human touch that is otherwise missing in the complexity of his theoretical writings. Through his letters we can follow his progressive transformation from a frail and "nervous" youth into a witty observer and idealistic artist who pursued his work with astonishing perseverance and almost without interruption—even as he lived through two revolutions, two World Wars, four emigrations, personal disappointments, political persecutions (mainly under National Socialism), and the loss of distressingly many of his art works. The fact that this considerable turmoil left no trace whatsoever in his art is further proof of its objective greatness, as well as of the artist's extraordinary character.

Notes on the edition

Kandinsky wrote most of his letters, often quite long ones, by hand and put pen to paper very quickly; the abbreviations (almost abstractions) he used allowed him to write at a rapid pace. From the early 1920s on, he also used an old typewriter for his German and French letters.

The underlined words, ellipses (sometimes several dots, but reduced to three here), dashes, parentheses, and abbreviations are Kandinsky's own, as is the occasional double date, signaling the thirteen days of difference between the Russian and the Western calendar. There are occasionally small errors of orthography and grammar in both his German and his French letters, which the English translation does not reflect.

Brief explanations [*italicized in square brackets*] and [...] omissions are by the editor. The original language of each letter (Russian, German, or French) is noted in parentheses. The writing of Russian names follows the rules of current transliteration, unless the person named is historically known in English according to past conventions (as is the case with Kandinsky himself). In the same vein, Arnold Schoenberg's name appears in its anglicized form.

Abbreviations:

MES Gabriele Münter and Johannes Eichner Foundation, Munich
NKVM Neue Künstlervereinigung München
 (New Artists' Association Munich)
BR The Blue Rider

The Letters 1889–1944

Apr. 23, 1889, Moscow, to NIKOLAI KHARUZIN (Rus.):
[*Kharuzin was a university friend who, like Kandinsky, was primarily studying ethnography and at that time was working in Gurzuf, Crimea.*] Very happy for you, dear Nikolai Nikolaevich, that you have confirmed the truth of what I described: Living in Gurzuf means constantly seeing with your own eyes the inspiration for Aivazovsky's and Sudkovsky's paintings. In my opinion, that's where the beauty of the Black Sea shows itself most vividly. Here it touches your nerves. [...] When I think of Gurzuf, I feel the weight of my Moscow life even more. I'm sitting here, the sun is sending hot rays through the window, but I am sweating over consistories [*he lists several law books and adds "etc. etc."*]. But my thoughts wander somewhere between the Crimea, Paris, or the Zyrians [*where he would soon travel for ethnographic research. He continues here describing an exhibition of the Russian Realist painters, the "Itinerants":*] What a picture by Polenov, if only you could see it! [*Vasily Polenov,* Christ, *1888, State Tretyakov Gallery, Moscow.*] The warm tones of a southern summer sun, a green lake, bluish mountains at the horizon, an incandescent sky. A miraculous beauty, and—Christ. He is walking and He is more glorious than all of nature. Only His face is hardly visible. The whole expression lies in the figure. My awkward little sketch on page one should give you an impression of the idea and the structure. There is nothing better than this picture in the whole exhibition, but people hardly notice it, because one doesn't recognize the face. I feel sorry for Polenov.

On May 20 I start off for the Zyrians. Best if you write to me general delivery in Vologda. After that I will send you the next address. Please write, I always very much look forward to getting your letters. I shake your hand and I wish that you become healthier and stronger, stronger.

Ever yours, V. Kandinsky. Greetings to P.M-ich [*Petr Mikhailovich Bogayevsky, their fellow student and friend*].

[*1889: Kandinsky spent June and July in northern Russia studying "peasant law" (where corporal punishment was still in use!) and investigating the remains of*

"pagan" belief among the Zyrian tribes. He published his observations on "common or habitual" law and an article on the Zyrians in the journal of the Imperial Society of Lovers of Natural History, Anthropology, and Ethnography, of which he was a member (see below). His two reports are published in Kandinsky, Autobiographische Schriften, *2004.*]

KANDINSKY, "On the Legislation in the Northern Provinces of Russia," in *Trudy obshchestva lyubiteley estestvoznaniya, antropologii i etnografii* (News of the Imperial Society of Lovers of Natural History, Anthropology, and Ethnography), vol. IX (Moscow 1889), 17 (Rus.):

Concerning women, we find particularly original ways of handling their crimes. [...] "Lack of respect" towards the husband as well as "hiding from him" count as insults to the husband, be it without reason or—what is punished more strictly—with (good) reason. The provincial judge of S. condemned a farmer's wife to 2 days of imprisonment, because she had dared to use physical resistance, when her husband was beating her.

Dec. 2, 1889, Moscow, to NIKOLAI KHARUZIN (Rus.):
Pappe has not completed his work. And has declined to remain a member of the bibliographical committee, so I was left with 15 journals, which I have to look through, as well as other publications. This means that the bibliography will be delayed, which I am very embarrassed about. Also not a single bibliographer showed up at the meeting, and I don't know when they will turn in their work. In short, I am sad and desperate. My goodness, how everything always ends in an inhuman way! — Today I waited for you until half past two. Were you ill?

Dec. 27, 1889, Odessa, to NIKOLAI KHARUZIN (Rus.):
Gray sky, gray sea, some sort of mist in the air, empty streets, houses dark, people dull ... here you have the miraculous South. Went to the sea; it lazily laps against dazed stones. One can hardly imagine a song

1890

sadder than this. How can we ourselves avoid being stupefied? No escape, everything is hopelessly dull. If not for my family, I would run away—but where to? It's the same everywhere. How to avoid becoming neurasthenic? Or finally, a hypochondriac, persuaded that our heart is nothing but a mechanical wheel, spinning without purpose in the void? [...] It would help to become a "rational mind" and just observe our dullness; but to sit and wait for such a beneficent metamorphosis is not for everyone. And in the end, even such "minds" get bored: they know everything and they all think alike. Everything is dull: getting up without purpose, then visits, dinners, evening events, sleep ... Perhaps sleep is yet the best part, but one cannot sleep all day long. Forgive me, dear Nikolai Nikolaevich, for my whining. But I cannot write any other way, and not to write at all is impossible as well.

Today I will attend a performance of *Carmen*. Music is a good thing. How come you so rarely listen to music? I ended up not bringing my "double bass" here nor my oil colors, and now I am dwelling in self-flagellation. But art, even dilettante art, is that promised land where one can hide from oneself. Art paralyzes bodily sensations, i.e., one does not feel one's body and lives exclusively in what is usually called the soul, and that means serenity.

June 25, 1890, Troekurovo [*Moscow province*], to NIKOLAI KHARUZIN (Rus.):

[*Kandinsky had just refused to take his exam in Roman law.*] Imagine a hot day, so hot that you are sure to melt, to perish. Imagine that on such a day you walk along a shady path, above your head entangled branches full of the bright fresh foliage of young linden trees, you walk toward a flowing icy creek, jump—naked as Adam—into the water and splash around like an innocent fish, and far, very far away, like the wisp of a cloud melting in the burning rays of the sun, Roman law is almost evaporating. — Or in the evening, when it has cooled down, on the back of Perkun [*the mythical horse*] you ride along winding paths through old forests, listening to all kinds of birds, or you're risking your life

1890

galloping at full speed across the fields, the hills fly by, one after another, the rye is waving in the wind, the wild cornflowers nod, farther, farther, and somewhere far away in the rising fog you hear the flute of a shepherd. Isn't that poetry? Or then a moonlit night? Or a sunrise? And music? But … like a black raven, like the ghost of the Devil stepping out of his grave, like a witch on her broom, suddenly and pitilessly the glimpse of a thought: "Exams." But oh well! I am happy here.

You know that your sisters are back from Finland and are living now in Kuntsevo? They probably wrote to you already. — Also happy to hear that you are well now. Only the exams. Have you already passed many?

You know, I can hardly believe that you are so far away. It seems to me that were I to come to Moscow, I would see you there. But I cannot possibly come to Sarapul [*in the far north where his friend was then doing ethnographic research*]. I kiss you affectionately, dear Nikolai.

June 4, 1890, Troekurovo [*Moscow province*], to NIKOLAI KHARUZIN (Rus.):

[…] Why do I write so seldom? I wondered, and well, that is the case with everything. I concluded that it is partly due to my lack of discipline, partly (and mainly) it is just an aspect of my character. I simply cannot write, even were one to butcher me, kill me! And now something embarrassing has happened. Since father left, I have only written him 1 letter, usually I write to him every 10 days or more often. Yesterday I had to force myself to send him a tiny note explaining that I simply cannot write.

Of late I managed to fall ill again, so I could not visit your sisters. Tomorrow I will go, even if I haven't quite fully recovered yet— but I long to see them so much. […]

Except for lessons I am reading all sorts of junk. Serious work is impossible. […] I am ashamed, because I had promised father I would recover well, and the doctor had recommended the same. But I am old and weak [*twenty-four years old!*].

Nov. 5, 1890, Moscow, to NIKOLAI KHARUZIN (Rus.):
My dearest one, yesterday a heavy fever shook me, even my teeth were hurting. I filled myself up with cognac and quinine, slept for 12 hours, and today I am well; only my head feels more like a bucket. [...] In the evening, I will visit the Abrikosovs. Would you come over for an hour tomorrow? I would like to see you very much. How is your health? The nights? The head? [...]
I kiss you and expect you tomorrow.

Dec. 28, 1890, Odessa, to NIKOLAI KHARUZIN (Rus.):
[*Half a page of specific New Year's wishes to every member of Kharuzin's large family.*] Just as before, I hardly look at my watch, only in the morning (quite late) and in the evening (also late). Otherwise my watch lives its own life, and I live mine. I am hardly at home, I don't study for more than 3 hours, so most of the time my mind is completely at rest. [...] This year I am leading a more pleasant life than before. I leave town, I go to the sea. [...]
I won't return before the 11th, as my brother is holding me back [*probably Vladimir, his favorite brother, who would die in the Russo-Japanese War a few years later*]. I kiss you with great affection.

Jan. 5, 1891, Odessa, to NIKOLAI KHARUZIN (Rus.):
3 more days here, then off to Moscow. Lucky is he who lives and works in the same place. I am constantly tempted: to leave, but then leaving is also sad. Probably the vestiges of my ancestral nomadic genes. [...]
I kiss you, my dearest one. [...]
P.S. Shall we go to the Hermitage on the 12th? In case we have to have a reservation, please make one for me as well. [*A trip from Moscow to St. Petersburg was quite a luxury in 1891.*]

Feb. 21, 1891, Moscow, to NIKOLAI KHARUZIN (Rus.):
My dearest friend Kolya, one day a catastrophe will strike and I shall die of shame! If you want to avoid such a disaster, please forgive me once again, as you have always forgiven me so far. Some perilous destiny: again I invited you when I could not be at home. Ages ago, I had promised Anya I would attend a performance of *Ruy Blas* with

1891

her [*a drama by Victor Hugo. Anya (Anna Chimyakina) was his cousin, six years older, whom he would soon marry*]. Please come on Saturday. I would be very happy, and I will then again beg your pardon. I kiss you affectionately. Greetings to all your family.

Sept. 28, 1891, Odessa, to NIKOLAI KHARUZIN (Rus.):
Terribly sorry, dearest friend, that I could not be with you on Monday. [...] My brother Volodya [*Vladimir*] was very sad about my departure and asked me stay with him for another half hour. So I did not leave because, additionally, I had to be at Sheiman's in the evening, as it was his name day. So I am still here in the south, where it is especially pleasant to be in autumn, where instead of dark clouds you see the bluest of skies, instead of the "smell" of Moscow the freshest sea air, instead of torrents of rain the rays of the brightest sun; instead of dirty puddles—the endless sea. [...]

How are you? Are you suffering from nightmares because of the bad luck that destiny sent us? Here the sunny rays of joy would do away with it. [...] My God, how one longs for certainty, be it just any kind of certainty! But one also wants pleasure. Chaos in the heart. — I squeeze your hand firmly and kiss you affectionately—my brother in shared misery. [*They probably both failed their exams.*]

Nov. 6/18, 1891, Vienna, to NIKOLAI KHARUZIN (Rus.):
[*From his six-month-long honeymoon trip. He gives the Western and the Russian date.*] Today we have been in Vienna already for 10 days, and 11 days out of Russia. And can you imagine, I am already getting used to the local dialect [*examples*]. Many beautiful things here: old and new together in harmony. [...] With many affectionate kisses, and Anya asks me to send her greetings to you [*detailed greetings to all his family members*]. Again kisses, All yours V. K.

Nov. 25 / Dec. 7, 1891, Milan, to NIKOLAI KHARUZIN (Rus.):
Today I have been married and abroad exactly one month. How little and how much that is at the same time! The whole trip, but Italy especially, was a long-desired dream, and now, having come true, the reality is less prized than the dream.

You write that I am happy. And this is true. Yet there cannot be on earth the kind of happiness of which one had once dreamed, happiness where you are not afraid to dig deeper, lest you stumble upon betrayed hopes, an unconscious happiness to which you do not cling. All this is "oh dreams, my dreams, where is your sweetness?"! However, I will repeat again: I am happy. [...]

I am the same, Kolya, and I love you just as before. As before, you are dear to me, or, better still, you are even dearer to me. [...]

Tomorrow we go on to Nervi near Genoa. There we would prefer to live, not as tourists, but I will paint again. [*Some forty years later, he still remembers Nervi in a letter to Paul Klee.*]

Please write <u>more</u> about everything in your life now. And don't be afraid to spoil my good mood. That is not the way friendship should work. How is your health? Your head? Can you sleep? I kiss you very, very affectionately, Kolya. Anya also sends her greetings.

Dec. 27 / Jan. 8, 1891, Paris, to Nikolai Kharuzin (Rus.): Dearest Kolya, I start my letter with a wish. Of course with a guilty conscience too, since you are so occupied, but knowing you as a friend, I dare ask you to send me 2 books [*specialized literature*]. Soon I will start studying, but so far we are enjoying Paris and its art. — Happy to hear that you can sleep so well now.

Feb. 15/27, 1892, Paris, to Nikolai Kharuzin (Rus.): Dearest one, I am starting to worry seriously about your health. [...] I am attending lessons at the Sorbonne: medicine and law. Not systematically, of course, since classes already start at 8:30 a.m., and I still lack the courage to get up so early; perhaps God will one day send me that quality. — Please give my regards to the ethnographers. [*He encloses programs for the medical faculty, because Kharuzin's sister Elena wanted to study medicine in Paris.*]

July 12, 1892, Odessa, to Nikolai Kharuzin (Rus.): I waited and waited for a letter, dearest Kolya, but now I will write to you, even if I don't know where you are at the moment. In 2 days we will have been in Odessa a whole month, a month full of idle laziness

1892

aiming at rational hygiene. And not in vain for my health: I am gaining weight and strength, I don't catch colds as often anymore, my nerves are recovering, and my mind is clearer, able to think more freely.

Of course, one needs the appropriate conditions to fill the days: I organize dilettante theater performances, I go swimming, riding, I paint, walk, read light literature and ... well, even for that there is hardly enough time. Remembering your tired nerves, your weak health and frequent colds, I constantly tell myself: "If only Kolya could recover this way!" And how much do I want to show you by my own example, how one is able to recover by leading a quiet and, mainly, healthy life. In general, lucky is he who can from time to time interrupt his daily routine: it not only refreshes, but it seems to me that it even broadens your view. But we all tend to specialize and therefore become narrow-minded. What do you think?

[*Kandinsky worried more and more about the health of his closest friend, who worked too much, suffered from depression, and finally turned to alcohol for "help." Before dying at the age of thirty-five, Kharuzin had become a recognized ethnographer with a number of publications (see Aronov,* Kandinskij, Jerusalem *2010).*]

Dec. 26, 1892, Vasilevsky [*Moscow province*], to NIKOLAI KHARUZIN (Rus.):

[*Kharuzin was spending time in Paris with his sisters.*] According to the newspapers, Paris is suffering a cold spell; 5 people have already frozen to death. I imagine how you are freezing, and how you are busy stoking the fire. Here, too, winter is icy: there have been strong winds already for 3 days now, blowing up piles of snow so high that horses sink in it up to their necks. And then suddenly clear days, full sun and crisp frost down to minus 30° [*Celsius*]. I continue to go for walks, shovel snow, then go skating and skiing down the hills. Only my painting falters, since my fingers can only bear it down to minus 10°. [...]

But I should concentrate more on my bad English. Those darned Americans have the bad habit of writing in endlessly long sentences; I thought the Germans were the masters of that art. And now I have to read English more than anything else.

24

You and I, we have left Europe—you are researching ethnographic peculiarities in Africa, and I—economical ones in America. — I wish you much success in the New Year and durably strong health. Anya sends her greetings, and I kiss you many times. Don't forget me.

May 22, 1893, Moscow, ALEXANDER CHUPROV to
KANDINSKY (Rus.):
It is my honor to recommend Wassily Kandinsky […] to the Department of Political Economy and Statistics. His serious studies in political economics, and the disciplines related to it […] convince me that Mr. Kandinsky will in time become a serious scholar.

May 27, 1893, Moscow, to ALEXANDER CHUPROV (Rus.):
Owing to your kind support, I have now succeeded in stepping onto the path that has for a long time been my aim. I beg you to believe that I will try to justify your trust in me to the best of my ability.

Sept. 23, 1893, Vasilevsky, to NIKOLAI KHARUZIN (Rus.):
We have become awfully entangled, Kolya. So entangled that much work has to be done to clarify the past and present of our friendship. […] Were it to mean the end, I say it would be <u>against my will</u>. […]

There are those who say that I am softhearted and sympathetic. Others say that I am coldhearted and reclusive. I don't know the reasons why my relationships with people have been complicated. Here it is (I don't need to begin *ab ovo* but from school days): as a child I experienced two quite dramatic events: for two years I was embraced, then it changed, at first in a hidden way, later openly, to hostility and the wish to hurt me. Outwardly I did not change, but my soul suffered greatly. You will understand that I was very attached to some friends who remained on my side. I trusted them, I loved them. Until the upper grades. Then I came to understand 2 things: 1) that some of my school enemies were actually my friends, and 2) that some of my friends were my enemies. Time passed, and relations with my former friends weakened, and finally they ended in the first years of

1894

university. It has to be added, too, that <u>none</u> of my friends has <u>ever</u> had access to the innermost life of my soul. From university times, I have had only one <u>true</u> soulmate: Anya [*his older cousin Anna Chimyakina, whom he had married in late 1891*]. I trusted her, and no one else. [...]

When I met you, I was struck by your friendliness. Your whole family welcomed me in such a cordial way that I started visiting you all, although I did not visit any other families and only 4 of my own relatives. Not yet enthusiastic, as I had formerly been, but I approached you. I no longer sought a harmony of minds, of viewpoints, in order to become closer. I already understood at that time that not the mind, but the heart brings people together. [...] I cannot demand frankness, but your insincerity became clearer to me, so I closed myself off to you. [...] I really hope that no dregs of misunderstanding will remain in our souls. But whether this is possible—I don't know.

Mar. 25, 1894, Odessa, to NIKOLAI KHARUZIN (Rus.):
[*Probably after a death in Kharuzin's family.*] In Odessa there are peculiar rocks, seemingly firm, [...] but from which small pieces split off and constantly roll downwards. Sometimes I feel that we all are standing on such treacherous rocks, seeking a firm footing, but the rocks break and crumble. And suddenly we see with horror that people close to us, dear to us, have fallen. And in no way, in no way could we help them, nor hold them back. It is so terrible that one consoles oneself with the fact that we do not disappear into some black pit, but are transported to a better, firmer, and more beautiful world. It would be good to believe that. When one is young, everything seems enormous and infinite. But when one suddenly feels how unsteady and unreliable one's basis is, how helpless one is [...] then one seeks God. And it is good to find Him. But for those of us who haven't found Him, it becomes more frightful and dark. [...] It is terrible to see the void in our lives. I feel it so strongly. And I want to shake your hand firmly.

Apr. 14, 1894, Odessa, to NIKOLAI KHARUZIN (Rus.):
Well, we will see each other soon. I'm looking forward to it very much. It means we will sit and talk together in your study, which I already

feel connected to my soul. For a long, long time we did not talk with open hearts. But there are matters about which we have to talk. God grant that we will become so close to one another that no black cat will be able to slip between us [*a Russian metaphor for differences that arise between people*].

Thanks to the wise decision of the faculty, I am now forced to change all my plans. This reorganization has kept me very busy lately. I will tell you when we meet what harm that decision has done to me. [*He was forbidden to interrupt his studies and spend a year and a half traveling abroad.*]

Sept. 15, 1894, Moscow, to NIKOLAI KHARUZIN (Rus.): Dear friend Kolya, I am ashamed even to write you. [...] Thanks to my absentmindedness I, of course, had forgotten that it's Sheiman's birthday tomorrow and we have been invited over. Anya and I are awfully sorry that such a disaster has happened a second time. If you want to prove that you are not offended [...] please visit us Tuesday, and not at 9 but earlier, whenever you can. Yes?

Jan. 30, 1895, Moscow, to V. E. GRABAR, a young university teacher (Rus.): At the last meeting of students and professors we discussed the question of whether we are allowed to exclude from our common meetings those professors whose level of knowledge has proven inadequate and who have been guilty of offenses by which even uneducated individuals would feel insulted.

June 11, 1895, Vasilevsky, to NIKOLAI KHARUZIN (Rus.): I talked to Volodya [*his brother Vladimir*]. Tomorrow (since today is Sunday) we will telephone several places to find out how to solve this problem. I cannot be at your place tomorrow, because it turns out that I don't have to go to Moscow before Wednesday.

Please give my best to your family; greetings from Anya, and kisses from me. [*This is the last of twenty-five often very long letters to his close friend.*

1895

Any tension had disappeared before Kandinsky decided to become an artist in the spring of 1895 and moved to Munich the following year. No contact after this point has been documented. After Kharuzin's death in 1900, Kandinsky visited the family in 1910 and perhaps also before. He dedicated Maurice Maeterlinck's book La Princesse Maleine *(Brussels 1891), to which he had added thirty tiny, delicate pencil drawings, to the Kharuzin family.*]

Nov. 7, 1895, Moscow, to Prof. ALEXANDER CHUPROV (Rus.):
Deeply respected Alexander Ivanovich,
I regret not having written to you before. The whole of last winter I was still undecided, and later you were going through difficult times, so I did not want to bother you with personal matters. [...]

I have decided to give up my work in science. Your constant kind support evokes in me a strong wish to explain the reasons for my decision. Firstly, I have realized that I am incapable of constant and diligent work. Moreover, I do no not have, and this is the stronger factor, enough of deep, sincere love for science. [...] And most importantly, I have no faith in science. Why? That is difficult to explain, faith does not have a "why." However, my disbelief developed gradually; for a long time I believed in science and, maybe for that reason, I loved it. And since I have experienced similar disappointments before, I tried, as much as I could, to exercise discipline, and now I see that time moves me further and further away from my former work. And my old and previously hopeless love for painting attracts me more and more strongly.

[*After finishing his university studies in 1895 with a doctoral thesis (unpublished) on the minimal wages of unskilled laborers, Kandinsky turned down a university career in Dorpat (now Estonia) and worked for a year as a manager at a printing company. We know little about this experience, except his comment: "I was surrounded by ordinary workers."*

In 1896 he was struck by Monet's Haystack *at an exhibition of French art in Moscow, where it seemed to him that "the object is missing." Instead of Paris, he*

*chose Munich and moved there with his wife Anna in December. He began study-
ing at the progressive art school of Anton Ažbe, but soon preferred to paint small
spontaneous oil sketches on his own, using palette knives instead of brushes (fig. 2).
In 1897 Anna gave birth to a son, who survived only one day.*

*In 1898, Kandinsky submitted paintings to the Association of Southern Artists
in Odessa, where he would exhibit quite regularly until 1910. In February 1900 he
exhibited with the Moscow Association of Artists.*]

KANDINSKY, "The Wonders of Photography," in *Novosti dnya*,
Moscow, Jan. 15, 1899 (Rus.):
Would it have been possible to imagine a short time ago, some 10
years, that such a seemingly mechanical medium as photography
would give artists the possibility of using their individual vision to
create art? [...]
Visitors to the exhibition were bewildered. Were they seeing won-
derful drawings in 1, 2, 3 different shades, or real paintings, or photo-
graphs of paintings, or finally real photographs of nature, as men-
tioned in the catalog? [*Kandinsky gives precise professional explanations of
several new techniques for producing artistic photographs that resemble the paint-
ings of Corot and Arnold Böcklin.*]

KANDINSKY, "Secession," in *Novosti dnya*, Moscow,
Nov. 19, 1899 (Rus.):
In one of my previous accounts of art exhibitions in Munich, I spoke
about the strange, even oppressive atmosphere that visitors had observed
in the rooms displaying Scottish paintings. I wrote about the tedious,
monotonous impression of a thin veil of mist that covered all the
works of these artists: mist in the morning, mist in the daytime, in
the evening, at night, and mist in the sunshine [...] a beautiful, char-
acteristic mist that adds a certain fairytale-like and poetic note to
their paintings, but which becomes extremely repetitive, to the point
of exhaustion. [...] They have softened the colors to such an extent
that the sun is transformed into a ghost. [...]

1900

But in the midst of this "International Congress of all types of mist," here and there the first glimpses of a new light suddenly appear. This light is not really a new phenomenon, born of its own accord, but it has started rather timidly to plot its path. Among its ancestors, we meet, as always with great joy, Claude Monet and that major artist Arnold Böcklin, who simultaneously creates, through his treatment of color, monotonous paintings as well as coloristic masterpieces. Other artists follow them, seeking to render the purity of color and the power of spots of color in their oil and tempera works. [*In this long, detailed article, Kandinsky goes on to describe the new Arts and Crafts movement that had crossed from England to the continent, soon to be called "Jugendstil" in Germany and "stil modern" in Russia.*]

Feb. 22, 1900, Munich, to ANDREI PAPPE [*an engineer in Odessa and a family friend*] (Rus.):
[...] Your drawing of a portrait is not bad for someone who knows nothing yet about drawing. My judgment: you have talent. But only later will one be able to see how strong it is and in which field you are especially talented. You have what one calls "an eye," but an undeveloped one, because you don't have any knowledge yet. In my opinion you should buy a "skull" and draw it accurately with the utmost diligence and rigor. Without this there simply won't be any progress, only technique, which is of no importance. At the same time one can of course draw portraits, but one should, so to speak, sense the skull under the skin and the flesh. [...] You should keep in mind the direction of each line with respect to the skull, as such. If you have studied one skull very carefully, you will have no problems with variations of other skulls. [...] Our teacher Ažbe taught us that no sculptor ever starts with the nose, eyes, or ears, but with the basic form, after becoming thoroughly familiar with the "principle of the sphere." [...]

Give my best to Alexandra Andreevna from me and from Anya.

[*A detailed postscript: how to prepare a canvas, using what proportions of glue, how long it has to dry, how to attach it to the stretcher, etc. And he repeats the*

30

words of an old master:] If you don't finish within a day, don't sleep, but try to finish your work. [...] And please ask questions, I will answer as best I can.

Mar. 25, 1900, Munich, to ANDREI PAPPE (Rus.):
I understand your feelings. I remember quite well that I also thought someone could tell me whether it would be worthwhile for me to take up painting. But now I see that it is impossible to form a clear judgment. Of all the very many artists here I would say only to three: "Give it up, the sooner the better!" But even they have already been working for years. How could I advise you, a beginner, in our cursed and eternally wonderful profession? I see nothing "hopeless" in your portraits. On the contrary. You have understood quickly what in other cases takes forever to learn. Weakest are the proportions. [...] Should I send you colors?

Mar. 29, 1900, Munich, to ANDREI PAPPE (Rus.):
Concerning early sketches for you to learn from: I threw away my very first drawings. Now I have asked a colleague, a successful draftsman, for his. He has agreed, and I may come and choose some. But I was not able to do so yet, because of stomach-nerves-Malaria-like symptoms. Please don't tell my family; basically they know, but not how serious my condition is. [...]

When working on people's portraits, feel their facial bones like a doctor would do (of course only with close friends!). So, good luck! Excuse my chaotic letter, but my head is aching.

[*Kandinsky sent him early studies by a colleague. In six long letters, he explained what he himself would start teaching a year later in his Phalanx school, about which we know very little; he followed the method of his teacher Ažbe quite closely.*]

Apr. 21, 1900, Munich, to ANDREI PAPPE (Rus.):
[...] For heaven's sake, skip all details! Our Ažbe has rightly said that for details one needs knowledge less than perseverance. If a study turns out badly, start a new one. Make a lot of sketches!

Now the "still life" comes into fashion here. Take a very colorful background and place some colorful objects (oranges, lemons, blue

1900

jars, etc.) in front of it. Render them as "spots of color." Only later will we proceed to less colorful objects. [...] How much trouble did I go through getting rid of the murky spectrum of those Serov-Korovin-Levitans! [*Famous Russian artists, not much older than Kandinsky.*]

May 15, 1900, Munich, to ANDREI PAPPE (Rus.):
Always and forevermore place the colors on the palette in the same order, so you hardly have to look at the palette while you work. One should constantly look at nature, occasionally at the canvas, and never at the palette. Apply the colors in thick layers, so that the brush becomes saturated. Use many brushes, so the colors do not become muddy. Clean the palette often, and the brushes daily; take new colors for every new painting. [...] Apply pure color to the canvas, then on top another layer of pure color. Never mix the colors on the palette for too long: the tone becomes dirty, the power dwindles. No compromises! If it goes wrong on the canvas, scrape it off and apply new color.

If we could meet in the summer in Odessa, it would all be easier to explain. [...] Since nothing colorless in nature exists, neither is there White nor Black; color burns and shines everywhere, and God forbid if one neglects that. This way nature is our best teacher.

July 25, 1900, Munich, to ANDREI PAPPE (Rus.):
Yesterday I finally realized that it is summer: green trees. And that after having painted a lot of summer-studies—I finally inhaled the perfume and the color of flowers and even suffered from the almost tropical heat. This paradox can only be explained by the fact that my thoughts overwhelmed me during my sketching trips to medieval towns (fig. 3). Tomorrow I would like to go to the mountains for a while for mountain-studies. [...]

Your color sketches lack exactly what should be necessary. One should, in painting, seek contrast, i.e., use the whole power of the color palette to create an abyss between dark and light. Only later, much later, do halftones and penumbrae come into play. [...] And don't think that "highlights" will make your painting lighter. On the

32

1900

contrary! Highlights kill the light. Try to render it by applying other lighter colors. [...] Forget failed attempts. Simply try again. I have observed the development of some "fast" geniuses who became dependent, "parasitic" creatures. But he who has his own mind and own eyes will succeed in creating something worthy. [...]

And furthermore do not choose wide views of landscapes, but smaller sections: a corner of a house, a piece of wall, a fence, 2–3 stones, etc., so that there is sun and shade simultaneously. Paint still lifes outside, taking advantage of the sunlight and shadow. Allow yourself easier tasks. — Your drawing of a head is already considerably better. Continue to draw, even if painting in color attracts you more. Send me both, your drawings and paintings. [*Kandinsky offered a similar explanation to his next student, Gabriele Münter: no wide views of landscapes!*]

Nov. 14, 1900, Munich, to DMITRY KARDOVSKY, St. Petersburg (Rus.):

[*Kardovsky, a former colleague and friend from the Munich art school of Anton Ažbe, had returned home.*] My dearest friend Dmitry Nikolaevich, all this time I've been rushing around like a true son of the new century, and therefore have not found the time yet to write you the letter I've been wanting to write for so long [...] so you would learn to what degree here everybody (without exaggeration), really everybody, remembers you and regrets that now we have to miss you. — As for me personally, I tell you frankly (though I am not a friend of such confessions) that your departure has left me even more lonely in my worries. I also regret so much to have lost you as a person. [...]

There are hopes that the "Moscow Association of Artists" will offer a separate space to a new group, which I have already mentioned to you. Members of this group will include, from Munich: Jawlensky, Salzmann, Seddeler, and me [...] from Petersburg, Kardovsky, if he accepts. [...]

And another project. This summer conditions were favorable and I decided to realize my old dream, so I spoke to several people about

founding a new association in Munich with permanent exhibitions of works of all forms of art. [*He founded "Phalanx."*]

From the bottom of my heart, I wish you all the best. Greetings to Olga Ludvigovna and my goddaughter.

Mar. 13, 1901, Munich, to DMITRY KARDOVSKY,

St. Petersburg (Rus.):

You are asking why I'm not feeling well? My uncle died, whom I loved very much and whom I now mourn … My nerves have suffered, and around me all has become empty and dark. My uncle has left me an inheritance, which will be sufficient for the rest of my life. Anya is in Moscow to handle these matters, so here I am now all alone.

Jawlensky and Grabar seem to have become best friends, and they both are looking for psychology + nationality. How do you like such an image?

[*Kandinsky continues to describe artistic life in Munich:*] The Spring Secession has opened, so stifling, cheap, complacent, and routine that one is disgusted. This arrogant, "brilliant" manner reeks of the swamp. Everyone seems to be clinging to the little he has achieved and hangs back from taking the smallest step for fear of losing something. Even the "youngest" artists, who get by on the achievements of others, are using the same "brilliant" manner. No new ideas anywhere, no fresh feelings. You write "gloom, gloom." And what can I answer if not the same?

Everything I do is in a way "preliminary." I simply don't arrive at what I really want; all sorts of ideas assail me, but I don't even find the time to sketch them down. I also lack knowledge, that's why I will go to Stuck [*Franz Stuck, the most renowned artist in Munich, with whom Paul Klee and many others also studied*]. I am lonely in my work. […]

I have exhibited with success in Odessa and Munich. I got a strange review in Odessa, which invoked the shadow of Puvis de Chavannes and called him an Impressionist. […] Yes, and in Odessa at a showing of the "Itinerants" I also saw Repin's paintings: executed quickly and badly. […]

Now it seems that I have found a good lacquer-based binder [*for the tempera technique*]. But one has to continue experimenting, reading, and learning ... If only I were 20 years old! But I constantly feel that it is too late for everything, and I get totally feverish. — You see how much I complain to you.

Mar. 24, 1901, Munich, to DMITRY KARDOVSKY,
St. Petersburg (Rus.):

Lately, I've been strongly attracted to tempera painting, which means that my palette knives are obliged to rest and wait for better times; for oils they are irreplaceable (fig. 2).

Sept. 16, 1901, Moscow, to DMITRY KARDOVSKY,
St. Petersburg (Rus.):

In Munich I prepared the exhibition and organization of the new association "Phalanx," where they suggested that I teach landscape painting. I also had my exhibition in Odessa, and here I am busy with the inherited house: lots of worries of all sorts. On top of that one has to join in the "hunt for the golden autumn," i.e., driving to the countryside and back again to Moscow.

At Phalanx I exhibited 6 small paintings, one portrait and 10 studies; I received good reviews and sold one painting and one study. In Odessa it will be 2 paintings and 10 studies. [...] At the end of the week, Anya and I move on to Odessa.

[*In 1901 Kandinsky wrote "Correspondence from Munich" for* Mir iskusstva *in St. Petersburg. He started teaching at the Phalanx school, where (in contrast to the Academy of Art and all official schools) women were admitted. He organized its first exhibition (ten more would follow until 1904). In the summer of 1902, he took his Phalanx class to Kochel in southern Bavaria, close to the Alps.*]

Mar. 29, 1901, Munich, to AKSELI GALLEN-KALLELA,
Finland (Ger.):

Our young association has set itself two main aims: firstly, to offer well-known artists the opportunity to exhibit numerous works collectively

1901, 1902

in the rooms of "Phalanx," and secondly, to give less known and totally unknown artists the possibility of stepping into the public eye.

According to our first aim we allow ourselves to ask you politely to participate already in our May exhibition with a selection of your works. [...] We take 10% commission on sales. [...]

With distinguished greetings, Phalanx, W. Kandinsky, 1. chairman.

June 13, 1901, Munich, to AKSELI GALLEN-KALLELA (Ger.):

[*Kandinsky is asking for several prints.*] There are already buyers for these items.

Oct. 10, 1902, GABRIELE MÜNTER to KANDINSKY [*not mailed*] (Ger.):

Dear K., [...] I sometimes feel very lonely because there is no one to whom I mean anything + of whom I am really fond, apart from my little brother. [...] Kandinsky is an awfully dear, nice fellow [...] he needs a greater—stronger—woman—I could not be that, even if I wanted to.

Nov. 8, 1902, Munich, to GABRIELE MÜNTER (Ger.):

I now have time to delve into my thoughts a bit. Up until now, I've felt only something disquieting, but I didn't know what it was. I think to myself that I'm doing nothing but stupid stuff, that I've forgotten my old ideals, that my dreams have become hopelessly confused, that the artist in me has died. No, not died! But has fallen asleep so deeply that sleep has become like death, that sleep can pass over into death. I have no rest from life, which penetrates me and turns me into a merchant instead of an artist. That is the personal thing pressing upon me. There's something else too: of late, I see only a lust for murder in people. And that alters my whole image of nature, the old image I cherished so much. It confuses my thoughts even more. I have terrible dreams and scream every night like a lunatic. And I feel lonely in my life. It seems to me I have to get far away from people. Stupid, isn't it? But that would be right, too. I can't offer happiness to anyone on earth. I only bring suffering to those I love. Damn. [...]

It's rare that I can be merry. But there is also joy in my heart, I enjoy life and nature very much, and from time to time I thank, from the bottom of my heart, the unknown power that gave me joy. One can read this joy in my paintings. But of what use is it to others?

Dec. 1, 1902, Munich, to GABRIELE MÜNTER (Ger.):
At times I take the palette and ruin within a quarter of an hour what I have worked on for months. Oh!

Jan. 30, 1903, to GABRIELE MÜNTER (Ger.):
If I wanted to characterize myself, I would say: always, constantly restless. Yes, that is the perhaps unexpected but purest truth. [...] Not a moment's rest, you understand. I'm always excited, my heart always feels different things together, at the same time [...]. There is plenty of joy in my heart. I love life so very much.

Mar. 13, 1903, Munich, to GABRIELE MÜNTER (Ger.):
Didn't I tell you already in K.[ochel, i.e., 1902] that I make everyone who gets close to me unhappy. That is my fate. I suffer from it myself. [...] It is not pessimism. I hate that.

May 7, 1903, to GABRIELE MÜNTER (Ger.):
In most of my works: sorrow shows its face, deeply hidden in the joy. That is also true for me: to me the world, the entire, great, eternal world is an eternal joy. It will all become clear later. The suggestions that nature communicates to me are still forming into a clear grand answer. The sorrow hidden in this joy is a reflection of my poor little soul. I want to delve into myself again. Through this open life and through this public activity I have become petty and vain. Away with it all!

[*In the spring of 1903, Kandinsky traveled to Vienna to see the exhibition of the Vienna Secession and meet his old Russian friend Benedikta "Bena" Bogayevskaya and members of his family. In the summer of that year, he took his Phalanx class to Kallmünz for a few weeks, where he and Münter became a couple. Later he traveled alone to Venice.*]

1903

Sept. 3, 1903, Venice, to GABRIELE MÜNTER (Ger.):
There she stands, like a fairytale city, incomparable and proud and solemn. Nothing can make her look kitschy! These svelte, long, slender, swarthy girls of the common people, with their long black shawls wrapped tightly round their bodies, their dark skirts and the fans in their hands, have something serious and quietly solemn about them that no painter (poor black souls that we are!) has yet taken away from them. Color, color! Noble, darkly luminous, crudely harsh and deeply harmonious colors, that show as clearly as is possible how poor, weak, and dirty our palette is! Damn! [*See the tiny sketch included in Hahl-Koch, Kandinsky, 1993, 105.*]

Sept. 15, 1903, Odessa, to GABRIELE MÜNTER (Ger.):
Haven't been here for 2 years. Just today I was with my mother at my sister's, where I met two tiny new creatures and saw my sister for the first time as a mother. Tomorrow the newborn child will be baptized with my sister and I will play the role of godfather. [...] Lots of children at the baptism—always makes me happy. But my dear aunt, who did so much for me during my childhood, is no longer here. [Concerning the Spiritual in Art *is dedicated to her.*]

Sept. 19, 1903, Odessa, to GABRIELE MÜNTER (Ger.):
[*He complains again about her "coldness":*] I must be such a very good Russian samovar, who can keep not only himself, but also others warm. I must be the kind of sun that also illuminates and warms even the cold moon; a fine role indeed, and a pleasant, flattering comparison! I love you very much.

Oct. 11, 1903, Moscow, to GABRIELE MÜNTER (Ger.):
I also feel sorry for you. It sometimes seems to me that you don't know at all what joy is, JOY, the most beautiful, purest joy that people do not produce. But the feeling of God, which suddenly brings almost complete clarity to the eternally unclear. If you have no knowledge of it, you must still have a sense that something like it must exist. When I was very young, I was often sad. I was looking for something, I was missing something, I was yearning for something. And it seemed

impossible to me that I would ever find what was missing. At the time I called this state of mind "the feeling of Paradise Lost." Only much later did I acquire eyes able sometimes to "peek" through the keyhole of the Gates of Paradise. But I'm too wicked and weak and I can't always keep these eyes open. I'm still searching for a lot on Earth. And he who is searching down here is certainly not looking for anything up there.

Oct. 31, 1903, Berlin, to GABRIELE MÜNTER (Ger.):

[*In 1903, Kandinsky exhibited at the Berlin Secession for the second time:*] I take my hat off to Böcklin again and have endlessly observed and admired him. If anyone should be called a master in our time, it is this artist, painter, draftsman, musician, poet. The old teacher Rembrandt, I have also admired time and time again. When one sees such things one really gains the desire and courage to be honest and to keep one's artistic soul pure. [...]

You're suffering quite typical neurasthenia: in the morning tired ... pessimistic, in the evening cheerful, full of hope ... I know it all so well: it was exactly like that in the old days. And even up until now I sometimes feel remnants of it in me. Those damned "black morning" glasses! And remedies against it: water and water and more water—hydrotherapy.

Dec. 24, 1903, to GABRIELE MÜNTER (Ger.):

I will make you my wife only when I'm convinced that you are unhappy in other ways too. I love you ever better and more seriously. That is why I don't only think of my own happiness but of yours as well.

Jan. 31, 1904, to GABRIELE MÜNTER (Ger.):

So strange that people only see the "decorative" side of my drawings and take no notice of the content. Yet I do not want to emphasize it any further. The content, the inner meaning, should only be felt. For me, intrusive content is ugly, uncomfortable, unrefined. It should almost always be a homogeneously beautiful form (artistically "beautiful," of course, thus perhaps "unbeautiful" to the uninitiated). Sometimes you don't have to see the beauty of the thing right away. Some

things must appear incomprehensible at first. Then the beauty comes to light. And only then the inner meaning, for the sensitive viewer. The thing must "chime" and through this sound one comes by and by to the content. But it should never be too clear or too one-sided: the more possibilities for imagination and interpretation, the better. Various contrasts of form-feeling are best combined if one wants to express deep, serious content. And the deaf and the blind just have to walk past calmly without noticing anything. If they notice something, it's a bad sign: then the content is certainly base, cheap. There you have my philosophy of art, which I am usually reluctant to talk about.

Feb. 18, 1904, to GABRIELE MÜNTER (Ger.):
I read Turgenev and came up with some not exactly amusing thoughts. Has man himself made such a terrible mess of life? Or, no matter what he does, life itself (or that incomprehensible power we always want to understand and cannot) makes man's destiny complicated, entangled, tragic? Old questions, old thoughts that suddenly awaken and beg for an answer! Why is it that everything that gives one pleasure almost without exception has to hurt someone else? [...] Why can't one build a tower in which one hears nothing of the world, of life? Why does life seep into everything, like dirt into a cracked shoe? [...] Again, I have seen life from above, in a way I haven't for a long time. Awful, wretched, unfortunate. Cursed be the minutes when one "sees life from above"!

Late Mar. 1904, to GABRIELE MÜNTER (Ger.):
When our souls come together even more closely, understand and immerse themselves even more deeply in one another, I will again be calm and full of life, as is my true nature. Remember how I used to torture myself almost constantly. One cannot endure that without it leaving its mark. But my inner nature resists and reemerges as it truly is. Just believe me and help me in my weak moments. Let's come to an agreement and both think more of one another. The result will be a harmonious, free life for us both, after these troubled times. We live together as one being. We understand each other, feel together, rejoice

together in life, in nature, in God. I would like to pass my faith on to you. I would like us to feel together right now. But things are also fine. Look at the progress we've made since last summer. We belong together. A great power has united us. And I'm grateful to that power, whatever its name, with all my heart.

Apr. 7, 1904, to GABRIELE MÜNTER (Ger.):
My painting "Battle in Red and Green" is constantly evolving. I might bring the sketch with me. It must be serious, strong, and solemn. One knight (green) rushes full of rage at the other (red), who remains calm and self-possessed. Background—old white prosperous Russian city, stormy sky; in the foreground, a brown-gray path and green lawn with many nicely executed flowers. I am looking forward to this painting and expect a great deal from it. The language of color is perhaps too clearly narrative. No matter! Saw much beauty today in color values—deeply resounding, tranquil organ tones. [*This painting is lost.*]

Apr. 8, 1904, Munich, to DMITRY KARDOVSKY,
St. Petersburg (Rus.):
As to my woodcuts, I would be very happy were you to choose some. It's not even necessary to ask. Please take as many as you like.

"Phalanx" is now showing two exhibitions simultaneously: French Impressionists and graphic art from Munich. Last week I quit the presidency of "Phalanx" [*where he had organized a total of twelve exhibitions*]: In May I will travel through Germany to have a rest, visit some shows, and look for interesting things on the German art scene, which could serve our autumn exhibition "Line, Form, and Color." At our next meeting we will admit Jawlensky as a member. I smile with pleasure at the thought that I will soon be rid of these constant worries about Phalanx, the never-ending trifling details. I have projects, plans, and ideas. My hands itch and my heart races.

I only painted 5 small paintings last winter, 3 of which are now in the "Berlin Secession," 2 still at home. A few woodcuts, quite a number of color drawings, that's all. Many a seed has germinated in my soul.

1904

I am almost ready for a definitive painting. I look forward to it eagerly. Perhaps I will succeed in saying here what so far (except in a small painting which is still at home) I have merely hinted at.

Apr. 10, 1904, Munich, to GABRIELE MÜNTER (Ger.):
It's the first time in my life that I'm giving more than I get in return. Only the dear Lord knows why I am so convinced that I will fully gain your love.

Apr. 12, 1904, Munich, to GABRIELE MÜNTER (Ger.):
I cannot work without joy. I understand this all too well now. When I'm miserable my art is …! [*"in the ass," but the word is omitted.*] Perhaps that is shameful, but I can't help it. I have to feel good, then I see God, and thank Him, that He lets me see here and there, even if only a ray of His glory.

Apr. 14, 1904, to GABRIELE MÜNTER (Ger.):
Spoke to my wife yesterday for 4 hours. I also never doubted that she would let me go. She said that she is happy when I am happy and that I should marry again. [*About traveling with Münter:*] This pre-legitimate state of affairs is least noticeable when traveling. In any case, I don't want to stay in Germany at this time, where law and society, the "world," are less liberal than perhaps in any other country. And now for the last point: not living together as long as I'm not free. Why? For what? For society? 1) As long as we are not recognized by the state as spouses, we live beyond society. And 2) are we really going to sacrifice, make a gift of, one year in my life to this society for which I have no respect? And 3) one more year not living with you is too hard for me. […] You call me careless. I'm not. If your brother wants, I will come to Bonn and speak with him. […] That not only your brother, but also you consider me to be careless, hurt me a lot. […] I've been working all evening on color theory and I'm tired.

Apr. 25, 1904, to GABRIELE MÜNTER (Ger.):
I have to delve deeply into myself in order to be able to judge the effect of color on my soul. […] I've come a long way in this matter, and the

42

path before me is quite clear. Without exaggerating, I can say that if I solve this task, I shall be pointing the way to a new, beautiful, method of painting, suitable for infinite development. I am striking a new path, which some masters here and there foresaw, and which will be recognized sooner or later. [...] At the last exhibition in Moscow I sold a small picture. Got another invitation from Wiesbaden, and I sent 9 drawings. In Rome one drawing also sold.

May 2, 1904, Munich, to GABRIELE MÜNTER (Ger.): Last day with my wife after 12 years! [...] She wants to console me.

[*In May 1904, Kandinsky and Münter traveled for a month together in the Netherlands. In the spring, Kandinsky's work had also appeared in the inaugural exhibition of the artists' group "Les Tendances Nouvelles" at the gallery of the same name run by the artist Alexis Mérodack-Jeaneau. Soon after, Mérodack-Jeaneau founded the review* Les Tendances nouvelles, *which would go on to publish some thirty-three of Kandinsky's woodcuts between 1904 and 1909.*]

Aug. 10, 1904, to GABRIELE MÜNTER (Ger.): [*The year before, Kandinsky had asked Münter if she would be interested in woodcutting. For him, the medium was akin to poetry as a form of expression, and his album of sixteen woodcuts,* Poems without Words, *had been published in Russia in 1903.*] Do you see, apart from the issue of success and sales (which can never be my first priority), there are also artistic purposes and goals that you don't understand, because they may not yet be expressed energetically enough. But don't try to hold me back from it. I am incorrigible as far as this goes, pigheaded and particular about even the smallest detail. It is impossible to influence me in any way here. And don't question me about the usefulness of this or that type of work: they all have the same purpose—I <u>must</u> do them, because I cannot rid myself of my thoughts (or possibly dreams) any other way. I can think of no practical use either. I just <u>have to</u> do the thing. You will understand better later. You say: this is playing! Yes indeed! Everything an artist does is also just playing. He torments himself, tries to

find an expression for his feelings and thoughts, speaks with colors, shapes, drawing, sounds, words, etc. What for? A big question! [...] This is why I do everything that I <u>have to</u> do: when it is ripe in me it <u>must</u> find its expression. When I play like this, every nerve in me vibrates, music sounds in my whole body, and God is in my heart. I don't give a damn whether it is difficult or easy, time-consuming or not, useful or not. And here and there I also meet people who are grateful to me for my stuff, who benefit from it. A well-known Russian artist came to see me yesterday and told me that he was in good spirits for a whole day thanks to my tall lady with child (fig. 5) (which I gave you as a present and he saw at Littauer's [*a Munich art dealer*]), kept seeing it in his mind all the time, so he finally went back to L's and bought the thing so he would always be able to enjoy it. And this makes me happy too. [...] That you ask so much of me pleases me a great deal, really a great deal, but do not expect everything from every single work, firstly because it is almost impossible; and if possible— detrimental and bad for the work. The best example—Munich art. Well, all the rest later in person.

I will make you powerful and strong and healthy yet. And God will speak to both of us. Joy, Joy! Inner happiness. A full life. Poetry, true poetry.

Sept. 5, 1904, Munich, to Boris Egiz, Odessa (Rus.):
Thank you for your information concerning the exhibition. Just started to ponder what I could send you, but I don't know when the exhibition is opening. I intend to be in Odessa around Sept. 20 in the Russian calendar, and I would be interested in learning about the Association's exhibition activities this time. I am enclosing the list of my works + prices.

Oct. 31, 1904, to Gabriele Münter (Ger.):
[*In addition to participating in exhibitions in Germany and Russia, Kandinsky showed his work for the first time at the Salon d'Automne in Paris in 1904.*] I've received requests for reproductions of my things from two [*French*]

publications. [...] Paris really offers opportunities! Not like these insipid (Hm! Sorry!) Germans who take years to get used to anything new.

Nov. 2, 1904, to GABRIELE MÜNTER (Ger.):
[*While visiting a family of artists:*] I fell in love with the painter's wife. Good heavens, what a beauty! I'm happy that I'm invited there for dinner next week: I'll see her once again. Her whole being and her manner are like a song. Her husband is my good friend and surely does not hold it against me that I have been staring at his wife so unashamedly.

Nov. 16, 1904, to GABRIELE MÜNTER (Ger.):
I am no patriot, Ella. And also only ½ Russian. [...] I grew up ½ German, my first language, my first books were German; as a painter I have a feeling for Germany and all things German, German antiquities mean more to me than to very many Germans.

Nov. 30, 1904, to FEDOR RERBERG, Moscow (Rus.):
Many thanks for your detailed letter, which I received yesterday. I would be happy to take part in the exhibition of the "Moscow Association of Artists." I am grateful for all your care and concerns about my matters. [...]

As for *The Old Town* (fig. 3), I would like to sell it in Russia, preferably in Moscow. The collection of my work is still in Warsaw, but it will travel in 12–14 days to another country. [*After Warsaw the painting was shown in Krakow, in Dresden in November, and in Berlin in 1912.*] Should Mr. Khodasevich really want to buy *The Old Town*, I would wait for the payment, although I would need the money for my next voyage [*to Tunisia with Münter, December 1904–April 1905*].

I shall be in Warsaw on Nov. 5 or 6. You can write to me general delivery: in Berlin approx. Nov. 7–9; in Cologne Nov. 10–16. After that my address will be Odessa, from where my mail will be forwarded to me.

Aug. 20, 1905, Munich, to GABRIELE MÜNTER (Ger.):
Off to Herrsching to see Chuprov. [*His Moscow professor had left Russia for political reasons. Kandinsky organized a cure for him at a sanatorium by a lake*

south of Munich. He likewise helped Chuprov's son and daughter.] Listened to Wagner [*then Kandinsky speaks about hiking in southern Bavaria*].

Frankly, I don't think that Jawlensky's dot painting is quite right. Anyone can use this style, if he wants to, but it is hardly to be recommended as a teaching principle. In any case, I would absolutely not dissuade you from working like that for a while—even with dots: as I said, you can learn something at J.'s and give up the method later if it doesn't suit you. [*Jawlensky was already well aware of the Pointillist method in France.*]

Sept. 8, 1905, to GABRIELE MÜNTER (Ger.):

The doctors identified a proneness to gout. I should eat less meat, rather vegetables and fruit. [...] A sad letter from mother, the loss is painful [*Kandinsky's brother Vladimir was killed in the Russo-Japanese War*]. In Russia a struggle between the government and intellectuals. [...] One of the greatest evils of our time is the press, which is allowed to spit on everyone publicly + is always right.

Sept. 17, 1905, to GABRIELE MÜNTER (Ger.):

[*He continues here after vividly expressing his enthusiasm for the Russian Revolution of 1905, with great hope for more liberalism and democracy.*] I'm not taking part in the Revolution in R.[*ussia*], Ella. You know what I think about that. I want to paint something great first, I want to express what has been overloading my soul for so long. And I still hope to blaze a new trail in painting.

Sept. 18, 1905, to GABRIELE MÜNTER (Ger.):

I have never written to any individual in such detail, yet you are dissatisfied. [...] The portrait I painted of you is a lousy painting [*literally,* Saumalerei *("a pig's painting"), probably because it is conventional, and portraits in general did not interest him—not a single self-portrait exists*] (fig. 6).

Sept. 20, 1905, Munich, to THE ASSOCIATION OF SOUTHERN ARTISTS, Odessa (Rus.):

I have the honor of sharing with you that my 2 paintings intended for this year's exhibition are at V. S. Kandinsky's apartment: 23 Gogol

Street, because I hadn't received any news about the opening of the exhibition and therefore couldn't take care of it myself. — P.S. I will be in Odessa on Sept. 20 (Russian calendar), at the address above. [*The difference between the Western and the Russian calendar is thirteen days.*] 1. *In the Village* (oil) 500 rubles (fig. 2) — 2. *Sunday* (oil) 300 rubles.

Sept. 11/24, 1905, Odessa, to GABRIELE MÜNTER (Ger.):
[*What*] the Russian government [*is doing*] in the Caucasus is such a bastard of a business [*Ger.* Regierungsschweinegeschichte]. Damn the government to all hell! [*Three days earlier, he had already complained about Münter's lack of interest:* "You are indifferent to my worries about Russia. You might try to sympathize in your heart, if not in your head."]

Sept. 12/25, 1905, Odessa, to GABRIELE MÜNTER (Ger.):
An astronomer, whom I had been wanting to meet for a long time, was invited to Ksidas's. He showed us the moon, Jupiter, Saturn. [...] We observed the stars and the Pleiades. In bad weather the astronomer gives lectures. I'm making progress in astronomy and can already recognize some stars. [*In the six-story tenement house he would build in Moscow in 1913, he planned a tower as an observatory.*]

Sept. 15/28, 1905, Odessa, to GABRIELE MÜNTER (Ger.):
It doesn't mean you are uneducated if you don't know about various historical events (to hell with when and where something happened!), but that the significance of certain tales necessarily escapes you. You must always consult your head and your heart in every case. [...] Things are going well in Russia. The peasants have founded a union (themselves), in which 200-thousand members are already participating! And it grows larger every day despite the administration.

Sept. 16/29, 1905, Odessa, to GABRIELE MÜNTER (Ger.):
If you only knew how happy the behavior of the Russians makes me. They act so wisely, <u>truly</u> liberally + independently of any influence, so seriously, confidently + calmly. [...] Yes, I know my country: I predicted this all a very, very long time ago: government and people! Hell and Heaven!

1905

Sept. 19/Oct. 1, 1905, Odessa, to GABRIELE MÜNTER (Ger.):
Father and I have both condemned the government and wished its
rapid end. Damn the government 100 times over!

Sept. 28/Oct. 10, 1905, Odessa, to GABRIELE MÜNTER (Ger.):
[*For Münter, who never joined him in Russia, Kandinsky lists all the names and
nicknames*—"a whole dictionary!"—*of his extended family and all the children
whom he loved dearly.*]
I still feel so close to my brother Vladimir [*who died in the Russo-Japanese
War*]. The dinners I don't like: boring, and there is quite a lot of drink-
ing, which I can't stand and therefore have to refuse many "cheers."
[*An enclosed newspaper clipping: 116 political attacks on government clerks—forty-
two dead.*]

Oct. 10/23, 1905, Odessa, to GABRIELE MÜNTER (Ger.):
Shura [*i.e., Alexandra, his brother's widow*] and I are both crying. She then
consoled me. Now I understand even better my brother's boundless
love for her. The love they had for one another is like a miracle in our
spiritless world. Still, I believe that I too am capable of it. [...] I got
an enthusiastic review in a local newspaper, a very long thing, but in
which they reproach my extraordinary talent of not wanting to know
anything about the revolution. Strange guys! — Also got various small
but good reviews from Paris.

Oct. 11/24, 1905, Odessa, to GABRIELE MÜNTER (Ger.):
I told mother everything yesterday [*about the mutual agreement with his
first wife Anna to divorce*]. She was very good to me. She said she feels
sorry for Anna, but that it is better for me. [...] Father is eager to get
to know you.

Oct. 12/25, 1905, Odessa, to GABRIELE MÜNTER (Ger.):
If only you knew how proud I am that my predictions about real
liberalism [*in Russia*] are coming true more and more. [...] My dearest
German Ella who can have a say! Stay liberal.

Oct. 26, 1905, Odessa, to BORIS EGIZ (Rus.):
I am sending you the text of our notes, which you can correct if

necessary and forward on to the publisher. — Sincerely, Kandinsky [*He enclosed his handwritten text.*]

Oct. 17/29, 1905, Odessa, to GABRIELE MÜNTER (Ger.):
It's difficult to reach Moscow: a general strike. Father has hoarded food. [...] The people want, by peaceful means, to force the government to make major reforms. Hopefully the government will finally understand the situation and give in. [...] Almost no violent acts. De facto freedom of press, although the old laws still exist. [*On Oct. 17, Nikolai II signed a decree granting civil liberty.*]

We both know that there is something in me. And the longer I'm not generally recognized, the greater the power that lies within me. Whatever is recognized too soon is always weaker. This calm opinion will not surprise you, since you know how conceited I am.

Oct. 18/30, 1905, Odessa, to GABRIELE MÜNTER (Ger.):
Ella, Ella, congratulate me! It has happened, at last, at long last. We have a proper constitution and are no longer subjects, but citizens, real citizens with all fundamental rights. After 25 years of anticipation I am living this day now, tears welling in my eyes. Great processions with red flags, thunderous "hoorays." — Finally, finally freedom. Congratulations, joy. There are some parties who already want much more. What for, if the right to legislate now belongs to the people? Happiness, Ella, happiness! Beloved one, my dear, I know you will rejoice with me.

[*But a few days later he was too shocked to describe the horror of the pogrom against the Jews and three thousand dead:* "Days of terror ... I don't want to describe them. Of course, the most beautiful moment of Russian history has been completely ruined." *His father was so disgusted he left Odessa. Kandinsky explains that the culprits were hooligans, murderers, the basest section of the people, but also the police, the clergy, the Cossacks, and* "the dear patriots."]

The reviews I got are certainly stupid, but good as proof that I have finally attained a high and secure status here [...] it took me 6 years to achieve. What's more, it will continue to spread everywhere and

reach greater heights. [*In the fall of 1905, Kandinsky exhibited at the Salon d'Automne in Paris and for the first time at the Salon des Indépendants.*]

Oct. 27/Nov. 8, 1905, Odessa, to GABRIELE MÜNTER (Ger.):
A secret meeting took place, where the foundation of a new association was discussed. The very well-known portrait painter, who helped me a lot during that first difficult time, said to me: "Stay here for a few months and take over the job. It needs great energy + an imperviousness to abuse in the press. All of this you have in great measure." [*He did not stay.*]

Dec. 2, 1905, Brussels, to FEDOR RERBERG, Moscow (Rus.):
My paintings are in the Historical Museum, where they were exhibited last year by the "Union of Moscow Artists." Please be so good as to arrange to have them sent to Helsinki, Ateneum, to Dr. Ernst Nordstrom. You remember, there are 25 works. Please have them packed in my cases and ship them as soon as possible.

[*In 1906, Kandinsky spent five months with Münter in Rapallo, Italy, during which time his father visited. From there they went to Paris for a year. In Sèvres, near Paris, they separated for some time, and Münter lived in the city and took drawing lessons. In the autumn, Kandinsky exhibited twenty-one works at the Salon d'Automne and was awarded a Grand Prix.*]

Mar. 1906, Rapallo, to DMITRY KARDOVSKY,
St. Petersburg (Rus.):
I just received a telegram from the "New Association," forwarded from Munich. At the moment I have almost nothing, but I would like to take part in your exhibition. I intend to ask the Dresden exhibition, where there are a lot of my works, to send you two drawings that I think are very good. I expect this to be done. When does your show open? — Drawings: *Early Morning*, 150 rubles; *In the Palace*, 250 rubles. [*Both drawings are listed in the St. Petersburg catalog as nos. 26 and 27.*]

Mar. 25, 1906, Rapallo, to BORIS EGIZ, Odessa (Rus.):
Just today I received news from Moscow that my paintings, which were in the last exhibition of the Association of Southern Artists in Odessa, have not arrived in Moscow. I have no explanation for this embarrassing fact. The large painting *In the Village* (fig. 2) has already been sold to Kiev, and now the buyer could cancel. I would like an explanation ...

Apr. 6, 1906, Rapallo, 1906, to BORIS EGIZ, Odessa (Rus.):
Thank you for your letter of March 3, which I recently received. Unfortunately, you don't answer my questions. [...] Please write to me at the address in Rapallo until the end of April (Russian calendar), after that to Bad Ems, Germany, general delivery.

P.S. As soon as my painting *In the Village* is found, please send it express to A. I. Duvan in Kiev [+ *address*].

June 28, 1906, Sèvres, to ALEXANDER CHUPROV
[*his former professor*] (Rus.):
It is indeed good here. It is also silent. I am so attracted to silence that I don't even want to go to Paris.

July 7, 1906, Sèvres, to BORIS EGIZ, Odessa (Rus.):
Here is my address in Sèvres (near Paris): Petite Rue des Binelles 4. Please let me know the date of the next exhibition. [...] My paintings are still stored at the railway station in Moscow, and I have not been able to get the "Artists' Union" there to fetch them yet.

Sept. 8, 1906, Sèvres, to BORIS EGIZ, Odessa (Rus.):
I am very grateful to you for all the trouble and care you have taken upon yourself concerning my affairs. Maybe one day I will be able to thank you for it, and not just with words. Let us hope that my 6 paintings will be found. — Enclosed is the list of those works that have probably already been sent from Munich to the address of Alexander Pappe, who has agreed to help me with the exhibition. This year I am only sending drawings and therefore do not seek to claim a space in

1906, 1907

the main room. But I would ask you to hang them as a group or at least close together.

Sept. 27, 1906, Sèvres, to BORIS EGIZ, Odessa (Rus.):
Please be so kind as to send my pictures to Moscow, to the secretary of the "Artists' Union" [*Rus.* Tovarishchestvo khudozhnikov], Mikhail Ivanovich Shesterkin.

Nov. 19, 1906, Sèvres, to GABRIELE MÜNTER, Paris (Ger.):
You forgot to take the *Tendances* and the prints yesterday. I'll send them to you.
[*A newspaper clipping enclosed: "Le president de la République a quitté Paris pour se rendre à Rambouillet, où il a offert une chasse en honneur des grands ducs Vladimir, Alexis et Boris" (The president of the Republic has left Paris for Rambouillet, where he is organizing a hunt in honor of the grand dukes Vladimir, Alexei, and Boris):*] All 3 are thieves.

Dec. 4, 1906, Sèvres, to GABRIELE MÜNTER, Paris (Ger.):
[*Regarding* Riding Couple, *1906–7:*] I have given form to many of my dreams in it (fig. 8): there really is organ-like music in it [...] and twice I've felt the strange fluttering of my heart that I used to have so often when I was more of a painter-poet. I have also come to understand some things further in theoretical terms. But do I have enough life and strength to put this theory into practice? I'll be 40 tomorrow.

Jan. 27, 1907, Sèvres, to ALEXANDER CHUPROV (Rus.):
I'm liking Paris, as well as France as a whole (as far as I have seen), less and less. It is so cold here, more than probably anywhere else. And impersonal. [...]

It seems to me that in this new era of art that is beginning (and perhaps in art as a whole), the French will only warrant a lesser ranking. Apart from Gauguin, and, to some extent, M. Denis, only a few seem to me to be up to the tasks with which artists are more and more clearly and explicitly confronted. These new responsibilities occupy my thoughts too, but the little that I have already resolved within

myself is hardly to be found in my painting. I hurry to work, although I know that one achieves nothing by forced haste.

Feb. 20, 1907, Sèvres, to GABRIELE MÜNTER (Ger.):
Suddenly my heart was so full that I unexpectedly broke into tears. It's been ages since I cried like that. I sat on the floor and could not contain myself. My entire life passed before my eyes … without exaggeration, I would have been happy to die at that moment. […] Why must I torment those whom I love most? Am I such a sinner, who does not deserve forgiveness? [*Much later he reminded Münter that she had said something so terrible to him that he asked her to leave for a while and move from Sèvres to Paris, which she did. He later recalled this in a letter to Will Grohman, Aug. 18, 1932:* "At that time I was going through a very difficult period, perhaps especially in Sèvres, troubled by many pernicious doubts concerning art, but also purely personal matters. Deliverance came only in 1908, when I was back in Munich. I don't generally like to speak about this."]

July 7, 1907, Bad Reichenhall, to GABRIELE MÜNTER (Ger.):
I thought the cure would help. But perhaps I will not recover entirely. Regardless, I will gain some strength and I'm already better than in France.

Sept. 20, 1907, Berlin, to BORIS EGIZ, Odessa (Rus.):
Many thanks for your information about the exhibition. I am sending a list of my works and the prices. Please give my Berlin address in the catalog (Kurfuerstenstr. 46), as my father does not live in Odessa at the moment. I will send my paintings to the agency A.[*lexander*] Pappe in Odessa. Several pictures are already there, the others will arrive well in time.

[*In 1907 Kandinsky exhibited in Angers, France, thanks to the good connections he maintained with the review* Les Tendances nouvelles, *which continued to publish his woodcuts. In June he left France and spent five weeks in a sanatorium in Bad Reichenhall, close to Salzburg. He then traveled with Münter to Switzerland and*

1907, 1908

in September to Berlin, where they stayed for six months until April 1908. There he encountered the theater work of Max Reinhardt and indirectly that of Edward Gordon Craig. He submitted works to the Berlin Secession and again to Odessa.]

Nov. 10, 1907, Berlin, to MIKHAIL SHESTERKIN, Moscow (Rus.): Could you please let me know if the exhibition of the "Union of Moscow Artists" is going on to Petersburg this year? If so, to what address should I send my paintings? The show in Odessa is coming to an end in the days ahead. If there is no exhibition in Pt., could the works be sent to the Historical Museum in Moscow?

[*In the spring of 1908, Kandinsky and Münter spent several weeks in South Tyrol and painted a great deal. Back in Munich in June, they discovered the beautiful town of Murnau between Munich and the Alps, where they both progressed considerably in their work.*]

Apr. 12, 1908, Munich, to GABRIELE MÜNTER (Ger.): Secession: So already in the first room I found the same oxen, the same Stuck, everything in the same old places. Only now Stuck signs: Franz von Stuck [*newly ennobled*].

Dec. 10, 1908, to GABRIELE MÜNTER (Ger.): Please bring an undershirt (in fine silk) for both the Hartmanns.

Dec. 15, 1908, to GABRIELE MÜNTER (Ger.): I slept miserably and dreamed about dying Werefkin. [...] I'm making woodcuts for Hartmann's album.

[*The first International Salon, organized by Kandinsky's friend Vladimir Izdebsky in Odessa in 1909, included paintings by Kandinsky and traveled on to Kiev, Riga, and St. Petersburg. In February and March, he spent two weeks with Thomas de Hartmann in Kochel, close to the Alps, working on their theater experiments. Soon after, the German/Russian circle around Marianne Werefkin formed the Neue Künstlervereinigung Munich (NKVM) with Kandinsky as president. Their first exhibition took place in December. The reactions of the press and the public were*

scathing. In August, Kandinsky bought a house in Murnau under Münter's name, perhaps out of concern for her in the event they never married. In 1903, the couple had already considered traveling to Great Britain (specifically to Gretna Green), one of the few places they might have been able to wed—and divorce immediately thereafter—all for the sake of giving Münter the title of a married woman.]

Nov. 12, 1909, Wernstein, ALFRED KUBIN to KANDINSKY (Ger.):
This time I cannot send anything to Izdebsky's exhibition. — Now about your manuscript! [*He refers to "On the Life of Colors," the first draft of* Concerning the Spiritual in Art.] I am very fond of it, your ideas are completely original, delving into profound depths. What you say about colors is extremely appealing. [...] In terms of style and language something is still lacking, but that is secondary.

Dec. 18, 1909, ALFRED KUBIN to KANDINSKY (Ger.):
I'm an old experimenter and I'm still not sure what role ornament will play in the art of the future. [...] For that reason alone I'd like to know how others, especially you and Jawlensky, feel about it.

Feb. 24, 1910, Naples, THOMAS DE HARTMANN to KANDINSKY (Rus.):
A thousand thanks for your letter, which is dear to us, and also for the trouble you took with the book. By the way, why don't you fetch Naumann's *Music History* from my house, 2 volumes, you'll find something about Indian music there—read it; perhaps it could be useful to you as a general reference concerning color—tone, instruments etc. [*They lived on the same street in Munich, and their doors were always open to one another. Kandinsky had asked his new composer-friend for information about the typical sounds of various instruments. Hartmann continues by writing about Rachmaninoff, Bruckner, Brahms, etc. Then he describes a very long dream connected to their collaboration on* The Yellow Sound.]

By the way, I'm reading Akàsha and the Theosophists, so it's forgivable to dream nonsense, right?

1910

Mar. 2, 1910, Murnau, to Boris Egiz, Odessa (Rus.):
Of course, I regret that the Artists' Union did not show my new studies
in Kishinev. I have progressed already considerably from my early
works, so I don't like to exhibit them without the recent ones.

It always makes me happy to see the large number of exhibitions
in so many places in Russia. Today Russia has reached a high level in
art. In the field of theater, it undoubtedly plays a leading role. The
music is excellent too. As for painting, only France can compete.
Russian art is so full of vitality ...

Kandinsky, "Letter from Munich," *Apollon* III, no. 7
(April 1910) (Rus.):
[*Regarding an exhibition of the French Fauves:*] Among these works, there
is not one that is mediocre. All are interesting, beautiful, serious.
Much of it consists of miraculous *peinture*. But among them, only
Matisse has gone beyond the "accidental forms of nature"—or, better
expressed, only he has succeeded in entirely discarding the inessen-
tial (negative) aspect of forms, replacing them with, so to speak, his
own forms (positive element). All the other artists represented here
(except, perhaps, Girieud) display almost to the extent of complete
inviolability that contingent attitude toward line, the same acciden-
tal delimitation of form that they have discovered in nature. It is curi-
ous to observe how their entire creative energies are directed solely
toward color. Why? Why is it only color that undergoes these modi-
fications, violations, substitutions? What prevents these artists from
also submitting the linear and planar aspects of nature to the same
artistically necessary transformations? Why does their creative urge
direct itself solely toward *peinture*, and why does the other, also power-
ful, essential aspect of painting—what we rather vaguely refer to as
"drawing"—remain untouchable? [...] Strange that one has to find,
discover, resurrect anew the principle of subordinating drawing, too,
to an inner purpose that was so clearly, so definitely resurrected from
the dead by Cézanne!

May 5, 1910, Wernstein, ALFRED KUBIN to KANDINSKY (Ger.):
[*Written shortly before Kandinsky's very first abstract painting of 1911 (fig. 12).*]
Dear friend, all in all you must be feeling wonderful, for you have opened up a completely new possibility for art in the direction of abstraction, and today you are the furthest along in it, and quite unique. Naturally you must encounter a lack of understanding because people today still experience things too clumsily. [...] Perhaps later you will be seen as the start of a new era of art. [...] Such a thing must grow slowly and mature organically, and then one day appear before the inner eye as a magnificent sequence of visions. You have all that already, as you yourself know—this is why your art fascinates me so much. Redon, Ensor, and I, we are all still too entangled in the material world. [...] Grossmann and Nolde are certainly arguably artists, but not <u>mystics</u> in <u>our sense</u>; the same is probably true for the French artists.

May 8, 1910, to ALFRED KUBIN (Ger.):
One can be infinitely convinced that one is on the right path, but the recognition of people whom one really esteems is in any case of great value. And even if this recognition seems exaggerated, like that which you have stated.

June 4, 1910, THOMAS DE HARTMANN to KANDINSKY (Rus.):
I'm still thinking of your and Ella Karlovna's [*Münter's*] friendly help and concern—it is less terrifying to live on this earth together with you.

June 26, 1910, to NIKOLAI KULBIN, St. Petersburg (Rus.):
Having learned that you are the chairman of the "Triangle," allow me the liberty of making a request of you. It seems that our association, which is still very young, has a lot in common with yours in its goals and aspirations. But our information about the "Triangle" is scant and incomplete. We would therefore be very grateful if you could send us your statutes, catalogs, etc. [...] I, in turn, am sending you

1910

our statutes, the catalog, and an announcement of our first exhibition, which will tour Germany starting in November. I would be very grateful for any information you send us. — Sincerely yours, Vasily Vasilievich Kandinsky, President, Neue Künstlervereinigung Munich.

Aug. 23, 1910, to NIKOLAI KULBIN (Rus.):
Just received both your letters. Sorry, but it is too late now to include your works this year. We were continuously unlucky with the organization of the Russian section. Let's postpone this until next year and prepare it carefully. Maybe I can be in Moscow in October, just as you're getting back from the Caucasus. It would be useful to meet. Could you be so kind as to let me know if this is possible?

[*The second exhibition of the NKVM opened in September with works by French and Russian artists such as Matisse, Picasso, and the Burliuk brothers. Kandinsky traveled to Moscow in October and then to Odessa, only returning to Munich for Christmas.*]

Oct. 5, 1910, Moscow, to NIKOLAI KULBIN, St. Petersburg (Rus.):
Your letter was forwarded to me from Munich only yesterday. It would be good if you could come here. I'm not sure yet if I can make it to Petersburg. [...] I have been invited to the All-Russian Congress; I registered and announced a lecture that I'm currently working on. On Saturday I read part of it here in a local circle. Thanks for your interest.

Oct. 3/16, 1910, Moscow, to GABRIELE MÜNTER (Ger.):
[*Here he writes about meeting Thomas and Olga de Hartmann accidentally in Moscow.*] So we spent 13 hours together. What a good, clear, almost turbulent joy! The dear little lady kept saying, "You're here! You're here! Oh, how wonderful!" And Tomik kissed me again and again. There is no doubt that this friendship will last forever. And they spoke about you so warmly. We talked and talked and could not get enough. At 3 o'clock Olga went singing, and Tomik and I walked around Moscow, had a look at the Kremlin and made plans. In the evening

58

we were joined by Yavorsky, Taneyev's best student, a leftist revolutionary in composition. His musical theory is the direct sister of my painting theory. [...] Please purchase Japanese engravings for Hartmann. Why don't you visit Anya occasionally [*his first wife*].

Oct. 7, 1910, Moscow, to GABRIELE MÜNTER (Ger.):
I wrote to you every day, apart from yesterday, which is not the case for you. Every evening with the Hartmanns (yesterday we read my brochure). Dined with Bena [*Kandinsky's old friend, Benedikta Bogayevskaya*] the day before yesterday. [...] She has become much easier and makes a good impression. Happy about this.

Oct. 10, 1910, Moscow, to GABRIELE MÜNTER (Ger.):
I read to a hugely attentive audience for almost two full hours, with 2 breaks. I showed the primitives + the Persians (the Hartmanns provided me with all the reproductions). That really interesting lady, Bryusova, was there [*Nadezhda Bryusova*]. She and Yavorsky, a famous musician (conductor), had answers for me. Clever and interesting. [...] Bena found it so interesting that she thought I should read it at the "Artists' Circle" as well. [...] As to my brochure [*his own Russian translation from the German of* Concerning the Spiritual in Art] 1) I haven't translated everything yet (I read an abbreviated version yesterday) 2) everything has to be arranged and transcribed. Bena wants to take on the latter herself: she reads my hieroglyphs splendidly. Now I will start making visits—artists, churches, museums, etc. Lunch with 3 Hartmanns (+ mother), then concert.

Oct. 13, 1910, Moscow, to GABRIELE MÜNTER (Ger.):
Was at the Kharuzins, old friends. Everyone claims I'm younger now than I was 7 years ago. So a child prodigy. Yavorsky said that he was enormously impressed by my lecture. Many said that there were such new and such profound and interesting ideas. [...] Have you received the 2 Tolstoy booklets? [*His efforts to teach Münter some Russian failed.*]

Oct. 14, 1910, Moscow, to GABRIELE MÜNTER (Ger.):
[*Again he praises his friends and his warmhearted family, with the many children whom he loved.*] Life is so warm here ... more intense and more thrill-

1910

ing. How will the old church art affect me? Will I find the essence that I want to seek, to touch?

P.S. What effect Moscow would have on you! [...] You must come with me next time. [*She never did.*]

Oct. 18, 1910, Moscow, to NIKOLAI KULBIN (Rus.):
It will be difficult for me to get to Petersburg. I'm spinning here! I'm only now getting around to visiting artists, and in 2 weeks I have to be in Odessa. — It would be excellent to organize a Russian section in Rome together. Or do you think it's already too late? [...] I mentioned it to Larionov. I think the Muscovites would be in favor of it.

Oct. 20, 1910, Moscow, to GABRIELE MÜNTER (Ger.):
I'm totally in love with Moscow. [...] And what still caresses me constantly—it's the general friendliness. [...] The streets lit by the moon and the [*new!*] electr. lamps are like magic.

Oct. 23, 1910, Moscow, to GABRIELE MÜNTER (Ger.):
Will be at Bena's this evening, correcting what's already typed [*his Russian translation of* Concerning the Spiritual in Art]. We (the Hartmanns and I) recently listened to Scriabin's music. Certainly interesting, but too beautiful for me. He also thinks a lot about the correspondence between musical and color tones, but, as far as I know, not enough. I may go to see him now that he's here. I quarreled a lot about this with Larionov, and Tomik helped me splendidly. [*He and Hartmann observed a demonstration by the superintendent of the conservatory of music.*] It was extremely interesting, for example, that what one considers as impossible and disharmonic today is extremely fine and directly harmonious on the natural keys. E.g., even the introduction of Si-Do-Re is ... harmonious! Now the inventor (Smirnov) is working on finalizing a perfected instrument. This could lead to a major revolution in the theory of harmony + counterpoint.

Oct. 13/26, 1910, Moscow, to GABRIELE MÜNTER (Ger.):
Yesterday, we (Tomik and I) went to Goncharova's. She was pretty

cold (she's the one who wrote that rude letter). I gave her a piece of my mind in the nicest way possible (she is very young), this impressed her, as she was happy to show me many paintings, which I allowed myself to criticize (very gently). <u>Very</u> talented things, with a <u>lot</u> of feeling, in a word <u>very</u> interesting, even if a bit too theoretical on the one hand, and, on the other, not really worked through. […] The Hartmanns send their greetings, also Mrs. Abrikosov [*a relative of his first wife who had already visited Munich and therefore knew Münter*].

Oct. 27, 1910, Moscow, to GABRIELE MÜNTER (Ger.):
Yesterday at the Hartmanns with Yavorsky: I read my 3 stage compositions. As I also suspected, Y. has similar plans. […] For more than 2 hours we discussed whether Tomik [*Hartmann*] would take over the "Giants" and postlude and Yavorsky the prelude and "Black and White." […] After Maeterlinck's *The Blue Bird* I hardly think that the "Artist's Theater" [*Stanislavski's well-known theater*] will take our piece. They are Realists after all. But we still want to try. […] Today I have the last corrections of my brochure with Bena.

Oct. 16/29, 1910, Moscow, to GABRIELE MÜNTER (Ger.):
Just got back from Lentulov's (the painter I turned down). […] Then lots of painters came: Konchalovsky (a friend of Le Fauconnier's) whom I will meet again the day after tomorrow at Mashkov's— Goncharova, Larionov, a few more painters. […] I spoke about Marianne [*Werefkin*]. […] Le Fauconnier had read many of my texts to Konchalovsky in Paris and told him he absolutely had to look me up in Moscow.

Oct. 19/Nov. 1, 1910, Moscow, to GABRIELE MÜNTER (Ger.):
Yesterday I was asked to draw up a list of our people (of my choice), so that invitations could be sent. I have already made a provisional list for you to choose from (of your paintings for here). [*Two days later:* "Now all our 8 people from Munich will be invited by me to participate in the Dec. exhibition *Knave of Diamonds*, with 2 works that will not be subject to a jury." *He added a pencil sketch and called it* The Long One with the Sword, *to be exhibited in Moscow with the avant-garde circle of the Knave of Diamonds (*Bubnovyi Valet*).*

It is illustrated, together with a larger study and commentaries on the final major painting Improvisation 8 (The Sword), *1909, priv. coll., in Hahl-Koch,* Kandinsky, *1993, 116–17.*]

From 5–8 spoke unobserved and passionately [*with Mashkov and Konchalovsky*]: first M. alone, who gave a whole speech against philosophy in art, later with both, where K. affirmed the opposite. But in the end, we got along well. What pleases me is that they are all searching a great deal and not clinging to what has already been achieved. Konch.: Matisse is an intelligent and thoughtful artist. [...] Hartmann immediately wanted to look for a studio for me for 2–3 months, so you could also come. Mrs. Olga said she would take care of you.

Oct. 23/Nov. 5, 1910, Moscow, to GABRIELE MÜNTER (Ger.): Wrote to Jawlensky and Erbslöh today about invitations to the Knave of Diamonds. Went sleigh-riding with pleasure yesterday. [...] Spent yesterday from 8:30 to 1 at Lentulov's (Hartmann, Larionov, Goncharova, Mashkov). Spoke and argued a lot about monumental art. [...] Larionov seems to be the most sensitive, and reflective.

Oct. 26/Nov. 8, 1910, Moscow, to GABRIELE MÜNTER: Saw *The Blue Bird* by Maeterlinck + was quite disappointed. Much too coarse in form for M. Half the theater was filled with children, which was an appropriate public: fairy-tale with fairies etc. + philosophy-occult patchwork. [...]

Your persistent effort to master drawing pleases me beyond measure. I like the sketches. Now, as you know, I'm generally against rigid, too precise forms. [...] I gave a really good, concise definition of form in my booklet [Concerning the Spiritual in Art]. Externally—delimitation; internally—external expression of the internal. If you can really feel what I mean by that (don't philosophize, just understand, feel!), then you will also discover form. You have to let form work on you and forget about all the Picassos and Picassore. [...]

Oct. 31/Nov. 13, 1910, St. Petersburg, to GABRIELE MÜNTER (Ger.): [*He had recently visited Sergei Makovsky, the editor of the journal* Apollon, *which had already published his five "Letters from Munich."*] Spent 3 hours at the

Apollon editorial office. Got to know Makovsky and several others. Talked a lot. M. said: "Write about them, then (my opinions)." I replied: "I already have." He said: "I would like to print it." I said on condition that it also appeared as a book in addition to appearing in *Apollon*. He agreed. [*Makovsky seems to have found Kandinsky's writing too difficult. Once Kandinsky had explained the content of his work, the editor understood and answered:*] "You have Oriental roots. You look and think as if you do." So one <u>word</u> is found and then he understands everything! Now he's very keen to publish the thing, but … the language! The language! These words! And the endless sentences! I write like an artist, but I should subordinate myself to literature. I explained briefly and determinedly: "I won't change a syllable." […] So then he gave me the same whole spiel that I got from the Germans. He regretted very much that I was sacrificing such an important matter to the wrong style. I insisted: "the style is exactly right." Then it got to the point where he'd accept it if I was prepared to countenance some <u>minor</u> alterations. I sensed that, but I just didn't want to do it.

Nov. 18, 1910, to Gabriele Münter (Ger.):

The Hartmanns send you their greetings and thank you for your concerns. He finished the ballet yesterday and really wants now to discuss the stage project right away, to make the most of the remaining days of my stay here. […] The Hartmanns are building a new [*tenement*] house, which might bring in a large income. There they want to have 2 studios made for us. […]

An association such as ours is a useful thing, and indeed we have the most interesting German painters in our group. What can one do if there are no better ones? I still hope that our people will become more serious and recognize their great duty. Then the paintings will also improve. An association is a spiritual force. In Paris + here too there are only individual forces (as always only a few artists), which together naturally create a denser atmosphere.

1910

Nov. 20, 1910, GABRIELE MÜNTER to KANDINSKY (Ger.):
I am diminished without you, you belong to me and enrich me, and
without you, this place is empty.

Nov. 21, 1910, Moscow, to GABRIELE MÜNTER (Ger.):
Was with the Hartmanns yesterday at the Shchukin gallery for nearly
2 hours. [...] The gallery is splendid: Monet, Pissarro, Raffaëlli, Degas,
etc., a large Gauguin collection, a few good Van Goghs, fine Cézannes,
and finally lots of Matisses, including very recent ones. I said a few
words and spoke well. Convinced Shchukin, by the way, that he must
buy some of the very latest Picassos, which had scared him. He became
thoughtful and acknowledged kindly: "You are right." I also spoke
well of Matisse, who had made a few ladies suspicious, and ended
with the words: "Well, actually, Matisse is already passé." That made
an impression, and even Sh. himself listened diligently. [...] Saturday
at Lentulov's was very nice. At 3:30 a.m. he still didn't want to let me
go home: "No, no, you're leaving soon, so you must stay here until 8
in the morning. Everyone is staying here for you. [...] I was dead. He
finally let me go with the solemn promise that I would come again on
Wednesday. [...] I walked along with Larionov and Sologub (architect).
Both shook my hand tightly and said that we (you and I) must move
to Moscow. And it was all from the heart, no pleasantries. Inciden-
tally, everyone wants us to live here, and only one person said: "No,
some of the time Kandinsky has to live in Munich too: he is very
much needed there." Larionov is the theoretician and the thinker here,
and he does not want to be eclipsed. A bit like Marianne [*Werefkin*],
but much more interesting and brighter. — What could Marianne
have against you?
Nov. 22, 1910, Moscow, to GABRIELE MÜNTER (Ger.):
[*Münter felt offended by Werefkin, but soon admitted that she had misunderstood.*]
Just let her have her moods, darling. After all, we want to do our duty
towards others as much as we can, and not worry about the results.
Right? [...] I'm happy about your relationship with Anya.

Nov. 25, 1910, Moscow, to GABRIELE MÜNTER (Ger.):
Yesterday another civil (i.e., non-religious) memorial service for Tolstoy. Everything proceeded in a very orderly way. Even the police couldn't create chaos.

Nov. 26, 1910, Moscow, to GABRIELE MÜNTER (Ger.):
Evening with the Hartmanns. Because of Tolstoy's death, there are peaceful manifestations and people speaking out against capital punishment. [...] Everyone I know wants me to stay here, move here, immediately.

Dec. 3, 1910, Odessa, to GABRIELE MÜNTER (Ger.):
Tea with mother and father, then I bought 3 historical books for Mashura and an airplane for Lilya to put together. [...] Took a cold bath, but I'm not used to it anymore, hence the cold. [...] Mother asked a lot about you and when we're getting married "since it is necessary in Germany." [...]

Form is important, but only as a means, and so at the same time it is not important at all. Form can be faultless, dazzling, and yet worthless because it is empty. So, long live form, and down with form! You personally have nothing to fear; you have something to say, it is given to you. Just put your ear to your heart and listen! Perhaps you should read a little more. Lots of good things. [...] The world chimes and nothing is silent. The ear must capture what it needs. And what it needs is beauty and truth. Therefore, there is no one beauty and no one truth. Rather, there are as many as there are souls in the world.

Dec. 8, 1910, Odessa, to GABRIELE MÜNTER (Ger.):
[*Kandinsky reflects on the contrast between his close family ties and his relationship with Münter.*] I wonder how I could stand it, I who was not used to pain. I had nobody, aside from you, with whom I could talk about it. Do you remember what you said about this once? That was in Sèvres, and I then asked you to move to Paris so that I wouldn't constantly have to keep a hold of myself. [...] Don't forget that this was me, who as a child had been spoiled and adulated (I may use that word here). [...] This time in Moscow has brought me back to that

1910

old atmosphere. But now I've reached the point that I'm ashamed to see this undeserved love (that too is a word I may use), and the unfairness of it hurts me. I've come this far. Hopefully perhaps I'll go much further. And that might be your mission. [...] If I could only get the better of my pride and be totally satisfied with this: that you love me a lot less than I love you. [...] I only want to live for art. Ah, to uproot trees! I want to uproot trees. I just don't want to have to pull out weeds.

Dec. 9, 1910, Odessa, to GABRIELE MÜNTER (Ger.):
Izdebsky and David Burliuk will visit me tomorrow. Izd. has debts of 4,000 rubles from his 1. Salon and now lives more than modestly.

Dec. 15, 1910, Odessa, to GABRIELE MÜNTER (Ger.):
[*Kandinsky writes about gymnastic lessons for twelve children. Then about a meeting with old friends.*] We (mostly I) spoke about art, religion, morals etc. They are so alive. [...] We both [*he and Münter*] are invited by the Burliuk brothers to their place in the country [*Crimea*] next year. They are very nice. Big, strong + so tender with each other, and each values the other more than he values himself.

Dec. 17, 1910, Odessa, to GABRIELE MÜNTER (Ger.):
I wish you were less often in such a gloomy mood. I feel sorry for you, when it presses upon you.

Dec. 17, 1910, Munich, GABRIELE MÜNTER to KANDINSKY (Ger.):
As for my inner substance, I have already told you that you overestimate me.

[*Kandinsky's increasingly abstract painting had begun to provoke tensions within the NKVM. He resigned as chairman of the association in January 1911 (while remaining a member), the same moment the young German artist Franz Marc joined. Throughout 1911, Kandinsky and his new colleague worked on the publication of an "art almanac." Kandinsky's book* Concerning the Spiritual in Art *was also published in Munich at the end of the year (although it was dated 1912). The artist's divorce from his first wife Anna was finalized in 1911, but he did not marry Gabriele Münter.*]

66

Jan. 18, 1911, Munich, to ARNOLD SCHOENBERG (Ger.):
Please excuse me for simply writing to you without having the pleasure
of knowing you personally. I have just listened to your concert here
and it gave me a great deal of real pleasure. [...] Our efforts and our
whole way of thinking and feeling have so much in common that I
feel quite justified in expressing my sympathy to you.

In your works, you have realized what I have greatly longed for in
music, albeit in an indefinite form. Independent progress towards
one's own destiny, the independent life of individual voices in your
compositions, this is exactly what I am trying to find in painterly
form. In painting at the moment there is a great inclination to discover
the new harmony by constructive means, whereby the rhythmic is
built on an almost geometrical form. My own sense of empathy and
ambition can follow these means only halfway. Construction is what
has been so woefully lacking in the painting of recent times. And it
is good that it is now being sought. But I think differently about the
nature of construction.

I think that our present-day harmony is not to be found by a "geo-
metric" means, but rather in a directly anti-geometric, anti-logical
way. And this means is that of "dissonance in art," just as much in
painting as in music. And "today's" pictorial and musical dissonance
is nothing but the consonance of "tomorrow." [...] It has given me
infinite joy to find that you have the same ideas.

Jan. 26, 1911, Murnau, to ARNOLD SCHOENBERG (Ger.):
Your letter gave me a lot of pleasure. I thank you kindly and look for-
ward very much to getting to know you personally. I have often gone
back and forth in my mind over some things (e.g., conscious vs. uncon-
scious work). Basically, I agree with your point of view. That is, when
one is already at work, then there should be no thought, but rather
the inner "voice" alone should speak and steer. Except up until now
the painter has in general thought too little. He has conceived of his
work as a kind of coloristic balancing act. But the painter should (and
precisely in order to be able to express himself) get to know all of his

material and develop his feeling to the point where he knows and spiritually trembles at the difference between [*parallel and perpendicular lines (Kandinsky included two small graphics here in lieu of words)*]. [...] I am very pleased that you speak of self-perception. That is the root of "new" art, of art in general, which is never new, but which must only enter into a new phase—"Today"!

Now there is another question that is very important to me. The second touring Salon will soon begin in Russia. It is an international art exhibition that will travel through the principal cities in Russia and which is dedicated to "new" art. The organizer, V. Izdebsky, a sculptor, is a good friend of mine. He asked me to recommend particularly good and interesting articles about art (everything, thus also music) or to name the authors. [...] I took the liberty of ordering a couple of issues of *Die Musik* in order to send one of them to Izdebsky immediately ... [*Kandinsky exhibited fifty-four paintings at Izdebsky's second International Salon in Odessa. He assumed responsibility for the catalog, contributing a text on "Content and Form" and an annotated translation of part of Schoenberg's* Theory of Harmony. *A precursor of* The Blue Rider Almanac, *the catalog also contained essays on music and science and examples of children's art. An Odessa journal,* Odesskie Novosti, *published the artist's long text "Whither the 'New' Art?"*]

Apr. 9, 1911, Munich, to ARNOLD SCHOENBERG (Ger.): I envy you very much! Your *Theory of Harmony* is already in print. How infinitely good (even if only relatively) musicians have it with their art, which has come so far. Real <u>art</u> that already has the privilege of dispensing totally with purely practical aims. How long will painting have to wait for this? And it also has the right (= the responsibility) to do so: color, line, in and of themselves—what boundless beauty and power these painterly means possess! And yet today the beginning of this direction can already be more clearly seen. One may now dream of a "theory of harmony" here too. I am already dreaming, and I hope to set out at least the first sentences of this great upcoming book. Perhaps someone else will do the same. All the better! As many as possible. [...] I warmly wish you much success with your work.

May 14, 1911, Munich, to FRANZ MARC (Ger.):
My first wife, Mrs. Kandinsky, was at your exhibition recently and told me about her first impressions yesterday. And since Mrs. Kandinsky has a particularly fine sense and a great deal of intelligence, I want to write to you briefly about her impression. She found your works to be composed more in a linear than a painterly manner, i.e., the drawing was very good and strong (compositionally), but the colors were not on the same level, "as though they were an afterthought." — P.S. If I cycle, I will definitely pass by you.

May 19, 1911, St. Petersburg, NIKOLAI KULBIN to KANDINSKY (Rus.):
As you may know, the All-Russian Artists' Congress is to take place in December and you will play an active part in it with your text. There are plans for exhibitions in connection with this Congress. [...] If the Russian members of your association wish to participate, their works will not be subject to a jury. [...] We will endeavor to keep the new art well away from the academic. [...] It is almost certain that the ARS (Association for the Synthesis of the Arts) will also be represented. The goal is to work toward a general synthesis of all art forms. It would be splendid if all the members of your group who are interested could join us.

June 9, 1911, Novaya Mayachka, Crimea, DAVID BURLIUK to KANDINSKY (Rus.):
Too bad that you won't be coming here soon, we waited and hoped. We agree to send 4 pieces each, at our own cost. Tell us when, where, and how much to send. This year we sent things to the Salon d'Automne in Paris, the cost was 50 rubles for a small painting, and of course our works were not accepted. Alexandra Exter was in Paris in the winter and wrote that Le Fauconnier suggested creating a Russian section at the Salon des Indépendants. They would give us a room (so he promised) or even a hall? That is tempting, because otherwise one stays unnoticed among the piles of paintings. Do write to him as well, so

1911

that he gets used to our coalition. Write to me about it please. [*He continues complaining about Roerich, Kustodiev, Somov, and the St. Petersburg artists as a whole.*] In general, it's the Moscow artists who are the shrewdest!

June 14, 1911, Munich, to ALFRED KUBIN (Ger.):
Do try to chase the dark thoughts away vigorously, to quash them. Why do you only see "the other side"? [*Kubin had published an extremely dark and pessimistic novel* The Other Side *in 1909. Suffering from anxiety, he preferred to live far from Munich in the calm of the Austrian countryside.*]

June 19, 1911, to FRANZ MARC (Ger.):
So! I have a new plan. Piper should be the publisher and we two ... the editors. A kind of almanac (yearly) with reproductions and articles written only by artists. The book should reflect the whole year, and a chain to the past and a ray of light into the future must give this mirror its full life. The authors will perhaps not be paid. They will possibly pay for their reproductions themselves, etc. etc. We could bring an Egyptian [*work*] next to a little toe [*a children's drawing*], a Chinese next to a Rousseau, a folk piece next to Picasso etc. and so much more! In time we get literary authors and musicians. The book could be called "The Chain" or something else.

July 11, 1911, Murnau, to GABRIELE MÜNTER (Ger.):
Now I'm making the woodcut with the jockey [*Lyrical*] (fig. 11). The contour plate is ready and very good.
July 20, 1911, Murnau, to GABRIELE MÜNTER (Ger.):
[...] *Lyrical* turned out well in wood, better than the painting. [...] Next week I'll start painting "Judgment Day" [Composition V].

July 19, 1911, Kuokkala, Finland, NIKOLAI KULBIN to KANDINSKY (Rus.):
As you know, the All-Russian Congress will take place in December, where your contribution will play a very important part. During the

Congress exhibitions will be displayed. Progressive groups have already been admitted into two of them. Your humble servant has also been selected for the organizing committee. [...]

[*Five detailed points about the conditions of participation.*] If in your group there are some members with special ties to Russia, their works will be accepted without submission to a jury. [...] One could make sure that progressive art is exhibited at some distance from academic art. [...] ARS (Association for the Synthesis of the Arts), which was founded in the spring, will also show. Its principles are 1) to be progressive 2) to unite all the different art forms. [...] Almost all the progressive musicians are participating (Karatygin, Yankovsky, Kryzhanovsky, Narbut). — Gorodecky will lead the literary section (Alexander Blok, Auslender et al). — Nik. Evreinov, responsible for the theater section. [...] Fokine has promised to take over choreography ... I will lead the section for painting and sculpture: the sculptor A. M. Matveyev will be included, alongside Chekhonin, M. N. Yakovlev, V. V. Toporsky, David and Vladimir Burliuk.

July 19, 1911, Munich, to Nikolai Kulbin (Rus.):
Thank you very much for your kind and detailed letter. I cannot say anything definite yet concerning the participation of our members, since they are almost all currently away. I, however, gladly accept your invitation. I believe that my wife [*Gabriele Münter*] would also like to participate, if she is eligible as a German. You have probably seen her work at Izdebsky's International Salon, as well as at the "Knave of Diamonds" show in Moscow. I am almost certain too that Marianne Werefkin and Alexei Jawlensky would like to show their paintings; as well as the very original and talented Elisabeth Epstein. [...] They are all members of our association. I also think that Franz Marc (a member as well) might join us. He is a very talented and serious artist. Our circle as a whole leans toward Russia and feels very close to Russian art.

Other members are real Frenchmen: P. Girieud and Le Fauconnier, both of them serious and important artists. Allow me to recommend

1911

to you a very original and talented artist, Elisabeth Ivanovna Epstein. [...] Also I would like to recommend especially Foma Gartman [*Thomas de Hartmann*], a man of outstanding talent and depth. His new compositions of course are not to be compared to those of his youth, the music for the ballet *The Pink Flower.* Are you acquainted with the great theoretician and revolutionary of music history, Yavorsky from Moscow?

Do you know how the Muscovites, such as Goncharova, Mashkov, Larionov, Lentulov, Konchalovsky, etc. will react to our participation? I am delighted that the Burliuks [*the brothers David and Vladimir*] will also exhibit with you. Did you invite Izdebsky too? [...]

P.S. Do you know the Viennese composer Prof. Arnold Schoenberg (see his article, which I translated in the catalog of Izdebsky's 2nd International Salon)? Two of his very interesting and radical quartets and three piano pieces were published by Universal Edition in Vienna. Use my name, if you want to get in contact with him, the same for Yavorsky [*he added the addresses of Epstein, Hartmann, Yavorsky, and Schoenberg*].

Aug. 10, 1911, to Gabriele Münter (Ger.):
Macke is good but young. He doesn't understand me, otherwise he would know how to benefit from some of my advice while painting. [...] A committee meeting [*of the NKVM*] 2 days ago. When Marc told us about it, we laughed so hard, things fell out of our hands! [...] It was again very nice at the Marcs. I feel very much at ease there, almost as much as at the Hartmanns [*Thomas and Olga de Hartmann, his best friends. Shortly thereafter, Kandinsky wrote "Lokal" about the aforementioned absurd committee meeting*].

Aug. 11, 1911, Murnau, to Franz Marc:
I would like to thank you and your wife from the bottom of my heart for the beautiful days I spent with you. I felt so well and warm. The return journey went very quickly: it only took me a little over an hour—downhill almost all the way. And it was incredibly beautiful.

Aug. 23, 1911, to NIKOLAI KULBIN, St. Petersburg (Rus.):
I have just received both your letters. I am very sorry, but it is too late
now to include your works this year. Let us postpone it until next year
and prepare it carefully.

Aug. 27, 1911, DAVID BURLIUK to KANDINSKY (Rus.):
Write to my father, David Fedorovich … From the 28th neither my
brother nor I will be at home. […] We don't want to lose contact with
you. […] I will let you know my Moscow address.

Sept. 1, 1911, Murnau, to FRANZ MARC (Ger.):
I, on my part, have written to Hartmann, told him of our association
and given him the title of "Authorized Representative for Russia." […]
I am also writing to Le Fauconnier. Dr. Wilhelm Niemeyer criticized
me so subtly in his "commentaries" that I didn't understand anything.
I only see that I, as a prismatic painter (good heavens), have no right
to need pure white, which is exactly what I did in *Presto* [Improvisation 5
(Presto)]. It's a good thing that this painting still remains "in the artist's
possession," as it says in the catalog.

From Hartmann I ordered an article about Armenian music and a
musical "Letter from Russia." […] We already have something about the
Italian trends in music, contained in the manifesto of the "*Futuristi*,"
which was sent to me. [Futurist Music. Technical Manifesto *by Francesco Ballila
Pratella, published in March 1911*]. Schoenberg must write about German music.
Le Fauconnier <u>must</u> get a Frenchman. Music and painting are already well
examined. Something new should also be in there. Schbg., for example,
has songs. We just have to show that there is something going on <u>every-
where</u>. We bring something on the religious movement in Russia, where
<u>all</u> layers of the population are involved. For this, I have my former
colleague, Prof. Bulgakov (Moscow, an economist and one of the most
profound experts on religious life). The Theosophists must be mentioned
briefly and energetically (statistically, if possible). [*They were not mentioned.
Kandinsky's initial interest in them, prompted by his student Maria Giesler, faded rapidly.*]

1911

Sept. 21, 1911, Munich, to FRANZ MARC:
Piper recommends including the following reproductions: Matisse (I agree), Van Gogh, Gauguin(?), Toulouse-Lautrec and ... Edvard Munch (I vehemently rejected this one). [...] Schoenberg will probably be here on Saturday. [...] Maybe you could also come over? In any case, bring your article along. [...] I translated the articles of Hartmann, Burliuk, and Le Fauconnier very rapidly.

Sept. 22, 1911, Munich, to ALFRED KUBIN (Ger.):
I don't even know how to begin!!?? You see me at the gateway of bliss. You have before you someone who, with his stupid (inartistic!) dreams, was thrown out of every decent place for real (the very best!!!) art. Someone who didn't want to wake up because he believed in the reality of his dreams. And the dreams were thin, emaciated, and anemic. ... well, anyway! We have established ... a new, really new, the newest society? No indeed! A truly liberal, clique-free, international (ha-ha) journal, which will be published irregularly as only really good things appear irregularly. Everything in more detail in our circular. Colleagues: in Paris, Le Fauconnier, Girieud; in Vienna, Arnold Schoenberg (musician); in Moscow, Th. de Hartmann, the 2 Burliuk brothers. Everyone's fired up. Le Fauc. wants to mobilize all of Paris. Now what's still missing (oh, he is missing!) is Kubin's final word, and particularly his first contribution. — Yes! Publishers. [...] Piper is publishing my book *Concerning the Spiritual in Art*. After 2 years! I owe all this happiness to the fine Franz Marc. He is an absolute magician and also a true friend.

Oct. 2, 1911, to FRANZ MARC (Ger.):
Picasso [...] divides the object and scatters individual parts of it all over the canvas; the picture consists of the jumble of these parts. Extremely interesting! Picasso continues to pursue his course. Hopefully he'll also transcend the <u>external</u> bond with nature as well. [...] No! This is not the remedy! But it is enjoyable nonetheless. Some of

74

Picasso's things are like mental reflections of decay; this is the result of the imperfect liberation from naturalism.

A former student of mine [*Elisabeth Epstein*] was at Matisse's when he got my letter. He found it interesting. [...] I'll write to Picasso as well.

What do you think about that repugnant and dirty event? About this Italian war? More than 2,000 people have already murdered each other. Such things are hard to digest [*Italy had annexed Tripoli and Cyrenaica, the eastern part of Libya*].

Oct. 4, 1911, Munich, to FRANZ MARC (Ger.):
I'm going to buy No. 85 [*Picasso's engraving* Buffalo Bill]. The piece costs 5 francs. [...] This decomposition is very interesting. "Wrong" in my eyes, of course. But I'm really pleased with it as a sign of the immense urge for the non-material!

Oct. 4, 1911, Munich, to NIKOLAI KULBIN (Rus.):
You will find enclosed the prospectus for my almanac *The Blue Rider*. No. 1 is in production and will probably appear after Christmas. In order to stir up some ideas on music, I have taken the liberty of including your "Free Music," probably in its entirety [*in the end, he significantly shortened the radical ten-page pamphlet on microtonal music*]. Did you receive my letter to Finland? Would you be so kind as to let me know how things are with the ARS [*Association for the Synthesis of the Arts*]? I would like to place a note about it in the almanac. [...] By the way, all our collaborators waive their honoraria. Would you allow the same for your "Free Music"? [*He did.*]

Oct. 6, 1911, Moscow, THOMAS DE HARTMANN to KANDINSKY (Rus.):
Dear Vasia, don't get angry, I (rascal) have not written. But we are translating Bryusova's article; my head is spinning and I'm becoming foolish ... I think of you, since you are still much busier than I ... I'll keep my own article short—giving only an overview, purely objectively, on Rus. music, since Bryusova is treating new Rus. music. [...]

1911

We almost left Russia, together with Taneyev, in order to perform T's symphony in concert-form + Scriabin's *Prometheus* [Prometheus: The Poem of Fire, Op. 60, *a tone poem*], but now it's too late, it would have just been hasty. Also, one should cooperate with Yavorsky. [*Bryusova's detailed article never appeared in* The Blue Rider Almanac; *the manuscript is now in the MES, Munich.*]

Oct. 7, 1911, Munich, to ARNOLD SCHOENBERG (Ger.):
Will you give *The Blue Rider* anything else? The beginning of "Teaching" [*"Problems in Teaching Art," 1911*] is unbelievably good: every sentence like a gun shot. Bang! Bang! Bang! [...] Do you see Kokoschka? Is he doing fine things? Could one get photos? Don't be annoyed. You know how important it is that the first number of the *Rider* turns out well: varied, serious. If it is at all possible, give us one more article (albeit a very short one).

Oct. 9, 1911, Munich, to FRANZ MARC (Ger.):
A very nice answer from Matisse: I may reproduce everything I want; he cannot write anything: made an X and swore not to repeat it ("one has to be an author to be able to do something like that"). [...] Yesterday I met Klee through Moillet. There is quite something of a soul. Kahler's selection of work at Thannhauser's is very interesting! It pulsates! I would really like you to see it! But it only remains on display this week. It's so fortunate that there are so many different sounds now. All together they form the symphony of the 20th century. [*Eugen von Kahler, the Bohemian-German painter from Prague, died in 1911. Kandinsky wrote an homage for* The Blue Rider Almanac *and showed two of Kahler's works in the second exhibition.*]

Oct. 29, 1911, Munich, to FRANZ MARC (Ger.):
What a wonderful man this Rousseau was! And naturally he was connected to the "beyond." And how profound his paintings are! Just a few days ago I thought: No. 1 of the *BR* with no Rousseau! The

editors should be condemned [*Ger.* violett werden, *literally "turn purple"*]! And now I was being whipped, completely shaken. Oh God! That's the root of realism, of the new realism! That's a still life! [...] I think that Rousseau belongs in our company: Kahler, Kubin, Epstein, Schoenberg, Münter. My antipodes! Is that the reason why I love and esteem them so much? [The Blue Rider Almanac *contains more reproductions of Rousseau's work than of any other artist.*]

Friday [*late October*], Murnau: my absentmindedness sometimes makes me very unhappy. [*Franz Marc's wife, Maria, had suggested including an early, fairytale-like work by Kandinsky in* The Blue Rider Almanac:] Not a good idea, it would spray a fairytale scent over all of my paintings.

The Hartmanns may come already in a fortnight. The concert will not take place until early or late December. Maybe the four of us can come over to you. [...] I'm very happy that I will soon see Schoenberg's paintings.

Nov. 5, 1911, Munich, to ROBERT DELAUNAY (Fr.):
In general, we don't take contributions from critics, because artists, even if they don't speak very cleverly about art, generally say living things. Writers, on the contrary, speak of things that have already crystallized, i.e., they don't see them in motion, but in a state of inertia, of "death."

Nov. 16, 1911, to ARNOLD SCHOENBERG (Ger.):
Your letter pleased me very much. Fine—all your concerts! When will the one in Munich take place? I am really looking forward to it. A whole evening in Paris—very splendid. I could get something in the press there through Le Fauconnier. Would that suit you? [...] Now, *The Blue Rider*! It will appear at the earliest in mid-January, perhaps even at the end. And you have therefore a good month for your article. Write 10–15 pages! As I said, <u>first</u> number without Schoenberg! No, I won't have it. We will certainly have 3–4 articles on music—from France, Russia. [...]

1911

[*Surprise! The composer was also a painter and had sent photos:*] I see a <u>great</u> deal in your paintings. And two roots: 1) "pure" realism, i.e., things as they are and also how they sound internally. That is what I foretold in my book as "fantastic in the most austere subject matter." It is diametrically opposed to <u>my own</u> art but ... grows spiritually out of the same root: a chair is alive, a line lives—and that, after all, is fundamentally the same thing. I love this "fantastic" element very much in general and especially in your pictures! [...] 2) The second root—dematerialization, romantic-mystical sonority (thus, also that which I create) I like <u>this</u> way of applying the principle less. And ... yet these things are also good and interest me very much. Kokoschka too has this second sonority (= root) (seen three years ago, i.e., "had"), + the element of "strangeness"! That interests me (I am happy to see it) but it does not make me tremble inside. For me this is too binding, too precise. When something like this stirs in me, I <u>write</u> (<u>I</u> would never <u>paint it</u>). And just say: he had a white face and black lips. That's enough for me, or better, it is <u>more</u>. I feel it more and more strongly: in every work there must remain an empty space, i.e., not binding. Perhaps this is not an "eternal" law, but a law of "tomorrow." I am modest and content myself with "tomorrow"! Oh yes!

Please do write to me also, to let me know how my works in the "New Secession" affect you. I was actually always sure that <u>you</u> would understand and appreciate Münter. In general, she is very little appreciated. Yes, these dear elephant hides! I am fine: I bruise the hides of the dear little beasts! Here you and I meet perfectly in the middle. So make Hell properly hot for the Berliners! Those fellows must sweat and writhe. Naturally we don't need to take care of this <u>deliberately</u>. [...] I have a lot of work. And many painterly wishes. Why is there so little time? [...] I shake your hand warmly and we both send you and your wife our regards. Has the little one completely recovered?

Your Kandinsky

Nov. 24, 1911, Munich, to NIKOLAI KULBIN, St. Petersburg (Rus.): Could you please tell me urgently if Münter, Marc, Macke, and I will be showing at ARS or "Triangle"? When will those exhibitions open? If it is during the Congress, then we should send our paintings as soon as possible.

Dec. 7, 1911, Munich to MICHAEL SADLER (Ger.): My texts [*his prose poems* Sounds] have no connection with my wood-cuts. I wrote them because at the time I couldn't express those feelings in a painterly way. But there is [...] a <u>deep</u> inner kinship between the texts and the woodcuts. And, actually, even an external relationship: I treat the word, the sentence very much like I treat the line, the spot.

KANDINSKY, "Vorhang" (Curtain), in *Klänge* (Sounds) (Munich: Piper Verlag, 1912) (Ger.): The rope came down and the curtain went up. We had all waited so long for this moment. The curtain hung. The curtain hung. The curtain hung. It hung down. Now it's up. When it went up (started to go), we were all so overjoyed. [*In 1911 he also wrote the stage play* Violet Curtain *in Russian. The German version was titled simply* Violett.]

Dec. 8, 1911, Munich, to FRANZ MARC (Ger.): Today a letter from Kubin: he resigned because my painting was rejected, which shows that the NKVM has forfeited its original prin-ciples. — Just received a telegram from Hartmann: "Sending official resignation from the association today." [*When Kandinsky's* Composition V *was rejected from the NKVM's third exhibition, he resigned entirely from the asso-ciation—followed by half of its members. He and Marc then officially founded the Blue Rider.*]

A letter finally came from Izdebsky. He is suffering from neurosis, I think: looks like it from his handwriting. He is in the country to rest and make new plans.

1911

Dec. 12, 1911, Munich, to Nikolai Kulbin,
St. Petersburg (Rus.):

Thank you for your detailed letter. Your reports are all of interest to me. Izdebsky wrote to me that he would like to show his entire Salon during the Congress [*All-Russian Artists' Congress, late December 1911– January 1912*], asking me if I was willing to participate. Perhaps you know that he has about 60 of my works that were shown at his International Salon exhibition in Odessa? If the Salon does not come to Petersburg, I would ask Izdebsky to send several works to ARS. And I am sending you 2 posters, my French album and the book *Concerning the Spiritual in Art*, which has just been published; as well as my small album, printed by the Stroganov publishers in Moscow [*his series of woodcuts,* Poems without Words, *1904*].

I am pleased about your exhibition project: I too strive to see the arts of different countries coming closer together. I would be happy to help you with this. [...] Perhaps I'll be in Russia in the spring, and we could start out then. It would be good to print invitations in French. <u>Beautiful</u> ones. [...] "Important" French artists are difficult to entice (e.g., Matisse, Picasso). The same applies to Berlin. I don't know anything about Scandinavia at the moment, but will soon, because I'm expecting a visitor. I have connections in England. An Englishman will visit me in the next few days. I will question him. In my opinion the exhibition doesn't have to be large, but very serious. [...] If you agree, I will organize things in Germany, France, England, and, as soon as I get detailed information, also in Scandinavia [*Kandinsky had contacts in the region—the Swedish artist Carl Palme, for example—from his time with "Phalanx"*].

May I ask you for a very personal favor? A very old wish of mine is to buy a *lubok* [*a type of Russian popular print*] of the "Last Judgment," as old and primitive as possible (with dragons, devils, etc.). If you find such a thing, please buy it and send it to me. I would be infinitely grateful to you. But really only if it's not too much trouble for you. I hope that we will succeed one day in finally overcoming our contact by

correspondence only. [*Kandinsky accumulated a collection of over one hundred sheets of Russian* lubki *and included several as illustrations in* The Blue Rider Almanac.]

KANDINSKY, "On the Question of Form," in *The Blue Rider Almanac*, (Munich: Piper Verlag, 1912) (Ger.):

[*Regarding Münter's* Still Life, *which was reproduced as a full-page illustration:*] It shows that the uneven, unequal translation of objects within one and the same picture not only is not harmful, but, on the contrary, can, if handled the right way, achieve a powerful, complex inner sound. The concordance of sounds, which produces a superficially disharmonious impression is, in this case, the source of an inner harmonious effect.

Dec. 22, 1911, Munich, to FRANZ MARC (Ger.):

[*The first Blue Rider exhibition was held in Munich in December 1911 at the Moderne Galerie Thannhauser, then went on to Cologne, Berlin, The Hague, and Frankfurt. Kandinsky's* Composition V, *which had been spurned by the NKVM, was on display, alongside major works by Delaunay and others.*] Our exhibition was well attended last night. We came across almost the whole of NKVM there! [...] An enthusiastic letter from Kubin: he has heard good things about the "B.R." in Vienna. Loos and Kokoschka are for us. It seems that Kokoschka wants to participate as well. But his drawing in *Der Sturm* is not very good. Let's see. [...] Very good drawings from Goncharova arrived today. [...] If you go to Paris, don't forget that Delaunay and Le Fauconnier don't get along. D. didn't even want to exhibit with him.

Dec. 24, 1911, Munich, to FRANZ MARC (Ger.):

Even as an editor I feel calm: my objective has always been—freedom. So I would easily allow an entire article or also individual sentences <u>against</u> me to be printed. [...] Mrs. Epstein sends her regards and writes that Delaunay is enthusiastic about us and cannot be swayed from us: "he has a very decent, honest nature." Letters keep raining down on me and I write and write … Delaunay gave me the drawing *La Tour,* which makes me very happy. [...] Larionov and the "Knave

1911

of Diamonds" are calling me energetically back to Moscow. And Kulbin to Petersburg. How can one not overestimate oneself?

Dec. 31, 1911, Munich, to FRANZ MARC (Ger.):
On Jan. 11 a lecture (at the Moderne Galerie Thannhauser) by Hagelstange: New Painting up until Van Gogh.

I have bought the *Head* by Epstein. So we have 8 sales, a favorable notice. That's better than a "good" review. Don't forget to invite the Berliners to our black-and-white exhibition. I have already written to Paris and Moscow about it. [...] The "Donkey's Tail" [*Rus.* Osliniy khvost] also invited me to their exhibition and gave me a mandate. Too late, of course, since we've been working with the "Knave of Diamonds" for a long time [*two Russian avant-garde groups that included Larionov, Goncharova, Malevich, Tatlin, and others*]. Let them fight it out about us! The article by Sabaneyev on Scriabin is very interesting and will certainly make a great impression. Hartmann and I worked diligently on the translation all evening yesterday. I hope to be completely finished with it today. Tonight we are going to the Deutsches Theater and afterwards we will drink punch at the Hartmanns. We will also raise a toast to the Marcs.

Dec. 31, 1911, Munich, to KARL WOLFSKEHL (Ger.):
I would also like to be useful to Marc in some way. I thought I'd advise Thannhauser to buy one of his paintings. [...] But then I thought again: my word does not mean very much to Th. And so I thought again of you. If you dropped such a hint to Th. it might perhaps have more success. I say "perhaps" because with Th. you can never know for sure in advance. His will is a tiny sailboat on an ocean of random advice, "public opinion," "the people's conscience" (Prussians!), etc. etc.

[*In 1912 Kandinsky showed work in the second Knave of Diamonds exhibition in Moscow and in Ekaterinenburg, Russia; his paintings also appeared in Cologne, Frankfurt, Berlin, Bremen, The Hague, Zurich, and in Paris at the Salon des Indépendants. The second exhibition of the Blue Rider opened in February at the Galerie Hans Goltz*

82

in Munich with over 300 paintings by artists including Picasso, Braque, Vlaminck, Larionov, Goncharova, Malevich, and others.]

Jan. 6, 1912, Munich, to FRANZ MARC (Ger.):
Do you really feel how nations are mystically pushed towards each other? Governments can hold battles. Bodies can be thrown against each other and ... torment each other. But souls will help each other. Whenever I feel this certainty, my heart trembles and a round, warm wave rises, swells in my chest. Of course, I'll talk to Arp tomorrow about us all—because of the exhibition in Zurich. [*Hans Arp et al. founded the Moderner Bund in Switzerland in 1911. He, Gimmi, Helbig, and Lüthy were all featured in the second Blue Rider exhibition.*]

Jan. 13, 1912, to ARNOLD SCHOENBERG (Ger.):
I'm really ashamed; but it's not laziness! I just want to tell you briefly what I am busy doing: 1) *The Blue Rider*: i.e., writing, reading, and correcting articles, etc.; 2) overseeing the first exhibition of the B.R.; 3) preparing the second exhibition; 4) inviting the Germans, French, and Swiss to the exhibition in Moscow (I have an unlimited mandate, and therefore also limitless responsibility); 5) helping to buy and sell other people's paintings; 6) constantly reading urgent, often complicated, often very unpleasant letters, writing (there are days when I get letters from each of the five mail deliveries [...]; 7) I owe letters; 8) I don't paint; 9) I neglect my own affairs. I have written 80 letters in a fortnight. [...]
I was firmly convinced that I had immediately thanked you for your book. It really gave me a lot of pleasure. And the dedication! But I had hardly stuck my nose in it when Hartmann came and snatched the book from me; he wanted to read it <u>absolutely</u> and <u>immediately</u> and couldn't find it here in stores. I was annoyed with Hartmann but also grateful, because he explained a lot to me that I certainly wouldn't have understood. [...] Shouldn't you send your book to the Moscow Conservatory? It's a pity that Hartmann [...] had to go directly to

1912

Russia. <u>Perhaps</u> I will go to Russia in the spring. Then to Berlin. So I will see you then. In letters one says so little.

Jan. 16, 1912, to ARNOLD SCHOENBERG (Ger.):
The new Petersburg society ARS wants to organize concerts as well. I wrote to them already in the early autumn about your music [*to Nikolai Kulbin*]. And their people showed a lot of interest in you. [...]

May I send you something to proofread? It is an article about Scriabin that I had to translate myself and I am mortally afraid that I have misused some different technical terms! Oh, please help me! The article is quite short. [*In fact, it was quite long.*]

Jan. 13, 1912, Munich, to NIKOLAI KULBIN (Rus.):
Just briefly: I sent you 2 posters and 2 books. Could you exhibit them? Did anyone read my lecture? [*An abbreviated version of* Concerning the Spiritual in Art *at the All-Russian Artists' Congress.*] Could you please ask to have the congress proceedings sent to me. And perhaps four copies of the offprint of my lecture? [*The monumental* Works of the All-Russian Artists' Congress, *in which his lecture as well as the important accompanying charts appeared, were published only in 1914, and it seems unlikely that Kandinsky saw them. He never mentioned the proceedings again, and they were not in his possession in Paris.*]

Jan. 16, 1912, Munich, to NIKOLAI KULBIN (Rus.):
You will understand how happy I was to hear about the interest in my lecture. Please accept my sincere thanks for all the trouble you took upon yourself: to read, to explain, to demonstrate etc. I have been so terribly busy (really, unimaginably busy!) that, as I see now, I forgot to send you the copy of my book that I had prepared for you. I am sending it now. You will see, it is the same lecture, but with several additions. [...] May I ask you perhaps to recommend the book to some Petersburg bookstores (with a foreign book department), referring to the success of your lecture. Sales of the book in Germany are a lot better than I ever expected. [...] Perhaps now a Russian publisher might be interested? You understand how sad I am that my book

does not exist in Russian. There are even plans for an English translation. […]

You know that there are 60 paintings of mine at Izdebsky's [*second International Salon in Odessa*]. In the meantime, there are plans in Germany for a collective exhibition. I should, therefore, get everything back from Russia. In Paris too I have the possibility of exhibiting my work. But it will be very difficult for me to get everything back from Russia without having shown it in Petersburg and Moscow. And so I ask you: would it be possible for me to exhibit in Petersburg? As for Moscow, I will write to David Burliuk, who is so friendly and always likes to help me. At the moment Hartmann is in Petersburg, talk it over with him, if you happen to see him. His address: Kazanskaya 32, residence of General Schumacher (his father-in-law). — Do you know the composer Arnold Schoenberg, today's most radical musician? It would be a good idea to organize a concert in Russia! [*A concert took place in St. Petersburg in 1912, directed by Schoenberg himself.*]

Jan. 14, 1912, Munich, to FRANZ MARC (Ger.):

[*Regarding a number of photos that Marc had sent him of works by artists of Die Brücke:*] Have received a bunch of the Berliners, and I'm very grateful. You know how much all that interests me. I understand you too: last year (1910!) I got a similarly strong impression from the Muscovites, who also impressed me with their mountains of canvases. Now I must say, even though it may annoy you, that I … prefer us Munich residents. That is, I value more our perhaps slow (but only outwardly slow), careful work, done with reverence and deliberation. And we're more personal too. That's evident not only from our "great inner significance," but also from the solitude in which we work. Not for us the lashings of the competitive whip, nor the steps that others have built and on which we are generously allowed to set foot. [*Kandinsky also remarks sardonically with regard to the "wild" Brücke artists:*] Out of 24 photos, 9 and ½ are nudes with or without pubic hair, 5 bathers, and 2 circus pictures.

1912

Jan. 17, 1912, Munich, to FRANZ MARC (Ger.):
Kulbin wrote to me that he read my lecture [*a shortened version of* Concerning the Spiritual in Art] at the St. Petersburg Artists' Congress and that it aroused great enthusiasm. [...] As you know, I expected my book to be a very small success at best.

Jan. 13, 1912, Nuremberg, to GABRIELE MÜNTER (Ger.):
Yesterday I looked at the wood carvings in the "Germanisches" [*Germanisches Nationalmuseum, Nuremberg's cultural history museum*]. It became particularly clear to me that as early as the fifteenth century there was a definite striving towards the real. And the more real things became, the more lifeless. Rococo looks like a spasm of despair in the face of approaching mindless realism.

Jan. 20, 1912, Nuremberg, to GABRIELE MÜNTER (Ger.):
Kulbin writes to me that my lecture was a great success. He was asked to reread it in another association and wants my permission to do so.

Feb. 2, 1912, Munich, to FRANZ MARC (Ger.):
What do the Berliners do and what are they like [*the painters of Die Brücke*]? They are partly people of great talent, enormous energy, who continue painting entirely in an impressionistic manner, helping themselves only to the new discoveries in color (mainly Matisse, <u>who himself</u>, in all his <u>serious</u> works, takes form—drawing!—into account, not just piecemeal, but <u>as a whole</u>). In all the works that I have with me now I see no trace of using (or needing) the graphic form, not to mention composition! It is in general exactly the same as with the Muscovites, which is why they did not appeal to me at all for the *B.R.* <u>book</u>. One should exhibit such things. But to immortalize them as a somewhat decisive, authoritative force in the record of our contemporary art (and that is exactly what our book should be)—in my eyes, it is not right. In any case I would be against <u>large</u> reproductions. I mean: such artists can become something, such art—not. [...] A small reproduction means: this [*work*] is <u>also</u> being done. A large one: this is being

done. [...] And where is the art that is our divine? You do know what kind of divine I mean. "Hallelujah" and "Lord, have mercy" is not obligatory for everyone and can be colossally inartistic (and ungodly); and a cabaret and 11 executioners can be divine [Die Elf Scharfrichter *(The Eleven Executioners) was a famous literary cabaret in Munich*].

Feb. 7, 1912, DAVID BURLIUK to NIKOLAI KULBIN (Rus.):
[*Concerning a debate event held by the Knave of Diamonds in Moscow, proving that Kulbin read Kandinsky's* Concerning the Spiritual in Art *in Moscow as well:*] The problem of the lectures is now solved: 1) N. I. Kulbin; 2) Kandinsky's text (which is with you); 3) my small lecture on Cubism.

Mar. 4, 1912, Munich, to ARNOLD SCHOENBERG (Ger.):
I greatly wanted to go to Prague for your concert, but how could I have done it—I, poor slave of *The Blue Rider*. [...] The editor of *Der Sturm* [*Herwarth Walden in Berlin*] is organizing what appears to be a really splendid exhibition (French artists, Hodler, Munch, Kokoschka) and has invited our first exhibition to participate: freight, own rooms. We accepted. Now comes the serious and heartfelt request of you: please lend those of your paintings already mentioned in the catalog, and the portrait of a lady that hangs in your dining room! [*Schoenberg refused.*]

Mar. 18, 1912, Munich, to FRANZ MARC (Ger.):
Ella [*Münter*] has not received an invitation from the Sonderbund. Such idiocies make me awfully angry and sad. Angry, because men allow themselves to treat women so stupidly. Sad, because especially in Münter's case the programmatic (= restricted) response is so apparent. [...] Why, apart from you and me, do only Mrs. Kandinsky (Russian), Schoenberg (Jew), Stadler (Jew) hear the special chiming line (not to speak even of the color) in Ella's works?

1912

Spring 1912, Franz Marc to August Macke (Ger.):
Kandinsky completely denies that differences of opinion between him
and me are in any way possible: merely the very personally offended
vanities of Münter, whom I, as she and he (hidden behind her) say,
treat like a chair. [...] It's hilarious, as you say, but also very sad for me
because of Kandinsky, whom I love very much and whose association
was dear to me.

Mar. 28, 1912, Munich, to Franz Marc (Ger.):
[*On Mar. 22, Marc wrote to Kandinsky after Münter had damaged her relations
with August Macke and his wife beyond repair:* "No one practices this virtue (of
closing oneself off against others) more strongly and sometimes more brutally than
Miss Münter." *Kandinsky answered six days later:*] In today's life, when people
(and even artists!) so seldom understand each other internally, and
where we could form quite a rare exception, we should do everything
we can to save our inner relationships.

Mar. 28, 1912, Munich, to Nikolai Kulbin (Rus.):
It has been an immense pleasure for me to receive your news about
the *lubki* [*popular Russian prints*]. Thank you from the bottom of my
heart! [...] And if, with the help of N. E. Dobychina, it is possible to
find some more in the province, I would be more than happy. [...]
Perhaps you would like to receive one of my oil sketches? I would be
glad to thank you at least in this way. [...]

I have heard about your lecture from Muscovites, and even from
the newspapers. What a city, this Moscow! 1,400 listeners plus 1,000
unlucky fellows who were not admitted! Unbelievable, in Germany
that would have been impossible. [...] Did I write to you about the
success of my book: the first edition sold out in 3 months, so the second
edition will be printed immediately. I am receiving reviews and whole
articles about the book even from England. Perhaps I will even see a
Russian edition one day.

88

Apr. 1, 1912, Munich, to ROBERT DELAUNAY (Fr.):
The Blue Rider is ready and should appear in 2–3 weeks. You will surely remember that I asked you last autumn to give us an article about art. I addressed the same request to several other French artists. Sadly everywhere without success. [...]

P.S. A Swiss artist, living in Munich, will visit you in the coming days. It is Mr. Paul Klee. He has a lot of talent and is <u>very</u> nice.

Apr. 9, 1912, DAVID BURLIUK to KANDINSKY (Rus.):
[*In his typically rough style:*] Around 15.4. I'm going to Berlin with father for 2 days, then to Nauheim, Papa will cure there. I'm then free, can come to you, if not too far (have no map here and cannot find Murnau). Want to take a look at Berlin, especially new art. Let me know who's important there. [...]

Here, with me, is Viktor Khlebnikov, I'll send you his article. [...] For me Foma [= *Thomas de Hartmann*] is interesting. Did he tell you the truth about the "Knave of Diamonds"? I have "robbed" him a little (30 rubles), I needed money and "sold" him 2 things. Perhaps such a "soft" character could have been put off by this. [...] At the Knave of Diamonds exhibition Sergei Shchukin showed special interest in your works. [*This last statement contradicts Kandinsky's own impression. In May 1912 Burliuk, on his way to Paris, paid Kandinsky a visit.*]

Apr. 25, 1912, to FRANZ MARC (Ger.):
[*Kandinsky is ready to reject certain paintings by artists from his own ranks, such as Heinrich Campendonk, for inclusion in* The Blue Rider:] For me, there is nothing I hate more in art than translating it into the indifferent and amiable. That's money-lending in the temple.

Apr. 25, 1912, Munich, to ARNOLD SCHOENBERG (Ger.):
Were you in Prague for the lecture about Mahler? [...] What do you think of the exhibition of these "free" Italians? In their manifesto they say a lot that's right and important. But at the same time there are so

1912

many immature, belated, and strange thoughts and for my taste too much … policing: "Go right! (maybe left!)" "Don't stand still!" and so on. And what do you think (I've wanted to ask you for quite a long time) of Scriabin? Do you know his latest, major works?

And once again: how are things? With you? Your family? I would like so much to get together with you again. We have only ever briefly seen each other and the topics that interest us are unlimited in number. — Very warm regards to you and your family. Do write!

June 9, 1912, DAVID BURLIUK to NIKOLAI KULBIN (Rus.): During the coming season something extraordinarily important and radical is expected: 1) an exhibition in Moscow; 2) exhibition in Petersburg—and discussions. Kandinsky will be in Moscow this winter. Get ready for winter! Write sharp polemical articles for the collective volume of Knave of D. […] Something about theater would be good. Pamphlets! Necessary! Couldn't Meyerhold or the other, with his monodrama [*Nikolai Evreinov*]? … This winter you have to publish: about yourself and the volume! In Petersburg! We publish in Moscow.

June 24, 1912, Murnau, to THOMAS DE HARTMANN (Rus.): Dearest Tomik, Burliuk and Konchalovsky have been here. Both have their hands full of projects and complain very much that you don't like the "Knave of Diamonds." Between you and me: Burliuk proposed all sorts of things to me. Late autumn I hope to participate personally in several events in Moscow. […]

I'm finally sending you the time-schedule in minutes and seconds of *The Yellow Sound*. Check it and write to me about your impressions. I have considered it several times, and it seems to be good to me. You will have almost complete freedom. Several things, however, have to be stressed, "rubbed in," so to speak: for example, the contrast between the growth of color and the retreat of music (picture 3: "like a snail")—that is a decisive moment: the yellow is growing, and everything is melting before it! Here I distinctly see wood instruments … [*Here Kandinsky included the*

complete, annotated Russian text of The Yellow Sound, *which they had worked on together in Kochel, Bavaria, in 1909 and then later in Moscow.*]

Infinitely sad that we cannot see each other, again and again, and cannot discuss it. But perhaps it is better this way! Do you remember how in Kochel we constantly quarreled? [...] Kulbin writes to me about a ton of projects (some already begun, others still in an embryonic state). About Meyerhold he writes: "He is extraordinarily alive and throws himself upon everything that is new." It was him whom we intended to get! Here Alfred Mayer is helping me a lot, he has many contacts (in the field of theater). Perhaps something will come out of it. [*Nothing happened until 1914 when Hugo Ball wanted to perform* The Yellow Sound *in Munich, but the outbreak of World War I prevented it. Kandinsky never saw it performed but published the piece in* The Blue Rider Almanac.]

June 26, 1912, to ALFRED KUBIN (Ger.):
[*On the art theories of the famous German art historian Julius Meier-Graefe:*] What a parochial and nasty mind that is. One cannot help but be amazed that such narrow-minded people [*Ger.* schmale Schädel, *literally "narrow skulls"*] without heart can devote themselves to the theory of art. No, actually, he is supposed to be one of the better theorists!

July 2, 1912, Murnau, to VOLDEMĀRS MATVEJS (Rus.):
In principle I will be here in summer, in the country. It is possible that I will travel in September. In summer I have things to do in Munich and will spend several days there. Therefore please, let me know in advance when you intend to come to Munich. Many thanks for your journal, I find it interesting. I am pleased that your association is pursuing such important and worthy aims. [*Best known at the time by his pen name Vladimir Markov, Matvejs spearheaded the Russian avant-garde artists' group and magazine* Soyuz Molodezhi *(Union of the Youth).*]

July 29, 1912, Murnau, to VOLDEMĀRS MATVEJS (Rus.):
The book on Cubism is very likely to appear in summer in Paris, if it has not been published already. Picasso will be discussed in it. I also

1912

know another article with a lot of illustrations in a Bohemian [*Czech*] journal. I received it from my publisher because my books have been reviewed in it. But you probably don't read Bohemian [*Czech*], so the article will not be useful to you; and there is not much else of interest in there except the "Blue Rider"—which you know about? Concerning Africa etc., you will certainly find enough material in Parisian libraries! [*Matvejs had a particular interest in African and Oceanic art.*] I am sending you 2 of our catalogs. D. Burliuk was here already about two months ago; soon after that Konchalovsky also passed through.

July 31, 1912, Murnau, to VOLDEMĀRS MATVEJS (Rus.): The name of the journal is *Umělecký měsíčník* [*Kandinsky writes "Mesyachnik"*] and the address: Prague 1, Frantichkashore 20. The illustrations of Picasso's work have been published today in the July issue. I also heard that the Berlin journal *Kunst und Künstler* has published his works.

Aug. 20, 1912, Murnau, to THOMAS DE HARTMANN (Rus.): Dearest Tomik, [...] End of Sept. I'm heading to Odessa to stay there for a month—then passing through Berlin (where my work will be exhibited in October) on the way back to Munich. I intend to leave on Sept. 25, so come immediately after your cure, both of you, and we will live together here for at least two weeks. Apart from some fun, we could work seriously on your music. I have been proposing exactly that for some time, and it would be consistent with the principle of *The Yellow Sound*, that is, the music should not be a musical poem but one of 3 lines that together form the substance of the whole stage play. It is therefore subordinate to the destiny of the other two lines, at times converging, at times diverging, at times disappearing altogether, that is, it participates through its silence. [...]

I am so happy about your success; you certainly know this yourself. The sad part of it is only that I cannot experience all of it together with you. How much I wish for this. To hear your works performed before a large audience, if possible in Moscow!

Aug. 20, 1912(?), Munich, GABRIELE MÜNTER to
ARNOLD SCHOENBERG (Ger.):

[*Regarding Erich Gutkind's book,* Sidereal Birth, *under his pseudonym "Volker":*]
I would like to draw your attention to a book that I think would bring
you a lot of pleasure. [...] I myself am ploughing through it rather
slowly, unfortunately with a lot of breaks. I get as much out of it as I
can bear. I cannot follow it all the way, and I think by the end it will
have become too much for me. But it is like a heavy gold chain slip-
ping, link by link, phrase by phrase, through my fingers [*the content is
highly idealistic, but the style was probably too ornamental for Kandinsky's taste,
so he passed it on to Münter and she to Schoenberg*].

Now I am quite certain that Volker is your man! On page 31 he
describes the elements of Kandinsky's *Compositions II, IV,* and *V,* etc.
Not in connection with Kandinsky of course, since he was probably
not at all acquainted with either him or his work at that time! I believe
it is important that such people get to know each other (remember
how I found your address initially?) [*After Schoenberg's concert in Munich
in January 1911, Kandinsky was eager to write to the radical composer and had
asked Münter to find his address in Vienna.*]

Aug. 22, 1912, to ARNOLD SCHOENBERG (Ger.):

In October my fairly large collective exhibition will take place at [*the
gallery*] Der Sturm. I myself will be in Russia, and I only <u>hope</u> at the
end of October to come back by way of Berlin. Münter will probably
be there before I am.

The fact is that the most urgent need of musicians today is to over-
throw the "eternal laws of harmony," which for painters is only a
matter of secondary importance. For us, the most necessary thing is
to show the <u>possibilities</u> of composition (or construction) and to set
up a general (very general) principle. This is the task that I began to
sketch in my book—in very "liberal" strokes. "Inner necessity" is just
a thermometer (or yardstick), which at the same time leads to the
greatest freedom and sets the inner capacity as the only limitation of

1912

this freedom. In continuation of this work, which now is ripening in me step by step (and has been for some years), I touch, in providential moments, the universal root of all forms of expression. Sometimes I want to bite my elbow in rage that things happen so slowly. [...]

Briefly put: there is a law, which is millions of miles away from us, towards which we strive for thousands of years, which we anticipate, guess, apparently see clearly and to which we therefore give different forms. Thus is the evolution of "God," religion, science, art. And all these forms are "right," because they have all been seen. Yet they are false, because they are one-sided. And <u>evolution</u> consists exactly of this, that everything appears many-sided, <u>complex</u>. And always more and more so. [...] And behind this <u>last</u> law, there is one much further still, since this first one is also only one-sided. It could drive one to madness or make one sing Hosanna.

Sept. 25, 1912, to HERWARTH WALDEN (Ger.):
Among the last things I have before me to send by special delivery, you will also find the *Old Town* (fig. 3), which I consider to be my best work from the period (1902) and which I don't want to give away cheaply. So I have increased the price to 3,000 marks. I'm more than happy if nobody buys it.

Sept. 29, 1912, to HERWARTH WALDEN (Ger.):
I'll write to the Deutsche Bank in Munich immediately—ask them to wire you 500 marks. I know what it means to seek money for a good cause and I can't refuse you, even if it's a bit unreasonable. — It's a coincidence that I just got 2,000 for my paintings. A <u>nice</u> coincidence, because I hardly knew how I was going to be able to travel (and I have to travel). [...] We know very few rich people. And I've already been burned by those I do know, i.e., chronic rejection. [*Herwarth Walden hosted Kandinsky's first solo exhibition, which opened on Oct. 2, and he wrote to him on the occasion:* "You are an extraordinary artist. I am proud of the exhibition. The strongest that Europe has to offer today."]

94

Sept. 27, 1912, Odessa, to GABRIELE MÜNTER (Ger.):
With mother and her husband. Then lunch with father. Bought gifts
for the dear little nieces. I feel very comfortable here. [...] Walden
wants to tour my collection for 2–3 years. My visitor numbers (i.e., to
my exhibition) are quite good for Berlin and Der Sturm (6–20 daily).
The Belgians had 1–2. [...] W. introduced me to his fiancée, a young,
pretty, very clever Swede, who is already his right hand—especially
in the editorial and gallery offices [*Nell Roslund*].

Oct. 2, 1912, to GABRIELE MÜNTER (Ger.):
It was always unpleasant for me, often repulsive, to leave the figure
within the realm of its physiological laws and at the same time have
it undergo compositional distortions. [...] This should not and will
not be my solution to the question at hand [*the problem of figuration*]. In
this way, the object in my pictures gradually began to dissolve more
and more of its own accord. [...]

Yes, I also think that fundamentally or <u>eventually</u> everything
becomes <u>one</u>. It is at the same time a double movement: 1) from the
complex to the simple; and 2) vice versa. That's why I was always
unconsciously trying to unite these two currents in my paintings. I
always wanted to connect these two seemingly unconnected principles.
All revelations are like rays of light that in the end only have to form
<u>one</u> "sun," the truth [*illustrated by a small drawing of a sun with rays*].

Oct. 15, 1912, Odessa, to GABRIELE MÜNTER (Ger.):
My parents are very happy with my achievements. I tell them a lot so
they have their fun. As always in such cases, my own feelings are
mixed. They've become even more mixed when people buy my new
works. I sat in a high, lonely tower for a long time. Now I'm no longer
alone. Is the tower still high?

Oct. 22, 1912, Odessa, to GABRIELE MÜNTER (Ger.):
[...] I want to "work on" Shchukin, i.e., win him over for the cause
and especially for Walden's sake. [...] A letter from the Hartmanns
yesterday: they're not coming to Moscow (anytime soon) and leave
the servants at my disposal (the cook and the housekeeper). They are

1912

doing well. But he is in a bad mood because his compositions aren't progressing. I think he is standing (just like you) at a crossroads. Take piano and theory lessons from Mrs. Klee? It would certainly be useful for you and also for the Klees' purse.

Oct. 23, 1912, Odessa, to ARNOLD SCHOENBERG (Ger.):
I am very pleased that you are going to Petersburg yourself. I will write to Dr. Kulbin about it, a pleasant, sympathetic, energetic doctor, a military academy professor, artist, organizer, etc. He will give you the best advice and certainly help you sincerely in every way. [...] K. knows everyone, i.e., all the important artists. My standing with liberal (not radical) Pbg. is poor. K. also knows these circles, I believe. In our sense, there is not much going on in P. In this, too, Moscow takes first place, which of course the people of St. Petersburg don't want to see. Hartmann also lives in Moscow as a rule (he's in Naples at the moment) but may be in P. in Nov. and Dec. I'm traveling to Moscow in 14 days to stay there for 3 or 4 weeks; then perhaps a few days in Petersburg and back to Munich by way of Berlin. [...] My exhibition is at [*the gallery*] Der Sturm and remains in Berlin until the end of Oct. Then Holland, and so on. [*After Berlin his solo exhibition traveled to Amsterdam, Brussels, Aachen, Magdeburg, and Stuttgart. The Munich publishing house Piper printed a luxury edition of his engravings and prose poems* Klänge *(Sounds), partly financed by Kandinsky himself.*]

Nov. 9, 1912, Moscow, to GABRIELE MÜNTER (Ger.):
Shchukin was very nice and invited me over again next week to see his gallery under electric lighting. The 30 Matisses are hanging in his large salon with furniture from the … 18th century! And it's amazing. That man has good taste. He considers Matisse and Picasso to be the best contemporary painters. He doesn't particularly appreciate my humble efforts! And actually my *Compositions 2–5* would work well in his place. I imagined it vividly … If I lived here, I'd soon convince him … Many people want to get me to do it, I mean to live here. There

96

isn't a noteworthy theorist here, especially not for new art. I'd be set up as a "canon" against the Petersburger Benois [*an enemy of modern art in general, as will become evident in later letters. Kandinsky continues to write here about his project of building a new six-story tenement house in Moscow*]. My idea is to build a studio with a living area under the roof in the new house. [...] Wrote to father and the Hartmanns and asked if I could get a loan.

Nov. 12, 1912, Moscow, to GABRIELE MÜNTER (Ger.):
Thanks for the reviews. Someone had dared to speak about lack of talent—now others are doing the same. [...] Yesterday I went sleigh riding. I haven't done anything artistic yet. Today I'm expecting Burliuk. I don't particularly feel like giving a lecture. Maybe I'll decide to do it. But I definitely want to do something else: sell my house and have a big, new one built. I'm going to see Hartmann's architect tomorrow. [...] Schoenberg is asking me to go to S. Pbg Dec. 17–20, as his concerts will take place around this time, and then go on to Berlin with him. But that will be too late.

Nov. 15, 1912, Moscow, to GABRIELE MÜNTER (Ger.):
The [*tenement*] house will cost 200,000 rubles, and my income will double. [...] "Knave of Diamonds" and its almanac (session yesterday from 7 until 1:30 a.m.), visits to artists with lots of discussion; I must write a "manifesto" for the KofD (already done) and I'm translating my "Question of Form" for [*a lecture in*] St. Pb. as well! All that aside, I'm visiting relatives, friends, churches, museums, writing letters. [...] I'm finding Moscow quieter this time (I'm not overly excited), but I'm still soaking it all up and quivering almost non-stop. I feel very much at home here, and the contrasts here are closely akin to my own. I long for work though, my work, painting, and for it I want to have complete and tranquil peace. The seed must ripen and start to sprout in silence. [...]

Nov. 16, 1912, Moscow, to GABRIELE MÜNTER (Ger.):
I'm terribly sorry that you misunderstand me, dear Ella. Your letters have hurt me. You should know how much I wish to see you content,

1912

to feel you spiritually warm. [...] My task was, as much as possible, to sow freedom among artists here, and to strengthen the bond between Russia and Germany. [...]

I'm not meeting Schoenberg in Berlin, so only Walden remains. I'm still translating my "Question of Form," which has to be finished this week. It's also important that I meet a major publisher tomorrow, through the very nice painter [*Georgiy*] Yakulov. I also want to visit not only the "KofD," but also other painters ("Symbolists") and get to know some of those who have come here for a Petersburg exhibition. Among them [*Nicholas*] Roerich, who has always interested me. I get on very well with Yakulov, maybe better than with the others, and he wants to help me a lot. I've also accomplished quite a lot with the "KofD" and am very pleased.

It seems that Walden's approach to music is less liberal. It's always easier to keep an open mind in foreign territory.

Nov. 22, 1912, Odessa, to GABRIELE MÜNTER (Ger.):
How boring to read the idiocies of these "professional art theorists"; they are narrow-minded and devoid of both imagination and energy. Well, on the other hand, I'm pleased by their "lack of understanding," as you know. If these boneheads understand me today, my concerns wouldn't actually be worth much.

I'm staying until Friday, because my sister is coming home from the hospital. — Greetings to Fanny, Anya, and Daisy [*the housekeeper, his ex-wife, and her dog*].

Nov. 25, 1912, Odessa, to GABRIELE MÜNTER (Ger.):
I have already been thinking that I might (in the case of war) return via Finland and Sweden. I'll manage to come back somehow. The Russian population is unanimously against war. Exceptions—only our dear "patriots." Volker [*Erich Gutkind*] very kindly wrote to me and asked among other things whether I would agree to the translation of my book into Dutch. [...] I have had no love affairs. I'm just really sad sometimes.

98

Nov. 27, 1912, Moscow, to GABRIELE MÜNTER (Ger.):
I'm really very tired from all the adventures and long for the quiet of
home. Hopefully it will be quiet too. [...] Are you well? And how is
Fanny [*the housekeeper*]? That wretch does not write. Be nice to her, you
know how much I appreciate her as a best friend, and how I want her
to feel very comfortable with us. [...]

Yesterday I attended the opening of the local "Secession." It is one
also in the moral sense of the word. In general, much of the stuff by
the artists was not to my taste. I still like Lentulov and his wife best,
that is as people. And also D. Burliuk, whom I really appreciate as an
artist [*the two soon parted ways, however, when Burliuk printed four of Kandinsky's
prose poems in his manifesto of Russian Futurism,* A Slap in the Face of Public Taste
*(1912). Kandinsky protested the rude, coarse, and intolerant content and tone of
this publication in two newspaper articles*]. He, Larionov + Goncharova send
you their regards. Both of them are full of life and beauty. — Today
I'll visit Shchukin again. Our contact is strictly platonic, which is fine
with me.

Nov. 29, 1912, Moscow, to GABRIELE MÜNTER (Ger.):
A long telegram yesterday from the Hartmanns from Naples. "Letter
to follow." So get ready to build [*his new Moscow tenement house*]. Yester-
day I was at Shchukin's again for 3 hours, where there were a lot of
other people. [...] Shchukin isn't buying anything from me. He is still
very far from such ideas. Only great success in Paris could move him
towards it, I think. But how to achieve this success. And in the end,
that doesn't matter either. I'm very sorry that I <u>can</u> think of such
things at all.

Late 1912, to HANS ARP (Ger.):
I promised to write you a few lines about my watercolor. [*Regarding the
bridge between form and content:*] Anyone can build the necessary bridge
here, proceeding from the origin (desire) and through the ensuing
result (image) to the inner "meaning" of the image, to the content.
To be half a poet is enough here. But to be a full poet is indispensable

for the 3rd kind [*of work*]. This third type exists when the external is completely stripped away and the inner "meaning," the content, is given expression by means of a completely different external form. So you can play a picture, versify a piece of music, carve a poem, dance a sculpture, paint a dance, etc. [...] The asynchronicity (the negative rhythm, so to speak) of the individual forms was what mainly appealed to me during the period to which this watercolor belongs. — The so-called rhythmic element always comes to the fore of its own accord, since in general human beings are themselves built rhythmically. So, outwardly at least, the rhythmic is innate in man. Children, "primitive" peoples, even the layman's hand draw rhythmically. — At that time, my soul was particularly enchanted by the mismatch between the drawn and painted form. Line serves the spot [*of color*] by circumscribing it. And in the case where the independent spot broke the bounds of the line delimiting it, it made my heart pound: line and spot don't match! That was what caused a strong inner emotion in me, the inner "ah"! — Whoever cannot participate in such experiences, to them such images remain silent. The destiny of the line, of the spot, and thus (further on) the connections etc. has always been the inner content of the work. I cannot marvel enough at those who are surprised by how "revolutionary" this law is. — The fact that this law manifests itself particularly strongly today is only proof that today's art is particularly strong.

Dec. 30, 1912, to FRANZ MARC (Ger.):
The Hartmanns are here for 3 days. They are traveling in a hurry to Russia, where the upper circles are definitely expecting war in spring. Apart from the personal question of where I (we) would then go, war is simply terrible. I feel the devil's hand in it so vividly that I grow cold. The dreadful possibilities can unfold endlessly, and the sordid consequences will leave a stinking trail in their wake around the globe. And ... mountains of corpses.

[*Kandinsky exhibited at the Armory Show in New York in February 1913. The gallerist Alfred Stieglitz bought* Improvisation 27 (Garden of Love), *now in the Metropolitan Museum of Art. The possibility of a solo exhibition at Stieglitz's gallery was also discussed, but World War I derailed these as well as other plans. Over the course of many years, Kandinsky had written some "prose poems," which Izdebsky had intended to publish in Odessa in 1911. In 1913, after Kandinsky had translated the poems into German and added a few more recent, more "alogical" ones, they were published as* Klänge (Sounds) *by Piper Verlag in Munich. Black-and-white woodcuts, as well as twelve colored ones, were included in the volume. Herwarth Walden published the artist's short autobiography,* Rückblicke (Reminiscences) *in the album* Kandinsky 1901–1913 (Berlin).]

Feb. 16, 1913, to HERWARTH WALDEN (Ger.):
I thank you from the bottom of my heart for your energetic help! Just received your letter + criticism. I'm so hardened when it comes to such things that the whole event didn't make much of an impression on me. It is very important, however, that criticisms of this kind should not go unpunished. [*When the writer Kurt Küchler derided Kandinsky's painting as bungling idiocy in the* Hamburger Fremdenblatt *(Feb. 15, 1913), Walden organized an international protest to which Arp, Marc, and many others contributed; see doc. 1913.*]

Mar. 8, 1913, Munich, to FRANZ MARC (Ger.):
Yesterday we all attended a lecture by Dr. Julius Meier-Graefe, now called Julianus Apostata because at the end he advised the audience to take this emperor as an example [Julianus Apostata *was the title of a book by Dimitry Merezhkovsky published in German by Piper Verlag in 1911*]. The new art is nothing but profiteering, without soul nor spirit, and one should unite against it. [...] The man spoke for almost 2 hours, and there was literally not a single valid idea in it. He spoke about Dostoevsky's [The Brothers] *Karamazov* for about 20 minutes and showed clear as day that he literally didn't understand a single word. He turned it into a dime novel [*penny dreadful*], but without meaning to. His intention was rather to praise Dostoevsky to the skies. [...]

1913

I'm working these last few days with desperate energy on a large composition that I have been carrying around with me for a year [Composition VI, *now in the Hermitage, St. Petersburg*]. I have been offered 1,260 marks (of which I get 1,000) for my painting in America [*by Alfred Stieglitz*]. I agreed.

May 10, 1913, Munich, to HERWARTH WALDEN (Ger.):
I just don't want to invite those people <u>personally</u>, as their style of promoting art has become extremely unappealing to me over time. I am giving you the addresses here, so that you can send official invitations: M. Larionov, Moscow, Trekhprudny 7/2, kv. 10; N. Goncharova, same address; D. + V. Burliuk, Novaya Mayachka, gouv. Tavry, Crimea.

May 11, 1913, Munich, to HERWARTH WALDEN (Ger.):
It's about an exhibition + my book *Concerning the Spiritual*. All the latest news I get from Russia shows me very vividly how readily and systematically my case had been silenced there lately. [*There seemed to be a resemblance between Orphism and his own ideas; thus he would not object*] if my *Concerning the Spiritual* were to be published in French! In the worst case, I would give up my fees (I'm getting 500 marks in England—just between us).

May 30, 1913, to HERWARTH WALDEN (Ger.):
An educated lady, Mrs. Dobychin [*Nadezhda Evseevna Dobychina in St. Petersburg*], opened an art gallery a year ago, is directing it well (as Dr. Kulbin writes) and would like to organize an exhibition with me.

June 20, 1913, to NIKOLAI KULBIN (Rus.):
I am very grateful to you for your cooperation. We should proceed as follows: I will give N. E. Dobychina a small selection of mainly watercolors and smaller new works; I will pay the transport. [...] Such a small exhibition could go on to Moscow, where I will probably arrive in early July and stay for four weeks at the home of the Abrikosovs.

June 28, 1913, Moscow, to GABRIELE MÜNTER (Ger.):
The painting *Two Poplars* was sold in London for 300 marks.

July 3, 1913, Moscow, to GABRIELE MÜNTER (Ger.):
You can give the sketches for *Painting with White Border* to the Herbstsalon [*Autumn Salon*]. But I don't want to give the sketches for *Comp. 6*. [...] The Hartmanns are coming soon, he's conducting a concert here, so I'm leaving later. H. finished his article about me [*"The Undecipherable Kandinsky"*]. I received it a few days ago and am going to translate it. [...] Tomorrow a tour of Hartmann's studio and perhaps the cemetery with father, Saturday another cemetery, where my brother Waldemar is buried [*Vladimir, whose name Kandinsky germanized for Münter's sake*].

July 4, 1913, to GABRIELE MÜNTER (Ger.):
You know me. Nothing external can affect me indefinitely. I constantly turn my gaze inwards. My task in art is so great, and I have achieved so little, that it is no easy demand to "be patient."

July 18, 1913, to HERWARTH WALDEN (Ger.):
"Knave of Diamonds" definitely wants to stage a big exhibition. Last winter they exhibited very successfully in Petersburg—400 paintings. Next winter they want to show 600. But there is a lack of material. So they would certainly like to add a selection from a third party. I was put to the test and answered quite clearly that we would only participate if they pay the freight, local insurance, etc. The secretary really wants to speak to me again.

July 25, 1913, to NADEZHDA DOBYCHINA (Rus.):
From what I have heard from Berlin, my exhibition there will continue through all of the autumn until Feb. 14. So our plan to show my paintings in autumn in Petersburg cannot go ahead. Would you agree to exhibiting them in winter instead? [...] If I succeed in getting to Pbg. in 10–12 days, we could talk it all over [*she showed six woodcuts and seven paintings*].

1913

July 19/Aug. 1, 1913, to GABRIELE MÜNTER (Ger.):
I really can't number, dear Ella. I always write suddenly, in a hurry
and don't have a permanent table [*Münter numbered her letters*]. [...]

I do what I can against the leading power in Paris. This idea finds
sympathy everywhere. In any case, it's high time we stopped bowing
and scraping to the French.

Aug. 8/21, 1913, to GABRIELE MÜNTER (Ger.):
Beffie finally bought 3,000 marks' worth from me. A Mr. Eddy from
Chicago came to my place in Munich. Fanny [*the housekeeper*] showed
him my things.

Sept. 14, 1913, Moscow, to HERWARTH WALDEN (Ger.):
My unfortunately very cursory translation of Hartmann's article is
enclosed. Would you be so good as to correct it a little. As for the
content, I have treated it very carefully. Only on p. 14 (top) and 15 (at
the bottom) I couldn't come up with the right word. [...] Have my
pictures for the Herbstsalon arrived yet? What is the submission like
so far? Already a lot? Good? I would really like to see what you wrote
about me for the album? Is that too impertinent a wish?

Sept. 17, 1913, Moscow, to HERWARTH WALDEN (Ger.):
The texts by Marc and Hartmann will probably not take up more
than 10–20 pages together. It would be a great pity to leave them out!
All the more so, since they would be highly appreciated in the Russian
edition [*Hartmann's "The Undecipherable Kandinsky" was meant for the 1913
album, but Walden did not include it. The manuscript and the translation are
now in the MES, Munich*].

Sept 29, 1913, to FRANZ MARC (Ger.):
[*In September 1913, Kandinsky exhibited important new works at the Erster Deutscher
Herbstsalon (First German Autumn Salon) at the Galerie Der Sturm in Berlin.
He made sure that Gabriele Münter's painting* Paul Klee *received a prominent
place in the show. He was less impressed by other works included in the display:*]
I'm quite aware that one can use any material to create a great work

104

of art. On the other hand, I know just as well that the choice of material bears some relation to the intent. So I hardly believe that a desire highly important (to the artist) would misappropriate a very frail, ephemeral material [*for its expression*]. In my eyes, this transience (inner sloppiness) discredits the artist's desire. [...] I try to put a part of my soul, if not all of it, into every work, and it hurts me to know that alongside my work there are works that are created "this way." [...] Delaunay's little horse [Cheval. Prisme. Soleil. Lune, *1913*], Yakulov's circles [Dissonances, *1913*]. Things like this are just as wrong for me as the futuristic inscriptions in the catalog [*"Futuristic Picture Explanations" in the foreword to* Der Sturm. Zweite Ausstellung: Die Futuristen *(Berlin: Der Sturm, 1912)*]. These are exactly the same as the earlier explanations: "General X. on the left, Emperor Y. in the middle, Hussar Regiment Z. on the right." Does any of this have anything to do with painting and especially with the picture? In my opinion, all of this means placing the brain between the soul and the image.

Oct. 6, 1913, Munich, to ALFRED KUBIN (Ger.):
My old wish has been fulfilled and I now have a publisher in Moscow. The two publishers are young musicians [...] educated men. They asked me about interesting German books and naturally I immediately mentioned your *The Other Side* [*Kubin's novel,* Die andere Seite, *published in 1909. Grigory Angert and Evsei Shor, Kandinsky's Russian "publishers," became good friends with the painter and hoped to publish a Russian edition of Walden's 1913 album on the artist, a translation of* Concerning the Spiritual in Art, *and a book of Kandinsky's prose poems; they also intended to show his work in Moscow. The outbreak of World War I derailed all of their plans*].

Oct. 17, 1913, Munich, to JEROME EDDY, USA (Ger.):
You are asking me to recommend Munich artists to you. [...] The formal side is of very little importance to me, I demand that the artist carry a "sacred spark" (if not flame) within himself. [...] Böcklin was right to say: even my poodle could learn how to draw. I had more

1913

than a hundred colleagues and about 40 of my own students—all of them learned such a thing, many over time could draw very well anatomically, and yet … they didn't become artists, not 5 pennies' worth. […] Apart from Marc, whom you already know, I want to name the following 4: Paul Klee, Gabriele Münter, Albert Bloch, and Alfred Kubin.

Nov. 12, 1913, Munich, to HERWARTH WALDEN (Ger.):
[…] but if possible, don't emphasize the Italian Futurists too much. You know how I feel about them in general, and their latest manifesto (painting of noises and odors—without Grey! without Brown! etc.) is almost even more frivolous than their earlier ones. Please don't blame me, dear Mr. Walden. I'm not comfortable talking about it either. But art is indeed a sacred thing that should not be treated lightly. […]

Nov. 15, 1913, Munich, to HERWARTH WALDEN (Ger.):
Recklessness and haste are characteristic of many radical artists today, which, as I have already mentioned, is why the Futurists have corrupted the good in their ideas. I am speaking of this at length so that you will not think that I suffer in my judgment from the same recklessness and haste. Such artists can only rejoice that our art criticism is impotent.

Dec. 21, 1913, Munich, to HERWARTH WALDEN (Ger.):
My *Concerning the Spiritual* will probably appear in a special American edition. The English one is already finished or almost. Mr. Sadler sent me a snippet of an article in *Camera Work* (New York), where Rodin, I, Matisse, and Picasso (this compilation and possible order may be of use to you in Sweden) are stamped as "objectively clear thinkers."

[*In January 1914, the society Kreis für Kunst (Circle for Art) in Cologne staged a solo exhibition of Kandinsky's work. His polemical text, "Cologne Lecture," written at the end of 1913, was never read there, perhaps because of its length as well as his attacks on art historians who were "standing in the way of any progress." Several*

of his prose poems were read (only to be greeted with subdued laughter). An additional solo exhibition took place in Munich at the Galerie Thannhauser, and his works were also shown in Hannover, Geneva, Malmö, and Tokyo.]

KANDINSKY, "Cologne Lecture"
[*Towards the end of his long text he stresses:*]
I do not want to paint music.
I do not want to paint states of mind.
I do not want to paint coloristically or uncoloristically.
I do not want to alter, contest, or overthrow any single point in the harmony of masterpieces of the past.
I do not want to show the future its only true path.

Apart from my theoretical writings, which until now, from a scientific point of view, leave much to be desired, I only want to paint good, necessary, and living pictures, which are experienced properly by at least a few viewers.

Feb. 5, 1914, to ARNOLD SCHOENBERG (Ger.):
Your letter gave me great pleasure—months ago! One can become giddy: the four colors—white, pink, green, orange—of the four seasons are simply rushing by. One imagines twenty such rotations in one's mind and sees oneself as an old man. And the work is actually just beginning. New possibilities are always revealing themselves piece-meal, in fragments, and in rare, happy moments as a <u>whole</u>. Perhaps one should occasionally sit locked up in a tower to be able to shake off <u>all</u> worries. But "life" scrambles up the tower as well and flows in through the keyhole. [...] Art is turned into a menagerie: the magnificent specimens sit in cages, and a bold animal trainer, whip in hand, explains the characteristics of the artists. Everything becomes incredibly simple; the secret has become venal. Be happy that no one wants to under-stand <u>what</u> you create. Let the dirty fingers grope your <u>form</u>! He who really needs the <u>content</u> will come in time. He will be recognized by his clean hands.

1914

Feb. 17, 1914, to FRANZ MARC (Ger.):
I would like very much for you to get to know Mitrinović. He could be very useful to the BR [*Blue Rider*]: I discussed a few things with him, and he gets to the heart of the matter in a flash. He will stay here another 5–6 weeks, then to Tübingen—to do his PhD. — P.S. Yes! Walden asks that, if possible, some mention be made of *Der Sturm* in *BR* 2nd edition. I wrote to him that we're going to ask Piper to run an ad for free. You don't mind, do you? [*Dimitrije Mitrinović, a Bosnian Serb, went to Munich in 1913 to study art history under Heinrich Wölfflin. On Feb. 23, Kandinsky mentioned the Serb to Marc again, writing that* "Today Mitrinović learned that several art schools and private individuals have returned the invitations in protest."]

Mar. 10, 1914, Munich, to FRANZ MARC (Ger.):
[*Regarding the project for a second* Blue Rider Almanac:] The time for the *BR* is not yet ripe. Artistically there is not enough; for other things we could only join in, but not lead. It would not be very faithful to, and would be a shame for, the cause. Let's just wait with the second book. One shouldn't do anything by halves or induce violent premature births. [...]

Mitrinović was here yesterday. [...] A reverie began that lasted until 2 at night, and so yearbooks for all intellectual domains have been founded. [...] Just think of the art humanity will create [*here he is referring to Erich Gutkind's project* "Bewegung zur Menschheit der Vollkultur durch ein Gesamteuropa" (*Movement towards a Humanity of Complete Culture through the Whole of Europe*). See Hahl-Koch, Kandinsky, *1993, 220ff.*]. — The Odessa spring exhibition asks me for some paintings by my friends. Free freight there and back, since I choose the items—jury-free. I am asking you, Klee, Münter, Bloch, for 3–4 pictures each. It is very urgent.

Mar. 25, 1914, Munich, to FRANZ MARC (Ger.):
I have sent your preface to Piper. You were right to sign it "F.M." I am going to put a "K." under mine. I cannot argue with what you are saying. But I would not have the courage to defend your view. My

feelings will not accept Däubler's maxim that "everything only begins here on earth." I "believe" in a different picture. That the works appear imperfect to us is "proof" of my ideas about inner necessity: their third element (the purely artistic) is expressed only to the extent that <u>this</u> time period is able to capture, meaning that a work is perfect in this time. Giotto, Michelangelo, Raphael, El Greco ... Cézanne, Matisse, Picasso, I <u>cannot</u> call imperfect. The content and form harmonize perfectly. […] Is Christ imperfect? Yet he didn't say "everything." What he said <u>cannot</u> be better said—it is perfect. Perfection = harmony of content and form.

Mar. 27, 1914, Munich, to ARNOLD SCHOENBERG (Ger.):
Today your portfolio arrived together with your letter and the one from Mr. Müller [*Conrad Felixmüller*]. I am very embarrassed that I can't be of any help to you. Please do believe me! But I cannot bend my conscience. The woodcuts are not bad and not lacking in talent, but rather far from what I consider graphic art and painting to be. The forms are modern-conventional, but made quickly, without feeling. […] Do believe me that your music would be but little honored by them. These things are not "inspired" by anything, or then only in an exclusively superficial way. What we call "creation" is <u>not</u> there. How could I defend them? I am very sorry to have to voice this harsh judgment. But I cannot do otherwise. […] There is <u>one</u> Schoenberg, but ten thousand or more such sheets.

Don't be angry at me! Both of us send our regards to you and your wife.

P.S. I keep reading about you in the Moscow *Music*: your successes in London, etc. etc. And every time I'm happy.

June 10, 1914, Murnau, to ARNOLD SCHOENBERG (Ger.):
[*After Kandinsky had already inspected and described in detail—including sketches—four holiday homes for Schoenberg's large family and a nanny:*] Wild (Achilles') is near the lake, has its own bathhouse, a good garden, and the rooms are a little larger than Staib's. On the other hand: no stove

1914

(kerosene was promised, which, as is well known, does more for the nose than for bodily warmth)—and even July can be cold here; it's far from town (shopping, doctors, pharmacy, which can be very important for children). [...] At Staib's: everything freshly painted and prepared. [...] We (I?) only reported one thing wrong: 15 minutes to the lake—true, but only for you (and me since I walk fast), but with children it will probably take 20–25 minutes. [...] Your neighbors would be real Murnau residents, who are generally nice and <u>discrete</u>. The Achilles' place, however, lies on a promontory that resembles a small provincial town: nothing but educated neighbors who, when cut off from the "world," usually like to stick their noses into other people's business.

[*In April 1914, an English edition of* Concerning the Spiritual in Art, *translated by Michael Sadler, was published in London as* The Art of Spiritual Harmony; *an American edition soon followed in Boston. In Russia, the* Works of the All-Russian Artists' Congress *of 1911–12 were published with Kandinsky's text and important color chart; see doc. 1911 and fig. 10.*

The Baltic Exhibition was held in Malmö, Sweden, from May to October. A number of Kandinsky's paintings were exhibited, including Composition VI, Arabs III, *and* Improvisation 2. *Kandinsky and Jawlensky attracted considerably more attention than German Expressionists such as Kirchner, Pechstein, and others, but the comments Kandinsky received were primarily unfavorable.*]

July 7, 1914, Murnau, to Dr. Fritz Burger (Ger.):
As I believe I once mentioned briefly to you, Mitrinović is planning a large international association—not in any official sense of course—with important personalities who live today but care for tomorrow, whose souls and minds are directed towards this "tomorrow." [...] The next link in the chain, what is called inner fusion, is the planned fusion of all nations. [...] All areas of the human spirit should be equally cultivated [...]: art, politics, religion, education, science, and philosophy. All forces that have achieved something efficient and significant (<u>really</u> significant) in these domains, <u>and</u> which remain

connected to the idea of "tomorrow," should be involved in this great and naturally occurring work. [...]

First, an almanac is planned, a programmatic work, so to speak, comprising the areas mentioned above. This book is to appear in the spring of 1915. M. is working with a rare energy to bring together the essential forces. He will travel to France, Russia, England, and Italy to gather the necessary support there, give lectures, conferences, etc. [*funded by Kandinsky*]. M. asked me to write to you to ask for your collaboration. He writes that "your view of the work of art as part of a general outlook on life" is "the most valuable idea that modern German art possesses." He is well aware that you took a fairly critical interest in his lecture and he told me two months ago that "we absolutely must have Dr. Burger with us"! [*Mitrinović had lectured on Kandinsky's art at the Historical Museum in Munich in the spring of 1914; see doc. 1914*] — I have unfortunately left my list of collaborators in Munich, but can nonetheless give you a few names: Chamberlain, Otto Braun (philosopher), Merezhkovsky, Fritz Mauthner, [*Stanisław*] Przybyszewski, Maeterlinck, [*Giovanni*] Papini, Däubler [*a German poet*], etc. [...]

Have you read Arthur J. Eddy's (Chicago) book on the new art? [Cubists and Post-Impressionism *(Chicago: A. C. McClurg, 1914)*] An unbelievable achievement for America. This Eddy (a lawyer) was in Europe a year ago, especially in Munich (I was in Moscow at the time), and he bought a small selection (around 20 of my works) from all periods. Recently he got me a small commission from New York that has been keeping me busy this whole time: 4 paintings for a reception hall [*for the entrepreneur Edwin R. Campbell*].

July 11, 1914, Murnau, to ERICH GUTKIND (Ger.):
[*Answering an invitation to an important meeting in Forte dei Marmi, Italy:*] Mitrinović left yesterday and asked me to write to you. [...] Today all of Europe is in great danger of war once again. [...] As soon as possible he [*Mitrinović*] would like to start lecturing all over Germany and be in Russia in 1–2 months' time, where I should meet him. Then he will

go on to London, Paris, Italy, and finally to America, where he hopes to find substantial material support. [...] I would really like to come to <u>Forte</u>. But certain things (very important for me) are happening so I must be in Moscow at that time. Besides this "must" there is a "want." I've been living in a state of deep, almost unrelenting longing for Moscow since the winter. I am now in a phase in my work that absolutely compels me to spend several months in Moscow. Unfortunately, I cannot make this profound love clear to you. The ultimate goal of my life is painting. I have allowed a lot (an alarming amount) of time "to slip through my fingers." Now I see with complete clarity that I will <u>only</u> attain at least part of my goal by sacrificing everything to it. So I am withdrawing from all sorts of things, renouncing many things that I love, that I consider valuable, necessary, beautiful, good. [...]

Moscow is the soil from which I draw my strength and where I can live inwardly as my work demands. Earlier I used to be able (perhaps "I had") to be in direct contact with the external world, to play an active part in it (this gave rise to various undertakings, such as the "Blue Rider"). It was probably necessary. Now it has become harmful, life-threatening. A few things have now become clear to me. This "clarity" about being an artist has little to do with reason. It belongs to the sphere of spiritual life, which needs the best conditions so that what has "become clear" can become corporeal. Without this realization, art is worthless and reduces the artist to a criminal. The strongest of flames must <u>first</u> burn in silence, so that it later gains the strength to withstand any storm. I hope to get news again from you in Potsdam. My inner voice will then tell me what to do.

[*This long letter, written three weeks before the outbreak of war, is now in the archives of the Schlossmuseum, Murnau.*]

July 18, 1914, DIMITRIJE MITRINOVIĆ to KANDINSKY (Ger.): Mr. [*Stanisław*] Przybyszewski answered us with great benevolence and promised his labor: a significant success. I don't need the money for

the moment. [*A day later he urged Kandinsky to write to Merezhkovsky, since he knew him personally:* "Getting in contact with Gustav Landauer, Dr. Hausenstein, the socialist and anarchist circles; trying to reach [*Peter*] Kropotkin through Landauer. … Erich Lilienthal. I will visit Chamberlain and Mauthner in Lindau … Gutkind, Papini, Hervé, Shaw."]

Aug. 2, 1914, Munich, to HERWARTH WALDEN (Ger.):
[…] There we have it! Isn't it horrific? I am torn from the dream. […] Mountains of corpses, horrible torments of all kinds, the scaling back of inner culture indefinitely. […] The hope that the war will not take on the dimensions expected does not leave me. […]

P.S. Of the 16 years that I have been living in Germany I have given quite a few entirely to German artistic life. How am I supposed to feel suddenly like a foreigner here?

[*At the outbreak of World War I on Aug. 1, 1914, Kandinsky, as a Russian citizen, was immediately expelled from Germany. Detained in Switzerland for a long time, he began his theoretical work on* Point and Line to Plane, *before he was finally able to travel (with difficulty, over six weeks) via Constantinople to Odessa and then on to Moscow. He informed Münter:* "Each of us should have complete freedom. Without it, I am increasingly aware that I am worthless." *He tried to keep in contact with his closest friends.*]

Sept. 10, 1914, Goldach, Switzerland, to PAUL and LILY KLEE (Ger.):
Dear friends, what does your silence mean? Mr. Klee? Yesterday some news about Mitrin.[*ović*]: he is safe [*in England*]. Today a postcard from Walden, dated August. He has dismissed his office staff, miserable financial situation. Otherwise, we hear nothing. Where is Marc, i.e., in which fortification? Do you have any news from Mrs. Marc? […] We are now getting the first messages from Russia—we knew nothing for 6 weeks. At least letter-based correspondence options are slowly emerging. What happiness will flow when these terrible times are over. And what comes next? I believe there will come a great unleashing of

1914

inner forces, which will also ensure a renewed brotherhood. Also, a great blossoming of art, which must now conceal itself in hidden corners.

Oct. 23, 1914, FRANZ MARC to MARIA MARC (Ger.):
[*Kandinsky's art is:*] a real <u>primal feat</u>. Times when one undertook a peaceful pilgrimage over the hill to a fellow spirit like Kandinsky! And today. These thoughts are actually the most painful for me today. Although I was often dissatisfied with Kand., and not everything was as we wanted—today this means nothing to me compared to the irreplaceable loss. For I fear he will be lost to me. He will stay in Russia + preach there; or in Switzerland—but I myself have become more German than ever.

Oct. 24, 1914, FRANZ MARC to KANDINSKY (Ger.):
I <u>live in this war</u> myself. I even see in it the salutary, if cruel passage towards our goals; it will not set mankind back, but <u>cleanse</u> Europe, get it "ready."

Nov. 8, 1914, Goldach, to FRANZ MARC (Ger.):
Until the last moment I <u>could</u> not believe that your expectations could be justified. I thought that for the construction of the future, space would be cleaned out in a different way. The price of this purge is appalling. Compared to your situation, I'm fine. But still I was only able to work for the first 6–7 weeks. [...] The Klees traveled through here and stayed with us. [...] Here I have been working on my theory of painting, something I have been slowly preparing for the past few years. By and large, I've laid out the basics. When I will get the chance to elaborate in more detail, one cannot know [Point and Line to Plane *was not published until 1926 in Munich*].

Nov. 16, 1914, FRANZ MARC to KANDINSKY (Ger.):
My heart is not angry about the war, from the bottom of my heart I am grateful: there was no other passage to the age of the Spiritual;

the stable of Augeas, old Europe could only be purged this way; or is there a single person who wishes to undo this war?

Dec. 24, 1914, to GABRIELE MÜNTER (Ger.):
Where are you now? And how do you feel? I kiss your hands and beg you to be healthy, lively, and industrious, dear Ella.

Dec. 25, 1914, Moscow, to GABRIELE MÜNTER (Ger.):
Of the 3,000 from Möller [*his Berlin gallerist*] keep 2,000. My conscience weighs upon me. [...] But time brings counsel. Our involuntary long separation will certainly bring clarity to some things.

Dec. 24/Jan. 6, 1915, Moscow, to GABRIELE MÜNTER (Ger.):
Recently I went to an exhibition. Good things, often tasteful, but nothing outstanding. All sorts of tendencies, all the way to imitations of Picasso. Large formats by the Knave of Diamonds group. Talented, as always, but superficial. [...] Lots of skill, elegance, and finish, but no sense of a powerful underlying spirit.

I deeply regret that you are not working more energetically: God's spark is in you, which is so rarely found in painters. And your external talent is certainly enough. Your swaying line and your sense of color!

Jan. 14, 1915, Moscow, to GABRIELE MÜNTER (Ger.):
At last I've started to work for real. For the time being, I'm making individual sketches for a large picture that was already vaguely taking shape in my mind in Goldach. It's gradually becoming clearer. But I still have to do a lot of preparatory work, because I want to be even more precise, almost pedantic, in this work more than in the earlier ones. I won't be able to paint properly until I'm at home, which won't be before June. I can only do small things here. What pleases me is that every temptation to tackle something that is not yet ready is out of the question for me.

Jan. 15, 1915, Moscow, to GABRIELE MÜNTER (Ger.):
I must prepare myself internally even for small, clear-cut subjects. So I'm practicing a lot with watercolors and with ink, and a few engravings. I can sense a proper state of mind gradually returning.

Feb. 20, 1915, Moscow, to GABRIELE MÜNTER (Ger.):
Yesterday I was at Tugendhold's. [...] He sent me an invitation here for Easter. I get a room to myself and can hang whatever and however I want. I have here *Comp. 7* and five other pictures that were exhibited in the south last winter [*in Odessa*]. — Anna finally arrived in Stockholm [*his first wife*]. All my friends send you their regards, the Hartmanns also asked about you. If you sell any of my paintings, please keep the money. I am always afraid that you don't have enough. [...]

I attended a concert (an orchestra of 50–60 players) with old instruments. It really was an experience. Two folk songs were especially fine. So in 8 days I'm going to a church concert.

Mar. 2, 1915, Moscow, to GABRIELE MÜNTER (Ger.):
I have been living alone now for three months and see that this form is the right one for me. I miss you often. [...] This is accompanied by the sadness and fear that I feel for you. [...] Only in art am I infallible like the pope and despotic like a monarch. In life I am like a sluggish river that flows strongly to nowhere because it wants to flow in all directions at once.

Mar. 27, 1915, Moscow, to GABRIELE MÜNTER (Ger.):
In 8 days we have Easter. The night service has always been an impressive experience for me. Hopefully it will be the same this time.

May 18, 1915, Moscow, to GABRIELE MÜNTER (Ger.):
My house is occupied, so I am renting [*a tiny place with a kitchenette, electric light, and telephone. All twenty-four apartments in the tenement house he built were occupied*]. Mother has sent some furniture and Shura plates [*Alexandra, widow of his brother Vladimir*]. Everyone is spoiling me. [...] Take as much of Möller's [*money*] as you need. Both of us will have full freedom. Without which, as I see more and more clearly, I'm not worth much. You will soon be happy too, and the bitterness will diminish.

3–4 days ago I saw the sunset from the fortress that I had described in my "Rückblick" [Reminiscences, *his short autobiography of 1913*], and I am still feeling the shock.

June 11, 1915, Moscow, to GABRIELE MÜNTER (Fr.):

[*From this point on, Kandinsky began writing to Münter in French because of Russian censorship. Many of these letters are included, both in the original and in English translation, in Barnett,* Kandinsky and Sweden, *1989.*]

I will start to paint in oil soon. I will do a panel for the Abrik.[*osov*] property. I will write you a few words every 8–10 days. The most important thing is to have news about each other's health. Don't you think? Don't write too often. I kiss your hand and wish you good health and peace of mind.

July 25, 1915, Moscow, to GABRIELE MÜNTER (Fr.):

You have changed your mind. You know very well what you promised in 1903. [*See the letter of July 27, 1922; due to Münter's never-ending reproaches, his ex-wife Anna and Olga de Hartmann also tried unsuccessfully to intervene.*]

Aug. 7, 1915, Moscow, to GABRIELE MÜNTER (Fr.):

Both of your letters are full of rebukes. [...] I will come to see you, and I want to do so very much, but I cannot live with you like we once did—as you know—always without any success.

Aug. 14, 1915, Moscow, to GABRIELE MÜNTER (Fr.):

Regarding our marriage, you have misunderstood me. I will tell you more about it when we are together again. My parents urge me not to leave Russia right now.

P.S. Your letter of Aug. 7 has just arrived, which makes me worry even more about you. [...] You really make me feel ill! [...] I'll find the money [*for the trip*], which won't be easy, but I'll do it.

Sept. 13, 1915, Moscow, to GABRIELE MÜNTER (Fr.):

I would very much like to paint in oil, but unfortunately I have no money at all for the necessary materials: easels, canvases, colors. I have nothing but my watercolors.

Sept. 21, 1915, Moscow, to GABRIELE MÜNTER (Fr.):

This year has been extremely difficult for me, and only this past month have I regained the equilibrium that I need for this work. For this work I need the constant impressions of color and internally the impressions of life in Moscow.

Oct. 8, 1915, Moscow, to CARL GUMMESON (Ger.):
I'll bring 15–20 recent watercolors and drawings that I made this year
(I haven't done any oil paintings). [*Some future forgers evidently failed to
realize this point.*]

Oct. 8, 1915, Moscow, to GABRIELE MÜNTER (Fr.):
You know that Scriabin died. What a loss! (Poor Taneyev, too, which
is also a great loss). And in October there will be four performances
of his works (also the symphonies, *Ecstasy* and *Prometheus* [*by Scriabin*])
and I'm in despair at not being able to attend them.

Nov. 16, 1915, Moscow, to GABRIELE MÜNTER (Fr.):
I'd like to create a large painting with immense depth and suggest the
effect of distance using subtle means, which one discovers only from
up close—an idea I've already had in the paintings you've seen—
but that I now understand on a broader, more practical scale, which
is the result of the many watercolors I've done recently.

[*Kandinsky received the opportunity to show his work in Moscow alongside the
Burliuk brothers, Larionov, Goncharova, Malevich, and Tatlin in the large exhibition
The Year 1915.*]

Dec. 18/31, 1915, Moscow, to GABRIELE MÜNTER (Fr.):
You know I usually live in a dream, as far as "real" life is concerned.
But now it's worse. I'm desperately craving work. I'd love to move into
my studio, shake off all practical worries, and plunge headfirst into
proper work! Oh yes! Be patient! When did I last hold my palette?
It was months ago.

[*Kandinsky arrived in Stockholm on Dec. 23, 1915. The Swedish dealer Carl Gum-
meson had given Kandinsky and Münter the chance to exhibit their work at his
Stockholm gallery. Kandinsky's solo exhibition opened in February, with the artist
in attendance, and he stayed until after the end of Münter's exhibition in March.
For more, see Barnett,* Kandinsky and Sweden, *1989. In 1916 Kandinsky's works were*

also shown in Berlin, The Hague, Helsinki, and at the Galerie Dada in Zurich. Hugo Ball recited prose poems from Klänge (Sounds) *as part of the "Cabaret Voltaire" and lectured on the artist's painting.*]

Apr. 12, 1916, Moscow, to GABRIELE MÜNTER (Fr.):
I see from your second letter that you have contact with people, that you have ideas and artistic aims. I know that this is far, far too little for you. But even so, it shows me that you have some way of living. [...]

But how could I help you by coming to you? Wouldn't it be the same torment as it was when I was last with you? In any case I don't have the strength <u>right now</u> to help you by visiting you. [...] I can't tell you how much you torment me. Sometimes I want to throw myself face down on the floor and howl like a dog.

Apr. 28, 1916, Moscow, to GABRIELE MÜNTER (Fr.):
As for Der Sturm [*Herwarth Walden*], don't start any arguments over the 15%. Don't forget that he has done a lot for me and will do more. An agent is always something very convenient for an artist, especially for an artist like me, who is not at all practical. [...] As for me, I'm alone a lot, I think, I work. I make very simple drawings—a few lines, a few spots. These are exercises of great value for more complex paintings. At the same time, I am making studies for the Abrikosov panel and for two fairly large paintings.

May 10, 1916, Moscow, to NADEZHDA DOBYCHINA, St. Petersburg (Rus.):
I was very happy to receive your letter. But your news was so sad that my joy immediately vanished. Is it really impossible to keep your gallery? Does it have to close down? I have always been convinced that your salon is the first and best and so vital for Russia that it will prosper in the future. I await further news from you. The Hartmanns are on their way to Moscow, so I'll see them soon. Perhaps they will tell me something. Perhaps you will come to Moscow yourself? I will

be here the whole month of May. Don't forget my telephone number. [*Dobychina exhibited two of Kandinsky's works in April.*]

May 14, 1916, Moscow, to GABRIELE MÜNTER (Fr.):
I feel thankful towards you. [...] At times you believed that it was for your body. But no, no! It was rather a spiritual bond. Possibly your art as well! From the very beginning I have loved your talent, and I will always love it, and perhaps I am the only one so far to recognize its worth.

May 21, 1916, Moscow, to GABRIELE MÜNTER (Fr.):
I am painting landscapes from my windows: with sun, at night, and when it's gloomy. I find it amusing and very useful—I enrich my palette, I research different harmonies. And when I think that I may be forced to leave this house, I feel very, very bad. [...]

It is a constant source of anguish to me that people are so good to me and yet I seem incapable of reciprocating. The excuse that I am made like this and can't change is no excuse. Even if it were, it's no comfort to me. Right now I crave a life of solitude, which I have not yet experienced and which I suspect is still a long way off.

May 26, 1916, Moscow, to GABRIELE MÜNTER (Fr.):
Your pictures have turned more serious, deeper, steadier; I find more individuality and a very special trait in them that will make you immortal.

June 4, 1916, Moscow, to GABRIELE MÜNTER (Fr.):
Could you write to W. [*Walden*] that I need money and that I would be ready to sell some of the larger things even at half price. [...]

I would like to paint a large cityscape of Moscow—all elements united—weak and strong parts, everything mixed—just as different elements make up the world. This should sound like an orchestra, I feel the basic idea, but the external form is not precise yet.

I went to the Kremlin at eight in the evening and observed the churches from an angle, which I need for the painting. And new treasures have opened up to me.

June 8, 1916, Moscow, to GABRIELE MÜNTER (Fr.):

[*Between March and June Kandinsky received thirty-seven letters from Münter, full of reproofs:*] Don't torment me incessantly. My heart breaks when I read your reproaches in every letter; you drive me to deepest despair. [...]

Mr. Sadler [*his English friend and translator*] has kept 2 watercolors and has sent me a check for over 10 pounds, which is worth 150 Rubles. He is very happy with the 2 watercolors and the engraving. But no money from America yet! Not for the panels [*for Campbell*] nor for Eddy's paintings. And the panels certainly arrived a while ago.

June 21, 1916, Moscow, to GABRIELE MÜNTER (Fr.):

I promised you that I would come in October [...] and I will, bringing the necessary paperwork for the wedding. What it will all come to— I don't know, but I will do it. At least don't torment me incessantly.

[*Kandinsky had finally consented to marry Münter "pro forma," but not to live with her; however, he never fulfilled this promise.*]

Oct. 16, 1916, Moscow, to GABRIELE MÜNTER (Fr.):

We spoke for hours on end in Switzerland, for example, in Stockholm as well and I think that you <u>do not want</u> to understand me. [...] You are <u>forcing</u> me to come now. You force me by taking advantage of my feeling of duty, which you think I lack. [...]

A moment ago I received your next letter full of unfair rebukes. [...] It is possible that I will have duties here even in <u>Moscow</u>. In any case, there will be <u>nothing</u> disagreeable about these duties.

[*By this point Kandinsky had already met Nina Andreyevskaya in Moscow, the young woman whom he would soon marry, although there is no mention of her in his letters to Münter.*]

Nov. 23, 1916, Moscow, to NADEZHDA DOBYCHINA, Petrograd (Rus.): Dear Nadezhda Evseevna, Thank you very much for all your efforts and concern. I'm happy that the pictures have finally arrived. There was a disagreeable incident [*in Sweden, having to do with Herwarth Walden*]. I have telegraphed that I will hold the people there responsible for any

losses. Please be so kind as to let me know the list of the works that have arrived, because frankly I don't know exactly what was on display in Helsingfors [*Helsinki*]. For good measure, we should also set a price list. It could even be that someone buys something, which would make me happy. Everything is so tight that, sorry as I am, I had to sell my house. So I couldn't even keep the apartment with the studio that I had had built especially for me.

Due to Germany's refusal to let artworks leave the country, my large exhibition in Stockholm, which was to take place in February in all rooms, had to be canceled. And there would have been sales there. Now I'm lowering my prices, because I'm forced to sell. As soon as I possibly can, I will raise them again. I paint slowly, very little, and I don't repeat myself.

I'm sorry to have heard from your nephew that you are ill [*he knows a good doctor*]. You should not strain your nerves so much. In order to recover, one has to try to find a healthy mental equilibrium as much as possible.

P.S. Please exhibit the engravings as well: they are especially relevant in terms of drawing and composition. [*She exhibited fourteen works (nos. 79–93 in the catalog* Modern Russian Painting, *Nov. 27, 1916–Jan. 1, 1917).*]

Nov. 26, 1916, Moscow, to GABRIELE MÜNTER (Fr.):
Despite the terrible times in which we now live the whole world over, I suddenly feel that my old dream is approaching its realization. You know that dream was to paint a large picture, the meaning of which would be joy, the happiness of life or of the universe. Suddenly I know the harmonies of colors and forms, which comprise this world of joy. [...] — Take care and work <u>well</u>. I kiss your hands.

Dec. 30, 1916, Moscow, to GABRIELE MÜNTER (Fr.):
I am content that you are less bored and that you have met someone in whom you are very interested. [*On Dec. 2 she had written:* "I am becoming interested in a young Swede. I don't know what will become of it. But you understand that I am less bored now."]

[*In February 1917, Kandinsky married Nina Andreyeskaya (who was pregnant). The couple stayed for a while in Akhtyrka with relatives of his first wife, Anna. In September their son Vsevolod was born, and they shared a modest apartment with fellow artist Alexander Rodchenko and his wife Varvara Stepanova in the tenement house Kandinsky had built. After the October Revolution, Kandinsky's assets were expropriated.*]

Jan. 29, 1917, Moscow, to GABRIELE MÜNTER (Fr.):
I am not at all angry that you are pursuing new interests—on the contrary—I will be happy if you find yourself an interesting and valuable life. If you need money, please take as much as there is in my account. I decided to sell my house because I can no longer afford the expenses.

June 12, 1917, Moscow, to GABRIELE MÜNTER (Fr.):
I received your telegram and I send you my cordial greetings. I am very well, and I am mainly working on glass and in watercolor— in the manner of the "bagatelles" that I exhibited in Stockholm. I am still hoping to return to large oil paintings. So far I haven't had enough strength for that. Last week Anya's mother died; she is totally exhausted. The Hartmanns are well, and she [*Olga*] has been singing a lot— and with success—in concerts. I kiss your hands.

May 6, 1918, Moscow, to DR. POUL BJERRE, Stockholm (Ger.):
After some thought, I decided to write you this letter. As a result of the changes that have occurred here, I find myself in a desperate financial situation: in a few weeks I will be completely penniless. Under normal conditions, I would be able to sell some of my paintings [*abroad*] immediately, but not now. My relatives here are also in such a position that borrowing from them is out of the question. I don't know if this letter will reach you, as I don't know your present address. So I am also writing to Gummeson to ask him to speak to you about my situation. [...] I would be happy to sell any of my paintings at half price at the first opportunity. A down payment or perhaps a loan of

1918, 1919

some 2,000 or 3,000 kroner would keep me afloat for a few months—
then I hope once again to be in a better position. [...] I hope, dear Dr.
Bjerre, you lead a better life than I do here, and that you and your
wife are in good health, I hope so with all my heart; and excuse me
for troubling you in this way. [*Either Bjerre or Gummeson received Kandin-
sky's letter and simply didn't answer, or the letter was lost. Either way, a newspaper
article titled "Kandinsky in Need" appeared in the Stockholm newspaper* Dagens
Nyheter *on Apr. 25, 1919, but to no effect.*]

[*In 1918, Kandinsky's* Reminiscences *of 1913 were finally published in Russia as*
Artist's Text. Steps, *with minor changes and several additions, including:* "Just as
mountains are eroding slowly and gradually, so will frontiers between the people
erode slowly and unremittingly. And soon the word 'mankind' will no longer be a
word devoid of meaning."

From December 1918 to February 1919, Kandinsky exhibited in Moscow at the
Fifth State Exhibition. *In 1919 he cofounded the Museum for Painterly Culture
alongside Malevich, Rodchenko, Tatlin, and others, serving as its first director. He
also established twenty-two provincial museums with art works from all periods.
For this reason, a number of Kandinsky's own paintings are in the possession of
museums all over Russia.*]

KANDINSKY, "Malenkie stateiki o bolshikh voprosov: o tochke,
o linii (Little Articles on Big Questions: On Point; On Line),"
in *Iskusstvo. Vestnik otdela IZO NARKOMPROS,* Moscow 1919
(Rus.):
[...] Line has many destinies. Each creates a particular, specific world,
from schematic limitation to unlimited expression. These worlds liberate
line more and more from the object, leading to complete freedom of
expression. [...] For there can and do exist cheerful lines, gloomy and
serious lines, tragic and mischievous lines, stubborn lines, weak lines,
forceful lines, etc. etc. In the same way, musical lines, according to
their character, are denoted as *allegro, grave, serioso, scherzo.* [...]

[At least one important letter is missing here: when Kandinsky's young son Vsevolod became ill (he would die in 1920), he contacted his cousin in the countryside, where, during a time of severe shortages, better food might still have been available. But Maria Vladimirovna Tikheyeva, a schoolteacher and owner of a tiny estate, was herself in need. Grateful neighboring farmers had warned her (Rus.): "Leave immediately, tomorrow we have to burn down your property." Published in full in German in Elena Preis, "Mein Großonkel Kandinsky und unsere Familie," in Hahl-Fontaine, Kandinsky-Forum IV, 2015, 29–32.]

July 1919, Moscow, to Nadezhda Dobychina, Petrograd (Rus.): Please be so kind as to send my painting *Yellow Mountain*, which you exhibited 2–3 years ago, to A. M. Rodchenko [*who, with his wife Varvara Stepanova, leased an apartment in the building Kandinsky owned*]. And if you don't need my sketches, engravings, and woodcuts anymore, send them along as well. [Yellow Mountain *is lost.*]

Apr. 30, 1920, to Varvara Stepanova (Rus.): Forgive me for using your own paper, there just isn't any other. We will return to Moscow tomorrow (Thursday) at night. So we will see each other, but only briefly. — Etchings are in the studio on the <u>table with the books</u>. I cannot let them go for less than 7 thousand. Drawings and watercolors in the <u>hall</u> can be taken. […] Please take only abstract ones, and, if possible, signed ones. I cannot let watercolors go for under 25 thousand and drawings at your discretion. Please be so kind to ask the nanny to prepare a samovar for us at midnight. Bread would be good too. We will bring other things with us: eggs, milk, etc. […] Kind regards and thanks for your help.

Sept. 22, 1920, Moscow, to Valery Bryusov (Rus.): I have tried to telephone you several times, but unfortunately in vain. And now I am deprived even of this possibility, because sometimes my telephone functions only for incoming calls. Would you be kind enough to telephone me—2–04–83, sometime in the evening. I would

very much like to talk with you about the Institute of Artistic Culture in relation to the theory of poetry. I would be very grateful.

KANDINSKY, "Muzei zhivopisnoi kultury (The Museum of Painterly Culture)," *Khudozhestvennaya Zhizn* (Artistic Life) no. 2 (Jan.–Feb. 1920): 18–20 (Rus.):

The usual way to organize an Art Museum, an approach that is well-established everywhere (i.e., in Russia as well as abroad), is the historical way. Museums divide art up into one period after another. [...] The Department of Fine Arts [*of the People's Commissariat for Education (IZO NARKOMPROS)*] has decided to embark on a new path of museum organization, making a definite principle and system its first priority, to conform with one common goal [...] giving strict prominence to two aspects of artistic development: 1) New contributions of a purely artistic nature, i.e., the invention of new artistic methods, as it were; 2) The development of forms of pure art, independent of their content, i.e., the element of craft in art.

This unusual method of museum organization is the result of the burning desire of our age to democratize every aspect of life. [...] In this respect, Russia shows an unparalleled example in the state organization of museums [...] made possible by [...] the Commissar of Enlightenment himself, A.V. Lunacharsky. [*This text is one of Kandinsky's six major publications during his Russian years, along with two other articles, "The Great Utopia" and "Steps Taken by the Department of Fine Arts in the Realm of International Art Politics," published in the March–April issue of the same journal.*]

May 26, 1921, Moscow, to ALEXANDRE BENOIS (Rus.):

Perhaps you are familiar with my German book that was published in 1912 in Munich [Concerning the Spiritual in Art], which quickly went through three editions and was soon translated into English. Apparently, Comrade Grzhebin [*a publisher*] is not against publishing it in Russia, with your consent, as he puts it. An abbreviated version was published in the documentation of the All-Russian Artists'

Congress in the 1910s. The [*Russian*] book is almost finished and could go to press in two months. I dare to hope that you are favorably disposed to its publication. [*Benois was against it.*]

Oct. 5, 1921, Minutes of the Russian Academy of Artistic Sciences, Moscow [RAKhN] (Rus.):
[*Noting a decision*] to send a representative of the Academy, Moscow, to Germany for the purpose of establishing contacts and permanent exchanges with local institutions and important personalities. [*Now Kandinsky's desire to leave Russia could be fulfilled, mainly thanks to the Minister of Culture, Anatoly Lunacharsky, who promoted the avant-garde but would soon leave Russia himself.*

When Kandinsky arrived back in Berlin, Jawlensky soon came to see him, but otherwise it took the artist a long time to rebuild his network in Germany. Some paintings he had brought back with him from Russia were shown in Berlin from April to June, and three large and several small works were later featured in the First Russian Art Exhibition *at the Galerie van Diemen in Berlin in 1922, which was officially organized by Russia (i.e., without his help). Kandinsky left most of the works he had painted in Russia between 1915 and 1921 in Moscow; he never saw them again.*]

Dec. 21, 1921, Berlin, to PAUL KLEE (Ger.):
[…] But I definitely want to come to Weimar [*to the Bauhaus*] and thoroughly get to know their new system of art education. There, if it is of interest to German colleagues, I will speak about our [*Russian*] teaching reforms. In addition, I would like to establish contacts with young German artists, testing Weimar first.

Jan. 21, 1921, Berlin, to POUL BJERRE, Sweden (Ger.):
Now I'm in Germany once again. […] I wrote to you a few times from Moscow and hoped by chance that the letters would reach you. But this hope was very faint. I vividly remember my entire stay in Stockholm, your beautiful apartment and the time I spent with you. […] I wrote to Gummeson but got no answer.

I've experienced a lot in Russia since 1916, have worked a great deal in many different areas—museums, university education, work in the fine arts, and of course painting. Now I am totally exhausted and want to regain my strength. Here I have also been entrusted with aesthetics. These are subjects that I would like to discuss with you.

Feb. 16, 1921, Berlin, to POUL BJERRE (Ger.):

Thank you very much for your letter and the information about Gummeson. Would you be so kind as to tell Gummeson the following. Der Sturm [*Herwarth Walden*] is no longer my representative and manager in art matters. Unfortunately, I have even taken legal action against him, but have not lost hope that Walden and I can settle our accounts without further help from the court. [*Out of financial necessity, Herwarth Walden had sold about 150 of Kandinsky's paintings or left them to his wife Nell when they divorced. In 1914, Kandinsky had specifically asked him not to sell anything, and he never saw most of these paintings again. Chagall, Münter, and other artists also sued Walden.*] Still, I would ask Gummeson to turn only to me. [...] He can write in English, I can read it but unfortunately do not write it. — I have no objection to an exhibition in October. [...] [*After the last large exhibition in 1922, Gummeson would keep several paintings, something that came to light only later.*]

I am sincerely grateful for your invitation. I would like to discuss all kinds of interesting and important issues with you. In those last few months in Moscow, I devoted myself entirely to founding and launching an "Academy of Art Sciences." There, representatives of the art world and those of the so-called "exact sciences" work together. In terms of [*collaborations with*] other countries, Germany and Sweden are the first in line for consideration—I would like at least to sow some seeds in these countries and put in place some kind of reciprocal relationship between both countries and Russia. Are you interested?

Mar. 1, 1922, Berlin, to ALEXANDER SHENSHIN, Moscow (Rus.):

I met Thomas de Hartmann in Berlin, for whom I have been looking in vain for 5 years. He plans to establish a Russian musical company

in Berlin. To the NARKOMPROS commission he proposed purchasing musical instruments abroad and familiarizing the West with contemporary Russian music.

Mar. 7, 1922, Berlin, to POUL BJERRE (Ger.):
In spite of my resolution not to bother you anymore with my business affairs, I am forced to count again on your kindness [*still no answer from Gummeson*]. Because of my business and accounts in Germany it is very important for me to know the following: 1) Which of my works have been sold since I left Stockholm—when and for what price (title + no. of the work)? [*Six more questions follow.*] Walden's behavior towards me is really beyond description. [...] [He] presented the court with a list of sales that does not correspond to reality. I am missing a lot of my work and don't know where or how to find it. Here I have learned that Walden's "system" had long been an open secret among Berlin artists and that many good artists had more or less suffered losses from it. Artists' destiny!

I am to blame for much of it, since I hardly ever keep a precise enough list or insist on clear business agreements in writing; so when trust breaks down, I have no proof. I would be extremely grateful to you for this information. Kindest regards to you and your wife.

Mar. 11, 1922, Berlin, to POUL BJERRE (Ger.):
Before I left Stockholm, I handed over to Mr. Gummeson a manuscript ("Question of Form in Art") that I now need very soon: a book of mine is to be published in which this manuscript will appear as a chapter. Mr. G. should send it soon, well insured—whether he chooses the form of a registered letter or insured parcel. And let me know how I can reimburse him. [*For the postcard and Gummeson's answer, see fig. 17.*]

July 3, 1922, Weimar, to ARNOLD SCHOENBERG (Ger.):
I was very disappointed when I came to Berlin and found out that you were no longer there. When our trip was first planned, I was happy at the thought of finding you in Berlin. But I was told that you

1922

had left and would not be coming back. [...] I was hoping we would see each other very often and discuss so many questions. [...] Here in Germany I have been overwhelmed by new impressions. You know that in Russia we lived totally cut off from the rest of the world for four years—seven in all—and had no idea what was happening in the West. [...] I have not worked at all myself, and now lie buried under a mountain of different tasks that I have to deal with quickly. I have so much to do that I don't know where to begin. But it is a wonderful feeling to have so much to look forward to from my <u>own</u> work. In Russia I worked a lot, but for the "common good"; my own work was always left behind. [...] And I arrived here so exhausted and worn out that I was sick for a whole month and could only lie down and read silly books.

Please write to me about everything you are doing. In Berlin I tried to send your *Theory of Harmony* to the Russian Academy of Fine Arts through the Russian Commission. But I haven't succeeded so far —lack of money at the Commission. Russian musicians are desperate for your book. We spoke of you a great deal in several different meetings. A good friend of mine, the young composer A. Shenshin, who also has a fine theoretical mind, admires you especially. Perhaps he will come to Germany.

I shake your hand cordially, and hope to hear from you soon. Kindest regards to your family and your circle. My wife sends her regards as well.

July 27, 1922, Weimar, to GABRIELE MÜNTER (Ger.):
[*On July 13, 1922, Münter sent a forty-page letter full of reproach to Kandinsky. For more details, see A. Hoberg,* Gabriele Münter *(Cologne: Wienand Verlag, 2017), pp. 76ff.*] I don't want to deny my guilt. But it does not mean that nothing came of our marriage, that our life together was a constant torture for us both. We are both to blame. [...] In any case, a marriage can only last if both sides believe it is possible and wish it. [...] I had always hoped to meet one day in England [*Gretna Green*]—as agreed—

to marry there and get divorced immediately. I had wished it, because you attach great importance to formalities. I also sincerely hoped that our life together would be good. This hope often fell and rose again, until I finally had to fully acknowledge I had been wrong and that no effort in the world would make our life together not only happy, but bearable. [...]

I have told you many times that a life together is not possible. Last time in 1914 in Switzerland I definitively declared that we could no longer live together, as I also repeated in Stockholm. [...] There can be no talk of hatred on my part. You have brought much grief into my life, but you are so unhappy yourself that I cannot bear you any ill will. I wish that you did not hate me either.

Dec. 3, 1922, Weimar, to KATHERINE S. DREIER (Ger.):
My father in Odessa lives in <u>great</u> financial difficulties. It is prohibited to send large sums from here. It is therefore <u>very</u> important that he receive the ARA [*American Relief Administration*] shipments as quickly as possible. [...] My father is over 80, has broken his leg, and has had to stay in bed for months now. I would like to make sure, at least, that he does not lack necessities. I would be particularly grateful to you for help in this.

[*In March–April 1923, Kandinsky's one-man show took place at the Société Ano-nyme in New York, an organization founded by Katherine S. Dreier. She appointed him honorary vice-president for life, and the two became good friends. He also exhibited work in Detroit, Brooklyn, Munich, and Jena. In August–September he participated in a large exhibition at the Bauhaus. From this point on until 1932, he created thirty to fifty large paintings every year.*]

Apr. 15, 1923, Weimar, to ARNOLD SCHOENBERG (Ger.):
I was very happy to receive your letter, and only the manic tempo of present-day life can explain my long silence. [...] In Berlin I led a particularly frantic life, which I regarded as temporary, and I hoped

1923

to find sufficient peace in "quiet Weimar." But this was an illusion. I never accomplish half of what I would like to do. Yet it is good here: there are many possibilities, and above all the possibility of building a center that can radiate and transmit its energy outwards [*the Bauhaus, where he was now teaching*]. How often have I said to myself: "If only Schoenberg were here!" And imagine, he could perhaps now come [...]. <u>Perhaps</u> the decision depends only upon you. <u>In confidence</u>: the local music school is looking for a new director. And we at once thought of you. Do write back <u>immediately</u>. [...] P.S. Is the new edition of your *Theory of Harmony* out? Russian musicians are awaiting it impatiently.

Apr. 24, 1923, Weimar, to ARNOLD SCHOENBERG (Ger.):
[*After Alma Mahler spitefully defamed Kandinsky as an "enemy of the Jews" to Schoenberg (with the intent of derailing Kandinsky's hopes and those of her ex-husband, Walter Gropius, of seeing Schoenberg as director of the Weimar Music School), Kandinsky answered the vitriolic letter he had received from the composer:*] I received your letter yesterday, which shocked and offended me terribly. In earlier times I would never have been able to imagine that we—of all people—could write to each other in such a way. I don't know who or why anyone would be interested in upsetting what I thought was our enduring, purely human relationship. [...] I love you as an artist and as a person, or perhaps as a person and an artist. In such cases I think least of nationality—it is of the greatest indifference to me. Among my friends who have been tested over many years (the word "friend" has such great meaning to me, I seldom use it) there are more Jews than Russians or Germans. I have a steady relationship with one that dates back to my high school days, thus lasting over 40 years. Such friendships endure "until the grave." When I did not find you in Berlin, after our return to Germany, I was very sad, because I had been looking forward to our reunion for years. [...]

There are times when "the devil" surfaces and seeks out suitable brains and mouths for his activities. [...] Why didn't you write to me at once? You must have a frightful picture of the "current" Kandinsky:

[*supposedly*] I reject you as a Jew, but nevertheless I write you a good letter and assure you that I would very much like to have <u>you</u> here to work <u>together</u>! [...] We, so few who are inwardly free to some extent, should not allow evil wedges to be driven between us. [*Four years later they met again, and not a word was said about this tragic "misunderstanding."*]

Nov. 11, 1923, Weimar, to GALKA SCHEYER (Ger.):
The two watercolors you mentioned are now at the Jury-Free Art Show [*Ger.* Juryfreie Kunstschau] in Berlin. But if it's urgent (I don't know how long the show will be open there), then with the help of Klee I'll choose something else and of course from the best. You have, however, named the most expensive ones: No. 77 – 124 dollars, No. 71 – 150 dollars [...].

We are happy for you and we envy you your trip to America. How long I have been dreaming of it, and my wife would also like to go there. But for that many dollars are necessary. That you intend to wake up slumbering Switzerland is so good. If you write to Jawlensky, please give our warm regards to the whole family.

Jan. 17, 1924, Weimar, to GALKA SCHEYER (Ger.):
In Berlin I will check with Nierendorf [*his Berlin gallerist*] as to what would be suitable for you in America (and Zurich), because for the time being I have very few smaller works here. How many <u>approximately</u> would you like to take with you? [...]

Concerning our small group of friends, we—Feininger, Klee, and I—discussed it, and suggest the name "<u>The Four</u>," i.e., 4 friends or 4 comrades-in-arms—one can interpret it as one likes. But on the whole, it is characteristic and modest. And Feininger said that "4" is good for America. All 4 of us are very different, which I think is particularly advantageous. [*Alexei Jawlensky was the fourth artist in the group. The complete letter appears in Wünsche,* Galka E. Scheyer and the Blue Four, *2006.*]

May 2, 1924, Weimar, to GALKA SCHEYER (Ger.):
Muche is already back, very enthusiastic about America, life there, but found that art is completely superfluous there in our sense, that

1924

a European can only achieve something there if he not only discards all our perspectives and our mentality, but also forgets it all completely. Hopefully you will have a different experience over there. In any case, as Muche says, the impression is overwhelming. You will experience it more beautifully. Much joy, happiness, and success and warm regards from both of us.

Aug. 11, 1924, Weimar, to WILL GROHMANN (Ger.):
If it's still possible, I would be happy to include an emphatic statement in your text: I have no interest in politics at all, I am completely apolitical and have never been involved in political activities. [...] I was recently attacked [*in the* Braunschweigische Landeszeitung, *no. 260*] in an incredibly outrageous way. [...] For once, I have released a reply. There I am described as a dangerous Russian Communist who "has been proven to be an agitator," who led the political Russian exhibition in Germany [*he was not involved in organizing the* First Russian Art Exhibition *in 1922 in Berlin*]. [...] And that my wife was "equally well-known and notorious." These are all groundless lies. [...] Even in artistic matters, I have never been biased, as *The Blue Rider* and its exhibitions sufficiently show. People shouldn't be allowed to write such lies about me: I've been in Germany for almost 20 years (16 before the war and almost 3 years now) and one should really know me at least from this side.

Aug. 16, 1924, Sylt, to VLADIMIR BEKHTEEV, Moscow (Rus.):
[*A colleague from the Munich period who had also been expelled from Germany and now wished to return.*] Thank you for your letter, I was very pleased to receive it. Please accept my and Nina Nikolaevna's congratulations on your marriage. [...] I had received no reply to my two letters to you 2 years ago so I feared that they had not reached you. There I had described to you in great detail the situation of art in Germany and what you might expect; also about my discussions with Dr. Reiche [*Richart Reiche, director of the Kunsthalle Bremen, where the NKVM exhibited*]. He promised to write to you himself, but of course I don't know if he

134

did. — I am very sorry to have to disappoint you, especially because you state your question so radically: "Now or never"! [...]

This whole year, the financial situation has been <u>disastrous</u> in Germany, and consequently the situation for new art was even worse [*referring to the hyperinflation of 1923*]. Graphic works by famous masters are offered—and bought—for a few marks. [...] At the moment, many are drawn to America. But people there hardly understand new art. It still finds the greatest understanding in Germany, and, of course, one day the situation will improve—but when? I highly recommend that you write to Dr. Reiche yourself. [*Address.*] [*Olga de Hartmann is leaving for Moscow:*] She questioned me thoroughly and will be able to tell you a few things about art in Germany. As you can see, you have many friends here, so do not despair. It is very fortunate that you have such a loving wife: together it is easier to endure injustice and hope for better things. [*As members of the aristocracy, they were both banished to Siberia for eight years.*]

Sept. 29, 1924, Weimar, to WILL GROHMANN (Ger.):
It's a time of nasty reactions, from which I suffer quite a bit. [...] I don't wish for complete "recognition"—I just don't want to see stones constantly thrown at my feet, and I would also like to have calm, objective criticism.

Oct. 5, 1924, Weimar, to WILL GROHMANN (Ger.):
Your article [*in the review* Cicerone] gave me great pleasure and I thank you for the profound seriousness with which you treated the question. May I point out to you 3 small passages I don't think are quite right?

1. For personal reasons, the mention of G. Münter is not very pleasant for me, nor objectively clear in my view: G. M. is a very gifted painter, but during the time mentioned here, she owed her artistic development principally to me. She had also been my student for a while and continued working under my influence. [...]

3. Closing lines. It looks like I owe my interest in synthetic work to the Bauhaus. But my interest in the cooperation of the arts in one work is already quite evident in *The Blue Rider* (even in *Concerning*

1924

the Spiritual, written in 1910). [...] Synthetic work in space, including architecture, is my old dream (unfortunately the only major attempt of this kind was my painting for the reception hall of an art museum commissioned by the Jury-Free, exhibited in 1922 at the Lehrter train station [*Berlin*] with this association), which I hoped to realize when I arrived at the Bauhaus (but unfortunately in vain thus far) [*it was finally executed in 1977 at the Centre Pompidou, Paris, and is now at the Foundation Maeght in St. Paul de Vence, France*]. But: apart from synthet. co-operation, I expect from every art form an ongoing, powerful, unprecedented inner development, completely freed from external purposes, moving toward a deepening of the human spirit, which is only beginning to touch the universal spirit.

Nov. 23, 1924, Weimar, to WILL GROHMANN (Ger.):

For me, the waves of attacks against abstract art, which had recently subsided to some extent and are now almost desperately rising up again, are 1) a particularly compelling proof of the inner power of this art, its inner tension, and its consequences for "life" in general; and 2) a clear sign of an acute crisis that will not last long. And it is precisely here that one could create a fresh and vital atmosphere in the academy. It is very good that many forces are now being derived from "free art" (that has been my old dream), but it is not good that in this case people surpass all limits in their reaction. And against this reaction, I'm already sensing a new reaction in the air (which is also gradually developing at the Bauhaus) and which should yield a sound basis. I don't know how widely this need is being felt today (I think I really have a nose for such things). [...]

Finally, I would like to ask you to accept a watercolor of mine that I made especially for you, as a memento of your work on me.

[*In the autumn of 1924, Kandinsky exhibited at the Vienna Secession together with Paul Klee, Fernand Léger, and others, giving a lecture there. In 1925, his solo exhibition was shown in Erfurt and Wiesbaden, and he participated in group shows in Zurich, Amsterdam, Düsseldorf, and New York.*]

Feb. 6, 1925, Weimar, to ALEXANDRE KOJÈVE [ALEKSANDR KOZHEVNIKOV] [*his nephew*], Berlin (Rus.):
Thanks for your postcards. We had already heard that your mother was able to make it back to Moscow, but no details. What do you know? Why has she been arrested and where? [...] Please write what you know about Shura [*Alexandra, Kojève's mother. This postcard was reproduced in the exh. cat. Derouet, Kandinsky, 2009, 336. There, the word "arrested" was misread as "absent."*]

Feb. 9, 1925, to GALKA SCHEYER (Ger.):
Please pass on my regards to Mr. Neumann and David Burliuk [*Burliuk had arrived in America via Asia*].

June 25, 1925, Weimar, to WILL GROHMANN (Ger.):
The higher salary in Dessau [*3,000 marks per month*] is not enough to take care of 5 people (my Russian relatives, who would literally starve to death without my help), so I have to secure some income in addition to my salary. Art dealers could not, or did not want to help, and several collectors were willing to do so. [*In 1925, Otto Ralfs founded the Kandinsky Gesellschaft in support of the artist and did the same for Paul Klee.*]

Sept. 1, 1925, Dessau, to GALKA SCHEYER (Ger.):
[*Regarding their vacation:*] We spent all of August in Binz on Rügen and only just returned the night before last. It was lovely there in every way and our laziness had no limit. [...] [*Once again complaining about materialism:*] Sometimes it drives one to despair and one would like to see nothing but one's studio. It's no less distressing, when one wonders for whom one is really working and for what purpose! But fortunately, an artist can no more shake off his work than the drinker his schnapps. So pour me another one!

Oct. 6, 1925, Dessau, to GALKA SCHEYER (Ger.):
You can hardly imagine the "orgies" that "art criticism" has been celebrating more and more in Germany lately: "Expressionism is dead

as a doornail [*Ger.* mausetot]!" — That is how enthusiastic articles in magazines begin and "Expressionism" is mainly understood to mean abstract art. Today "New Objectivity" has become fashionable—a flat sort of realism, which draws on the old Germans. The "national" way of thinking! It is a trivialization that one could not have imagined even a few years ago. [...] I've been working all day for weeks on my book "Point and Line to Plane"—purely theoretical work that gives me a lot of pleasure. It is a detailed expansion of my "spiritual" thoughts, which I drafted 11 years ago at Lake Constance—the first months of the war.

Nov. 21, 1925, Weimar, to WILL GROHMANN (Ger.):
I really want people to finally see what is hidden <u>behind</u> my painting (because that's what interests me exclusively and precisely: the "question of form" has always played only a subordinate role for me—see the *Blue Rider*!!!), and not content themselves with stating that I use triangles or circles. I <u>know</u> the future belongs to abstract art, and it pains me when other abstract artists content themselves so much and often exclusively with questions of form.

Nov. 22, 1925, Weimar, to WILL GROHMANN (Ger.):
I was made aware of [*Wilhelm*] Waetzoldt [*general director of the Berlin State Museums*] when it came to the question of [*Ludwig*] Justi [*director of the Nationalgalerie in Berlin*]. He is said to be decisive in such matters and apparently the Justi fortress can be reached via the Waetzoldt bridge. W. knows me and was very kind to me in Berlin. What do you think of this political course? [...] Klee, who is with us at present, maintained his wish to write something short about me for the catalog [*for the exhibition at the Galerie Ernst Arnold in Dresden in 1926*]. [...]

You misunderstood me about my Russian paintings. I have works there (you have the list) that do not belong to the Russian museums but to me—they are only stored in one of the museums—you know the address ([*Boris*] Ternovets [*director of the State Museum of Modern Western Art in Moscow*]). One should contact this gentleman directly,

1925, 1926

there the government has nothing to do with it and will not prevent their return. Perhaps the Arnold office is writing to him along those lines? [*Regarding one of his frequent walks together with Klee along the river Elbe:*] Whistler could not have painted this and nor could have Monet. [...]

Dec. 11, 1925, Weimar, to GALKA SCHEYER (Ger.):
I am pleased that, as you write, your connection to my work is becoming stronger and stronger. [...] It isn't actually easy to get "behind" my work and to feel whatever it is that lies beneath the often very silent form.

[*In 1926, the theoretical treatise that Kandinsky had begun before 1914 was published in Munich as a Bauhaus edition:* Point and Line to Plane, *his second major publication. For his sixtieth birthday, an exhibition took place in Braunschweig before traveling on to Dresden, Berlin, Dessau, and Munich. Kandinsky's father died in Odessa.*]

July 1926, Dessau, to ALEXANDER SHENSHIN, Moscow (Rus.):
[*Kandinsky now shared one of the newly built masters' houses with Paul Klee.*]
We now are living as in a village: one hears chickens, birds singing, dogs barking, it smells of hay and linden blossoms. [...] Within a few days, I've become a different person.

July 18, 1926, Dessau, to GALKA SCHEYER (Ger.):
Certainly it is not that easy for a foreigner, particularly one who represents such a strange type of art. [...] I did not understand properly. Whether you sold 2 or 3 of my lithographs. Unfortunately, I can't find your last letter at the moment: my papers are in a terrible mess, because despite the three-week struggle, we still can't bring order to our house. We live here splendidly—our 7 new masters' houses are right in the forest. We are happy to be rid of the bad Dessau smell (sugar refinery, gas works, etc. etc.). [...] We've had the most beautiful sun here for

1926, 1927

many days but can't fully enjoy it because I finally got my things from Munich, which had been stored there at a shipping agency for 12 years. [*After a three-year legal dispute, Gabriele Münter had finally returned Kandinsky's furniture and household items, but only some 14 paintings and several sketches. The works that she kept she later hid from the Nazis in her house in Murnau, and in 1957 donated everything to the municipal museum, the Lenbachhaus in Munich.*] The Klees became our neighbors a few days ago. And, at the end of the month, the Feiningers will also move here. Only the 4th of our "Blue Four" [*Jawlensky*] is still far away. We haven't heard from him for a long time—since Russian Easter. I must close now, because we have to eat: tonight, we have been invited over by the mayor and his lovely wife.

Dec. 28, 1926, Dessau, to GALKA SCHEYER (Ger.):

[…] That is the first totally abstract painting of mine that hangs in a large gallery, so a fundamental victory [*in late 1926, the Staatliche Gemäldegalerie in Dresden purchased* Several Circles, *after long negotiations over the price (fig. 19)*].

[*In 1927, many of Kandinsky's paintings, along with those of Klee, Mondrian, Picasso, Léger, and others, were featured in an important exhibition at the Kunsthalle in Mannheim,* Wege und Richtungen der Abstrakten Malerei in Europa *(Ways and Directions of Abstract Art in Europe). He spent his vacation in Austria and met Schoenberg again. Christian Zervos, editor of the influential review* Cahiers d'Art, *visited Kandinsky and from then on would help him exhibit in Paris. They became friends.*]

Feb. 29, 1927, Dessau, to KATHERINE S. DREIER (Ger.):

It is truly very sad that Americans have so little interest in new (and, in particular, apparently abstract) art. They will buy our paintings later, once we are all dead and our paintings command tens of thousands. And it is very nice to see how, despite all the difficulties, you never lose your courage and your incredible energy, but keep working and never shy away from any kind of work. Hopefully, your

countrymen will one day learn to appreciate this. [*Dreier published an English translation of* Point and Line to Plane *in 1947.*]

Undated, Mar. 1927, to WILL GROHMANN (Ger.):
Despite my dramatic "exit" from the association [*the NKVM in 1911*], I still think back to this time with great pleasure: there was the first excitement, the first loading of bombs, which consequently flew out of Schwabing into the world—and shocked, ignited, and finally fertilized this world. At that time I sometimes thought: what will it look like in 20 years? Surely we will have all become professors, i.e., spiritually buried people who fight against anything new and hate the young? [...] It never occurred to me that I would still be fought and sometimes even insulted 20 years later. [...] I also knew there was still a nasty struggle against superficial materialism, a struggle that was inevitable and that would not soon yield a victory. But the excitement was great and I had faith in our strength. Even today, I am no less certain that the long struggle will one day lead to a conclusive victory, even if it still takes centuries (or millennia).

Excuse my reminiscences! It's not for nothing that one has actually become a professor ...

Mar. 9, 1927, Dessau, to WILL GROHMANN (Ger.):
I have heard several times lately that my painting in Dresden is hanging "miserably" because it cannot be seen from any side without glare. Is that true? Could one do something about it? [...] Klee and Feininger are also said to be poorly hung, and the three of us are overpowered by three huge Kanoldts, etc. Oh, you, dear art politics! [*Alexander Kanoldt was one of the younger and least progressive members of the NKVM, who was never admitted to the* Blue Rider *exhibitions.*]

We constantly have many German and foreign visitors. Very interesting for us were 2 visitors from Moscow, who came a few days ago—one communist, the other neutral (both astute and proper, but with different narratives). Sometimes entire companies of people arrive and soil the floors in an instant—to my wife's dismay.

1927, 1928

Dec. 17, 1927, Dessau, to GALKA SCHEYER (Ger.):
Enclosed is a small picture as a New Year's greeting [*a miniature painted pendent*], to which we—my wife and I—attach invisible but heartfelt wishes. [...] Were I to do everything that was necessary and that had no connection to painting, I would have no time for painting.

We went to Zurich recently, where I had a large exhibition [Ausstellung Giacometti, Kandinsky, Soldenhoff *at the Kunsthaus*] and was invited to give a lecture. Since we were there for barely 3 full days, the impressions added up and were quite condensed. The people of Zurich are mostly conservative, but have such a great and energetic interest in art, as has not been the case anymore in Germany for quite some time. But the strongest impression was that we didn't see a single beggar there. [...] Today our students are celebrating Christmas at the Bauhaus, and of course we have to go. Sometimes such parties are great fun and very amusing.

Jan. 5, 1928, Dessau, to ALEXEI JAWLENSKY (Rus.):
Many thanks for your help with my things at Kirchhoff's! You very, very correctly advised him to buy the smaller painting. As small as it is, it has quality, and I personally would be delighted if it were included in this collection. The choice of this watercolor was, in my opinion, quite correct. [...] We partied a little here over the holidays, but most of the time I'm working, glad that the whole Bauhaus is away, so one doesn't have to go to classes or meetings. In general I like teaching, but there are times when I want to do nothing else other than paint. [...]
P.S. When will you come to Dessau to see us?

[*In March 1928, after a long struggle, Kandinsky and Nina were finally granted German citizenship. In the summer his paintings were included in an exhibition in Frankfurt at the Galerie Ludwig Schame, with Klee, Feininger, Jawlensky, Kokoschka, Otto Dix, and others. He also showed work in New York and Brussels, at the Kunsthaus Schaller in Stuttgart, the Nationalgalerie in Berlin, and the Museum*

142

Folkwang in Essen. The (only) stage production Kandinsky created—Pictures at an Exhibition, *a* Gesamtkunstwerk *combining sound, color, and motion inspired by Modest Mussorgsky's piano cycle of the same name—was performed at the Friedrich-Theater in Dessau. He worked with Paul Klee's young son, Felix, who later gave me a photocopy of the whole piano score with his own handwritten comments according to Kandinsky's instruction, indicating at what moment which cardboard form had to be moved onto the stage and when it had to be removed, etc.—a very precise choreography. See Hahl-Fontaine,* Kandinsky-Forum III, *2010, 155ff.*]

June 11, 1928, Dessau, to WILL GROHMANN (Ger.):
We are now expecting the visit of our friend Shor [*Evsei Shor, the Russian-German-Jewish thinker and musician*], who will show up any moment, whom we have not seen for 5 years and whose visit we are looking forward to very much. [...]
Mrs. E. Scheyer came with us from Braunschweig to Dessau and is now dealing with Feininger; afterwards she is going to Berlin and coming back the following week to stay with us and will then occupy herself with my work and that of Klee. She has achieved fabulous things in California, which she will probably tell you about herself, since she also wants to visit Dresden.

July 21, 1928, Dessau, to CHRISTIAN ZERVOS (Fr.):
My wife and are leaving for Nice tomorrow via Switzerland (Geneva), where we will be from about July 30 until August 4. [...] Lastly we will go to Paris with a stay there from August 30 until September 4. [...] Will you be in Paris at that time?
Oct. 31, 1928, Dessau, to CHRISTIAN ZERVOS (Fr.):
The Zak gallery is proposing the time from December 15 to January 1 to me. Permit me to ask your advice about this period, which is as far as I have heard one of the "dead" seasons for exhibitions in Paris. Having not exhibited in Paris for more than 15 years (you told me that I am known from "before yesterday"), I would like to "debut" at a time when people interested in this type of painting are in Paris. [...] Lastly

1928, 1929

the month of December is already almost irrevocably pledged in Germany, as I counted on this time in Paris as being unfavorable. [*The Galerie Ferdinand Möller in Berlin hosted an exhibition of Kandinsky's watercolors along with Erich Heckel's works on paper. In November, Kandinsky also exhibited in Berlin with the Novembergruppe.*]

Nov. 10, 1928, Dessau, to WILL GROHMANN (Ger.):
[*Regarding painting titles (he had already written along similar lines to Münter on Sept. 11, 1905):*] This time, too, I noticed that my solution to the difficult problem of titles was not understood. People would prefer that instead of "Veiled Green" I say something like "Primal Cosmic Forces"; or possibly "Circles in Infinity" instead of "Several Circles"! — My titles ought to make the paintings "inconsequential" and "boring." For me, pretentious titles are ghastly. Usually every title is a necessary evil, as it always limits instead of broadens—just like the "object." I am speaking about my paintings, where the precision of the forms is enough to guide the viewer's imagination.

[*With the help of Christian Zervos, Kandinsky had his first solo exhibition at the Galerie Zak in Paris in January 1929, showing sixty-six works and selling a good number (André Breton bought two watercolors). He met the critic E. Tériade, who wrote brilliantly for the small catalog. There were many exhibitions of his work, including in Chicago and Oakland. He received visits from Marcel Duchamp, Katherine Dreier, and Solomon R. Guggenheim (with Hilla Rebay), who bought two of his works.*]

Jan. 19, 1929, Dessau, to CHRISTIAN ZERVOS (Fr.):
The Galerie Zak let me know your intention to write about my exhibition in *Cahiers d'Art* and to reproduce photos, of which they sent me the proofs. I like the choice a lot. I was very happy to hear that Léger and other artists and collectors had a good impression [*of the show*]. [...] Permit me a request of you and do me the very, very great pleasure—will you do it?—of accepting the watercolor that you

like best! You are helping me in such a cordial way that it would be a great joy for me to know that one of my works was with you.

Feb. 3, 1929, ALEXANDRE KOJÈVE to KANDINSKY (Rus.):
The fact that I had not written to you is, of course, not because I had forgotten you. As a matter of fact, there is no explanation for it, except our family's aversion to letters. You know that I not only appreciate you as an artist, but simply really love you. [*Quoted in Kojève*, Kandinsky: Incarnating Beauty, *2022, 79.*]

Feb. 9, 1929, Dessau, to CHRISTIAN ZERVOS (Fr.):
Without wishing to pay Latin or Roman countries a compliment, it must objectively be noted that it is only there where one notices first the qualities of the painting and where theory and "science" are not blind to these qualities. [...] I love theory, but painting much more. That is why I occupy myself with painting a lot and theory very little. [...] If people "understand" me so little, it's the fault of the "theorists" and not mine: my art is very simple. But too often people think rather than look. [...] It appears that Mr. Lhote [*the painter André Lhote, art critic for* La Nouvelle Revue française] does not intend to deal with my exhibition. Have you heard his opinion?

Feb. 27, 1929, Dessau, to CHRISTIAN ZERVOS (Fr.):
Be so good as to send some subscription forms for *Cahiers d'Art* to Mr. Otto Ralfs in Braunschweig, who would like to publicize the *Cahiers*. [...] He is a very important collector, a first-rate enthusiast of new art and a man of exceptional energy. In Braunschweig he founded a "Gesellschaft zur Förderung der jungen Kunst" (Society for the Support of Young Art), of which he has been president for several years. He particularly collects my and Klee's work, and each of us has a whole room in his home.

Feb. 25, 1929, Dessau, to WILL GROHMANN (Ger.):
[...] at my exhibition in Brussels, I noticed in a particularly pleasant

1929

way that the French are more interested in quality = achievement than in the theoretical basis, which I have rarely experienced in Germany— hence my desperate preface at Möller's [*in the catalog of the 1928 exhibition in Berlin,* Blaue Vier *(Blue Four), with eighteen of Kandinsky's paintings*]. This theoretical question has been discussed for almost 20 years now—is it possible, in principle, to paint in an abstract style? To what extent? For how long? ("He is still painting abstractly!") Which nation should be allowed to do so? Does proper painting perish as a result—and art altogether as well? Where does painting end and ornament begin? The difference between a painting and a carpet? A tie? Socks? ... And all this signifies the inclination of Germans towards philosophy.

Mar. 7, 1929, Dessau, to ALEXANDRE KOJÈVE (Rus.):
I enjoyed your letter. I often wondered why I didn't hear from you, as if you had completely forgotten about me. But with the exception of my sister Lisa, all my relatives on Kozhevnikov's side are a little odd. […] I hope Lisa and her husband will leave Odessa soon and visit their daughters. [*Lisa's daughter Lydia was already living in Athens.*] Their life in Odessa is terribly difficult, it hurts to think about it. […]

It would be very nice if you and your wife would come to Dessau. Visiting the Bauhaus is interesting in itself, it is currently a unique institution worldwide. We could talk about various interesting subjects, as I liked to do with your father [*Vladimir, his favorite brother*]. Once we started at 6 p.m. and didn't stop until 2 a.m. […] I am pleased that you have not lost your interest in my painting. And even more gratifying that you're so right about many things. Only a few come so close to the core meaning of my work, and I rejoice especially that you are among them.

[*In April 1929, Kandinsky exhibited with other Bauhaus artists in Basel, Switzerland. In the summer in Belgium, he exhibited in Antwerp and visited James Ensor in Ostend. Group exhibitions followed in Berlin, Wiesbaden, Cologne, and Breslau. Kandinsky and Nina spent their summer vacation with Paul and Lily Klee on the Basque coast.*]

May 20, 1929, Dessau, to GALKA SCHEYER (Ger.):
It is very kind of you to defend me so vigorously, to work on translations and to get people used to looking through or behind the surface of my painting—woe to those who remain on the surface! So woe to almost everyone! ...

I'm enclosing some subscription forms for *Cahiers d'Art* and asking you to find some smart people to subscribe. [...] In one of the next issues there will be an article by Grohmann about my art, with many reproductions. [...] My wife and I recently went to Belgium (a birthday gift to my wife), where we experienced many beautiful, interesting, and stimulating things. In Antwerp there is a show right now of *Kunst van Heden = L'Art Contemporain* [Contemporary Art] to which 4 artists from Germany were invited (Campendonk, who is "at home" in Belgium, Georg Gross, Klee, and I). [...] I'm happy for Archipenko, who has not been doing very well in New York so far, as Miss Dreier told me—she was with us for 4 days 8 days ago. I was very pleased to hear that she spoke of you with great sympathy.

Aug. 7, 1929, vacation in Hendaye-Plage, KANDINSKY, "To think or not to think"? (Ger.):
I received the answer to this question long ago. I was then a little school student in a blue coat with silver buttons, a heavy backpack, and a large drawing board. I greatly admired [our drawing teacher] at the time, because not only could he paint heads or landscapes, but he also had a little table on which he had painted paper money, a silver coin, and a fly so perfectly that they exceeded "nature" in my eyes. This teacher used to say: "Boys, drawing is a hard thing. It's not Latin and it's not Greek—here, you have to think!" — After about 20 years I studied drawing in Munich at the then famous art school of Ažbe. [...] I didn't like anatomy very much and I asked Ažbe if I absolutely had to learn it. — "Yes, my dear, you must know anatomy very well. But woe to you if you think about anatomy in front of the easel! When at work, the artist should not think!" I follow these two pieces of

1929

advice to this day and will remain true to it to the end. [*Published in Kandinsky*, Autobiographische Schriften, *2004.*]

Sept. 10, 1929, Dessau, to GALKA SCHEYER (Ger.):
In October we "Blue Four" will have a joint exhibition at Ferdinand Möller, Berlin. [...] But there are currently 3 large exhibitions in which I am involved ("Deutscher Künstlerbund" in Cologne, "Große Kunstausstellung" in Kassel, and "Novembergruppe" with the "Jury-Free" in Berlin), where I can no longer change the prices. These prices are not very low: approx. RM 3,000 for a small painting, larger ones up to 10,000. [...] Perhaps it could be meaningful for publicity purposes that a few days ago I received a gold state medal from the Reich Ministry for my paintings in the exhibition of the "Künstlerbund."

Nov. 22, 1929, Dessau, to WILL GROHMANN (Ger.):
Painting pictures isn't very difficult, but being understood is. [...] You haven't forgotten about Jawlensky's affairs? I recently had a very sad letter from him: sick, 9 doctors with large bills. [...] A purchase by the Dresden gallery would mean not only pecuniary help for him, but also a great deal of moral encouragement.

Nov. 26, 1929, Dessau, to CHRISTIAN ZERVOS (Fr.):
I was very happy to have received No. 7 of your *Cahiers* with the article by Mr. Grohmann and the very successful reproductions. I would like to thank you kindly for your interest, which I see also on the part of the Galerie de France—the result of your negotiations. This gallery has accepted the dates Mar. 1 to Mar. 15 for my exhibition. I only have to take care of the transport of the canvases.

[*In December 1929, Kandinsky was expelled from the Russian State Academy of Artistic Sciences (GAKhN) "as an emigrant" and his paintings were "nationalized." He never saw them again. In early 1930, his work was shown at the Staatliches Museum in Saarbrücken, then in Essen, and also in California at a show organized*

148

by Galka Scheyer. Kandinsky's exhibition at the Galerie de France in Paris ran from Mar. 14 to Mar. 31, 1930, showing thirty-two of his paintings. He also joined Michel Seuphor's abstract art group Cercle et Carré *and became friends with Jean Hélion.*]

KANDINSKY, "The Blue Rider (Recollection)," *Das Kunstblatt* 14, no. 2 (February 1930): 57–60 (Ger.):

[*Kandinsky had already been published several times in* Das Kunstblatt *when he was asked to recount his memories of the Blue Rider. His words appeared in the February issue of the review in honor of the fiftieth anniversary of the birth of Franz Marc and took the form of a letter to the editor Paul Westheim. As he had done for his biographer Will Grohmann, the artist described what neither young art historian could have known: the atmosphere around 1900:*] Schwabing, where a person—man or woman—without a palette, a canvas, or at least a portfolio, immediately stood out. Like a "stranger" in a "nest." Everybody painted ... or wrote poems or made music or danced. [...] Schwabing was a spiritual island in the middle of the great wide world, isolated from Germany and even from the rest of Munich. [...] I lived there for many years [*on the same street as Thomas de Hartmann and Paul Klee*]. [...]

And then came Franz Marc from Sindelsdorf. One conversation was enough: we understood each other perfectly. [...] I owe the publishing of *Concerning the Spiritual* by R. Piper Editions to Franz Marc: he paved the way. [...] Long days, evenings, sometimes even half the night we discussed our approach. [...] I dealt with the Russians (artists, composers, theorists) and translated their essays. Marc brought a large number of works on paper from Berlin—it was "Die Brücke," then being built and as yet completely unknown in Munich. [...] [*Our*] basis was: no propagation of a specific, exclusive "direction," the juxtaposition of the most diverse phenomena in painting from an international basis. [...]

My neighbor in Schwabing was Paul Klee. He was still very "small" then. But I can claim with justifiable pride that I was able to detect in those small hand drawings (he did not yet paint) the great master

1930

of later years. [...] My plan for the next volume of the *Blue Rider* was to juxtapose art and science: origin, history in the way of work, purpose. Today I know much better than then how many smaller roots can be traced back to one big one—the work of the future. [...] But then the war came and washed away even these modest plans.

Mar. 15, 1930, Dessau, to CHRISTIAN ZERVOS (Fr.):
To my surprise, I heard from Mr. Grohmann that you would like to publish a book about my art. You understand, dear Mr. Zervos, that this news makes me very happy. I see that Mr. Grohmann is very interested and intends to start work soon.

May 27, 1930, ALEXANDRE KOJÈVE to KANDINSKY (Rus.):
Joseph Szigeti [*the Hungarian violinist*] [...] spoke with great admiration about you as the greatest modern painter. [*Quoted in Kojève,* Kandinsky, *81.*]

June 26, 1930, Dessau, to ALEXANDRE KOJÈVE (Rus.):
[*Answering his nephew's very negative opinion of Picasso:*] I also have the impression sometimes that Picasso "amuses himself," but he is a great master, so one can forgive him his eccentricities. And if one does not, if one condemns him for it, he will continue along the same path: his name allows him to do so. What do you think about Klee's watercolors? [...] Yes, nowadays it is difficult to leave Russia. It is the same for Nina and her mother: they have not seen each other for 6–7 years. The Moscow rulers are hard men.

July 21, 1930, to POUL BJERRE (Ger.):
Around Christmas this year a book about my painting will be published in Paris. It will be a comprehensive and beautiful edition of 900 copies. [...] I would be very sorry if Sweden were completely absent. However, as far as I know, Swedish collectors have no recent paintings of mine. On the other hand, Dr. Christiansen in Stockholm owns a very characteristic painting from 1909 [Picture with Boat;

Kandinsky asks for help, since Christiansen has not answered his request to have a photo sent to Grohmann]. Don't you intend to visit Dessau once with your wife, to get to know the Bauhaus […] and give me the great pleasure of seeing you again.

[*During his vacation in Ravenna, Kandinsky was deeply impressed by its Byzantine mosaics. In the second half of the year his works were shown at the Deutscher Künstlerbund in Stuttgart, at the Biennale in Venice (with Klee, Feininger, and Schlemmer), and at the Salon des Artistes Indépendants Bordelais in Bordeaux.*]

Undated, before Sept. 18, 1930, Dessau, to ALEXEI JAWLENSKY (Rus.): Dr. Grohmann visited us, we talked about you, and he offered to speak to Dr. Wiese, director of the Breslau Museum. Wiese has been in Paris and bought one of your pictures for 1,200 marks. […] This makes me truly happy.

Sept. 18, 1930, Dessau, to ALEXEI JAWLENSKY (Rus.): Nina Nikolaevna and I pity you from the bottom of our hearts. […] How did you catch such an agonizing illness? […] Got your letter and immediately wrote to Mr. Schardt, with whom I am on very good terms. But Halle, like so many German cities, is having a very difficult time economically. […] Let's hope Schardt can sell to private collectors. Perhaps I, too, will succeed. I also asked Klee to help find buyers for you. Times are tough, but I hope something will come of it.

Oct. 12, 1930, Dessau, to WILL GROHMANN (Ger.): You once spoke about the circle, and I agree with your definition. It is a link to the cosmic. But I use it primarily in a "formal" way.

Dec. 7, 1930, Dessau, to WILL GROHMANN (Ger.): […] What is still missing from the inception is the vital connection between art and science. At the time, I wanted to make the first attempt in this direction in Volume 2 of the *Blue Rider*. Marc was very enthusiastic about it [*this edition was never published*]. I tried again in Moscow with young scientists: we held a few enthusiastic meetings. […] I left

1930, 1931

Moscow, my dear colleagues were forced to put aside any "philosophy." But one day this task will also be fulfilled.

Dec. 16, 1930, Dessau, to GALKA SCHEYER (Ger.):
My book, published by *Cahiers d'Art*, comes out in early January. But there are also 2 booklets in sight, one in France and one in Belgium [*Will Grohmann*, Wassily Kandinsky, *Paris, late 1930; André de Ridder et al.*, Wassily Kandinsky. Sélection, Chronique de la vie artistique, *vol. 14* (*Antwerp: Éditions Sélection, 1933*)].

We are doing—as they say in Europe now—"relatively well." No, thank God, we can't complain, and we just hope things will continue like this. Unfortunately, I cannot say the same of poor Jawlensky. Do you know he is still very ill, has to lie in bed, and can barely move at all? It's supposed to be bad rheumatism. Sadly none of the treatments are helping at all so far. And a dreadful lack of money too! [...] Perhaps you could do something for him? Sales are also very important to his morale. He was so happy when you sold one of his paintings (in the summer?). — Feininger's health is not very good either—heart troubles. [...] Klee is doing very well in every way. [...] For Christmas we—my wife and I—have given each other a beautiful radio. [...] Perhaps soon a hole will be drilled through the globe and then we could say hello to each other. Radio is such a miracle that nothing would come as a surprise anymore.

Feb. 7, 1931, Dessau, to CHRISTIAN ZERVOS (Fr.):
[*Concerning Grohmann's book and Zervos's art review, which Kandinsky helped to make known in Germany:*] I thank you very much for this wonderful publication and for all your trouble and the large amount of work you undertook. [...] In Germany everything you have done and everything you are doing [*to promote art*] is <u>very well</u> known: painting, sculpture, stage production, photography. [...] I don't mean to flatter you, but in Germany (without doubt in progressive circles) *Cahiers d'Art* is considered the best review in the world.

[In February 1931, Alfred Flechtheim organized a large exhibition of Kandinsky's work in Berlin (forty-five paintings and twenty-two watercolors). Galka Scheyer showed the Blue Four in California and Mexico. Further exhibitions of his work were mounted in Belgrade, Brussels, Frankfurt, Zurich, and New York. In May 1931 with the help of his Bauhaus students, Kandinsky created ceramic walls for a music room in Berlin (fig. 20).]

Mar. 15, 1931, Dessau, to WERNER DREWES (Ger.):
Hannes Meyer wanted to turn the BH [*Bauhaus*] into a Marxist school, some students were pushing politics so madly that the rest (by far the majority) could no longer come to work.

Apr. 10, 1931, Dessau, to ALEXANDRE KOJÈVE (Rus.):
I feel infinitely sorry for your mother, her husband, and all our relatives who are in Russia. Some are no longer alive, which we only found out by chance and much later. <u>I would be very happy to get a letter from you</u>. All I know about Alyosha is that he is alive. [*Alexei (Alyosha) was the last of Kandinsky's three younger brothers still living.*]

Apr. 25, 1931, Dessau, to ALEXEI JAWLENSKY (Rus.):
I hasten to inform you that Dr. Grote bought your *Renaissance Head* of 1913 from Möller for our museum here. [...] The mere fact of a museum purchase is <u>very</u> gratifying, and I am really happy for you. [...] When one observes how well Grote, after only a few examples, understands the new art, and how he has to count literally every penny while on the other hand some directors of large museums spend enormous sums in a completely senseless manner, one becomes quite sad.

How is your health now? [...] Send me the address of our rogue "Galka"; not a word from her: she took paintings with her, what about them now?

May 5, 1931, Dessau, to GALKA SCHEYER (Ger.):
Please give Diego Rivera my heartfelt thanks for his lines for the

catalog! It should be repeated in the Belgian monograph [*see doc. 1933*]. Until now only I have known that my paintings are a reality that is "real in itself," not "relatively real." But I myself was not permitted to express it so precisely—an "arrogance"! And "the maximum of possibility for the dream and for the enjoyment of matter" is aptly said. And finally, the fact that it is not art for snobs, but rather is becoming universal is a highly valuable statement for me! [...] It is very nice to hear this conviction from another mouth, especially from the mouth of an artist who is my exact opposite.

May 9, 1931, Dessau, to GALKA SCHEYER (Ger.):
The very large "German Architecture Exhibition" [*Ger.* Deutsche Bauausstellung] opened in Berlin today, with international participation, including America. We got back from there only yesterday, because I created a music room for it—a painting done in ceramics.

July 17, 1931, Dessau, to GALKA SCHEYER (Ger.):
I would like "abstract" painting rather to be called "real." The clumsy word "abstract" has led to a lot of very unpleasant misunderstandings.

July 18, 1931, Dessau, to GALKA SCHEYER (Ger.):
It seems to me that among Americans one tends to find people who are <u>primarily</u> emotional about art. The mind is not a superfluous thing, but it's bad when it becomes too prominent. The task of the mind is to reflect <u>afterwards</u>, but not to get in the way of the experience. In Germany especially, people think so much that any feeling ultimately dies. [...] Just recently I heard from an art dealer that today's public has little connection to abstract art as there is so much to think about ... Poor thinkers who are slowly becoming soulless! In abstract art, thinking is precisely an impediment to experience. With abstract art in particular, you don't need to think if you know how to experience. If not, then even the most profound thinking will not help. These smart people keep getting smarter and smarter until they're finally dumb. That's why the world looks so stupid today. [...]

It will probably be a long time before people as a whole realize the impasse they have reached with their "realistic thinking." There are

still a few (though very few) people in the world for whom one can work. Otherwise I often have to say I'm working for nothing.

[*In 1931, Kandinsky spent his summer vacation in Egypt, Palestine, Greece, and Italy.*]

Sept. 7, 1931, Cassis-sur-Mer, to ALEXANDRE KOJÈVE (Rus.):
We are returning to Dessau on the 19th, so we're sorry to have to postpone our meeting. But it is important for me to come back <u>completely</u> rested.

I have watercolors here and would like to send them to you with the request that you take them to the Galerie de France at the beginning of October.

Oct. 11, 1931, Dessau, to ALEXANDRE KOJÈVE (Rus.):
[*On Sept. 20, 1931, Kandinsky's nephew wrote to him about the seven watercolors he had received. He found* Fleckig, *1931, to be amazingly good, but was less impressed by other works in which, he explained at length, he saw "hardened" and "ossified" forms and "a traditional approach to form."*]
I found your criticism of my watercolors very interesting. You have a fine understanding, which is not often found among people of "intellectual" talent, which is why I appreciate it especially. You differ from "mindless" people and above all from those without sensitivity in this way: these people see no life at all, not even "artistic meaning" in my "stark" works, while you reserve them a place in my "past" (as it seems to you). You say: "they were alive, but began to petrify." I don't know, perhaps it's true. But <u>until now</u>, when painting serious things, I have been in a state of high tension. I need a great inner energy for it: the character, the dimension, and the place of every one of these stark forms is dictated each time by an "inner urge," a sort of "premonition." And I have the impression that such an elated state would not be possible in the case of petrified forms. Many people say my stark works are also cold. There are Chinese pastries that are hot on the outside (straight out of the oven), while the inside is frozen. My paintings are like Chinese pastries, but the opposite: cold on the outside, scorch-

1931, 1932

ing on the inside. So here you have my self-defense. Always write frankly what you think about my work.

Dec. 14, 1931, Dessau, to GALKA SCHEYER (Ger.):
If either the Nazis or the Communists come to power, I will be unemployed.

Jan. 23, 1932, Dessau, to FERDINAND MÖLLER (Ger.):
Today I spent almost the whole day making a selection of drawings, and it was hard work. Since I have never exhibited drawings (except at the Bauhaus in autumn), I naturally wanted the variety in the exhibition to be clearly emphasized. The principle was: no repetition, and not even any too-near affinities. [...] It is about [...] the purely linear possibilities in so-called abstract art. It has always been my conviction that this painting offers no fewer possibilities than representational art—rather more! I definitely think: more! Originally I wanted to make do with 30 sheets, but realized this limit would be outright harmful. So I am sending you 53 drawings. [...] The great variety of sheets must surely appear sufficient, even to the most stubborn skeptic, to undermine the mental prejudice against abstract art. [*To make the exhibition less costly, the sheets were left unframed, and the artist and the gallerist were both satisfied with the effect (fig. 22).*]

Jan. 30, 1932, Dessau, to HILLA REBAY (Ger.):
How does it look in America now? From what we hear and can observe from here, not too pleasant either. And perhaps the early stages of war? It's really bad here in Germany and doesn't look like it will improve. But we still have courage. The right-wingers are trying again to swallow up the Bauhaus, but without success. The last few months especially were really aggravating. But we continue to work calmly ... Would you advise me to hold an exhibition in New York in the near future, or somewhere in America?

156

Feb. 19, 1932, Dessau, to OTTO HOFMANN [*former Bauhaus student*] (Ger.):

There were exciting moments here in Dessau when the municipal assembly considered the question of the continued existence of the Bauhaus, since the Nazis submitted a proposal for its permanent closure. It was rejected with a small majority and we live on [*the situation was to change in April 1932, when the National Socialists won a majority in the regional and municipal elections in Anhalt*].

Mar. 10, 1932, Dessau, to ALEXEI JAWLENSKY (Rus.):

The days are packed with all sorts of things. Today is the first day of my Easter vacation and I immediately started a letter to you. [...]

Neither Feininger, Klee, nor I have received an invitation to participate in the Venice Exhibition and we have not heard anything about it. So, if none of us has been invited, then the exhibition does not concern us. Even if we are the "Blue Four," we still are "multi-colored," so to speak, we appeal to different tastes. That's why we cannot offer anything to any single taste. It seems to me, therefore, the main taste there is an official, "academic" one.

Nina and I and our closest friends think of you often and worry about your health and how slowly you are recovering. [...] You write you have new things that are "not bad" (can you even paint bad pictures??). That means you are still working, and that, apart from health, is the most important thing for us. Sales are rare, and our salary is constantly being cut. It's best to forget that! [...] Warmest regards to you and your family. The Feiningers and Klees also send their greetings.

[*In March 1932, Galka Scheyer's exhibition of the Blue Four was shown in Santa Barbara. Diego Rivera's homage to Kandinsky was published in the catalog, and Kandinsky thanked him by giving him a watercolor. He also participated in shows in New York, Essen, Stockholm, Vienna, Amsterdam, Königsberg, and Danzig.*]

1932

May 4, 1932, Dessau, to GALKA SCHEYER (Ger.):
Surrealism seems to be more or less at an end, which cannot be said about abstraction—rather the opposite. One sees more and more that the future belongs to abstract painting (at least for the most part). [...] In music today "pure" music is very prevalent. And so it will be with painting. The "public" (which unfortunately also includes the press) will not understand this well enough for a long time. But it must be educated to do so. And your work in America is extremely import-ant. I congratulate you for this, dearest "Minister."

June 3, 1932, Dessau, to GALKA SCHEYER (Ger.):
It seems I am lucky with Chicago lawyers. Eddy was the first [*prior to World War I, he owned the largest private collection of the artist's work*]. In Europe, a sale is now (for months) a great rarity and getting worse. Things are also looking bad with the Bauhaus: the new government (in Anhalt) is not a friend of the BH, which may end in closure. We are very con-cerned.

July 23, 1932, Dessau, to FILIPPO MARINETTI (Fr.):
[*Desolate at the prospect of the Bauhaus closing, Kandinsky hopes the Italian Futurist impresario might lend his support and convince German authorities to keep the school open:*] I received your postcard and waited for the whole month of May, but unfortunately without success. I intended to show you our "Bauhaus," this school of higher education on a synthetic basis, the only one of its kind in the whole world. [...] You probably know from the newspapers that we have had a new government in Anhalt [...] for the past 3–4 months, a fascist government (in German "*National-Sozialisten*"), which very much admires the political system in Italy, but which does not follow the Italian example in our case. At the same time that your *Duce* inaugurates an exhibition of modern architec-ture and speaks splendidly of this new style, our government intends to annihilate our school and to nullify our efforts! [...] The "Bauhaus" is accused of being Marxist, Judaic, Oriental, the enemy of German-ism. [...] I am truly distraught when I think that this unique school

will disappear only because it isn't understood by a few people averse to it. I am completely sure the Italian government would never have made the same mistake. Dear Mr. Marinetti, we have known each other for twenty years and it is truly natural that I ask you to help us in this tragic situation. How? I think an energetic word of your surprise and censure would make a great impression and would have a very sensible and essential result. [*Marinetti sent a telegram to Mies van der Rohe in support of the Bauhaus, and also contacted the Italian foreign minister about the situation, but to no effect.*]

July 30, 1932, Dessau, to GALKA SCHEYER (Ger.):
During the difficult revolutionary period I painted very little. In 1921 I only finished 7 paintings. *Red Spot* (fig. 17) I value much more than *Improvisation 29*, which in light colors and lines […] sold to Eddy. […] I will never paint these pictures again, this period is over. Actually I wanted to make *R. Spot* unavailable for sale.

Aug. 18, 1932, Dessau, to WILL GROHMANN (Ger.):
What you write about the two Zervoses [*Christian Zervos and his wife Yvonne*], is most gratifying. As long as such people live and work in different countries, there can be no doubt about the future. Already in the Bible one finds examples of a single "wise" man saving an entire city steeped in sin. I am sure the cleanliness of one person cleanses the spiritual atmosphere. That is why the deed alone is not decisive, as one thinks today, but also the thought, even the hint of a thought that has yet to crystallize. […] The spirit will win, in spite of all the kicks aimed at it today.

Sept. 1, 1932, to ALEXEI JAWLENSKY (Rus.):
I just received your letter and have already taken some steps: I spoke to Klee, who fully agrees with me about your significance as an artist. I immediately wrote the following to *Sélection*: "Among the names of participating artists, I see missing that of Jawlensky, who in my opinion

is one of the most important artists today. [...] I hope this omission will be rectified, and I enclose the address for your information."

Don't forget what sort of "nationalistic" attitudes prevail almost everywhere at the moment. The "sky" in both our names is a very disadvantageous final syllable ... It is too late now to cut that tail off; some 30 years ago we should have become Mr. Jawlens and Mr. Kandin (both with a nasal ending), then we would have been sincerely loved long ago.

[*On Aug. 22, the municipal assembly of Dessau, in which the Nazis had a majority, voted to close the Bauhaus at the end of September. Ludwig Mies van der Rohe elected to reopen the school as a private institution in Berlin (funded mainly through license income) in October. Kandinsky and Albers remained on the teaching staff.*]

Sept. 29, 1932, Dessau, to LUDWIG MIES VAN DER ROHE (Ger.):
I have always been proud of the fact the Bauhaus strives for a synthetic education, that young people who intend to become architects can get a certain idea of the general and current situation in painting. [...] I always tried not to talk about painting alone, or about art alone, but to make the deep connections to nature, to science, and of course to other areas of art understandable and tangible.

Sept. 30, 1932, to CHRISTIAN ZERVOS (Fr.):
Almost two months since your last letter of August 5. I have worked a lot since then, and we made a beautiful trip to Yugoslavia. [...] As of tomorrow [*the Bauhaus*] will no longer exist, but that won't last long and we hope to move our school to Berlin, which will then be the third city of work for the Bauhaus [*it moved into an empty telephone company building*]. We have lost the taste for official existence as either a state or municipal school and intend to form a "free" institution, that is independent of all political parties. [...] I think your opinion on the duration of the Nazi party is quite correct. We are already noticing some signs of its decline.

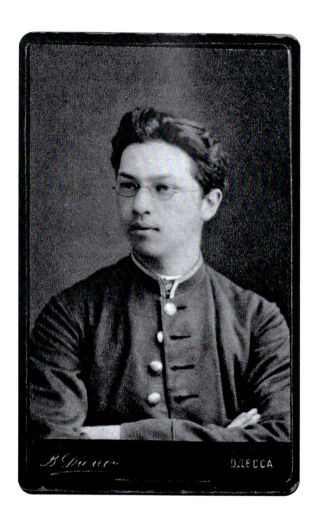

1 Wassily Kandinsky, c. 1885. This photo was taken in Odessa. It shows the artist as a young man, probably shortly after graduating from high school and before leaving for university in Moscow, where he intended to study law and economics but instead focused on ethnography. Private archive.

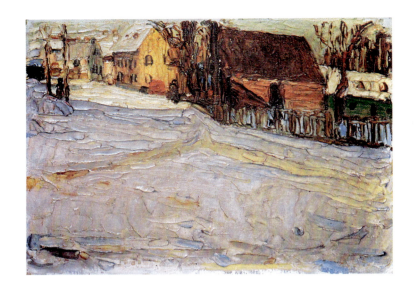

2 Wassily Kandinsky, *In the Village / City Landscape* (?), c. 1901–2, oil on canvas, 23.5 x 32 cm (9.25 x 12.6 inches), Odessa Fine Arts Museum. The painting may be the work Kandinsky referred to as *In the Village* (see letter of Sept. 20, 1904), which he exhibited in Odessa in 1905. It is also known as *City Landscape,* since it most likely depicts Schwabing, the new northern section of Munich, which at that time was called the "Village." The painting was exhibited in Moscow and Frankfurt in 1989. The reproduction clearly shows that the artist used a palette knife instead of a brush, his preferred technique for oil painting during this period (see letter of Mar. 24, 1901).

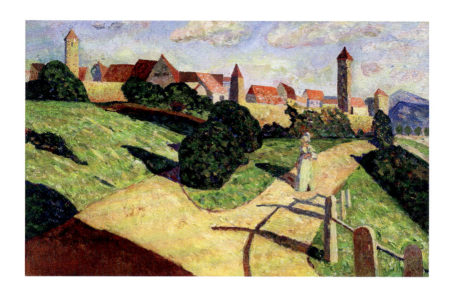

3 Wassily Kandinsky, *Old Town*, 1902, oil on canvas, 52 x 78.5 cm (20.5 x 30.9 inches), Musée National d'Art Moderne, Centre Georges Pompidou, Paris. Photo © Georges Meguerditchian. This painting is a major work from Kandinsky's early period, one that he himself regarded highly for a long time. It is a good example of his use of contrasts of light and dark (see letter of July 25, 1900).

4 Kandinsky with students from his painting class in Kochel, southern Bavaria, summer of 1902. On the left are Kandinsky and Münter with bicycles. Gabriele Münter and Johannes Eichner Foundation, Munich. VG-Bild-Kunst, Bonn.

5 Wassily Kandinsky, *In Summer (Lady with Child),* July 1904, 30.6 x 16.5 cm (12 x 6.5 inches), color woodcut on Japan paper, Musée National d'Art Moderne, Centre Georges Pompidou, Paris. The print exemplifies a technically demanding process in which the usual black outline block is omitted and a single printing block loaded with different pigments (much like a monotype) is pressed onto damp paper (see letter of Aug. 10, 1904; for more information, see Hans-Konrad Roethel's catalogue raisonné of the artist's graphic works as well as Hahl-Koch 1993, 99).

6 Wassily Kandinsky, *Portrait of Gabriele Münter*, 1905, painted in Dresden, oil on canvas, 45.3 x 45.3 cm (17.8 x 17.8 inches), Städtische Galerie im Lenbachhaus und Kunstbau, Gabriele Münter Stiftung 1957, Munich. Kandinsky himself disliked this all-too-conventional painting, did not include it in his own handwritten inventory, and called it *Saumalerei* (pig's painting) in a letter to Münter dated Sept. 18, 1905. He despised portrait painting in general and never painted his own likeness.

7 Photo of Kandinsky by Gabriele Münter, Dresden, 1905, Gabriele Münter and Johannes Eichner Foundation, Munich. VG-Bild-Kunst, Bonn.

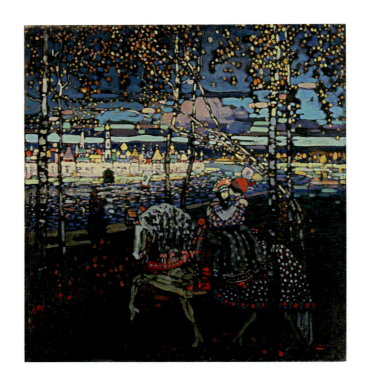

8 Wassily Kandinsky, *Riding Couple*, 1906–7, oil on canvas, 55 x 50.5 cm (21.6 x 19.9 inches), painted in Sèvres; not in the artist's inventory. The artist wrote to Münter on Dec. 4, 1906: "there really is organ-like music in it." The official medium "oil on canvas" has been analyzed by Rudolf H. Wackernagel as "areas of fluid lacquer heightened with impasto oil paint" (in *Das Bunte Leben*, exh. cat., ed. Vivian E. Barnett and Helmut Friedel [Cologne: Dumont, 1995], 558). In a letter dated Jan. 25, 1934, Kandinsky himself gave a detailed explanation of his "mixed media" techniques, suggesting that from early on in his career, few of his works were "pure" oil paintings or "pure" watercolors.

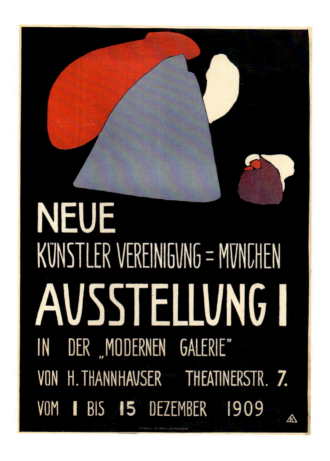

9 Neue Künstlervereinigung München (NKVM [New Artists' Association Munich]), first exhibition poster, December 1909, color lithograph, 94 x 64 cm (37 x 25.2 inches), Städtische Galerie im Lenbachhaus und Kunstbau, Gabriele Münter Stiftung 1957, Munich. Although Kandinsky himself repeatedly described *Picture with a Circle* of 1911 (fig. 12) as his first abstract work, some "abstract" forms are clearly visible in this poster from 1909.

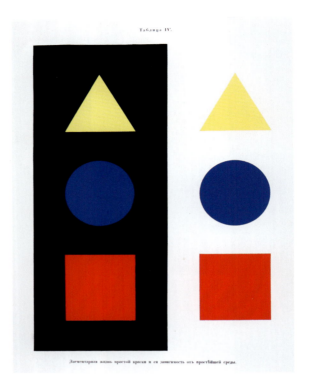

10 Wassily Kandinsky, *Color Chart*, designed summer of 1909, 34.5 x 25 cm (13.6 x 9.8 inches). The illustration was intended for publication in *Concerning the Spiritual in Art* to demonstrate the effect of a white or black background on colors. It was omitted due to the cost of color reproduction, but was later published in *Works of the All-Russian Artists' Congress* (Petrograd, 1914). It is remarkable as a work of "proto-Suprematism" and may well have given Malevich, who certainly saw the volume, additional inspiration for his Suprematism of 1915 (see letter of May 10, 1936).

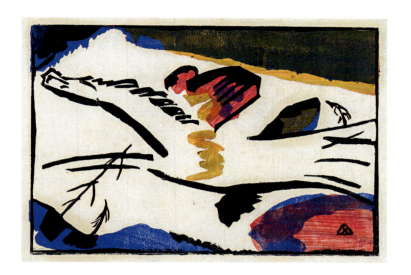

11 Wassily Kandinsky, *Lyrical*, 1911, color woodcut, 19.2 x 31.5 cm (7.6 x 12.4 inches), Städtische Galerie im Lenbachhaus und Kunstbau, Gabriele Münter Stiftung 1957, Munich. In a letter of June 11, 1911, the artist referred to the work as "Jockey." In *The Blue Rider Almanac*, this large-scale reproduction was printed alongside the programmatic essay "Zwei Bilder" (Two Paintings) by Franz Marc, who described the "deep interiority of the artistic expression" in Kandinsky's work. The horse and rider motif is a recurrent phenomenon in Kandinsky's art, even appearing in abbreviated "shorthand" in some of his late abstract works (see H. K. Roethel and J. K. Benjamin in *The Burlington Magazine*, 1977).

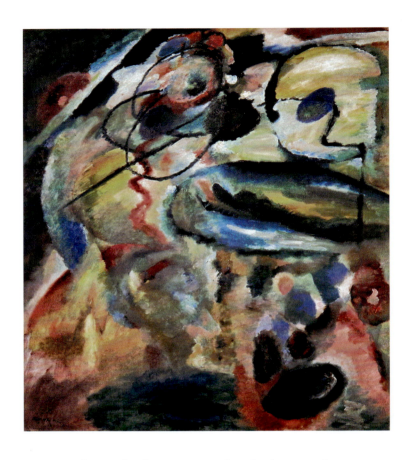

12 Wassily Kandinsky, *Picture with a Circle*, 1911, oil on canvas, 139 x 111 cm (54.7 x 43.7 inches), Georgian National Museum, Tbilisi. Photo by Igor Kozlov. Not in the artist's inventory, title not by Kandinsky. He frequently referred to this work as his first abstract painting (e.g., in his letter of May 25, 1935). H. K. Roethel devoted an essay to this historically important work (*The Burlington Magazine* 119, no. 896 [November 1977]: 772ff.), although at the time only a single black-and-white photograph existed. Reproduced in color for the first time in Hahl-Koch 1993.

13 The "Blue Rider" group on Kandinsky's terrace on Ainmillerstraße in Munich, 1911–12. Gabriele Münter and Johannes Eichner Foundation, Munich. From left to right: Maria and Franz Marc, Bernhard Koehler, Kandinsky (seated), Heinrich Campendonk, Thomas de Hartmann.

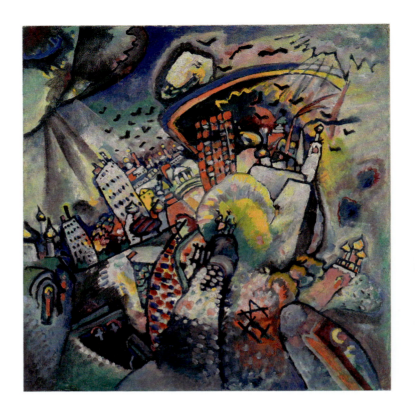

14 Wassily Kandinsky, *Moscow I*, late 1916, oil on canvas, 51.5 x 49.5 cm (20.3 x 19.5 inches), State Tretyakov Gallery (Donation of Georges Costakis), Moscow. In several letters to Münter, Kandinsky mentioned his longing to create a particular painting, one that took him a long time to realize. Finally, on Nov. 26, 1916, he wrote: "I suddenly feel that my old dream is approaching its realization. You know that dream was to paint a large picture, the meaning of which would be joy, the happiness of life or of the universe. Suddenly I know the harmonies of colors and forms, which comprise this world of joy."

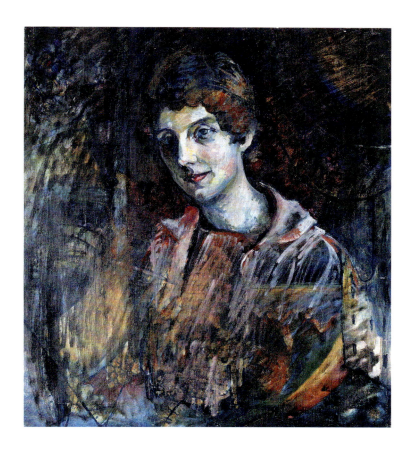

15 Wassily Kandinsky, *Nina Kandinsky*, 1917, oil on canvas, 67 x 60 cm (26.4 x 26.2 inches), Petr Aven Collection. Photo by Igor Kozlov. Exhibited for the first time in 1922 in Moscow, and then not again until 1994 at the State Tretyakov Gallery. Lacking materials, Kandinsky painted over a Moscow landscape (see the X-ray image and discussion by Natasha Avtonoma in *Kandinsky Forum I*, 2006.) Nina disliked this work, where Kandinsky, instead of depicting her beauty, concentrated on the dynamics of form and purely painterly concerns.

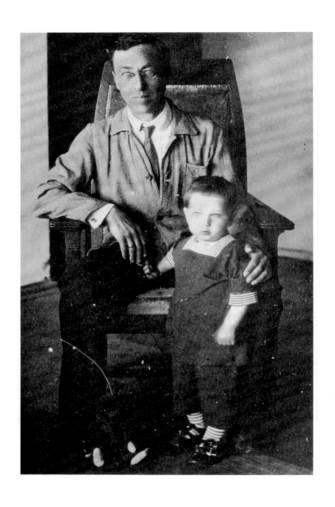

16 Kandinsky with his son Vsevolod in Moscow, 1919. Vsevolod died in 1920. Private archive.

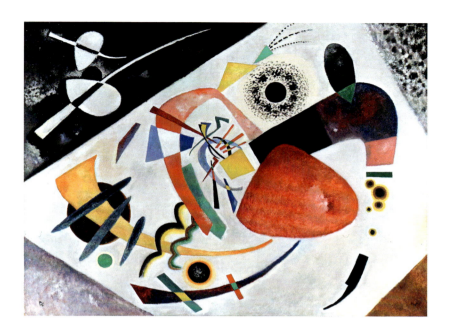

17 Wassily Kandinsky, *Red Spot* (*Krasnoye pyatno*), 1921, oil on canvas, 137 x 181 cm (53.9 x 71.3 inches), Städtische Galerie im Lenbachhaus und Kunstbau (purchased with funds from the Hypo-Bank, now UniCreditBank AG), Munich. The artist himself considered this work an example of his "reticent period" and valued it so highly that he even wanted to make it "unavailable for sale" (see letter of July 30, 1932, to Galka Scheyer).

18 Postcard from Kandinsky to Poul Bjerre, Stockholm, Mar. 11, 1922, and a note in Swedish from Carl Gummeson to Poul Bjerre: "To Dr. P. Bjerre. I sent 3 texts to K. on 9/3—special delivery. Greetings, Carl Gummeson."

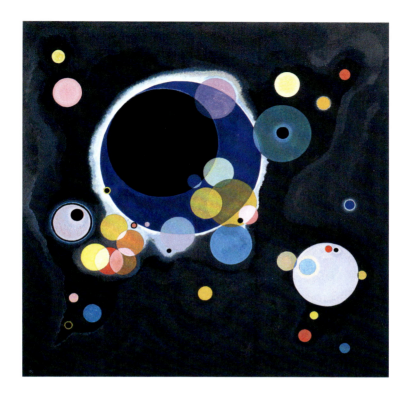

19 Wassily Kandinsky, *Several Circles*, 1926, oil on canvas, 140.3 x 140.7 cm (55.8 x 55.4 inches), The Solomon R. Guggenheim Museum, New York (previously in the Staatliche Gemäldegalerie, Dresden, where it was exhibited at the *Internationale Kunstausstellung* in 1926). In a letter to Galka Scheyer dated Dec. 28, 1926, Kandinsky wrote: "That is the first totally abstract painting of mine that hangs in a large gallery, so a fundamental victory."

20 Kandinsky and Nina in front of his ceramic mural for a music room by Mies van der Rohe, Berlin 1931. Musée National d'Art Moderne, Centre Georges Pompidou, Paris.

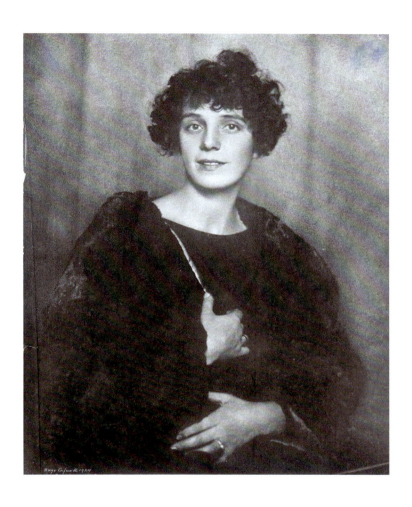

21 Nina Kandinsky, 1931, Musée National d'Art Moderne, Centre Georges Pompidou, Paris. Photo © Guy Carrard.

22 Exhibition wall at the Galerie Ferdinand Möller in Berlin, February 1931, showing Kandinsky's unframed drawings. Musée National d'Art Moderne, Centre Georges Pompidou, Paris. Photo © Hugo Erfurth.

23 Letter (in Russian) from Kandinsky to his lifelong best friend, the composer Thomas de Hartmann, dated Jan. 8, 1933, with Alexei Jawlensky's address in German on the left. Gilmore Music Library, Yale University, New Haven.

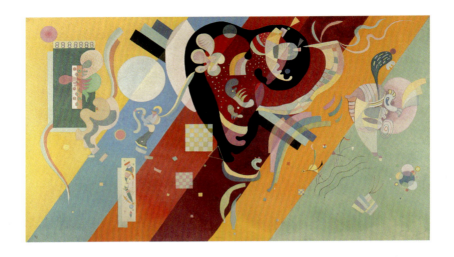

24 Wassily Kandinsky, *Composition IX*, 1936, oil on canvas, 114 x 195 cm (44.9 x 76.8 inches), Musée National d'Art Moderne, Centre Georges Pompidou, Paris. In the artist's inventory, the work is also listed under February 1936 as *L'un et l'autre* (One and the Other). This was the only major painting sold to a state museum in France: it was acquired by the Musée du Jeu de Paume, Paris, in 1939 (see correspondence with André Dezarrois, February–March 1939, as well as Hahl-Koch 1993, 328ff., with preliminary drawing, frame sketch, and commentary).

Oct. 6, 1932, Dessau, to ALEXANDRE KOJÈVE (Rus.):
Our Bauhaus here is closed for good. But the result is amusing: the city [*of Dessau*] had to agree to pay us our entire salaries until April 1, 1933, and then half until April 1, 1935. This way it will be possible for us to transfer the Bauhaus to Berlin, where it will continue its activities as a <u>private</u> school. [...]

It seems things in Russia are disastrous. A terrible famine is expected. [...] But I have little hope the "logisticians of materialism" will finally break their necks. The turbulent waters are only spreading further, in all directions.

Nov. 28, 1932, Dessau, to WERNER DREWES (Ger.):
Lately I've become very taken with minimalism, which was my old dream, but which I couldn't realize earlier. Painting is no easy thing, but the very scant work, where the few means are really perfect, requires such great concentration and inner tension that the outwardly richer work seems almost easier. If I trace ten lines on paper, it doesn't really matter if they are perfectly right. [...] But if only one of 3 strokes is wrong, then the whole work is worth nothing. [...] This is also how I explain my long-standing love for the circle—it is the most concise of all forms and, at the same time, carries an inexhaustible richness.

Jan. 8, 1933, Berlin, to THOMAS DE HARTMANN, France (Rus.):
Dear Tomik, your letter made me truly happy. For the first few years after you left for Paris, Nina Nikolaevna and I went to the Russian tea shop every single time we visited Berlin to get information about you from Olga Arkadievna's sister. But we could not get anything precise. I am so glad you have now put "all that" behind, as you say. We were even in Fontainebleau around 1928, where we asked about you but could not find out any news.

Jawlensky has been living in Wiesbaden for 10 years and unfortunately he has been very ill in recent years. From time to time we keep in touch as good friends. Marianne [*Werefkin*] continues living in

1933

Switzerland (Ascona) where she is popular. I haven't seen her, but others say she is healthy as always and full of energy and enthusiasm. [...] Jawlensky would be happy if you wrote to him: Wiesbaden, Beethovenstr. 9 (fig. 23).

Jan. 8, 1933, Berlin, to CHRISTIAN ZERVOS (Fr.):
Our Bauhaus has plenty of financial concerns—unfortunately! Among other remedies, we want to employ a solution typical of Berlin [...] a masquerade ball at the school itself. The highlight of the festivities will be a lottery of works by artists of rank. [...] Can we count on your help? [...] I allow myself to ask you kindly to call and ask from time to time whether works are on their way. [...] Here are the artists: Léger, Gleizes, Dufy, Arp, Miró, Mondrian, Chagall. The name Picasso was also floated but I know very well we'd get nothing from him— at least directly. The same for Matisse—isn't that so? [...]
I have an old friend, a very interesting musician who is doing [*music for*] films in Paris. It's Thomas de Hartmann. [...] But unfortunately he doesn't have enough money to buy Grohmann's book *Kandinsky*. And since I, myself, have only two copies left, I would like to ask another big request of you: could you perhaps send him a copy free of charge?

Jan. 25, 1933, Berlin, to ALEXEI JAWLENSKY (Rus.):
I am writing to you on behalf of the Bauhaus with a heartfelt request. To plug some financial holes, the BH plans to organize festivities with a lottery (of paintings and sculptures) on Feb. 18. That's why we turn to the best artists in Germany and France ("cannons"), asking them to donate a small painting (no drawings and no watercolors). [...] All important Berlin painters and sculptors have agreed.
Feb. 10, 1933, Berlin, to ALEXEI JAWLENSKY (Rus.):
Forgive the pencil! I can't find the spare ink bottle. Thank you for your letter and the donated painting, which will be a jewel of our lottery.

1933

Feb. 24, 1933, Berlin, to ALEXANDRE KOJÈVE (Rus.):
I'm asking you a big favor again! You have my painting no. 409 (*Line-Plane*) (not a watercolor). Bring it to Christian Zervos, *Cahiers d'Art*, Paris 6. I would be very grateful. If you go to Paris, you could take it yourself, if not, please send it. But it is <u>very</u> urgent [*Kandinsky was giving this 1927 painting to Zervos for an auction on Apr. 12 in support of* Cahiers d'Art].

Mar. 2, Berlin, 1933, to ALEXEI JAWLENSKY (Rus.):
This year [...] an exhibition will take place in Chicago, and based on the number of countries participating, it will be a large, international one. Miss Dreier said when she was here that she had been asked to suggest German artists. When I mentioned you, she immediately said, "Of course!"

Mar. 6, 1933, Berlin, to ANDRÉ DE RIDDER (Ger.):
[*Regarding the special issue that De Ridder, editor of the Belgian review* Sélection, *was devoting to Kandinsky:*] Please be sure to pay attention that the reproductions in your journal are the right way up, and not upside down! I had marked on the back of each one "up"! Believe me, whenever I see a reproduction upside down, I'm almost seasick! I feel as if I'm hanging in the air, with my feet up.

Mar. 8, 1933, Berlin, to ALEXANDRE KOJÈVE (Rus.):
You know we've been German citizens for 5 years already, and whatever the future holds, only God knows. I'm surprised by Ksidas's silence. There, in Greece, it's worrying also [*with regard to the rise of fascism and autocratic rule in Greece*].

Apr. 10, 1933, Berlin, to WERNER DREWES (Ger.):
So far, the [*Bauhaus*] continues. [...] But there is also a sharp reduction in the field of art: many museum and academy directors have been put on leave: [*Walter*] Käsbach [*Kunstakademie Düsseldorf*], [*Ernst*] Gosebruch [*Museum Folkwang, Essen*], [*Fritz*] Wiechert [*Städelschule, Frankfurt*],

163

1933

Hartlaub [*Kunsthalle Mannheim*], [*Julius*] Baum [*Ulmer Museum*], [*Hans*] Pölzig (Berlin Academy), etc. In the Dresden gallery, all the "modern" paintings have been taken down, the Nationalgalerie [*Berlin*] was also cleaned up, as were the smaller provincial towns. Hofer and Schlemmer themselves took "a leave of absence." I heard all the Liebermanns were taken out of the Nationalgalerie. Many Jewish lawyers and doctors have had to give up their practice: a quota was introduced. Quantities of weapons and ammunition were found on the Communists. I believe the communists were preparing an energetic uprising throughout the Reich and the fire in the Reichstag building was a signal to start. [...]

Well, we'll see how it goes on and what becomes of our art! In any case, artists should remain apolitical and think only of their work and devote all their energy to it. But one should leave full freedom to art and science: whatever is false dies of its own accord. [*On Apr. 11, the police and the SA searched and sealed the premises of the Bauhaus, arresting thirty-two students.*]

Apr. 12, 1933, Berlin, to GALKA SCHEYER (Ger.):
House search of the "Bauhaus," nothing found. Exaggerated press reports about it.

Apr. 23, 1933, Berlin, to WILLI BAUMEISTER (Ger.):
[*Baumeister had asked Kandinsky whether he should join the Kampfbund für Deutsche Kultur (Combat League for German Culture). Kandinsky, idealistic as always, hoped education might dissuade the National Socialists from their campaign against modern art:*] You ask what to do or what not to do. [...] Many of today's measures can be explained by the fact that people in certain circles are not at all clear about what the new art movements mean and what their purpose is. Just consider the nonsense about the new art that has been served up in the press over the last 20 years. [...]

But it is even worse that art was forcibly drawn into politics. [...] And so came the instinctive jokes, coloring the same art on the left

as purely bourgeois and on the right as communist. The fog couldn't get any denser. [...] It seems to me the most suitable place for clearing this fog would be the Kampfbund für Deutsche Kultur. With skillful, calm, and factual explanations, I think important things could be achieved. But without anger, only with the greatest calm. [...] As far as I know you, you would be the right man for such a task.

Apr. 27, 1933, to ANDRÉ DE RIDDER, Belgium (Ger.):
It might be advisable not to put on an exhibition in difficult times like these, when even art lovers don't have the time or money to go to exhibitions, let alone buy art. To be candid, I didn't know the situation in Belgium was so difficult. The only country that's interested in art and where stuff still sells every now and then is America.

June 8, 1933, to ANDRÉ DE RIDDER, Belgium (Ger.):
The financial conditions are difficult and my personal income has undergone an unpleasant change—I am forced to save.

June 13, 1933, Berlin, to THOMAS DE HARTMANN (Rus.):
Thank you for your concert program! So tomorrow we'll keep our fingers crossed. I ask you to be so kind as to write <u>in detail</u> how everything went and later also about the press. A great, great pity we can't experience the concert. [...]

Obviously you didn't get together with the Zervos. [...] Six months ago I asked Zervos to send you and Olga the book about me, and he replied that he had sent it. [...] But both of the Zervoses are invaluable people: capable of making sacrifices for a good cause dear to them. And such people can be counted on one hand. There is a warm-heartedness one can only marvel at when one encounters it. [...]

Unfortunately it won't be possible for us to come to Paris soon, my income is pretty middling and we're cutting back. We dream of going south at the end of summer—sun is <u>necessary</u>, different scenery and a vacation from the politics seeping into every crack. My "Aryan" origin is doubted, is not officially recognized. But this is of great

1933

importance now. It is even worse with my artistic "radicality," especially with abstract art. Exhibitions are no longer possible at all. But my work is exhibited in America, with some success. In Europe, already for the past two years it's been a small miracle if one can sell anything. But I do manage such miracles from time to time. [...]

Your *Kriss* [*a film for which Hartmann composed the music as "Thomas Kross"*] was suddenly shown in Berlin about 2 months ago. [...] How is your financial situation now? How is your cinema work going? We are grateful for any details.

July 15, 1933, Berlin, to GALKA SCHEYER (Ger.):
If the [*Bauhaus*] were to reopen against all expectations, my classes there would hardly be sanctioned—"abstract art = decomposing art." So I'm not really tied to anything and could easily travel for months. What would be your advice? Do you think I could make money over there? [...] If the trip to America were possible, we would of course forego the short trip [*to Paris*]. In a few days my issue of *Sélection* (Antwerp) will appear with 3 texts (main text by Grohmann) and many homages, with 59 reproductions of drawings, 12 of paintings. [*On July 20, rather than bend to National Socialist demands to rewrite the school's curriculum and dismiss Kandinsky (as well as Ludwig Hilberseimer), Mies van den Rohe and the teaching staff decided to dissolve the Bauhaus.*]

July 23, 1933, Berlin, to WERNER DREWES (Ger.):
At the moment there is a struggle for the recognition of "Die Brücke," which is only partially affirmed. Apparently abstr. art still has a long way to go! The National Socialist students campaigned very energetically for painters such as Nolde, Heckel, Schmidt-Rottluff. There is also very spirited fighting for Barlach and Lehmbruck.

Prof. Dr. [*Alois*] Schardt [...] recently gave an excellent lecture on "What is German Art?" and was celebrated like a world-famous singer. [...] Of course not everyone was enthusiastic.

1933

July 25, 1933, Berlin, to OTTO NEBEL (Ger.):
Prof. Dr. Schardt (Museum in Halle) was recently moved to Berlin and appointed as provisional director of the Nationalgalerie and gave a truly excellent lecture on the subject "What is German Art?" [*Schardt had replaced the ousted Ludwig Justi, but himself only lasted until the end of November, and the galleries he reorganized were never opened to the public*]. The thunderous applause he received can, with a clear conscience, be called an ovation. When he got into the car, a large number of young people accompanied him, some in SA uniforms, clapping and shouting "Heil!" and "Bravo!" He proved unequivocally that German art from its known beginnings (a few centuries before Christ) was always "expressive," "irrational," and "unnaturalistic" with a touch of the non-representational. The root of abstraction could be found from the outset. Brilliant examples were shown in slides, which then gradually concluded with "Die Brücke"—Nolde, Barlach, Lehmbruck, Feininger, Marc. From time to time indignant heckling was audible, but only occasionally, because the rousing applause […] immediately silenced them. The entire press, with the exception of the *Völkischer Beobachter*, reviewed the lecture very positively. You may have read that a very large number of National Socialist students organized a meeting in the Auditorium Maximum [*at Humboldt University*] and declared the "Brücke" painters—Nolde, Heckel, Schmitt-Rotluff, Barlach—to be the best contemporary German artists. As a result, a corresponding exhibition was opened at Möller (but not without a fight), which we have not yet seen. […] Strangely enough, some want to use Greek antiquity as a model for modern artists (Rosenberg), which forms a sharp contrast to Schardt's views. At the same time, the disagreement in art is very welcome and only heralds the degeneration of the "struggle" into "convulsion." However, this struggle must remain in harmony with the national state—otherwise it would of course not be tolerated. […] P.S. The *Neue Zürcher* [Zeitung] can be bought here. Except we still don't read newspapers at all. Barbaric—isn't it?

167

1933

Aug. 3, 1933, to ANDRÉ DE RIDDER, Belgium (Ger.):
Thank you again for your beautiful tribute. […] This is exactly what is lacking in today's world—the ability to encounter painting with complete freedom.

Oct. 29, 1933, Berlin, to OTTO NEBEL (Ger.):
After the beautiful days of relaxation in Les Sablettes in Toulon we spent a whole month in Paris—an exhausting but interesting time. […] On the day of our departure a large exhibition of the "Surindépendants" was opened. […] The Surrealists reject "abstr. art" and confuse it with Constructivism. Only 2–3 "abstracts" are recognized by them, including me. […]

Max Ernst recently exhibited in London with great success (also financially). Incidentally, I met him in Paris and he left a <u>very</u> amiable impression upon me. — There are now 65,000 painters living in Paris (instead of 60 thousand 3 years ago), who of course are badly off across all borders. On the Place de la Madeleine, painters sell (or try to sell) their works in the open—flowers are sold across from them, which is still better than sausages. Although some artists would gladly give up their painting for a few such sausages. […]

As you know, I'm definitely at odds with the "Geistreich" [*his "follower" Rudolf Bauer, who, thanks to a stipend from Solomon R. Guggenheim, had opened his own museum in Berlin named Das Geistreich (The Realm of the Spirit)*]. As far as I heard, the proud sign still hangs over the "Palazzo." His new book is said to be available in bookstores. In vitrines. My name should also be mentioned in this book.

The basis of your work is broad and deep and the general development of art is very convincingly portrayed. The general public in particular often has the facile opinion that this development is a purely chaotic and inorganic one. Every new serious work on this subject is called upon to oppose this erroneous view and to open an intrinsically valuable eye to the new art. In this respect, too, I very much welcome your book.

168

Nov. 18, 1933, Berlin, to HERBERT READ (Ger.):
I thank you kindly for sending your book *Art Now*, which made me very happy and which I read with great interest (as much as I can in English!). Allow me the trouble of drawing your attention to a German movement that—it seems to me—you do not know well enough. I feel entitled to speak specifically about a German issue since you mention "Die Brücke" extensively in your book.

In 1912, I published a book called *Concerning the Spiritual in Art* which specifically raised the problem of abstract art. [...] This book, which went through 3 editions in one winter, made a strong impression on the young German generation of the time and is still read by young people today, although it has long been out of print. As a natural consequence of this first book, I published a second one very soon after, entitled *The Blue Rider Almanac*. Franz Marc, who unfortunately died in the war, enthusiastically accepted the plan for this publication and energetically and deftly helped me put the images together. We also organized two exhibitions at that time, in which artists from different countries took part at our personal invitation. The second edition of the *B.R.* was published during the war. I refused the third one because Marc was already dead. I can say with certainty that this movement [...] had a decisive impact on the development of German art and is still known to every German who is interested in art. Incidentally, the two books are not entirely unknown abroad either.

If you are interested in these communications, I would be happy to provide you with further information. As an "object of exchange" for your valuable book, I take the liberty of leaving you with my monograph (Editions "Cahiers d'Art") 1931.

[*By October 1933, the recently established Reich Chamber of Culture (*Reichskulturkammer*) had brought all areas of cultural production under control. No longer able to exhibit or sell his work and deprived of all income, Kandinsky's situation became untenable, and at the age of 67 he was again forced to leave Germany. Otto*

1933

Nebel's diary entry for Dec. 19, 1933, reads: "The Kandinskys are here on their way to Paris, where they will move. They have given up their Berlin apartment because of the hostile attitude of the brown rulers to art. Our conversations revolved around the situation of those affected. K. has retained his benevolent manner."]

Dec. 9, 1933, Berlin, to THOMAS and OLGA DE HARTMANN (Ger.) [*typed*]:

Thank you for the lovely letter that arrived today. I also want to answer quickly.

[*Preparing for their move to Paris:*] We now live in an alpine landscape: small hills, medium-sized mountains, Zugspitze to Mont Blanc—this is what our apartment looks like. Yawning gullies (suitcases, baskets, boxes) slowly being submerged beneath laundry, books, painting supplies, crockery, etc. etc. This melts the mountains. So we'll stick with the apartment you already know. The old stuff we are discovering in the process is horrible! In the course of life, frightening amounts of all sorts of things amass that one no longer needs. Sifting through it is one of the painful parts of packing.

Wish us luck in getting rid of all these worries soon! — Anyway, we hope to spend Christmas near you. For this reason (not only because of lack of time) I will now be brief. — We are very happy you are doing so well and Tomik is working so successfully. P.S. A big request! We will need a housekeeper (*femme de ménage*). [...] We would be infinitely grateful!

Dec. 28, 1933, to ALOIS SCHARDT (Ger.):

[...] my "severance agreement" with the city of Dessau was terminated on the grounds that I had "acted as a Marxist" at the Bauhaus. All my rejoinders came to nothing. [...] I am a passionate anti-Marxist and left Russia for that reason at the end of 1921. I became a German citizen so I was able to advocate my standpoint not only freely but also successfully in Germany. You can easily imagine my indignation. [...] Since my maternal grandmother was German, I spoke German

as a small boy. [...] My artistic career began in Munich and in that wonderful city I wrote a number of art books that had an impact on young German artists. There I founded the Blue Rider, which is a typically German art phenomenon. It was also there that I painted my first "abstract" picture in 1911, which unfortunately was taken away from me by the Russian government when I acquired German citizenship. So it should be clear to everyone that I belong among German artists.

Dec. 29, 1933, Neuilly, to ALOIS SCHARDT (Ger.):
I've been in Paris for a few days, where I intend to stay for a year, and I'm concerned that my "relocation" might be misconstrued. I was shocked when the German authorities stamped my papers as an "emigrant." Nothing is further from my mind than emigrating from Germany. From time to time I get the urge to change my surroundings. [*Some artists*] travel the world to enrich their creative powers. [...] I also belong to this species and therefore had to pick up my "walking stick" here and there from an early age. [*The situation in Germany at the time was still very uncertain, and Kandinsky was hopeful that his relocation would only be temporary and that he might be able to return to his adopted country.*]

Jan. 5, 1934, Neuilly, to GALKA SCHEYER (Ger.):
We've been in Paris for good since December 21. The move cost, and still costs, a lot, so I'm accommodating you as much as I possibly can on *Red Spot*. I would settle for 6,000 marks and suggest 2–3 installments. I would never do it under any other circumstances, as this picture is really very nice, large, and one of the last of the so-called "cool period" (stupid and a misnomer, it's absolutely not true), which was very much insulted at the time, to the point that I wanted to get rid of almost everything from this period—it seems to be appreciated again now. — We understand why you haven't written for so long. But apart from business matters, there are human feelings. If you don't write for that long, we'll worry about you.

1934

Jan. 9, 1934, Neuilly, to Josef Albers, USA (Ger.):
We live very nicely [*in Paris*]. From the windows of the 3 adjoining rooms we can see the boulevard that runs along the Seine. [...] The inhabitants are from all over the world. [...] A German couple, then English, Argentinian, Indian, and only one French couple. One of the shops where we do our shopping belongs to a Jewish family from Berlin. After the experiences you know all too well, this international mix has a very beneficial effect—truly <u>very much so</u>!

Jan. 13, 1934, Neuilly, to Thomas and Olga de Hartmann (Rus.):
Forgive the pencil, and especially my long silence! We have now become your fairly close neighbors, which wasn't easy at all. — In Berlin we started to prepare for the move and since then we have been working without a break, even now at the same pace with the transfer of things and especially the furnishing of the apartment (and the task is not easy for the wallet either). — Additionally, we both caught colds while running around in wet weather, and I also had the flu and bronchitis. [...] Do you have a phone? If not, call me from somewhere soon.

Jan. 23, 1934, Neuilly, to Alexei Jawlensky (Rus.):
We don't want to leave Germany forever (we have deep roots there), but we want to stay in Paris for 1–2 years. [...] The art market in Paris is almost dead. You can't sell anything, and the exhibitions, which otherwise hardly exist, are poorly attended. [...] These are difficult times for artists.

Jan. 25, 1934, Neuilly, to Galka Scheyer (Ger.):
The practical point of the "carte blanche" you have is that you can take up to 50% off the price without asking me first.
In recent years I have painted with pure oil, but also <u>a lot</u> in mixed media—tempera, watercolor, glue, and binders of my own invention, sometimes glazed with oil, sometimes in a glossy varnish, sometimes unbound, etc. So the term oil is misleading. I have to say the same

about watercolors—some of my "watercolors" are oil or mixed. Before the war I also painted a few "oils" with nothing but watercolor, or with pure tempera, and also a few times with gouache. Don't think me obnoxious if I'm being pedantic here. I put no stock, either, in the public knowing which binders I use. [*Regarding works by Josef Albers:*] They are <u>beautiful</u> things made of glass in a quite extraordinary way.

Feb. 1, 1934, Neuilly, to HILLA REBAY (Ger.):
[*From this point on, letters to Hilla Rebay are quoted from the translation in Rebay,* Wassily Kandinsky Memorial, *1945, 93–99.*] My situation in Germany became very unfavorable because I have three full "minuses" — 1) I am not a born German (even a "former Russian"), 2) a former Bauhaus teacher (something that today, it is [*strange*] to say, is almost equal to being a Marxist), 3) an abstract painter. I have, so to speak, three vulnerable spots. In accordance therewith I was attacked, or to make it plainer, I was "given the cold shoulder." The artist groups to which I have belonged for years, passed me over in their exhibits. The museums have placed my paintings in storage. My contract with Dessau, according to which I am still entitled to half of my salary until April 1st, [*1935*], was forcibly dissolved. Exhibitions, even in private galleries, became impossible for me. Therefore, also, the art dealers were no longer able to represent me energetically. In one word my hands were tied. I left with a heavy heart, as I have lived in Germany since 1897 and had gained a great footing there ...

Feb. 20, 1934, Neuilly, to ALEXEI JAWLENSKY (Rus.):
As far as exhibitions go, I can say that apart from America and recently England nowhere else is worth it. In Belgium almost all galleries for new art have closed. In general, one buys nothing there but Belgian art. Furthermore the galleries are now asking for money for their rooms! If you can set up an exhibition in Belgium free of charge, it is of course worth showing your work, as there is still great interest there in new art. [*Heinrich*] Campendonk, who is <u>very popular there</u>, has the best

1934

relationship with Belgium. Perhaps write to him? […] Marcel Duchamp was with us yesterday; he recently returned from America. Life is much livelier there and what is particularly gratifying is that the art market there is beginning to recover. […] Incidentally, the prices here have fallen catastrophically, in part because they were previously inflated artificially. The Parisian dealers, who have already enriched themselves, don't mind, but the artists groan, all of them without exception.

We also met Chagall, who is very nice. He has grown fat and is bald. We're going to see again him soon. He has a very amiable wife. — As always, we met the Hartmanns, very friendly. They send you their <u>very</u> warmest regards. […] I spoke to Zervos, he will print an article in *Cahiers d'Art* on your anniversary.

Mar. 5, 1934, Neuilly, to ALEXEI JAWLENSKY (Rus.):
Yesterday I heard that there appears to be an exhibition of Italian Futurists in Berlin and that Marinetti will probably speak about the new art. Did you hear about it? M. always speaks very enthusiastically, informatively, always very clearly and interestingly!

P.S. The Hartmanns also send their warm regards.

Mar. 23, 1934, Neuilly, to ALEXEI JAWLENSKY (Rus.):
Nina Nikolaevna and I embrace you with all our hearts, congratulate you and admire the great artist in you, who deservedly occupies an important place in contemporary art, indeed in art history as a whole. From the bottom of our hearts we wish you better health and that you can continue to work with joy for many years to come. — We have known each other since 1897, so in 2–3 months it will be 37 years! Among many things I remember how you taught me and [*Nicolas*] Seddeler how to draw heads. I learned a lot from you back then and I will always be deeply grateful to you. I was less concerned with the "head" than with organic connections, the unity of form that only exists in the "summary." Do you remember how some of our colleagues struggled? […] It was a lovely time. And so many different memories! — You probably already have news from Grohmann. He wrote to me: "I am happy to write an essay on Jawlensky for *Cahiers*

174

d'Art." [*Kandinsky had suggested the article to Zervos.*] And I am very glad he is so enthusiastic about his work.

Apr. 15, 1934, Neuilly, to Werner Drewes (Ger.):
The question of whether the artist should also deal with politics has long been answered in the negative for me. I firmly believe artists, scholars, and clergymen must stay away from all politics. [...] "Political" questions will only be solved when there are no more politicians. [...] As far as I'm concerned, I didn't find the answer to this question until I was 30 years old. Before, I thought a Russian particularly has only one choice—to become a practical or theoretical (scientific) politician. [...] As a student I smiled pityingly at Tolstoy's words, "no political or social system can help bad people—one must start with the people." Everything I've observed to date confirms this thinking. [...]

It's not for nothing that the German word "*Geist*" and the Latin word "*Spiritus*" now mean schnapps. And having a lot of "*esprit*" in French means to be witty. But of course there is also an "*esprit du vin*." And despite all the darkness, all the wildness, all the lack of spirit, all the hate and hustle and bustle, I firmly believe the new era has begun. But it doesn't start in politics. It is inhibited, trampled on, crushed by politics.

Apr. 20, 1934, Neuilly, to Galka Scheyer (Ger.):
Red Spot is one of my best works, and it is listed among my paintings as a unicum. In this case, I don't want to compare myself to Picasso or Braque, who have "so-called" periods, i.e. vary the same thing 10–20 times. [...]

I was strongly advised to move here, as collectors would certainly come to the aid of an artist who had to leave his country. Now I see this was "idealistic optimism" and that collectors have no interest in the situation of artists. In this case I even regret I can no longer be surprised at all—it would be more natural to be surprised. Dear Galka, my letter sounds bitter. [...] I am aware of the general state of

1934

the global economy today, but it is either underestimated or remains unknown.

June 19, 1934, Neuilly, to JOSEF ALBERS, USA (Ger.):
I had 2 exhibitions—one in Milan, the other in Paris [*the Galleria Il Milione in Milan hosted an exhibition of Kandinsky's watercolors and drawings in April–May. In May, Zervos also mounted an exhibition of forty-five of Kandinsky's paintings in Paris, with a dedicated article appearing in* Cahiers d'Art]. Since it was my debut in Italy, I had to do it as well as possible. It was worth it. [...] Hilla v. Rebay is now in Paris and asked me, among other things, what I think of your art. My answer may be of use to you. She regrets that you are in NY right now while she is in Europe, but hopes to see you there sometime. I suggested she go to your Monte-Negro (Black Mountain) and see the college too. [...] I had a card from Milan once on which [*Alexander "Xanti"*] Schawinsky warmly wrote to us. The Schlemmers now live in a small village on the Swiss border; the Klees now have a good apartment in Bern and are very happy there. [...] The Grohmanns would certainly be delighted to receive a letter from you. [...] Couldn't you subscribe your college to *Cahiers d'Art*? [...] Without doubt, it is the best review in the world, it brings only good things in a variety of ways. It is terribly nice that you acquired my English book for the college and hung up my works. Glad to know your students are getting an idea of my art.

June 26, 1934, Neuilly, to OTTO NEBEL (Ger.):
The big trump card at the moment is Dalí, who even has 2 exhibitions on simultaneously. Do you know him? Pure sexuality, but even that with limited "motifs." [...] A few weeks ago, a young man named Balthus, who also belongs to this most modern movement, made his debut in one of the new galleries here. One of his paintings was so expressive it was hung in a special room (or rather a storeroom) that not every visitor knew about. I don't want to describe this picture to you, if only out of respect for Mrs. Nebel.

176

July 1934, Neuilly, to THOMAS and OLGA DE HARTMANN (Rus.):
Dear Tomik, dear Olga Arkadievna, I congratulate you both again
from the bottom of my heart. [*Eugène*] Bigot [*a French conductor*] con-
ducted so well. [...] The orchestra played powerfully and wonderfully.
[...] And how well all of Tomik's "coloring" came across, such a "rich"
coloring, just like the symphony as a whole. It is now clear that a piano
performance would not express even a tenth of the richness and beauty
of an orchestration. God continue to grant such successes and greater
ones. [...] We fled from Wagner, so we didn't say goodbye. We would
like to know if Tomik himself was satisfied with the performance and
would like to exchange further impressions.

July 3, 1934, Neuilly, to ALEXEI JAWLENSKY (Rus.):
Excuse my late response! Been overloaded lately. <u>Of course</u>, neither
Zervos nor Grohmann would ever accept money. You don't have to
send anything to Z. either—believe me. Just drop him a line and
thank him for his attention to your anniversary. But if I were you, I
would send Grohmann a small piece of work, which I'm sure he'll be
happy about.

We recently went to the Hartmanns' concert and really enjoyed
it. You would be amazed how OA [*Olga Arkadievna de Hartmann*] now
sings—a consummate artist. [...] It was a great success. They have
both remained as sweet, simple, and sincere as they were on Ainmiller-
strasse. Yesterday they visited us and send you their warmest regards.
— Did you receive an invitation to the German exhibition in Zurich?
An influential Swiss man came to see me and I gave him your address.
You should be invited. I didn't fail to tell him you were—Prussian.

July 20, 1934, Neuilly, to GALKA SCHEYER (Ger.):
Great success in Milan. The articles of Zervos and Galka have pleased
everyone. [...]

What particularly pleases me is the energetic recognition of my art
by young people—I have many followers among young people. What

1934

can be worse than being demoted by the younger generation as an "old wreck"! Even the Surrealists, who otherwise completely reject "abstract" art, have a very positive attitude towards my painting. Have I shown off enough? I can do that with you. ... [...] the young Romanian Jakovsky. He writes poetically, not boringly "philosophically" or distortedly "art-historically"—lively and his depths are clear. Carl Einstein is his direct opposite—philosophical, art historical, with such murky depths one can see nothing more. [...] Admittedly, the young artists also have it easier than we, who paved the way so smoothly for them, even sprinkling sand so they wouldn't slip. An art historian once said that about me, i.e., I could have had more external success and even deserved it, but the law of nature dictates that "the pioneer paves and points the way, but never gets anything out of it himself."

Aug. 9, 1934, Neuilly, to THOMAS and OLGA DE HARTMANN (Rus.): Dear friends, we are amazed and even a little worried by your silence. No letter from you, so we can't write a "reply." We are happy you are in the countryside. Oh, but Tomik works so much! He needed rest.

Aug. 9, 1934, Neuilly, to ALEXEI JAWLENSKY (Rus.): Yesterday we were invited to the Arps, very nice people, we get on well with them. Mrs. Arp had come back from Zurich recently where she had seen an exhibition of German artists. Nina and I were happy to hear your works were well received there. Mrs. Arp (who, as you know, is an artist herself) said your paintings were the best in the whole exhibition. She was really enthusiastic about the subtlety and depth of your painting. [...] Tomorrow we leave for Normandy, to relax and swim.

Sept. 3, 1934, Calvados, to HERMANN RUPF [*his Swiss collector and friend*] (Ger.): There were fantastic, indescribably beautiful colors in the sky and especially in the water. Hardly any moment of calm, and often at the

178

same time one could observe pure white, emerald green, deep violet on the ocean waters. In addition, the dry sand in soft yellow. [...] I was not tempted to paint seascapes, but I greedily soaked up these impressions.

Sept. 13, 1934, Neuilly, to ALEXEI JAWLENSKY (Rus.):
The Arps asked about you the other day and they, like us, are deeply touched by the persistence with which you work. [...] You may be wondering why the issue of *Cahiers d'Art* with the article about you has not yet appeared. There was a delay [...] and Zervos then made the right decision not to publish the magazine in the "dead season"— from mid-July to mid-September. Paris is still "empty" as people are only gradually returning. So the magazine will come out towards the end of the month. [...]
P.S. Our Galka has been completely silent. Did she perhaps write to you? In America it's probably not exactly pleasant either.

Nov. 3, 1934, Neuilly, to TONI KIRCHHOFF [*widow of the collector Heinrich Kirchhoff*] (Ger.):
The news of the death of our dear Heinrich Kirchhoff has greatly surprised and shocked both my wife and me. We extend our condolences to you from the bottom of our hearts.
A great number of artists and sincere art lovers will always remember their departed friend and patron. Such a sincere, heartfelt love of art is not usually an everyday occurrence and especially in an age that only warms to material things. Kirchhoff left a big void for us all, as his enthusiasm ended with him. With heartfelt regards from my wife too, your very devoted Kandinsky.

Nov. 17, 1934, Neuilly, to GALKA SCHEYER (Ger.):
Finally, a letter from you. Your long silence really worried us. [...] I am happy for Schoenberg that he made it to America. If you see him, please give him my cordial regards. He could write a few lines

1934

to me. It would interest me to know how he and his wife are doing, what plans he has, etc. [...] My *Concerning the Spiritual in Art* will be translated in Italy, with an excellent introduction, characterizing me artistically and personally [*edited by Giovanni Antonio Colonna di Cesarò, Rome 1940*].

Nov. 19, 1934, Neuilly, to HANNES and MATILDA BECKMANN, Prague (Ger.):

[*Hannes Beckmann was a former student at the Bauhaus.*] Of course, I remember both of you perfectly well, and I was happy to receive your letter. — It is probably better for you not to go to Spain, where things are very uneasy, and where, as they say, the unrest is still far from over. In this respect, you are better off in Prague. You will earn a satisfactory salary there, which today is an art in itself. My wife and I have been living in Paris for a year now, and we feel at home here. [...] I have known Paris for over 40 years or even longer, and often I am surprised to find the identical ways of life, which persist totally unchanged (lifestyle, furniture, etc.).

Nov. 23, 1934, Neuilly, to OTTO NEBEL (Ger.):

Recently we saw a really interesting exhibition of the sculptor [*Julió*] González in the rooms of *Cahiers d'Art*. [...] Afterwards, as is almost always the case here, we spent an hour or so in a café with painters, sculptors, architects, etc. It's a nice custom here, which brings some warmth into the artistic sphere, despite all the downsides in dealing with art politics. [...] Of course, the ladies come along here, which is why the conversations stay cleaner. [...] The ladies here are quite something. I have known French women for many years and can't help but highly admire their development. But my wife, for whom life here is still new, is really pleasantly surprised by French women and their qualities. Perhaps the most curious thing is that a French woman does not lose her qualities even as an artist's wife. She is extremely capable [*Ger.* tüchtig] (a good German word!), helps her husband, even earns

180

their living, if the artist cannot do it himself (especially nowadays!), works incredibly hard, and yet remains a woman—presentable, pleasantly "flirty," and ... natural. None of us (our circle) can complain about our wives, that is, we are right to be proud of them. [...]

There are, however, other—even artistic—circles where women are treated the "communist" way, where a young husband is told, "if you want to belong to our circle, lend me your wife" (usually for a short time). And the man, of course, gives up his wife, otherwise what kind of "modern" person would he be! [...]

Autumn is wonderful here—the colors! The air (though not in the Métro)! The fog! We live 10 min. from the small castle "Bagatelle" with its fantastic park. [...] Children play, nannies gossip, lovers kiss (they kiss everywhere). Far and wide not a policeman in sight. But here and there an artist at his easel. [...]

A political crisis almost every day. A change in government every two weeks. — Don't forget to let me know if the book about you (in Dresden?) has been published. And if so, are you satisfied? And ... could you lend it to me.

Dec. 17, 1934, Neuilly, to HANS THIEMANN (Ger.):
The few friends who welcomed my very first attempts turned their backs on me as I progressed or turned into my active enemies. Believe me, I'm not exaggerating this situation in the slightest. I have experienced "active combat" and "passive resistance" in all forms for years. If I didn't break my neck, it was due to the inner voice that alone affirmed my path and which I ruthlessly followed. [...] Resistance also possesses creative power because it leads to concentration and a strict self-control that is organically related to concentration. [*Thiemann answered that resistance in Germany can also lead to the concentration camp.*]

Dec. 19, 1934, Neuilly, to MARIA MARC [*Franz Marc's widow*] (Ger.):
I write about my memories of Franz Marc with particular pleasure. [...] Damn politics has the ability to slip through every little crack. I

1935

fill the cracks as well as I can. Here, for example, a war was certainly expected to begin. The memory of those war years scarcely past has faded so much that the demon of war no longer appears so terrifying to some people.

Jan. 3, 1935, Neuilly, to WERNER DREWES (Ger.):
I prefer to live where I am not hindered or disturbed in my work, where I am free. Perhaps, as someone born in Russia, I hate any form of coercion more than people from other countries do. I consider it a wicked crime, when governments—whichever ones—interfere in matters of art and science and want to instruct there. What nonsense it is to demand proletarian art or national art or science! This is my reverse "Marxism," for which our Bauhaus Marxists so resented me. By the way, almost all of them have become Nazis these days.

Jan. 21, 1935, Neuilly, to JOSEF ALBERS, USA (Ger.):
Arp brought me your woodcuts, and I finally had an opportunity to show them to Zervos. To my great delight, he found them <u>very</u> good. [...]
[*Regarding former Bauhaus students:*] Our loudest "ranters" [*Ger.* Schrei-hälse] have become orthodox Nazis. And so on. I heard from another source that painters who don't belong to the official art organization aren't allowed to paint <u>at home</u> either—it's a punishable offense.

Feb. 4, 1935, Neuilly, to OLGA DE HARTMANN (Rus.):
A small, but impertinent question: do you perhaps have any chance of getting tickets for Toscanini? This will probably be an expensive pleasure. Or maybe it could be good, but not too expensive, seats for Feb. 26. And it would be nice to go with you.

[*In February–March 1935, Kandinsky participated in the large exhibition* These, Anti-these, Synthese *at the Kunstmuseum in Lucerne alongside Picasso, Arp, Taeuber-Arp, Léger, Miró, Mondrian, Ben Nicholson, and others. The recently emigrated German dealer Israel Ber Neumann exhibited Kandinsky's works in New York.*]

Feb. 9, 1935, Neuilly, to BEN NICHOLSON (Fr.):
Thank you for your letter. I read it in English very easily even without consulting the dictionary. Unfortunately I cannot reply in English. My wife and I are also very happy to have met you and Mrs. Barbara [*Hepworth*] and we hope to see you again soon. [...] Yes, Miss [*Myfanwy*] Evans sent me the first issue of *Axis*. I congratulated her on the launch. A great warrior once said that fighting a war requires three things: 1. money, 2. money, and 3. money. They are the same things that an art review needs—above all a modern art review. Miss Evans has the good will, the candor, and the energy needed (she made a very amiable and serious impression on me), the only thing she lacks is money. I nearly forgot one thing almost as necessary for a modern art review—patience in the face of annoyances and a strong enough nerve. [...]

And all of us who want to show possibilities in art, new paths, are warriors without wishing to be. Fortunately, we can shoot our "cannons" from our studios without involving ourselves directly in the "battle." But in staying peacefully in our studio we don't avoid the ferocious blows of our "enemies."

To show some of my little "cannons" I would really like to be able to have an exhibition of my gouaches and drawings in London. Don't you think Mr. [*Herbert*] Read would be able to speak about such an exhibition to the Mayor Gallery, which I've been told has enough space for 40 or so sheets? [...] England is the only large European country in which I haven't yet exhibited enough, i.e., with a sufficient quantity of my work.

Mar. 15, 1935, Neuilly, to JOSEF ALBERS, USA (Ger.):
Your friendly invitation to come to Black Mountain is very, very tempting. Very! But what good does it do, if we <u>cannot</u> give in to our great desire to accept your invitation.

Apr. 1, 1935, Neuilly, to HILLA REBAY (Ger.):
Our life here has its rewards, and we would be completely happy if

financial problems were not always threatening. The main thing here in Paris is that I can work so very well. I spent time painting larger canvasses. These I like, as I had to relinquish them for years, because I had only three full days to paint during my time at the Bauhaus, the other days were filled with teaching, meetings and preparations to teach. [...]

You know what it means when one is well in form to create, and yet, as of command, has to put down the brush. Besides the spiritual side, how often is it technically impossible to break up suddenly such work. And besides loss of time, how much loss of strength, of nerves, the Bauhaus has cost me. This waste of energy lasted twelve years. Very much though I enjoyed working with young people, and I was happy to give them something. [...]

Apr. 2, 1935, Neuilly, to BEN NICHOLSON (Fr.):

[*After some confusion involving the Mayor Gallery in London, which rejected the idea of showing Kandinsky's work:*] It was my fault alone. I had too much confidence in my knowledge of the English language and read your letter too quickly. I have read it again now a second time and I was mistaken. You wrote that you had asked the Mayor Gallery if it had any interest in my exhibition. And reading it too quickly I understood it <u>was</u> interested, but that it thought my prices too high for England. [...]

It's unfortunate that galleries (not only in England but in all countries) are becoming more and more reactionary. The same must be said of the public. It's a "vicious circle," because the galleries, in their reaction, pull the public and are at the same time pulled by the public's reaction. An exhibition such as the one in Lucerne [These, Antithese, Synthese] is a rare exception to the reactionary "rule." Let us hope it produces favorable results. I have often been told at least of the very large number of visitors.

Apr. 3, 1935, Neuilly, to ALEXEI JAWLENSKY (Rus.):

Believe me, I often speak about you. Even putting together my own exhibition in Paris is very difficult and very easy. Easy because art

dealers (and some of them with big names) rent their rooms to painters for a fee. […] Art dealers only exhibit free of charge those painters with whom they have a contract and from whom they have bought themselves. […] So sales border on a miracle. Write to Grohmann in Dresden, although I doubt that he can arrange anything. But it's worth a try. […]

P.S. A few days ago we spoke to [*Elisabeth*] Epstein on the phone. She's just as sweet. The Hartmanns have just come back from Nice, they will visit us, and next Wednesday they will go to England for a whole month.

May 19, 1935, Neuilly, to GALKA SCHEYER (Ger.):
My relationship to nature, to the outside world? I love all of LIFE and therefore also nature, and my experiences in nature are the sources of my creations. […]

The move to Paris has completely changed my palette. […] What also really suits me is the Parisian light, which shook me so much after moving that I wasn't able to work at all for a few months. The difference in the light from that of central Germany is very stark: here it is powerful and gentle at the same time. We have overcast days here, but with no rain, which is rare in Germany. The light on these gray days is incredibly rich, with a large range of colors and endless degrees of tone. These qualities of light remind me of the light conditions in and around Moscow. So I am "at home" in this light. As a big contrast, I love the light in Bavaria, where it's like "thunderbolts," illuminating great chasms, and always "fortissimo." I learned a lot there. I am also pleased that my few remaining Bavarian landscapes from around 1908–9, which I still possess, are well liked here. But what I'm really proud of is that the colors remain perfectly fresh to this day— as if they were still damp. Not for nothing have I wrestled so much with technical matters. Self-praise!

Concerning technique: what a lot of illiterates there are today, one can hardly believe it. No question: one has to master one's craft. What

good is the most finely designed shoe, if the leather splits after a few days? Strangely, a lot of importance has been given to "brio" and "primitive savagery in painting" here. These qualities are supposed to indicate "temperament"! No, temperament doesn't consist of noise, but more of mastering and directing inner tensions.

May 25, 1935, Neuilly, to ISRAEL BER NEUMANN (Ger.):
[...] it's nearly 25 years since my first abstract work, which I painted in 1911 (fig. 12). What I mean by that is that I never gave up and have stayed firmly on my "perch." What else could I have done, since in my work I only obey my driving force, or should we call it more solemnly, "my destiny." [...]
An "ism" becomes dangerous when it negates the fundamental laws of art: that every artist of every period draws his artistic "nourishment" from external things. The difference is one of variety in "expression" or a question of "form." The other danger is not necessarily directed at art but against the artist himself. This danger consists of constructing some "infallible principle" he thinks he has to follow at all costs. Programs are always a "mortal danger" [*Ger.* Mordsgefahr] (I love that Bavarian expression), be it in politics, medicine, physics, or whatever. But the consequences are worst in art, because they lead to the death of art. Luckily, art has an extraordinary ability to save itself from death! But it can remain in a death-like state for a long time, as happens today in countries where art is expected to be produced "under diktat." I have saved myself from such diktats twice already, as I am convinced that art can develop only in complete freedom. [...] Once the situation is finally well understood and "digested," then true abstract art will also be fully appreciated. It will celebrate great victories, as it is capable of revealing a new, as yet unknown world in art. People will thank us over and over again. Perhaps this will come sooner than expected. In your America, where one is not governed by morbid traditions (to be distinguished, of course, from healthy ones) to the same extent as in Europe, it may happen soonest.

1935

June 7, 1935, to BEN NICHOLSON (Fr.):
[*After Nicholson had sent him two woodcuts, one of his own and one by his eight-year-old son Jake:*] Thank you very much for the two woodcuts, which I received yesterday. I like the woodcut by the young artist very much—the composition and the lines, rich in feeling, are really very pretty. Have you yourself worked a lot in wood? It seems to be the case. It's a beautiful material. My wife and I like your woodcut and we both thank you. The balance you seek everywhere around you is in my opinion successful. [...] I was at *Cahiers d'Art* yesterday and they didn't tell me anything about your works there. Next week I will be there again and I will ask them to show me. Warmest regards from we 2 to you 2 + 3 = 5. The 3 young English citizens are wonderful—without wanting to flatter you! [*Nicholson and Barbara Hepworth's triplets were born in October 1934.*]

June 19, 1935, Neuilly, to GALKA SCHEYER (Ger.):
In Germany my drawings also met with what at that time was—for me—quite unexpected success. Non-experts have understood that the strength of abstract painting does not lie merely in color and that it is not a "formless" art. Experts have noticed, however, that I know how to handle black and white in such a way that it creates a multi-colored impression.

July 4, 1935, Neuilly, to ISRAEL BER NEUMANN (Ger.):
I am in Paris the whole of July and I'll be happy to wait for you another 8–10 days in August. [...] In case you came before Aug. 1, you can still see my exhibition in the rooms of *Cahiers d'Art*: paintings from 1934 and 1935, watercolors of the last 4 years, drawings from 1910 onwards. [...] Mrs. Galka Scheyer wrote to me that she will get in touch with you directly about the oil paintings.

Aug. 4, 1935, Neuilly, to ISRAEL BER NEUMANN (Ger.):
When I left Moscow [*in December 1921*], some of my paintings, including some large formats, remained in the care of the Museum of Western

187

1935

European Art. Among them is my very first abstract work of 1911 (this is the very first abstract painting ever painted in our time) (fig. 12). Unfortunately I don't have a photograph of it. I wasn't happy with the painting at the time, so I didn't number it or write on the back like I usually do. I didn't even include it in my private catalog. It is a large picture, almost square, with very vivid shapes, and a large, circular form at the top right. When I took German citizenship, all these works were declared the property of the Russian state and I could not get them back. If it were possible to get a good photo of this first abstract painting I would be very pleased. [*See the letter of Dec. 28, 1935.*]

Oct. 11, 1935, Neuilly, to OTTO NEBEL (Ger.):
It was a great pleasure for me to receive your monograph. […] Don't you want to send proofs to young art reviews for discussion? In any case, I will give you some addresses at the end of this letter. […] It's a pity that German readers who are of interest to us will only see the book by way of exception or not at all. Of course it is more comical than sad that we (of all people) are considered "spiritual Bolsheviks" in the new Germany. A newspaper was recently brought to me from there, with reproductions of Kirchner, Klee, Belling, and me and an article written about us that goes to great effort to present far-fetched evidence of our "Bolshevism."

P.S. addresses [*of international reviews*]: *Axis* (Engl.); *Konkretion* (Danish); *Bolletino della Galleria del Milione* (Ital.); *Gaceta de arte* (Span.).

Oct. 15, 1935, Neuilly, to HANNES BECKMANN (Ger.):
I thank you very much for the beautiful portrait. My wife and I are truly enthusiastic about your photograph [*see back cover*].

Oct. 21, 1935, Neuilly, to ISRAEL BER NEUMANN (Ger.):
Of course I too have "periods," with the difference that I never stick to the same theme, expression, or technique within a period. This is

a characteristic of mine that makes it difficult to "understand" my works. [...]

I have selected watercolors at Probst's for you. There are "dramatic" and "lyrical" sheets, hot and cool and very cold, heavy and feather-light, but almost all with my special "equilibrium," which, as Zervos says, always remains enigmatic. I know how to achieve balance, and I like doing it, but in such a way that it seems unbalanced. Talking of external appearance, balancing out is not only very easy, but very boring. [...]

I already wrote in *Concerning the Spiritual in Art* that "all means are sacred if they stem from inner necessity" (something like that). There are many people who travel very far but eat their native dish wherever they go. It's due to that damned force of habit, which makes people deaf and blind. [...] Try to show the New Yorkers that they should be glad I am not always the same, and that I am able to show them very different worlds.

Dec. 28, 1935, Neuilly, to ISRAEL BER NEUMANN (Ger.):

[*On Dec. 10 Neumann had written:* "Finally the photos from Moscow have arrived. [...] I am really proud to have obtained something from a Soviet Museum." *Kandinsky wanted at least photographic evidence of his very first abstract painting,* Picture with a Circle *(fig. 12). Neumann sent those sixteen photos to Kandinsky.* Picture with a Circle, *now in the Museum of the Georgian Republic in Tbilisi, was exhibited for the first time in 1989 at the* Die erste sowjetische Retrospektive *in Moscow and Frankfurt.*]

[*Concerning an exhibition of engravings:*] Is it really necessary to frame them for the exhibition? 200 dollars is a lot of money. Once I put on an exhibition of watercolors at Möller's gallery in Berlin, and we decided to experiment and hang them unframed. It looked good to him and to me, so we left them unframed, and many "experts" were enthusiastic (fig. 22).

Dec. 23, 1935, Neuilly, to ALEXEI JAWLENSKY (Rus.):

I have told the Hartmanns how happy you were to hear about the success of his symphony. And they want to write to you themselves. Both work very hard and even too much! After all, apart from "con-

1936

templation," he has to think about making money. They are both wonderful, loving people, that's a rarity. The symphony is also supposed to be performed in Brussels and almost certainly in London. Here it was performed twice, and with increasing success. [...] There is a wonderful exhibition of Flemish painting going on here—masterful van Eyck, Breughel, Bosch ...

A. K. Benois has visited us recently, and we had friendly exchanges. [...] He is a great connoisseur of old art but has no feeling for the new tendencies.

Jan. 2, 1936, Neuilly, to Hans Thiemann (Ger.):
As far as themes are concerned, "psycho-analytical" motifs have always repulsed me, although objectively I am forced to praise your power of expression here as well. As always, I'm speaking to you very openly, because I appreciate you not only as a person but also as an artist and I have respect for your serious intentions. I stand before some motifs as if before a riddle and I ask myself why nowadays genitals interest some (I could almost say "many") artists so ardently. [...] Does it have something to do with "emancipation," i.e., with the reasonable, but somewhat exaggerated "unveiling" of otherwise carefully hidden things? — I'll tell you a little anecdote on the subject. A few months ago a lady came to a modern art exhibition at *Cahiers d'Art*, saw works by me, by Leger, etc. and asked the organizer why he was actually exhibiting such ugly pictures. "Don't you like a single painting in the exhibition?" — "Oh, no! This one is very pretty." — "Why do you like it so much?" — "Because it shows such a pretty flower." — The organizer was embarrassed and did not dare to enlighten the lady—the "flower" was a light green part of a woman's body bearing the Latin name "vulva." The strangest thing about this tale was that I too had taken the beautiful body part for an ugly flower. It was my fault, of course, as I have the bad habit of noticing the painting first and then recognizing the subject. Since the painting was abysmal, to say the least, miserable, I had no time for the rest. [...]

Perhaps I'm an eccentric in this case. When I was quite a young boy, my classmates sometimes used to hold my hands, so I couldn't cover my ears, and then shout all sorts of "dirty" things in my ears. It made them happy that after such experiments I used to smash everything in reach to pieces. The aversion has stayed with me throughout my life. So perhaps I don't understand some very "natural" things. [...]

Vilhelm Bjerke-Petersen [*a former Bauhaus student from Denmark*] has been here and asked some artists to lend him photos for his art review *Konkretion*, which has been out for a few months now. P. is interested in abstr. art, but especially in Surrealism, because he also belongs to this tendency. If you are interested, you could send him some of your photos, and refer to me if you wish. [...]

There is currently a wonderful exhibition of old Flemish painting here. Realism intertwined with the fantastic and a fantastic that is realistically persuasive. The painting itself is of the highest quality. A real treat. [...] But the largest mass [*of exhibitions*] is beyond all criticism.

In a month or two a lady, Miss Myfanwy Evans, who has been editing an English art review, *Axis*, for a few months, will be coming from London. At least that's what she intends to do, and if she really comes I'll show her your photos. Her main interest is abstr. art, but not at all narrowly defined. *Axis* is really good.

Jan. 25, 1936, Neuilly, to GALKA SCHEYER (Ger.):
At your request at the time, I sent Mr. Rivera a very nice watercolor as a gift and received a great silence as a word of thanks. Everything has its limits. How often have I been told since my youth that one should treat people as coolly and politely as possible in a cocky way so they learn respect. [...] I get used to being cool and snooty regularly and consistently. I suffer from it like a painful injection, but it "works." [...]

There's an abstract art exhibition coming up soon in London where I am the oldest among a lot of young artists. I work a lot but slowly. The Russians have a saying: "Drive slowly—that's how you'll get further." Rarely, but occasionally, I produce a medium-sized painting at light-

1936

ning speed. Then I say "phew!" and go at a slower pace. Now I have been painting a large picture since almost New Year's and the drawing alone took about two weeks.

I often use color combinations that are "forbidden" in Paris, and young people love my "audacity." In general, the old "harmonies" still prevail here and always the same old themes—still life, figures, landscapes. This is how the "*pompiers*" paint, and then the drawing is "correct." This is how the "avant-gardists" paint, and then the drawing is "distorted." Paris has much in common with a small provincial city, not only in this respect. And yet Paris is unique. [...] Neumann is organizing a large exhibition in N.Y.

Jan. 28, 1936, Neuilly, to WILL GROHMANN (Ger.):
In another gallery (Paul Rosenberg) we saw the latest works by Braque. Same impression as usual: at first glance "Fine painting! Beautiful painting!" Then, after a few minutes: "but a bit boring ... still always the same ..." Just between us: it is a Parisian characteristic to paint the same thing over and over again. I don't think the painters in any other city are as "consistent" as here—year after year an artist paints the same thing with tiny variations that are sometimes so microscopically small that only the artist himself sees them. Even young and very young painters do the same. It's one of the reasons why Picasso excites so much: every season an "upheaval," a "new discovery," which is greeted with an enthusiastic "A-a-h!" Again between you and me: his new paintings (especially since we arrived here) are "post-discoveries"— they are painted in the spirit of 1910/12—Dada plus Expressionism. E.g., a woman in profile with two breasts—one on the stomach, the other one above it, closer to the chin. If I am asked if I like it, I answer modestly, "I don't understand. Is it Egyptian?" [...]

But DADA in general is becoming fashionable again. My wife has already written to you about Man Ray's "ladies' saddle." But I no longer remember if she mentioned that such a saddle is a sophisticated symbol? I much, much prefer the old authentic Dadaism—there was a saucy

joke in it that pulsated strongly. Today's seems geriatric to me. No, truly, it's really old people who need <u>such</u> titillation. The Surrealists flourish in this soil, and since today there are enough old people around, they have a well-defined, sizeable audience that considers this art to be a kind of revelation. In Paris, for example, they have a very specific circle of admirers, made up chiefly of snobbish aristocrats—a "fine society." "Sex" is an international topic, and not without reason are there even Japanese and Mexican Surrealists. The English will have to come to grips with Freud and politics, or they won't be "in." [...]

In Moscow a luxurious catalog of the "Museum of Western European Art" will soon be published. [...] The man who originally bought all these works for his private collection, [*Sergei*] Shchukin, died here a few days ago. The collection of Mr. [*Ivan*] Morozov, which was also very valuable, was likewise added to this museum. Both collectors were Moscow merchants. These peculiar Moscow merchants worked not only for Russian civilization, but also for culture, with much love and devotion. [...] Such "eccentrics" are disappearing more and more. [...]

Have you noticed "abstract" art is spreading more and more to different countries? Here there are quite a few talented French artists and other nationalities representing this art. In England there is a larger number, most of whom are very radical and lean partly towards Constructivism. The most radical ones, however, are in Italy, where there are perhaps 20 such artists. They're sprouting up like mushrooms after abundant rainfall. [...] Our Albers creates quite interesting abstr. paintings and engravings in America. The Surrealists are energetically rejecting [*abstract*] art and make an exception only for Arp and for me. In my opinion, everyone has the right to clothe his own thoughts=feelings in the attire that fits best. And there exists only one criterion for judgment—the enigmatic "quality."

Feb. 2, 1936, Neuilly, to ALEXEI JAWLENSKY (Rus.):
Thank you very much for your gift. [...] I <u>really liked</u> your small painting, and Nina Nikolaevna loved it no less. Very good, deep, and

1936

authentic tones. The overall impression: depth and freshness. You once wrote that your bodily suffering does not interfere with your mental vitality and freshness. One can only marvel at how, despite your terrible pain, you have retained both qualities, of which this painting is the best proof. — Of course I will offer you one of my paintings in return, but how? All my works are too large. Let's wait for an opportunity for someone we know to go to Germany. Do you know that your "Tver" has already disappeared from the map of Russia? And been renamed "Kalinin"? Lord, may they at least leave Moscow alone. P.S. An edition of Gogol with Kardovsky's illustrations has been published. — No news from Bekhteev.

Feb. 18, 1936, Neuilly, to OTTO NEBEL (Ger.):
We haven't heard from you for ages. How are you? Everything alright? Healthy? Working well? The last few months we have had such bad news from Bern that a long silence from friends is frightening. Poor Klee and no less poor Mrs. Klee, who fortunately are finally improving. [...]
Next Sunday we hope not to miss Anna Pavlova's film. The film is said to be excellent, and since both of us, unfortunately, have never seen Pavlova dance, we're glad at least to get to see her that way (slow motion included!). — We have been out quite a bit lately — by our standards. Invitations, a wonderful concert by Joseph Szigeti, house concerts, exhibitions [...] one where there were first-class works by Henri Rousseau. [...] Almost all modern Parisians rush manically, which is justified by the "time dictator" Picasso. And he himself rushes as if trying to beat records. [...]
The Parisian Surrealist poets are no longer communists because communism in Russia has become too "bourgeois" for them. They founded a circle named "Contr'attaque." This means they are even more "leftist." — I'm glad that immediately after moving here I retired to "an island," from which they initially wanted to lure me out into the "roaring sea." I'm actually not a passionate hermit and like

looking at this roaring sea, even if the sight is awful and makes me ill. But the studio is a good remedy for this seasickness.

Feb. 27, 1936, Neuilly, to ISRAEL BER NEUMANN (Ger.):
It would be dangerous to make a writer out of me or to dress me up like a writer. What did Goethe say? "Poet, don't write!" At the time the most dangerous thing for the artist was to write something, in which case he would have been suspected of being able to think. I used to tell my students how scared the earlier artist was of thinking. He sat and waited for his Muse to show up. He sat habitually for hours in the bar. Then the Muse would appear and ask, "pale, medium, or dark beer?" and he would pinch her.

Mar. 21, 1936, Neuilly, to ISRAEL BER NEUMANN (Ger.):
I have good news from G. Scheyer about the success of my exhibition in Los Angeles. [...] I've been working a lot and have painted some large pictures that are not too bad. Of course, these days, large formats are almost exclusively a "self-indulgence" [*Ger.* "platonischer" Genuss].

It's incredible that no effort is spared to help the academics who had to leave Germany. They get a warm welcome everywhere, while we artists, who also suffered, are left out in the cold. People are even trying to take advantage of the situation by making ridiculously low offers and then complaining we are stubborn. This, no more and no less, supports the Nazi policy regarding art.

[*In addition to being shown in Los Angeles and at Neumann's gallery, Kandinsky's works were also featured in Alfred Barr's iconic exhibition* Cubism and Abstract Art *at the Museum of Modern Art in New York as well as in the show* Abstract and Concrete, *which traveled around Britain. The dealer Jeanne Bucher, who became a good friend of Kandinsky, showed his work in her gallery in Paris. Kandinsky befriended Anton Pevsner and César Domela.*]

Mar. 23, 1936, Neuilly, to GALKA SCHEYER (Ger.):
"The function of art is not to present facts but to create emotion"— excellent! When will it be fully understood? Of course, these "emotions"

1936

shouldn't stay on the surface, but rather lead into an <u>organized depth</u>. [...] I call people who don't think only of their own interests and who are capable of loving something other than themselves "abnormalities." Today's "normal" person is more than terrible, and to call those rare exceptions "eccentrics" is just not sufficient. No, "abnormality" is more correct. With my slightly tattered but still incorrigible "optimism" I know the future belongs to the "abnormalities." We won't see it, but it will happen. Definitely. [...]

My old friend, Thomas de Hartmann, asked me to ask you to please inquire at "United Artists" whether anyone there can find out anything about Sergei Bertensson.

Apr. 13, 1936, Neuilly, to WERNER DREWES (Ger.):
[*Regarding an exhibition of Picasso's most recent works:*] Almost all of them were extremely enthusiastic and stood in front of the paintings like a true Catholic stands before a crucifix. [...] As far as I'm concerned, I admire the unbridled power, the spontaneity, and the often rare, beautiful color combinations. What I find unpleasant are the purely Expressionistic forms, the rediscovered Expressionism, which today can only lead to an illusory life.

Apr. 21, 1936, Neuilly, to HILLA REBAY (Ger.):
I just see from my house catalogue that from the period 1916–20 I have only the one painting, *In Grey*. That was the time of the war and the first years of the revolution, which I spent in Moscow. I would not want to experience such years again. [...] Aside [*from*] "moral" shocks, I also experienced considerable financial shocks. Just before the revolution I was able to provide for myself financially, for the rest of my life. I was not rich, but had money enough to work without worrying, without having to think of earning money. This condition lasted only a few months. Later on, I even had to teach for 14 years; something which I did not dislike doing, but which was very disadvantageous to my own work. You know as an artist, that for us only

196

that is advantageous which allows us to think only of painting, think with head, soul and all other senses. However, I am happy that all these difficult conditions in the end did not keep me from making very important paintings. Self-praise! [...]

To my great pleasure the catalogue of the S.R. Guggenheim collection has finally arrived [...] my compliments! The reproductions are very well spread and well executed. [...] Do you know that the printer [...] in one instance did not know, what was top and what was bottom? Happy to say, only in one single case—that is the reproduction of *For and Against*, catalogue number 90. Did you notice it afterwards?

May 4, 1936, Neuilly, to ISRAEL BER NEUMANN (Ger.):
Here I am deliberately not counted among the "abstract" artists, because people don't like that word. I don't give a damn about terms, so I was happy to take part in an exhibition with young abstract artists. [*Exhibitions in California and in New York also marked Kandinsky's seventieth birthday.*]

May 10, 1936, Neuilly, to ISRAEL BER NEUMANN (Ger.):
[*Thanking him for Alfred Barr's book,* Cubism and Abstract Art *(New York: Museum of Modern Art, 1936):*] The book has worthwhile aspects. Including one that rarely exists. The typical art historian (not without reason was the word pronounced "art hysterian" in Germany) usually suffers from an inflated ego, feeling himself bound to "criticize," to allocate "value," to praise [...] like a teacher would small children. Barr has avoided it and has actually written his book as a historian. Of course, he suffers somewhat from the Parisian disease of tracing everything back to Cubism. [...] I have to explain here to patriotic art connoisseurs that abstr. art, in the way I create it and founded it, has nothing to do with Cubism. [...]

Barr also derives Suprematism from Cubism, which may be true, but that is not all. When the founder of Suprematism [*Kasimir Malevich*] heard about my book *Concerning the Spiritual in Art*, he had someone

1936

translate the whole book for him because he didn't know German. At that time he was painting Expressionistic Russian peasants and maybe Cubist ones as well. After the translation, however, he immediately discovered his Suprematism. [*What Kandinsky could not know, since he never saw the* Works of the All-Russian Artists' Congress *(published in 1914), was that Malevich was in contact with one of the editors and very likely saw Kandinsky's chart printed as a full-page color illustration (fig. 10), bearing a striking resemblance to a Suprematist work: a triangle, a circle, and a square on a background that was white on one side, black on the other. Malevich showed his first Suprematist works in late 1915. See Jelena Hahl-Fontaine, "Die vielfältigen Varianten der Schrift 'Über das Geistige in der Kunst'," in W. Kandinsky,* Über das Geistige in der Kunst *(Bern: Benteli, 2004).*]

May 14, 1936, Neuilly, to ISRAEL BER NEUMANN (Ger.):
I once gave a lecture in Plauen. A distinguished gentleman approached me and suddenly thanked me for his ... millions: "I'm the first lace-manufacturer to use abstract patterns. At first my colleagues laughed, but now they admire me, because I've made millions from abstract laces. And do you know what gave me the idea? It was your paintings. For that I thank you." I said: "You're welcome. But where's my commission?" He laughed like an Olympic god.

May 14, 1936, Neuilly, to ALEXEI JAWLENSKY (Rus.):
Well, hackney-drivers and artists don't have it easy. The first are being squeezed out by taxis. And we by everything that serves Mammon instead of the spirit. People are convinced that art is a luxury, but jewels, furs, cars, 500-franc lunches, even private planes are "life essentials." [...]
Our Galka works hard. Sales are almost impossible everywhere. Here one is astonished at any sale. Only the "kitsch" artists are better off. No matter how skilled the art dealers are, even they cry. It has been a tiny bit easier lately, but here too "threatening political clouds" appear and ... panic.

KANDINSKY, "Franz Marc," *Cahiers d'Art* 8–10 (1936): 273 (Fr.):
People ask with a concerned expression whether Marc's art has

198

Germanic roots, meaning a "German soul," and if his paintings are truly German. I really think so, because Marc loved his country. In my opinion it would be essential to see behind the "national soul" to its universal human origins. [*Kandinsky's article was censored in Germany.*]

May 29, 1936, Neuilly, to GALKA SCHEYER (Ger.):
I have always been interested in "opposites," which I later used in a less literary way, until I arrived at purely "painterly" contrasts. I said to my Bauhaus students that "there is only one eternal law in art—the law of contrasts." [*Kandinsky complains about Feininger, who quit the Blue Four without notice, and then mentions Hans Arp, who helps colleagues without envy.*] Arp would not be an awkward "replacement." I would be very happy if you could give him a little help in California. [...] Arp's poem about my last exhibition appears in my monograph [*the Spanish monograph that Eduardo Westerdahl, editor of the Tenerife review* Gaceta de arte, *was publishing (see letter of Nov. 17, 1934) and that was to include:*] a poem by Arp, dedicated to my last exhibition, and probably 2 of my own poems. Are you familiar with my *Klänge* (Sounds)? They sold out immediately, and my 2 copies disappeared from my possession after the war. I haven't seen the book for years and had pretty much forgotten about it. But Arp owns a copy that he values so much that he doesn't lend it to anyone. [...] Arp would like to translate several more of my poems into French. I value his judgment because he writes beautiful things himself. [...]

[*Referring to the "influences" that Alfred Barr identified in his book,* Cubism and Abstract Art, *1936:*] Barr suffers from discovering influences that at times look rather comical. E.g., the combination of my landscape *Two Poplars* with a work by Gauguin! Or my old watercolor with Malevich, not bad either. What topped it all, however, was the claim that my Parisian painting was influenced by Arp and Miró. Barr might just as well have said Corot instead of Arp and Velásquez instead of Miró. One learns something everywhere—even from weaker talents (although one should not!). Miró told me once he would be eternally grateful to me for having "liberated" him. I often hear such things from

1936

younger artists who have no reason to flatter me. Anyway, "influences" on form are not important, but art historians are rarely aware of this. They often call such external connections "schools." In my opinion, school is the spiritual stimulation of the next generation. The passing on of form is epigonism. <u>I am grateful to Barr</u>, however, because he didn't trace my painting back to Cubism, as is often the case in Paris, but directly from Cézanne, which is also what I think. — My initial shock came from Monet's *Haystack* when I was still in Moscow. At the time I vaguely, "unconsciously" understood that the object was absent in it. With Cézanne I understood that the painter must paint. [...]

June 4, 1936, Neuilly, to GALKA SCHEYER (Ger.):
A general strike is due to begin in the next few days. Heaven knows where it will lead. We are thinking of Russia and Germany 14–15 years ago: the bathtub is filled, buckets and jugs are full of water, one buys candles, etc. etc.

June 9, 1936, Neuilly, to ISRAEL BER NEUMANN (Ger.):
Seeing a dictatorship arise for the third time holds little appeal for me. So I am mentally preparing to grab my pilgrim's staff once more. God, if it were only a staff! But furniture? And especially paintings? And above all, money, which is necessary to move and to settle down in a new country?

June 22, 1936, Neuilly, to ALFRED BARR (Ger.):
I was very interested in your book, *Cubism and Abstract Art*, and it is a pleasure for me to tell you that I am delighted with its publication. The plan of the book and the method of depicting developments are purely scholarly, something which to my knowledge has been completely lacking in modern art literature up until now. The table on the cover [*Barr's now famous diagram*] is very clear and brings a clarity to the question of development that until now has largely been missing.

It would be impossible to ask you to know the situation in different countries without assistance. And so it's perfectly clear that some-

times you had to rely on other experts. On the other hand, it is also natural that some inaccuracies appeared in the book as a result. Allow me to mention just a few that relate directly to me. [...]

I didn't paint the first abstract pictures in free forms in 1914, but in 1911: *Improvisation 23* [...] and a large picture now in Moscow that was not given a title. [...] The next abstract picture (i.e., without "abstracted" objects) I painted in 1912—*Black Spot*. [...] I've never worked "programmatically," and I've never forced myself to use a formal language that didn't originate directly in me and develop slowly. Therefore, at the same time that I painted the first abstr. work, I was also making ones that included "abstracted" forms, and even landscapes. [...] I never said to myself "An abstract painter <u>may not</u> paint nature." [...] In my first book (*Concerning the Spiritual in Art*) I wrote "there is no MUST in art" and <u>everything</u> that stems from inner necessity is allowed. I hold this view to this day. [...]

May I tell you your expression "under the influence" can be a bit dangerous. What is "influencing"? Of course, like any human being (perhaps even more so), the artist is influenced by all the impressions he experiences. Nothing can be said against such influences. On the contrary: they must only be welcomed as they enrich one's inner life. But unfortunately, too often the word "influence" is understood as an <u>external</u> adoption of another artist's form. [...] If you believe (and perhaps rightly so) that the geometric forms of the Suprematists have influenced me, then I have to say this influence took a long time to come to fruition. The square! I saw Malevich's square, also reproduced in your book, in 1918. I only painted my *Square-Poetry* 10 years after that. Likewise, my small *Circle A* and *Circle B* were only painted in 1928.

July 1, 1936, Neuilly, to ARNOLD SCHOENBERG (Ger.):
I was happy to get a few lines from you through Mr. Danz. He also gave me his book *Zarathustra*, where I kept coming across your name. I repeatedly asked Mrs. Scheyer about you and your well-being, and

1936

I know you are finally in a brilliant position, which I am heartily pleased about. Mr. Danz confirmed the information and said you were now a (or rather "the") music supremo in California. Wonderful! I hope you are happy with this calling, and that your dear wife is too.

Both of us—you and I—have led a really "busy" life for many years—one just flew around and often out. We actually have the right now to a little peace. [...] We live almost in seclusion here, that is, I try specifically to keep myself as far away as possible from "art politics," also from too close a contact with colleagues. Art politics, however, is like a mosquito, in that it is petty, if not exactly small, and has a dreadful ability to slip through the smallest of keyholes. [...] Both types of color—physical and spiritual—are very stimulating here. By spiritual I don't mean the local painting directly, but rather the spiritual atmosphere of Paris—God knows where it comes from and of what it consists. Undefinable. The confusion and contrasts here suit the "Slavic soul." Indeed in no other country could one hear an explanation from a policeman like I have heard from a French "constable"; "Monsieur, it's idiotic, but that's nevertheless the way it is." [...] Do you still remember, dear Mr. Schoenberg, how we met—on Lake Starnberg—I arrived by steamboat in short leather trousers [...] you were dressed in all white. [...] And later the summer in Murnau? All of our contemporaries sigh deeply at memories of this lost time. [...] How wonderfully life vibrated then, what quick spiritual triumphs we expected. Even today I expect them, with the utmost certainty. I only know there is still a long, long time to go.

July 16, 1936, Neuilly, to ALFRED BARR (Ger.):
[...] The importance and meaning of your work compel me to tell you what I think is missing from the "catalog."

During the Russian Revolution, a special value was placed on "invention" in art. That importance is definitely there. But what is an invention in art? Allow me to take myself as an example. When I was

1936

painting landscapes and figurative compositions back in the old days, painting without a subject lured me at the same time. It lured me and I knew such painting was possible. So it was, if you will, a "discovery." Much later, in *Concerning the Spiritual in Art*, I gave hints on geometric shapes and at the same time I practiced with triangles, circles, and squares myself. I conceived of these exercises as a kind of "laboratory work." Did they have value? Definitely, but not artistically, since artistic value only arises when an idea actually creates a work of art. Only in 1921 did I manage to use the circle as a real element of art, and only in 1926 did I experience the circle in such strong artistic terms and master it that I was able to create a few works exclusively of circles. […] I mean, in art it's not enough to know, to conceive, to "discover" something, you also have to be able to make it. Make! That's the only proper word. Here comes the greatest difficulty, since this "making" is linked to the almost insoluble question of quality. To a certain extent one can prove why the work really is a WORK, but this is not sufficient for a purely scientific answer. That's why painting, for example, is an art. A painting can be made according to all known rules, everything will seem "okay" and … the work will have no life. This LIFE enters the work in an indefinable way, imperceptible to the artist himself. A tap, a small stroke, a tiny change somewhere—and the image starts to pulsate—it's alive. When? Why? Nobody knows. And probably no one will ever know.

However, you can also get all sorts of important ideas in science or in technology that you could also call "discoveries." But again, they come to life when dressed in the proper form. Not sooner. How many people (including greats like Da Vinci) have had "ideas to fly," but one work in this case was the first airplane actually to fly. "Achievement"— just as in art. It's just that in art it's (unfortunately or fortunately) harder to notice and so determine at what moment the achievement is created. […]

When I moved to Paris, I was so shaken by the local light and nature I didn't want to look at anyone else's pictures and couldn't paint

1936

for almost two months. I first had to "digest" my impressions. [...] Paris with its wonderful (strong-soft) light loosened up my "palette"— other colors came up, other forms that were completely new, or some that I had used years earlier. Of course, all this was unconscious. There was also a different "brushwork," often a new technique altogether.

[...] Since I have done a number of different things in the last year, it would be very significant for me to be able to present these new works to you. Consider that in your catalog you bring an end to all my painting in the year 1921! i.e., with a picture I painted 15 years ago [...] you might think I haven't done anything important in these 15 years. Then please tell me frankly. I have experienced a lot of "rejections" in my life and have acquired quite a thick skin. [...] I appreciate clarity above everything. In my little "feature" on page 212 you call me a "painter and theorist." You also name other achievements for some other artists. I would like to draw your attention to the fact that I have created quite a large corpus of graphic work, that I have also made murals, written poetry, and worked for the theater as well. [...]

If I have written all this to you frankly and in such detail, it means I am aware of your reputation. I know you as an objective, impartial theorist who is also free from "art politics," as you have already proven in a letter to me. It is not usually my habit to write such letters. Warm regards to you and your wife, also from my wife.

P.S. I have written all my concerns down in such detail so if you do find time to visit me, I no longer need to speak about them verbally.

July 23, 1936, Neuilly, to ISRAEL BER NEUMANN (Ger.): The Surrealists are the panopticon mirror in which all the pathological phenomena of our beautiful times are beautifully reflected, i.e., in maximum form. But so-called abstract art is a reflection of the healthy roots of the future. The proportion of the healthy to the sick is 1:100. And in spite of all this I know the future belongs to the healthy. In any case, it's wonderful there are people so interested in art, like you, Galka Scheyer, Nierendorf, and a few others, but not many.

July 26, 1936, Neuilly, to ALEXEI JAWLENSKY (Rus.):
Only "dead old masters" are selling here now. These are the words of art dealers. [...]

Also we've got fresh competition from the Surrealists. They are chic, cheap, and have snob appeal. Their big exhibition in London more than recovered its costs. Now the Museum of Modern Art in New York is planning an even bigger exhibition of Surrealist art. In America, where "sex appeal" counts for a lot, they will probably find even greater success. Long live Freud and his followers! Dadaism in the West and "Donkey's Tail" in Moscow caused no less of a stir, but that was 20 years ago.

Aug. 8, 1936, Neuilly, to ALEXANDRE KOJÈVE (Rus.):
Thank you very much for your manuscript [*Les peintures concrètes de Kandinsky*] and your postcard from Brussels. I had only a little time to glance through your text, but it has impressed me deeply.

In 5 or 6 days we travel to Italy, mainly to Forte dei Marmi, not far from Pisa. — I'm enclosing a list of colors, only oil colors. If it is too complicated to transport, buy only the ones with a +. [...] I have a little money deposited with a German friend. Tell me the price and how long you are going to stay in Germany, so he can transfer the money to you.

Sept. 28, 1936, Neuilly, to GALKA SCHEYER (Ger.):
We have been in Forte dei Marmi. Our last impression was of Florence. One becomes envious because such things could only be created in times of the greatest spirituality. Maybe the architecture shook me even more than the painting and sculpture. And this perhaps because today people don't paint badly here and there, but the building is of inferior quality. I don't think architects back then were as passionate about "functionality" as they are today. But there was one feature that was less about the body and more about the mind. Therefore these structures look as if they fell from heaven to earth ready-made and placed themselves exactly where they were needed, where the "Earth"

1936

had been waiting for them. These buildings are "natural." Perhaps the two baptistries especially—in Pisa and in Florence. The country makes a happy impression today, the people are joyful and friendly. A completely natural, untrained friendliness.

Oct. 9, 1936, Neuilly, to OLGA and THOMAS DE HARTMANN (Rus.): I have written to [*Leopold*] Stokovski [*in Philadelphia*] and announced that Tomik would send him some of his works, and of course I added a "characterization."

Oct. 13, 1936, Neuilly, to OTTO NEBEL (Ger.): Needless to say, I would like to help you in Paris. But Paris! And the Parisian art dealers! […] They don't like to take "foreign" artists […] or, to put it more correctly, they constantly try to fight these "foreigners," keeping all doors firmly closed to them. Competition. […] What <u>we</u> call art cannot be sold here, or only occasionally abroad (in America mostly). […]
A gigantic construction is to be carried out in Moscow. The plans have already been approved. Wide at the bottom, ever narrower going up, high-high-high, on the top a Lenin will stand with an outstretched arm. And the height of this Lenin must reach 300 or 3,000 m. Or maybe 3,000 km. — This is how monumental buildings are made. There is a Russian word: "spit over," […] so the Soviets are trying and trying to spit over America. *Vive la république* and *la bêtise humaine*!
P.S. My wife reminded me that Baroness Rebay had already asked me about you a year ago. […] You certainly know that the Baroness is on very good terms with Guggenheim and helps to develop his collection.

Oct. 16, 1936, Neuilly, to HILLA REBAY (Ger.): I received very interesting news from Germany, which, as it appears to me, are in certain connection with you. […] Now I was also told […] the Folkwang Museum (Essen) had sold a pre-war painting (*Improvisation*

No. 8) to a Berlin art dealer, who had purchased the painting for a collector. Maybe I am all wrong if here too I think of the Guggenheim collection. At any rate, it would be hard to believe that the collector is a German. [...]

In connection with the depreciations (of the French and Swiss Franc) I had some losses, but poor [*Otto*] Nebel much more, something that took an almost catastrophical turn with him. Therefore, also from this angle, purchases from him would appear advisable. I am saying this to you personally. Don't you share my opinion?

Oct. 19, 1936, Neuilly, to OTTO NEBEL (Ger.):
Your news of the 16th interested me a great deal and made me happy. I am especially pleased about Bauer's inquiries. [...] I'm keeping my fingers crossed. [...] I told [*Hilla Rebay*] that a "broader historical underpinning" of the collection was of great importance and emphasized the need to incorporate your paintings. [...] She is a real woman, trying to place R.B. [*Rudolf Bauer, her lover*] at the center of the Guggenheim collection and treating other artists as stars who fade when the sun rises. Forever feminine! [*Kandinsky's intervention was successful, and more and more of Nebel's works were purchased.*]

Oct. 27, 1936, to BEN NICHOLSON (Fr.):
I understand you very well and you are totally right—you and your colleagues, Mr. [*Naum*] Gabo and Mr. [*Leslie*] Martin. It's a shame you didn't tell me at the beginning that you especially needed *Development in Brown*! I don't have a copy of it, but I am ordering one now and my photographer will send it to you shortly. If you don't need my other photos, I ask you to please return them to me—I would be grateful to you. I am asked often enough for photos and my "depot" is quite modest. When you do think you will publish the first issue of your review? [*The "review" was only published in a single edition: J. L. Martin, B. Nicholson, N. Gabo, eds,* Circle. An International Survey of Constructivist Art *(London: Faber and Faber, 1937).*] I am very interested in this retrospective

1936

article "The Constructive Idea in Art" [*by Gabo*]. But I hope the author will not connect my art to Cubism … I say this because in Paris they have the habit (inexplicably at times) of tracing <u>everything</u> back to Cubism—even the stars (those on earth and those in the sky). It's a bit the same as the new German habit of attributing everything precious and important to the Germanic race—even Chinese culture.

KANDINSKY, reply to *Gaceta de Arte*, Tenerife, 1936:
So-called "abstract" art is subject to the same laws [*as nature*]. If this tie does not exist in the work of art, it means it is not a work of art. [*In answer to the question of whether the artist can evade the influence of politics:*] It is possible to say, "From tomorrow on I will do political, social, Marxist, or Fascist art," but it is impossible to do it intentionally. When, at the beginning of the "Great War," one of my colleagues in Moscow said: "Good! Now let's paint the national feeling," I asked, "And after the war?" National anthems are now sung in almost all countries, but I am content not to be a singer. And I remain so even today.

Nov. 28, 1936, Neuilly, to ALEXANDRE BENOIS, Paris (Rus.):
Enclosed is an invitation to my small exhibition, I hope you will decide to visit it. [...] A dark, almost black spot is the fact that the Russian public [*in Paris*] does not know me at all. Partly because my career took place mostly abroad. And partly—God knows why. But you will understand how this point pains me. And this is where I develop "angry feelings" towards you.

Dec. 8, 1936, ALEXANDRE BENOIS to KANDINSKY (Rus.):
Let me be sincere. Yesterday I went to see your show, I studied it carefully, but I became convinced I did not understand anything! [...] I must be missing the right organ. On the other hand, I am willing to admit that theoretically such art may exist. In fact, it seems even possible yours is the true art, just as we know certain types of music to be: "pure music." But it has not been given to me to understand

1936

and enjoy such art. And if art does not give me any pleasure, I simply neither understand nor accept it.

[*Kandinsky was totally ignored by the large group of Russian émigrés in Paris. Benois did not help, and, in an article in the Russian émigré newspaper in Paris, he explained:* "I need comprehensible images for my rational self, but I do not find them in Kandinsky's work. [...] I am even ready to accept that those creations may have a great future; I would not be surprised, but for me this would be <u>deadly</u>."]

Dec. 9, 1936, Neuilly, to ALEXANDRE BENOIS (Rus.):
Thank you for your very open and sincere letter, which shows a genuine love for art. Despite my disappointment, I enjoyed your letter. While we belong to different "camps," I think we share a genuine respect for art, although we may even fundamentally disagree. [...] Cordial greetings.

Dec. 3, 1936, Neuilly, to WILL GROHMANN (Ger.):
Tomorrow both of us will have a "0" at the end of our age, won't we? My "0" isn't particularly pleasing as an accompaniment to the "7," even though I cannot in fact bring myself to believe the mathematical proof: 1936 – 1866 = 70. Will you turn 50 tomorrow? ... How often have we spent Dec. 4 together, and what happy occasions they were. [...]
You think European, I think Russian, i.e., your thinking is logical. We also think logically, but at the same time in images.

Dec. 14, 1936, to HANS THIEMANN (Ger.):
[*Regarding an article written by Thiemann for Kandinsky's seventieth birthday, published in* Berner Bund*, Switzerland:*] My wife also sends you her warmest thanks for this article. It is among the best I have ever received— again the "warmth," aside from the "factual" aspect.
Do you remember what I had said once in my Bauhaus teaching? I said at the time the wave of nationalism would continue to rise in all countries, that this rise was due to a necessity—and not just of an economic and political nature. Today it is like a large orchestra before the concert begins: each individual instrument is "tuned," taking care of

209

1937

itself without considering others. Result: cacophony. Hopefully there will be harmony afterwards, like in a concert, where everyone plays in his own "way," but subordinates himself to the whole. Optimism! Part of pessimism, however, is that this "tuning" will take a long, long time. [...]

At present we have a large Rubens show here. [...] Great force, heavy "earthly" power, and great boldness—I acknowledge that, but it does not "touch" me. As for the large *Exposition Internationale* in 1937, they are building a new museum for modern art ... specifically for French artists. Closed to foreigners. [...] For years foreigners have had their own museum (Jeu de Paume), where many countries are represented. But how! A true collection of international impotence. But here, too, there are exceptions.

Jan. 10, 1937, Neuilly, to HANNES BECKMANN (Ger.):
We're still fine and I just hope the damn politics don't get in the way. All countries have (excuse me!) their own crap—and the devil delights in human stupidity.

A Munich university professor was right when he said to his listeners: "Gentlemen! Everything in the world is limited except human stupidity." So I get angry sometimes (but rarely) and then go back to the easel. [...] What's nicer than standing in front of the easel when ... the work is going well? One can also see that in you, dear Mr. Beckmann, because in a short time, despite your photographic activities, you have painted so many works. Thank you for the photos, which interested me very much. I'm always happy to see that my former students remain true to art in spite of all the difficulties.

Jan. 16, 1937, Neuilly, to HILLA REBAY (Ger.):
I painted my first non-objective painting already in 1911. ("People's Museum" in Moscow). The Guggenheim Collection has non-objective paintings from me, painted in 1913—*Light Picture* (No. 68 of your catalogue) and *Black Lines* (No. 69). Then, also from the years 1918, 1922, 1923, 1924, 1925, etc. [...]

1937

You write (and not for the first time) that the spiritual is the important part. I believe that here we understand each other well, as I already wrote a book about this in 1910. I was particularly happy to find *Fuge* of 1914 among the photographs you sent. I considered the painting completely lost.

Jan. 24, 1937, Neuilly, to HANS HILDEBRANDT (Ger.):

[*Regarding Hildebrandt's book* Die Kunst des 19. und 20. Jahrhunderts *(Art of the Nineteenth and Twentieth Centuries), 1924:*] You only briefly mention Repin, for example, and do not name some other truly good "Realists" of Russian painting at all. […] Artists such as Repin and Surikov are held in very high esteem by today's Russ. authorities—not because they were recognized as great artists (in our sense), but because of the "social" point of view these painters took at the time. […] There were no painters with such views and, at the same time, of such high quality in any other country apart from Russia. […] Russia was the first country […] in which real artists were appointed as theater painters, first at private theaters and very soon afterwards at imperial theaters. […] Don't forget the ecclesiastical art (e.g., the cathedral in Kiev)! In the 20th cent. there was a Russian movement comparable to the "Fauves" or the German Expressionists. They called themselves, for some reason, "Futurists." One should not rank them below the Germans, as there were some very strong artists among them. In Moscow there were 2 groups, "Knave of Diamonds" and "Donkey's Tail," which turned all of Moscow upside down. […] Only then did the Constructivists come along, who—with very few exceptions in my opinion—were not painters in the true sense of the word, but programmers, who, like for example Malevich and Lissitzky, rejected painting (as something useless in our times!). Again, in my opinion: one should not violate art with impunity.

[*Kandinsky took part in an exhibition at the Kunsthalle Bern,* Französische Meister der Gegenwart *(French Contemporary Masters), from February to March 1937,*

showing seventy-one paintings and fifteen watercolors. On that occasion he visited Paul Klee and Otto Nebel.]

1937, extract from an interview by KARL NIERENDORF (Ger.):
Art can only be great when it is directly connected to cosmic laws and submits to them. One feels this law unconsciously when one does not approach nature outwardly, but inwardly; one must not only see nature, but be able to <u>experience</u> it. As you can see, it has nothing to do with using the "object." Absolutely nothing. […]

I saw a large exhibition of the Impressionists in Moscow, which was very much opposed in some quarters, because the painters "treated the object in a sloppy way." But my impression was that the <u>painting itself</u> had come to the fore, and wondered if one could not go much further along this path. Since then, I came to see Russian icon painting differently, that is, I now "have eyes" for its abstract aspect.

Mar. 22, 1937, Neuilly, to OTTO NEBEL (Ger.):
I think our common work (you as author, I as translator) has been a waste of time and effort: so far nothing has been published in the Russian newspaper [*the Russian émigré newspaper in Paris refused to print Nebel's report about Kandinsky's exhibition in Bern*]. Political surprises will never end. […] Could your article be published in the *Basel Nationalzeitung*? Maybe just with your initials, if you can't give your full name.

We ate the little food basket that you and your dear wife gave us for our trip with pleasure, always thinking of you both, and only 2–3 days ago put an end to it—the contents of the basket—not our thoughts about you. We were so spoiled by you both and Mrs. Klee.

Mar. 24, 1937, Neuilly, to ALEXEI JAWLENSKY (Rus.):
I have an exhibition in Bern right now, where my watercolors are also on display. After the end of the show, on Mar. 29, the "Kunsthalle" will, at my request, send you one of the watercolors. So you will get it in early April. Finally! We were recently in Switzerland ourselves

and spent 10 wonderful days in the snow-covered mountains (in some places the snow was 4 meters high), with correspondingly divine air and all the splendor of the mountains. [...]

We're old-fashioned fogeys, still seeking purity of expression. I often speak about you and mention that you work relentlessly, despite a serious illness. People hardly know your recent works, but without exception everyone knows your "prewar" paintings and are very enthusiastic. — We were very happy to see both Klees again, after almost 5 years.

Apr. 1, 1937, Neuilly, to MAX HUGGLER (Ger.):
[*Regarding Paul Klee:*] In Weimar and Dessau we were quite used to showing each other our works, and often. And now it's been an interruption of almost 4 years. I don't like to show my paintings to many colleagues. [...] But Klee is a great and rare exception, and besides, I value his judgment a lot.

Apr. 9, 1937, ALEXEI JAWLENSKY to KANDINSKY (Rus.):
Oh, what pleasure to have received your watercolor (tempera). [...] How beautiful, how interestingly composed, and what a treatment of color, what a masterful technique and overall tact. A wonderful picture. Thank you, thank you, for giving me such a valuable work.

Apr. 21, 1937, Neuilly, to ANDRÉ DEZARROIS [*director of the Musée du Jeu de Paume*] (Fr.):
It is not only sad but at the same time unjust that "non-figurative" and "Surrealist" artists will have no chance at all to take part in the *Exposition Internationale*, which will bring an enormous number of visitors from every country in the world to Paris. "Non-figurative" art has already been around for more than 25 years [...] and Paris—this world center of art—does not find the means to give it a place during the *Exposition*. The "Surrealist" movement is much younger, but is nevertheless quite well known in different countries and possesses a consider-

1937

able literature. [...] Without these two movements, the *Exposition Internationale* cannot give a complete presentation of the artistic movements in Paris. [...] Let me hope you will still find a way of correcting this current imbalance and of completing the exhibition by the Ville de Paris [Maîtres de l'art indépendant *at the Petit Palais*] with an exhibition at the "Jeu de Paume" dedicated to foreign art. [*Kandinsky's appeal was successful, and in July the* Origines et développement de l'art international indépendant, *which included Surrealist and abstract artists, opened at the Jeu de Paume.*]

May 8, 1937, Neuilly, to OTTO NEBEL (Ger.):
I'm expecting a change that will for once liberate humanity from today's atrocities. [...] Did you hear Miss Dreier bought 2 of your linocuts in the Galerie Bucher? [...] Don't you want to write to the skyscraper [*Solomon R. Guggenheim*] about your impressions of Paris, in the sense that you noticed a systematic fight against (or an intentional setting aside) of abstract art, which should result in a kind of countermovement. For example, the founding of an art journal, directed by a competent, honest, and able person? The name Tériade need not be mentioned—it would be self-explanatory. I, too, have spelled out similar ideas, to the two fairies [*Hilla Rebay and Rudolf Bauer*], but repetition is the mother of learning. You are right, it's easier to speak with the "Cloud" [*Bauer*] than with the "Sea" [*Rebay*]. It could perhaps come to something, if the "Cloud" grasps the situation. [*On June 3, 1937, Otto Nebel thanked him for his* "rescue! I gave 6 paintings to the Baroness (Rebay), she confirmed 5. The secretary paid me for 4 (but it was more than for 6: 500 Swiss francs!) So one work is a commission for Bauer and one for the Baroness (and Guggenheim always pays more anyway ...)." *The catalog of Guggenheim's show in Philadelphia in February 1937 lists sixty-nine works by Bauer and thirty-four by Kandinsky. The title page shows Bauer's portrait.*]

May 10, 1937, Neuilly, to ANDRÉ DEZARROIS (Fr.):
I have been thinking again about your plan for an exhibition of the history of modern art and, as before, I think it is wonderful.

1937

This exhibition [*Origines et développement de l'art international indépendant*] could finally show in a clear and convincing way the organic, natural, and necessary development of modern art from its roots— Cézanne, and bring order to the mixups and misunderstandings that can be observed in all countries on this subject. It's true the question is complicated and the terminology lacks precision. But after a first look at your plan, I have the impression you have succeeded in avoiding the dangers ...

The only point that leaves me in doubt as to its accuracy is the difference between the two "movements," both of which stem from Cézanne, but which later developed independently of each other. They are: Cubism and "abstract" art (which I prefer to call "concrete")—two movements that came into the world almost at the same time—1911. Cubism is rather a "brother" of abstract art, but in no way its "father."

And again: this abstract (or concrete) art shows two different paths, or one could say a kind of "subdivision" with the name "Constructivism." (Examples: the two Russians Malevich and Tatlin.) Constructivists generally see their origin in Cubism, which they have pushed to the exclusion of "feeling" or "intuition," seeking to arrive at art exclusively on the path of "reason" and "calculation" ("mathematics"). [...]

I have the impression I did not see Dada on your list, Dada which is undoubtedly the starting point of "Surrealism." Dada fought— perhaps unwittingly—"logic" by replacing it with the "alogical," a fact of great importance in art, since art has never been "logical" and the laws of art very often differ from "mathematics." [...] As far as I can remember, DADA was created during the war. In my view, the most important artists of this movement are Arp and Duchamp (as a theorist, I believe it is Hugo Ball).

A few more details. Arp should now be classed as a "concrete" sculptor. Among the sculptors it will be necessary to include, in my opinion, Antoine Pevsner (a naturalized French citizen) who has been working very seriously and with talent for many years. As an Italian

1937

Futurist will also be required, Prampolini, whom you know for sure ... A serious and gifted artist. Everything I said are important ideas from my point of view, but I would not like to impose myself. [*All of these artists later appeared in the exhibition.*]

May 12, 1937, Neuilly, to André Dezarrois (Fr.):
I beg your pardon for boring you again with this question, but I am also writing to you in the interest of my colleagues who find themselves in the same situation as my own. We do appreciate the French hospitality that allows us to live and work according to our purpose in Paris. But don't you think this hospitality could give us some hope of being able to show our works, which are in any case part of the *École de Paris*, to the French and foreign public during the *Exposition Internationale*?

June 1, 1937, Neuilly, to Christian Zervos (Fr.):
Permit me to present you with two facts that have irritated you and surprised me, and which threaten to destroy an old friendship.

1) You remember, I hope, that Magnelli, González, and I approached you with the request to organize an exhibition of mostly foreign artists who live in Paris and who were not invited to the Petit Palais. I emphasize that most of these artists are foreigners who find themselves in very difficult circumstances due to political reasons. I wasn't present at the first meeting with you, but Magnelli told me afterwards of your "enthusiasm." [...] But after a while, when we heard nothing from you? Magnelli and González turned to you again with the question of whether you still intended to help realize the exhibition. You replied that since the "great artists" of Paris had received the opportunity to exhibit their works at the Petit Palais you were "dropping the exhibition" in which you no longer had any interest. [...]

2) So we turned to Mrs. Bucher and Mrs. Cuttoli, who advised us to ask Mr. Dezarrois whether he wanted to put the rooms of the Jeu de Paume at our disposal for the exhibition. [...] I heard that you were "beside yourself" about this, which surprises me greatly. I would

1937

rather have thought the success of this exhibition might have given you real pleasure, even as an injustice rectified. […] You reproach us for a kind of ill will you find in the list of participating artists, but you forget the list was compiled by you, in collaboration with Magnelli. If the names Braque, Léger, and Picasso have been removed, it is obvious these artists no longer need to be exhibited at the same time as the greater possibilities offered to them at the Petit Palais. You see, I hope, that the situation is perfectly clear and irreproachable.

June 1937, OLGA DE HARTMANN to KANDINSKY (Rus.):
[*She had tried in vain to console Nina for the inimical conduct of the Russian émigré press in Paris:*] For us it is even worse that our friends don't want to listen to Tomik's new music, compared to those people who just don't understand your art. [*Enclosed was a program:* Works of Thomas de Hartmann, sung by Olga de Hartmann. At the Piano: the composer.]

June 5, 1937, Neuilly, to OTTO NEBEL (Ger.):
[*Hilla Rebay had sent Nebel money so that he could live in Italy for a year. As a German, he was only allowed to live in Switzerland for short periods at a time, and as a foreigner was forbidden from selling his paintings.*] For us 4 materialists, however, the fact you have now been taken care of for almost a whole year is the most important part of the story. Congratulations again! —An Italian artist lives here, Alberto Magnelli, with whom I am friends and who comes directly from Florence, so has relatives and acquaintances there. If you would like, I could ask him for recommendations for you. M. is very likeable and personable. — Also: if you are in Italy for a longer period of time (e.g., 1 year?), you could have an exhibition there, specifically in Milan. I could then, if you wish, write to the Galleria del Milione. […]

June 29, 1937, Neuilly, to GALKA SCHEYER (Ger.):
I don't have any official obligations to Neumann and (or) Nierendorf, but I do <u>have moral ones</u>. Both take care of me energetically and

217

1937

warm-heartedly. [...] Both have long wished to organize a large retrosp. exhibition in N.Y., but don't have enough money for it. [...] It would in fact be high time to organize an exhibition in N.Y. like the one that took place in Bern—from 1902 to 1936, the whole development clearly presented.

The sale of one of my paintings (from the pre-war period) by the Essen Folkwang Museum to a Berlin art dealer (who, of course, acted on behalf of a collector) raised quite a storm in Germany and in the German part of Switzerland a few months ago. Newspapers wrote that the price for the work was the highest ever paid for a modern painting since the [*Nazi*] "takeover of power."

[*Ferdinand Möller had bought Kandinsky's large oil painting* Improvisation 28 *for Solomon R. Guggenheim for 9,000 marks (see doc. 1936). As Kandinsky had been struggling to sell his works for fifteen years, such resales, though they arguably saved works condemned as "degenerate," brought him no financial benefit and thus were bittersweet. This very long letter is included in its entirety in* Wünsche, Galka Scheyer and the Blue Four, *2006.*]

July 29, 1937, Neuilly, to OTTO NEBEL (Ger.):
Tomorrow is the opening of the exhibition *Origines et développement de l'art internat. indépendant.* [...] The *"Origines"* and the development are to be understood in a purely Parisian way: from Cézanne to Cubism to today. But definitely via Cubism! I have often tried to make it clear here that there were completely different phenomena in Germany at the same time as Cubism. But I rarely managed to convince the Parisians of this. [...] Our friends (Baron of "Clouds" and Baroness of "Snakes" [*Rudolf Bauer and Hilla Rebay*]) have been very active. Mainly the lady—and how! I have not yet seen either of them, because they are not content with me—I do too little "for our common cause." [...] According to American newspapers, the Baron will be going to America soon to give "a series" of lectures there in order to enlighten the Americans. If the two of them—he and the lady—make a big effort, then it will probably be blindingly bright in American minds [*see doc. 1939*].

1937

Did you hear about the [...] exhibition *Entartete Kunst* (Degenerate Art), in which I also take part—in the best company of my German colleagues? And the exhibition *The Eternal Jew* (also in Munich)? My dear Munich, what has become of you? [...] But things are moving— my paintings as well. Möller had to have all my paintings that were still in his gallery "hurriedly" packed up and picked up by the shipping company. There are supposed to be people particularly interested in art in Berlin who are chasing genuine art. Oh, you unworthy hunters ... As our Russian *Duce* so rightly said: at last a joyful, happy life has been achieved!

July 31, 1937, Neuilly, to André Dezarrois (Fr.):
I told you that the source of my "abstract" form was Cézanne, but that it never had anything to do with Cubism. My form and Cubism can be seen as lines independent of one another, but which received the same first shock from Cézanne and later Fauvism. I was especially struck by Matisse's painting between 1905 and 1906. I still very vividly remember a "decomposed" carafe with the stopper that had been painted quite far from its "normal" place, i.e., in the neck of the carafe. The "natural relationships" had been destroyed in this canvas. [...] At the same time, I found the courage to create my first abstract painting without ever having seen a Cubist work. I saw a photograph of Picasso (*Woman with Guitar by the Piano*) for the first time in 1912, which I reproduced in the book *The Blue Rider*. My large "abstract" canvas with the title *Composition V*, painted in 1911, was reproduced in the same book. [...]

I am happy to be able to tell you that this exhibition, so needed in Paris for years and now realized by you in an excellent manner, deserves the greatest success, which will surely not fail [*to arrive*]. Some more or less important defects could have been avoided, but the result is generally marvelous. This result will have very significant consequences not only in Paris, but everywhere, all the way to Japan.

1937

Aug. 2, 1937, Neuilly, to MARIA MARC (Ger.):
There have been "art sagas" here lately, i.e., hard fights for the exhibition that opened 2 days ago at the "Jeu de Paume" museum. [...] My relations with Zervos also suffered from these ugly things. A proper "cooling" has occurred. So I can't turn to him regarding the article about Franz Marc. Write to him yourself [*address*]. — I'm very happy that Marianne v. Werefkin is doing better. She carries an incredible strength within herself and will perhaps overcome the serious illness. It would be wonderful!

Sept. 11, 1937, Neuilly, to HANS THIEMANN (Ger.):
Take as much time as possible for Paris, as there is a great deal of value to see right now that will remain until the end of Oct. [*the* Exposition Internationale, *to which Thiemann was able to travel thanks to financial support*]. Hofmann knows how to set things up, which is not uncommon in today's generation. I would be happy to see him again.

Sept. 20, 1937, Neuilly, to ALEXEI JAWLENSKY (Rus.):
We haven't written to each other for a long time. Time flies like crazy. [...] We're back from our holiday in Brittany, went swimming and got to know the area. [...] And visitors are arriving again. Of course, I work too, "stupid habit," I say. But without this habit, life would be dull. As difficult as it is for us artists—in every respect—I would still become an artist again if I had the choice.
The *Exposition Internationale* is very interesting overall—lively, amusing. [...] How much I would have liked you to come to Paris. — I happened to hear that [*Dmitry*] Kardovsky is seriously ill and cannot work. [*Igor*] Grabar, however, seems to be flourishing [*former colleagues from Munich*]. Benois lives here and writes for the *Poslednie Novosti* (Latest News) [*Russian émigré newspaper*]. We met a couple of times, he is very nice, but unfortunately he is completely unfamiliar with the new art. We've been with the Chagalls a few times. — In general (between ourselves) we're a bit scared of artists—it's all too

220

spirited where it needn't be. We have a small circle of friends, only half of whom are artists. P.S. Mrs. Epstein is in Switzerland now, the poor thing is sick again. She is such a good, pure person!

Oct. 19, 1937, to GALKA SCHEYER (Ger.):
Hilla Rebay thinks I'm not doing enough for Rudolf Bauer! [...]
The Führer said recently: "Modern artists are either swindlers (money)—then they belong in prison—or convinced fanatics (ideal!)—then they belong in the madhouse"—so we have to choose. You must have read about the Munich exhibition *Entartete Kunst*? Poor dear Munich! Now the success is an unexpected one: the attendance is huge—over 1 million people have been there. It's said to be teeming with art dealers ... [*More than two million visitors attended this infamous exhibition. Fourteen of Kandinsky's works were shown, all of which had been removed from public collections, and some were sold.*] A former student said that interest in new art has never been as <u>serious</u> and lively as it is today—namely in Germany! Yes, this is the so-called "other side." Just as there never were such clever and truly Christian clergymen in Russia as there are today. It's probably not a pessimistic joke that people are educated for the better through suffering.

Nov. 15, 1937, Neuilly, to OTTO NEBEL (Ger.):
[...] Countless visits from strangers ... my former students, real friends for many years, and also those I didn't know before. The Grohmanns were here too, which was a real pleasure for us. [...] At the end of this week Mr. and Mrs. Ralfs are supposed to come from Braunschweig. [...] He has been my collector for many years and had a very nice collection overall. "Had" because he had to sell part of it, and heaven—or rather the devil—knows what will become of the rest. You know that German collectors always live under the sword of Damocles. Nobody knows what will become of the works that are currently on display in Munich as "degenerate art." From what I've heard, 15 of my images are included, all important images [*there were fourteen in total*].

1937

Of course, Klee is also among them and also with many works. It is said that Nolde's entire production is there. He also had the most paintings in German museums. [...]

Did I write to you that I had a "penalty" imposed on me for bad behavior? I didn't take enough care of [*Rudolf*] Bauer here, and was told that nothing would be bought from me for two years—"as a punishment." It's also not nice of me to allow myself to imitate B. too much. [*Bauer, whom other artists and connoisseurs recognized as an epigone of Kandinsky, benefited from the unbridled favor of Rebay, his lover and Guggenheim's right hand.*] A booklet has appeared here called "Nouvelles des Expositions" that is little known [...] where there is a whole page with portraits of Gugg., Baroness, and B. [...] and Bauer is named as the artist who brought the abstract form to full perfection. It is noted with regret that it is so poorly represented in the Musée du Jeu de Paume. This issue amuses people a great deal in Paris, which is no wonder.

An exhibition is being planned in London for next March, to be titled "Degenerate Art"—"without polemical intentions," but to clearly show the healthy power of truly international art. [...] Germany should be at the center of the exhibition, so there are two reasons for your invitation. [...]

And what about your return to Switzerland? Still having trouble?

Dec. 3, 1937, Neuilly, to WILL GROHMANN (Ger.):
[*We heard*] that the beautiful German Pavilion received many awards, which of course pleased us as much as it will please both of you. I once read in the newspaper that 80,000 Germans were among the foreign visitors to the Expo. [*Hitler's favorite architect Albert Speer received a gold medal for his design for the German pavilion at the* Exposition Internationale *in Paris.*]

We have an endless and endlessly beautiful autumn—the purest spring, which naturally includes the flu as an accompaniment. Through my studio window, which you now know, I see an indescribably beautiful light—"gray" harmony with soft, but strong-sounding colored accents. No, the light here is actually fantastically beautiful. — Today

1937

we drive to 3 vernissages where we will see works by Taeuber-Arp, Miró, etc.

Dec. 5, 1937, Neuilly, to JOSEF ALBERS, USA (Ger.):
One of my former students (a clever and talented man) told me that serious interest in modern art in Germany has never been as strong and profound as it is today. And other friends confirm it. Simply: the snobs have fallen away (it's a risk to show interest in such art) and so the atmosphere has become cleaner. The earlier authentic adherents have become even more authentic, so to speak. Surely they are now learning to distinguish between herbs and weeds. [...]

The *Entartete Kunst* exhibition in Munich was a huge success and over 1,000,000 people visited it [*in actuality, twice as many*]. Some foreigners went specifically to see the paintings. Some also wanted to buy works but were rudely dismissed. Mussolini behaves completely differently: about a year ago he congratulated Italian abstract artists on their art. That's good, he said, just keep going!

Dec. 8, 1937, Neuilly, to HANS THIEMANN (Ger.):
Thank you very much for your kind letter, which radiated with genuine warmth. It was a pleasure for me to see you again and hopefully the experience will be repeated soon. — It's been quiet for us since the *Exposition Internationale* is now over. [...]

It's really a pity that Hofmann's trip was thwarted by French resistance. It sometimes seems to me that I dreamed that earlier life, when one only needed money (and not much) for travel—there were no national borders, so to speak. Not even a passport was necessary, and the word visa was totally unknown. [...]

During my "dramatic" period I often worked very quickly, for example in 1913 I painted 30 pictures, including 2 very large *Compositions*. I quite deliberately gave up the feverish haste and, for example, only painted 10 in 1936, all of them larger in format and two of them decently large, i.e., almost 2 meters long. However, not everything

1937

happened so quickly in the past either, for example I worked on *Composition 7* for about a year and a half—many drawings, detailed, painted sketches in larger formats—painted the whole work myself in a few days, but from morning to night. [*He may have created the first watercolor for* Composition 7 *in 1911, but later signed it 1910, leading to decades of discussion: Nina Kandinsky insisted on 1910, although most art historians suggest 1913.*]

It is perhaps interesting that today these two types of work are divided between 2 different types of artists—some work with "swing" and are more "Expressionist," the others work slowly, slowly, with "braking" and are more "Constructivist"—quite frankly, neither type suits me: the first is too "ruffled" for me, the other too "licked." Or: the first is too "poetic" for me (like the former poets with wild curls), the other too "modern" (like today's "fine gentlemen" with firmly plastered hair). Or: the first reminds me of a young dog that has been "walked" and barks at everyone out of sheer joy, the second of a deep-thinking cow that philosophically chews the cud.

Dec. 23, 1937, to GALKA SCHEYER (Ger.):
Over time, all of today's "works" will be sifted through, and … not much will remain in the sieve. Of course (between us) there is something much too "constructive" in the movement, which I explain to myself (again between us) in terms of the constr. shape not requiring very much imagination, and imagination is a rare bird in all fields. But even that can be sifted through. Namely Constructivism. […] Surrealism seems to have come to an end. […] The success of the Surrealists is often achieved through scandalous art. One must have an eye for real art, and the eye must lead into the "depths," what I call the soul, according to the old custom. Eye and even soul into the bargain! Rare case …

Dec. 26, 1937, Neuilly, to WILL GROHMANN (Ger.):
D.[*ezarrois*] told me twice that he would like to buy a larger work from me, but my prices are too high for him. To which I replied twice that

224

I would be particularly accommodating for his museum. Later he said to me on the phone that he would call me to take a closer look at the paintings. Nothing since. That's the Paris pace.

Dec. 30, 1937, Neuilly, to HANNES BECKMANN (Ger.):
I'm always particularly happy when I see how efficiently and importantly our former Bauhauslers are developing and working.

Have you heard that the old BH [*Bauhaus*] became a New BH in Chicago? Brought up very modestly and at the helm is Moholy-Nagy, which is a bit odd. As far as I've heard, there are only 3 other teachers besides him, and none of them from the old BH. Gropius has been appointed a tenured professor at Harvard University, and so has Breuer, I understand. Train to America! A not inconsiderable number of my colleagues are there, i.e., former BH teachers.

Good luck with your article on "degenerate" art! In March there will be a large exhibition of this art in London. Perhaps your article could also be used there? If you are interested, you can contact Ms. Irmgard Burchard in Zurich [*address*]. The lady is a key contributor to this exhibition. I would be very grateful for a copy of your article. [*Burchard, a young Swiss dealer, had recently written to Kandinsky to solicit his participation in the* Twentieth Century German Art Exhibition. *This response to* Entartete Kunst *in Munich was to open in London in July 1938 and would include thirteen of Kandinsky's works (nine paintings and four watercolors). Beckmann's article does not seem to have been published.*]

We're fine. We were only tired after the end of the *Exposition Internationale* because we had a lot of foreign visitors on the occasion of the fair—from different countries. There were also some good old German friends among them.

Jan. 9, 1938, Neuilly, to PAUL KLEE (Ger.):
E. Tériade visited me today, former editor of *Minotaure* and now editor of the new art magazine *Verve*. [...] [*Tériade published a selection of Kandinsky's poems in his new review.*]

1938

Feb. 2, 1938, Neuilly, to GALKA SCHEYER (Ger.):
Now I'm finally getting a one-man show in London. The first! Isn't it laughable? It is taking place in a new gallery that has started very well. A retrospective of 34 paintings and some watercolors will be exhibited. — The reunion with Grohmann was wonderful—great joy after many years and with these unhappy conditions in Germany. [...] The Surrealist exhibition: it's actually "Dada"—with a 20-year delay. But not all Parisians notice this delay. So many people came to the vernissage the police were mobilized. [...]

Paris is actually a Biedermeier women's sewing table—all sorts of stuff in it, but divided into individual compartments. As a genuinely barbaric Russian, I like this variety of contradictions. [...]

I haven't seen the Zola film, it's banned in France. And the poor devil van Gogh, should he also be on the screen? Do you think the audience will learn something from this? It's "an old story" that the public understands great artists with a frightening delay. "Understand"! Good heavens! [...]

I always try to keep you up to date. So I'll add that I'm taking part in a group exhibition in Milan—Parisian abstract artists [*at the Galleria del Milione in March, alongside Arp, Domela, Alberto Magnelli, Kurt Seligmann, Taeuber-Arp, and Paule Vézelay*].

Feb. 11, 1938, Neuilly, to OTTO NEBEL (Ger.):
But I would like to read the "*Hakenkreuzigung.*" [*"Hakenkreuzigung der Kunst," a critique of Nazi cultural policy by Karl Frey under the pseudonym Konrad Falke, appeared in the second issue of the exile review* Mass und Wert. *The title was an amalgam of the German for "Swastika" (*Hakenkreuz*) and "Crucifixion" (*Kreuzigung*), a play on words that Kandinsky continued.*] Maybe one day I can get my hands on it. — Oh well! We can crucify [*Ger.* kreuzigen] art here too, albeit without a "hook" [*Ger.* Haken]. There is an international Surrealist exhibition to see here at the moment. The ceiling of the glass-roofed hall is covered with coal sacks (with coal inside). The floor has been turned into a not very clean meadow (maybe it's

226

1938

supposed to be a dirty building site?)—uneven, with holes and a rather large puddle surrounded by reeds. My wife fell into one of the holes—luckily without hurting her leg. It's almost completely dark in the "hall," and at the entrance the spectator is handed a small flashlight. So you discover that in the 4 corners there are 4 double beds. We were told twice that at the vernissage, among other "entertainments," a stark naked lady jumped out of one of the beds into a puddle and then jumped back into bed. The crowd at the vernissage was so large that 2 large police cars had to come to keep the spectators away from the entrance, as the rooms were so full it led to fainting. Perhaps the "air" also contributed to this, as it was extremely heavily perfumed. "The highest echelons of Paris" came in large numbers in the most beautiful cars. All in evening dress. However, some women were displaying so much cleavage that you couldn't see anything of the dress—just "flesh." [...] Such a Surrealist exhibition would not only have been appropriate 20–25 years ago, but also "organically correct." Its mistake is the delay. [...] But since one is always selfish, I prefer the "delay" inherent in human nature to the "leaps." We now know what becomes of humanity when it suddenly "awakens" and prepares to leap over "a thousand years." Then we, "poor brushes," have to put our brushes aside.

A poem of mine will soon appear (in an American review) [Transition *no. 27, April–May 1938*]: Steigemann and Sinkemann say to each other: "I'll come to you soon." And Steigemann: "You to me?" And Sinkemann: "You to me?" Who? When? To whom?

But I didn't think anything of it: the muse dictated it to me. Now I see I've painted an international "portrait." [...] I don't take my poetry very seriously—more of a distraction from the constant brushwork (which of course I take very seriously!!!). (Please don't take the "!!!" for irony !!!!!). [...]

I know some American art books that are so modern it makes one's stomach hurt. Despite my many years of experience, I still cannot calmly look at how art phenomena are often (too often!) taken and "analyzed" in a purely formalistic way. Fortunately, there are exceptions

1938

that sometimes come to me and put me in a good mood. But there is another danger here: such exceptions are sometimes so poetic that the poor belly suffers again. Yes, people generally don't have a sense of moderation—that's why there are so few artists. [...] The opening of my retrospective exhibition in London is on Feb. 17. It will be my first one-man show in England. It's at a new gallery called "Guggenheim Jeune." Are you amazed? The lady [*Peggy Guggenheim*] is the niece of "our" Guggenheim [*Solomon R. Guggenheim*].

Mar. 14, 1938, Neuilly, to HANS THIEMANN (Ger.):
So one must 1. get used to living on a lonely island, and 2. be happy that there are still a few people living on this island. And all around is an ocean of unconstrained stupidity. [...]

What can I tell you about this exhibition [*the* Exposition Internationale Surréaliste *organized by André Breton and Paul Éluard*]? The basis is alogical, i.e., a rebirth of DADAism. Hans Arp wrote about his memories of the Dadaist manifestations in Switzerland (23 years ago!) in no. 1 of [*the review*] *XX^e Siècle*. Very well written! — The second basis is the connection between "reality and the dream" for the Surrealists. I spoke about it at the time at the BH [*Bauhaus*]. According to my feeling, the dream always diminishes, the reality always intensifies. [...]

André Breton, the leader of the movement, was very knowledge-able about my painting for my English catalog, which I enclose for you. [*Breton's brief catalog text for Kandinsky's exhibition at Guggenheim Jeune in London was translated by Samuel Beckett: "Some Appreciations of the Work of WK."*] In general, the Surr.[*ealists*] reject "abstr." art, making an exception just for me and Arp. Especially A. Breton, who has "stood by me" for years and even bought watercolors from me when he had a bit more money. We have respect for each other and a sincere affection, although we sometimes assail one another.

Thank you for the catalog of *Entartete Kunst*. Very interesting! The tendency towards cripples and monstrosities cannot be denied among the "Expressionists." However, the models were not only "invented"

228

or "seen in this way," but also supplied in abundance by life itself. Decomposition in life has been reflected in art. I'm not into that sort of thing, and every decomposition gives me goosebumps. [*The term "Expressionism" was later also used for the Blue Rider group, although the Munich artists never called themselves "Expressionists."*]

Mar. 16, 1938, Neuilly, to HERBERT READ (Fr.):
It's only now that I received your address, and it gives me great pleasure to thank you for your wonderful article in the review *The Listener*. [...] Your opinion on my painting pleased me tremendously and I am especially grateful to you for the sentence in which you emphasized that I have never made any concessions. Yes, it was very difficult, above all at the beginning of my "abstract" painting, to stay resolute when I was really surrounded by hostility on all sides. And in the last years I have even been obliged to leave two countries, where my art was surrounded by the hostility of governments. Believe me that I have no intention of complaining, but I am only explaining to you why your words about my resolution were so gratifying.

Mar. 26, 1938, Neuilly, to ALEXEI JAWLENSKY (Rus.):
We send you warm congratulations on your birthday and hope your health improves. We haven't heard from you in a long time and we are concerned. [...] Then a message came that you were in the hospital. How sorry we are and wish you a speedy recovery. [...]
The other day we were with Lisa Epstein [*whose portrait Jawlensky painted in 1906*]. She has settled in very well in her apartment and studio and works well; only she is sick so often. Such a good, sensitive, dear person. [...] How sad that we live so far apart, which is particularly noticeable in times of illness. How we would like to visit you! — We've known each other for 40 years now, and we've experienced so much together. Sometimes I think of Giselastraße and the Ažbe school, I see the Munich carnival, the Oktoberfest with sausages. It was a beautiful, carefree time.

1938

Apr. 10, 1938, Neuilly, to OTTO NEBEL (Ger.):
I don't see any particular happiness in your last letter about your return
to Bern. It was with great pleasure that I saw in the Guggenheim
Foundation catalog that many new things had been acquired from
you. Hurrah! — That "Hurrah!!!" comes from Germany because our
upstairs neighbors (Alsatians) listen to the German bellowing on the
radio. [...] Good heavens! [...]

A few days ago Marinetti spoke here at the "École du Louvre" about
"From Futurism to *aeropittura.*" In the autumn a new chair for the
history of foreign art was established at this school. [...] M. spoke so
vividly, expressively, and captivatingly that the entire audience (around
500 intellectuals) listened wonderfully and continually rewarded him
with bursts of applause and enthusiastic exclamations. The next day
he was with us (with his entourage as always) and was very person-
able and easygoing.

My exhibition in London was a great success, according to the reports
there. [...] At the beginning of July a demonstration against "degener-
ate art" is supposed to take place there, i.e., a special exhibition of
German artists that would not be tolerated in the III Reich. I tried to
offer your paintings but to no avail—"too late, too little space."

May 9, 1938, Neuilly, to HERBERT READ (Fr.):
[*Regarding the* Twentieth Century German Art Exhibition *in London, which Read
was helping to organize, and the decision to exclude any mention of "degenerate
art":*] In my opinion, the decisions are truly perfect. This way, artists
living in Germany will be able to decide for themselves. And the exclu-
sion of the "political moment" from the presentation is a wonderful
decision [...] the situation of art in Germany is clear without forced
explanations.

I was really very happy to hear you have replaced the word "Con-
structivists" with "abstractionists."

I received the second edition of your *Art Now* from Faber and Faber,
for which I thank you very much. I easily found the pages where you

speak about my activity in Germany. It was a truly heroic time! They took me for a "fool," sometimes for a "Russian anarchist who thinks anything is allowed," in other words a "very dangerous case for young people and for high culture in general," etc. etc. So, I thought I was the first and only artist who had the "courage" to reject not only the "subject," but even every "object" outside painting. And I really thought that I was completely right—I was the first. Without doubt the question of "who was the first tailor" (as the Germans say) is not extraordinarily important. But "historic fact" should not be altered.

Have you read the new book by Mr. Zervos on *L'Histoire de l'art contemporaine*? In it he pushes the claim that Paris began to make abstract art before me: Picabia in 1909. It's the false Parisian idea to believe that everything important, or even everything new, always comes from Paris. I admire the role of France in the history of painting, but one shouldn't exceed all limits of reason itself because of a "patriotic" point of view.

Mrs. Guggenheim let me know that you think it necessary for me to send a few older canvases, primarily of "Fauve" character. I will do so willingly, and I agree with your intention. And there is still enough time for the shipment, isn't there? The canvases are supposed to arrive in London towards the end of June, I think. My wife and I hope to see you again soon in Paris and send you our best regards.

May 10, 1938, Neuilly, to FERDINAND MÖLLER [*former dealer in Berlin*] (Ger.):
Would you be so kind as to have the crate with my paintings sent to the Basel Kunsthalle, postage unpaid (i.e., also uninsured). It must be noted "for exhibition purposes." [...] You know that it is not really advisable to keep the crate in Germany any longer.

July 29, 1938, Neuilly, to OTTO NEBEL, Switzerland (Ger.):
The rumor in Paris is that recently you sold "wonderfully well" to the Guggenheim Foundation. It's a friendly question, without consequences.

1938

[...] I always disregard at least half the Parisian rumors, and yet there is something positive in this case. Is it true? [...] HvR [*Hilla Rebay*] is in Paris at the moment, I have reliably heard—i.e., not "seen," because I didn't get to see her. She and Mr. G. [*Solomon R. Guggenheim*] shop here. This is how the foundation grows from day to day. The catalog no. 3 is at least twice as thick as no. 1 was. I was glad to see Nebels there too.

But a sad chapter: a rumor that can hardly be doubted: Bauer is in jail. Did you hear about it? If it is as people say, then I really feel sorry for him. "Tight spot"! [*Rudolf Bauer was arrested for "illegal art dealing" and spent a few weeks in jail until Rebay secured his release.*]

The city has become almost empty—"dead Paris," which I am very fond of—favorable for concentration. I've noticed that I work "louder" at such times, but also "more seawardly," i.e., the colors of the Côte d'Azur somehow work their way into my paintings on their own. My wife told me today that the painting I'm working on gives the impression that we've already been to the sea. Unconscious impulses. Much like in the time just before the war when I painted "warlike" in bulk. Admittedly, I "heard" the thunder at the time. Like I "see" the wave now. [...] A few days ago we saw a <u>very</u> nice Klee exhibition. Delightful affair! Musically there were quite excellent things, artistically not so much. [...]

What about the authorities? Are you no longer given any trouble?

Aug. 13, 1938, Neuilly, to GALKA SCHEYER (Ger.):
I was extraordinarily pleased to hear from you that you set out at once to help Jawlensky and were immediately successful. [...]

We thought of your siblings repeatedly as we read over and over again about the "racial" [*Ger.* rassig] measures. Moving to America is no simple thing, and it will not be easy for you to help either. We can only wish you the best of success. Lucky that there are still democratic countries. [...]

I'm slowly trying to write poetry in French too, at present. Unfortunately, I can't "knead" the French language as easily as German. But practice makes perfect. [...]

1938

The *Twentieth Century German Art Exhibition*, which is taking place at the New Burlington Galleries, is going soon now to Brussels—Palais des Beaux Arts, where it will be greatly reduced in the number of artists and will thus become stronger and clearer. Paris, Prague, and NY have also been mentioned. [...]

In fact, I also notice that almost all of my works could be described as ending with "Yes!" I even named one that myself. This "yes" is never monotonous in my case, but rather highly varied, such that it never loses its <u>assertion</u>. I once wrote an article for *Cahiers d'Art* in which it says that a real <u>work</u> always calmly states: *Me voilà*! I am here! Full stop! And at the same time, I know that in my paintings there is a calm affirmation of LIFE—not of life. It is of great satisfaction to me that I have achieved this. This was my (initially unconscious) dream. I used to want more "noise," and in 1914, i.e., before the start of the war and the start of the revolution, I began to think about a "great quiet." I began with the strictest limitation of the means of expression, which was very healthy for me. Today, this calm "yes" remains true even in the most complicated pictures. That's good! A little splurge never hurts! [...]

Do you know what is preventing me from going to America apart from money? Loss of time. [...] Every time I go to another country (and how different America is!!!), I can't work at first. It's frustrating. When we moved to Paris, I couldn't work for 3 months. It was a shock. I thought, I'm not a painter anymore. No, it was extremely unpleasant. I never work during the holidays—I just soak it all in, unconsciously, but constantly. When I'm back, I won't be able to work at first either. Always a shock—damn it, it'll be like that again when I get back from the Riviera. However, later it comes like an explosion. [...]

Bear in mind that I didn't start working seriously until I was 30 years old. So I still haven't done enough. Not nearly! Not nearly enough! I would like to do something great—as great as the lightning that ripped through half the sky and seemed to hang in the sky "unendingly" a few days ago. That was power! Never seen anything

233

1938

like it. [...] Your letters always radiate such a clear and human feeling (a warmth that is very rare today) ...

Sept. 19, 1938, Neuilly, to JOSEF ALBERS, USA (Ger.):
The infamous "international situation" is having a shattering effect for the time being in matters of art—everything is paralyzed. Of course things are different in Germany—there art is flourishing to an unprecedented extent. As an example, I am enclosing *The Goddess of Art* by the art dictator, Prof. Adolf (what a meaningful first name!) Ziegler. This is the art that the PEOPLE want and appreciate and that "TEACHES" them. The hands are particularly well done by the artist. And especially the left hand of the goddess and the index finger on the right. The hair is painted with incredibly realistic power—especially under the navel [*Ziegler had been nicknamed "The Reich Master of Pubic Hair"*]. And the head! I'm lost for words. [...]

In order to renew my [*German*] passport, I was asked to provide proof of my Aryan descent. The certificate of baptism is insufficient, and my paternal grandparents were born in eastern Siberia, where they lived all their lives. Do you know the names of the cities of Nerchinsk and Kyakhta? I'm supposed to get evidence from there. If I can't, I only get a "short-term" passport—probably for 3 months. This favor tempts me little. But in the case of war, I am German with all the consequences that flow from it. I am dealing with this issue now. Painting is easier.

Sept. 20, 1938, Neuilly, to HERMANN RUPF (Ger.):
In general, we would both like to stay in France. Among other reasons, perhaps most importantly, we are both real Russians, for whom the French "manner" is the closest thing. Easygoing!

Sept. 22, 1938, Neuilly, to ALEXEI JAWLENSKY (Rus.):
What trouble it is for you to write letters, and yet you wrote to me, which touches me very much. But I don't believe that "nobody needs

234

your work." Note that all art business is at a dead end at the moment anyway. I've tried a few times to propose an exhibition for you, even without much hope of sales, but I've been told, "It's just an expense. And we have enough paintings. Sometime later, when the 'market' has recovered." It's good that Emmy [*Galka Scheyer*] supports you and has already achieved a lot. [...] Nina Nikolaevna and I were exhausted after the "season" and needed rest, which we managed to get on the Riviera. It was quiet there, infinitely beautiful and varied. We thought of you several times and that you don't have such opportunities. Back home, I haven't started work yet. [...]

I write to Elisabeth Epstein from time to time and, by the way, sent her your photos, which she was very happy about and which she thought were "quite wonderful." The poor thing was very ill, so she didn't write for a long time. She's better now. Nina and I love her very much.

Oct. 1, 1938, Neuilly, to GALKA SCHEYER (Ger.):
[*Immediately following the Sudetenland Crisis and subsequent Munich Agreement:*] It was only yesterday that the disgusting nightmare which, in the last days, was getting closer and closer and more and more threatening with every hour, passed away. You know pretty much everything from the newspapers. As for us personally, we were ready to flee to Switzerland because, as Germans, we were threatened with a concentration camp. No, it really wasn't nice.

The Seine flows before our eyes. There are anchored boats in the most beautiful order, each occupied by 2–3 anglers. It seems to me that these anglers represent a special "race" [*Ger.* Rasse] that has not yet been scientifically studied. Everything, everything was in the greatest commotion, and only this race kept a cool head: they sat in their boats and waited exclusively for the small fish that are caught here and only rarely. I don't know how many Parisians left the city. But there were innumerable extra trains, and cars loaded with luggage drove on one after the other. [...]

1938

Our vacation was excellent. We spent three weeks in a very good hotel on Cap-Ferrat, which we firmly believe is the most beautiful area in the whole of the French Riviera. I even suspected that the hotelier had his huge park perfumed every morning—the southern scent was so strong. And the walks. And the calm. And the meals, etc.

Oct. 6, 1938, Neuilly, to OTTO NEBEL (Ger.):
The Führer promised not to restart any disputes in Europe. But Dr. Goebbels announced the need for all Germans living in foreign countries to integrate into the III Reich. — Today there is a caricature in the Russian newspaper: one man says: "Now almost all the Sudeten Germans have become members of the German Reich." — The other: "It serves them right, the Sudeten Germans." Yes, the Sudeten Germans, but the Czechs, who also have to become "Germans"? [...] The impertinence seems to have long since reached its ultimate limits. But goes further. The Parisians who left Paris in large crowds are now coming back. [...]
I recently heard that Gugg. and HvR [*Rebay*] bought "heaps" [*Ger.* haufenweise] from some artists during their last stay here—Gleizes, Delaunay, some Domela, etc. [...] I would like finally to get back to my work in peace. I have individual fragments in mind, but I can't combine them yet into a unified whole. So I sit and wait. Damn politics! Well, it's coming on again—just rest and no violence. Sometimes an important leap comes after such "cracks."
Nov. 9, 1938, Neuilly, to OTTO NEBEL (Ger.):
Yes, here too a nationalist wave is rising once more and the "average Frenchman" is suffering from xenophobia again. Life isn't easy here either, and the competition is always increasing—so it's no wonder foreigners are blamed for it. — America is still currently an exception—lots of space and the need to introduce cultural forces. Of my Bauhaus colleagues, 6 or 7 are already very well employed and still interestingly engaged (with commissions and other things). [*Kandinsky names contacts in the US, since Nebel was having difficulties staying in Switzerland.*]

Nov. 24, 1938, Neuilly, to JOSEF ALBERS, USA (Ger.):
The German plundering of the Jews and inhumane abuse had a terrible effect on us (as on all reasonably decent people). Of course we also thought specifically of our Jewish friends who are still in the country, and therefore also of your relatives. How have they fared? [...] And dear Anni's other relatives? What a horrible and insane time. Indignation is running high in all countries, and it seems particularly so in America and England. I was pleased to read that in America Germans also protested loudly.

Nov. 25, 1938, Neuilly, to OTTO NEBEL (Ger.):
Brava Baroness! [*Hilla Rebay sent money to Nebel and bought paintings from him for the Guggenheim.*] She acted wonderfully and we understand your emotion. So now, praise God, you are no longer dangling in the air with short stays in Switzerland. Unfortunately, even these respites had too relative a value. I'm sure you'll be offered completely different opportunities in America. [...] I already have several German colleagues (Bauhauslers) in America, and they all seem to be doing well, sometimes very well.

[*Kandinsky continued to publish texts in defense of abstract art in 1939 as he had done throughout his life. Jeanne Bucher exhibited his works again; his paintings were also shown at the Galerie Charpentier in Paris as well as in London, New York (Museum of Modern Art), Seattle, and San Francisco. Kandinsky planned a dance performance together with Leonid Massine.*]

Jan. 5, 1939, Neuilly, to PIERRE BRUGIÈRE (Fr.):
The horizon remains stormy, politics, as for me I never cease to be optimistic, but optimism does not keep me from taking the necessary precautions. My naturalization now depends exclusively on the Ministry of Justice, since all the investigations of the district [*Fr.* préfecture] were indeed favorable. Do you think that I can also count on a positive answer from the Ministry soon? I would be infinitely grate-

1939

ful to you if you could talk to Mr. D. … I owe you a short explanation for my haste. […] I was rather seriously ill (a bad flu with the onset of pneumonia), and my doctor advises spending two or three weeks in the Swiss mountains to take advantage of the snow and sun. I was thinking of traveling at the end of the month and I would be very happy to do so on a French passport. […] Would you be so kind as to call me […] or to write me a short note as to what I can expect? [*His German passport had expired at the end of 1938 and was a danger to him anyway. The jurist Brugière and some other Frenchmen were able to help him.*]

Jan. 9, 1939, Neuilly, to PAUL CITROEN (Ger.):
So, we former Bauhauslers are scattered all over the world. There are even some who remained in Germany … and are earning excellent money there. Except that one should not speak aloud about one's Bauhausler-dom. Indeed, a fantastic and crazy world!

Jan. 10, 1939, Neuilly, to HANS THIEMANN (Ger.):
I am very worried about you. Your almost "mystical" weight alone is cause for concern. I have nothing against avoiding the army either, but not at the high price you are paying by losing so much body weight. How we would like to send you to a "Chinese" doctor, i.e., to a Frenchman who spent more than 20 years as a consul in China, and who thoroughly and diligently studied the truly fabulous medicine there. Wouldn't a visit here be possible?
[…] Just pour your heart out to me completely, you will always find a keen and sympathetic reader in me. Warmest greetings to you, dear Mr. Thiemann, from me and also from my wife.

Jan. 12, 1939, Neuilly, to HERBERT READ (Fr.):
The goal of this letter is to thank you greatly for all your efforts with the Tate Gallery regarding my canvas. I know that you made these efforts over the course of many months. […] Having a work in the Tate Gallery is a great pleasure for an "abstract" (I prefer to say "con-

238

crete") artist. Especially because the gallery now intends to bring in other "concrete" works and to create as such a whole section devoted to this painting.

This very fine intention has a not so agreeable outcome for me. Which is to say my painting will have surely have to wait years to be hung! I find this decision by the gallery's management rather unfair, because in truth my *Cossacks* is not a purely "concrete" work—as the title of the canvas already shows. It could, in my view, be hung in a "figurative" room as an example of a "veiled" object that has the intention of disappearing but is not yet able to. [...] Between us: this way the gallery would at least be forced to hang another painting of mine, and this time a truly "concrete" one.

Jan. 25, 1939, Neuilly, to HANNES BECKMANN (Ger.):
[*Regarding the political situation in Prague:*] It's understandable that you want to get out. It seems to me that it would be good if your wife's parents followed your example. Who knows how things will further develop! Of course, such undertakings are much easier to declare than to realize. The "Jewish question" is taking on increasingly cruel forms. Some countries are trying to make big money out of it. However, some succeed more or less. For how much longer? You ask me about Albers [*he gives his address in the US*]. I just had a letter from him a few weeks ago in which he writes how many, mainly Germans, want to come to America to create a new situation for themselves there. People often turn to him, and he "unfortunately can do so little" (that's roughly how he puts it). [...]

The urge for America is constantly growing, and from many countries. It's finally happening like it did in France—the screws are being tightened and the front door is getting harder and harder to open. Then there are restrictions and outright bans on pursuing money-making activities—for foreigners, of course. [...]

All I know about Canada, which you mention, is that it is a very beautiful country. A colleague from Paris has just spent 4 months

1939

there and brought back wonderful photos. [...] I don't know how things are with immigration there. [...] In America you can get by with a very poor level of English, at least for the time being. I have colleagues there who almost don't know a single word of English and ... teach. [...] Please write to me as your situation develops. Whatever is in my power, I'm really happy to do for you. Unfortunately, it is just too limited. [*He would write to five friends in the US on the Beckmanns' behalf, seeking a sponsor for their entry into the country.*]

Feb. 11, 1939, Neuilly, to ALEXEI JAWLENSKY (Rus.):
I have been told that you have pleurisy. Even without this, you suffer enough. I can hardly express how sorry I am for you. I really hope that you will get rid of the pleurisy and that you will feel better. By the way, I wanted to let you know that quite likely there will be 2 possibilities for you to participate in historical exhibitions, one in summer and one in autumn. For the first one you will be asked to send 3 works, but it might also be more. On the 17th, you might be asked to participate in a third exhibition, but so far these are only projects. But if they materialize, you will enjoy it.

Feb. 17, 1939, to GALKA SCHEYER (Ger.):
You know that my Spanish monograph had almost been printed when the Germans came and put a stop to it. After Franco's victory, the book will never appear.

Feb. 24, 1939, Neuilly, to ANDRÉ DEZARROIS (French):
The day before yesterday I received a letter from the Ministry for National Education with the message that my painting "currently at the 'Jeu de Paume Museum'" has been purchased by the State for the sum of 5,000 francs. — I was truly astounded and at first even thought that I was mistaken. But no! That was the exact amount. — Do you remember we talked about the different canvases I could let the Musée du Jeu de Paume have for the specified sum, but I told you it would

240

be completely impossible for me to give you *Composition IX* for this amount. I told you the price of this canvas would be 100,000 francs, but that I could give you a reduction of 50% especially for your museum. [...] You then spoke of the possibility of eventually finding a patron who might pay the difference. We even mentioned in particular the American collector Mr. S. R. G. [*Solomon R. Guggenheim*]. I am wracking my brain to find a way out of this embarrassing situation. [...] You could choose another canvas from me—undoubtedly a beautiful canvas that I could hand over for 5,000. Or, it becomes more and more necessary for me to have a major retrospective in Paris. We have already discussed this, and I know you had nothing against such an exhibition at the Jeu de Paume, but that certain circumstances impeded it. Or were impeding it. But perhaps today conditions have become less restrictive, and the exhibition might be possible. In this highly agreeable case, I would content myself with 5,000 francs for *Composition IX*. [...] What do you think? [*He never had a retrospective exhibition of his work in France during his lifetime.*]

Feb. 28, 1939, Paris, ANDRÉ DEZARROIS to KANDINSKY (Fr.): Mr. Kandinsky, I read your letter with astonishment. And I answer quite frankly: either you have lost your memory or you are mocking us.

For the past fifteen years, I have told you repeatedly, answering your many phone calls or reminders, that it was my earnest wish to acquire one of your paintings. But I have difficulties at the Ministry: the price and the principle stating that we will not purchase any Cubist or Abstract art. — My constant arguments in defense of your work, to which I accord a certain interest and importance, have made an impression on the person in charge, who, on his own initiative and without consulting the purchasing committee, where he certainly would have been outvoted, has authorized me to spend 5,000 francs. [...]

And now you repeat once more that your picture is worth a hundred thousand francs. Would you accept 5,000 francs in favor of the country that offers you shelter as a refugee? [...] I don't intend to go

1939

so far as to say that I regret having handed in a very favorable report concerning your application for French citizenship [...] but earlier you had confirmed that you naturally would help a poorly funded museum that had done you a favor by exhibiting your works. [...] If I have not received your acceptance in two days, I will ask the board of the Musée des Beaux-Arts to cancel the purchase.

Mar. 1, 1939, Neuilly, to ANDRÉ DEZARROIS (French):
The almost irritated tone of your letter astounded and saddened me. Under these circumstances a solution to this problem is impossible. So I am accepting the sum of 5,000 francs for my *Composition IX* and I will send my agreement to the Ministry of Culture.

Mar. 4, 1939, Neuilly, to OTTO NEBEL (Ger.):
What a pity! We are very sorry [*his entry to the US was not granted*]. Your case is especially difficult, because you have a German passport, and so many Germans are eager to reach America that they have to curb this. Don't forget, "Patience = Roses," and remember, that encouraging saying isn't from today. So now we have all become Rosicrucians—everyone carries his cross and hopes for roses. Rotten joke!
Mar. 16, 1939, Neuilly, to OTTO NEBEL (Ger.):
Today I showed your small photos to [*Gualtieri*] di San Lazzaro and he thought they were too small. [...] These items must be chosen in such a way that they come alive and are interesting in black-gray-white, i.e., that the colors are not too lacking. [...] Di S. Laz. found [*your things*] very interesting and beautifully executed. I have also mentioned your poetry to him. [*Di San Lazzaro was the publisher of the review* XXᵉ Siècle, *the first issue of which had been dedicated to Kandinsky. Otto Nebel had been a well-known poet since his period with Der Sturm in Berlin.*]

Mar. 27, 1939, Neuilly, to ALEXEI JAWLENSKY (Rus.):
We wish you a very happy birthday and a decisive improvement in your health. [...] Follow the example of Klee, who had been severely

sick for many years, but who is gradually recovering and is now well enough to work again. May God grant you the same! We think of you often, but how complicated everything is nowadays. [...]

There's a fine Cézanne exhibition here right now. Fifteen years after his death he's all the rage in Paris. Chic automobiles pull up and a chic audience crowds into the hall. "Belated success"!

Apr. 22, 1939, Neuilly, to HANNES BECKMANN (Ger.):
The first answer I just received is unfortunately a negative one. The friendly gentleman writes that the person who signs an affidavit undertakes to support the foreigner financially for the first five years if he gets into financial difficulties. And the gentleman in question has money worries of his own right now, as he doesn't currently have a paying job. Terrible thing! So I'm pretty much losing hope that someone will take on such a commitment. Now we need to wait for further answers. [...] Otherwise I hear few encouraging things from America. It seems to me that there is an even greater fear of war there than here in Europe. The first practical consequence of this is soaring thrift. Wealthy people limit themselves in expenditure, and most easily in the purchase of paintings. In such extraordinary times, artists are the first to suffer. And so we have to keep cultivating our thick skin. As soon as I get an answer I will pass it on to you.

Spring is indescribably beautiful here—everything is in bloom. For its part, nature does everything to create joy. People do everything to spoil it. But we want to remain optimistic.

May 23, 1939, Neuilly, to HANNES BECKMANN (Ger.):
I recently received the reply from Albers. Unfortunately also a negative one. He writes that he has already committed himself to someone and, to his sincere regret, is unable to undertake any more commitments. There are still 2 people I expect an answer from, but I don't have high hopes. Things are particularly bad with Germans—the quotas!

What could one do there? In England? Wouldn't be very easy either, but it seems more hopeful. With art—especially "abstract

art"—there probably wouldn't be much to do. But photography—there I think so. I heard things were not going badly there for Mondrian, who moved there some months ago—from Paris, where he had found no real home after so many years. But he is very well known in some circles and has been working abstractly for a long time. You know his stuff. It would hardly be an example of our circumstances. In England there is a very small circle of abstract art lovers, but they are mostly young and have no money—with a few exceptions. I recently heard that art dealers who represent modern art (particularly the "radical" kind) are having a very difficult time in England. [...] How often have I heard, "God, how is one supposed to buy works of art now when things are so uncertain and we don't know what awaits us tomorrow?" Cowards! For some this is only a pretense and a veil that hides disinterest. I'm really very sorry not to have anything good to tell you. But it would be wrong to lose patience. One way or another you will find a way out. Don't you think? [*In the end, despite his attempts, Kandinsky was unable to help the Beckmanns, and they arrived in New York only after surviving the concentration camps.*]

June 23, 1939, Neuilly, to GALKA SCHEYER (Ger.):
Fi-i-i-i-inally a letter from you! We had really started worrying! [...]
And I'm firmly convinced that my paintings offer a very safe investment: today they really don't cost much (especially for wealthy people—others are not looking for investments), "tomorrow" they won't be expensive yet, but certainly in a few years. My pictures are "unique," because I am also unique, especially because I don't produce "series." Here people are constantly astounded about the "variety" of my paintings, and rightly so. I don't want to brag about it, but the fact remains that each of my paintings is "unique." And more and more so. So I'm particularly sorry I can't send you anything new. [...] I'm looking forward to my "one-man show" in S.Fr[*ancisco*] and my only regret is that new and larger paintings can't be shown there. But hopefully it will go well anyway: 40 paintings is already quite something. [...]

1939

I have a large painting, *Composition IX*, in the Paris state museum of the "Jeu de Paume" since January, in addition to a gouache that was purchased about 2 years ago. People here are getting more and more used to the fact that I'm "Parisian" (which some colleagues don't particularly like to see). At present I have a nice exhibition of watercolors and gouaches with Jeanne Bucher, who is delighted with the large number of visitors. All sorts of "bigwigs" even came.

Our naturalization has been approved, and in a few weeks we will get our French passports, which we are very happy about. [...] Here the series of "non-figurative" exhibitions has now started. I imagine that my rebellion against the Parisian claim that everything in modern art originated in Paris and that "abstr." art stemmed from Cubism is helping, although slowly. [...] For your part, fight against the above misinterpretation.

June 29, 1939, Neuilly, to HERMANN RUPF (Ger.):
The democratic countries have shown a great deal of patience, but everyone now knows that National Socialism must be eradicated definitively and for all time. I don't think we will have to wait too long for that. How the whole world will breathe a sigh of relief! [...]

June 30, 1939, Neuilly, to OTTO NEBEL (Ger.):
Your 2 beautiful works are hanging in a beautiful space and make a very good impression. [...] People whisper that this second exhibition ("the foreigners") is much more interesting than the first one ("French artists"). Strange that something can surpass French painting. Or is it my imagination? Our friends are also exhibited there: [*Otto*] Freundlich, whom you probably know from Berlin, Hilla Rebay, Rudolf Bauer, whom you also knew in Berlin and afterwards too. Otherwise there is: Doesburg, Eggeling, Gabo, Hausmann, Lissitzky, Malevich, Mondrian, Magnelli, Pevsner, Schwitters, Vantongerloo + me. Mrs. Arp is French but was shown with us. [...] After the opening, we spent a really pleasant hour in a café with friends—Pevsner, Magnelli, Domela,

1939

and their wives. Indeed there are nice colleagues! [...] Fortunately, among artists there is little said about the "brown" and "yellow" peril. [...]

Your name was mentioned in the prospectus for a future exhibition—"Works after 1920." It's nice that you are being exhibited with us oldies, who refuse to grow old. — Yes, painting is a wonderful thing—mu-u-u-ch better than anything else.

Aug. 4, 1939, Neuilly, to PIERRE BRUGIÈRE (French):
I promised not to bother you anymore with questions about my naturalization. [...] I have been told that lately there have been many naturalizations and that because of this the Prefecture of the Seine has not yet received the decree of my naturalization. [...] Would you be able in this case to "push" this business a little? [...] I am really in a hurry because our room is already reserved in Croix-Valmer, where we want to spend our holidays. The political skies remain unfortunately tempestuous. I would be happy to be able to go there with a French identity card.

Aug. 9, 1939, Neuilly, to PIERRE BRUGIÈRE (French):
We leave next week for Croix-Valmer (Var). [...] My wife and I thank you cordially for your help and all your efforts during the process of our naturalization. We are very touched and will remember it most fondly. [...] So we are fellow lawyers. I think you certainly also studied law, in which case we are colleagues, because I did the same at the University of Moscow. I was promised an academic career before I decided to donate my library to the university and go abroad to study painting. [...] If we come to Tours, we will not fail to visit you. [...] Please don't forget to call us when you are in Paris.

Aug. 11, 1939, Neuilly, to OTTO NEBEL (Ger.):
I heard good things about both of your paintings in the exhibition. [...] In the Guggenheim catalog I saw many reproductions of your works, which made me very happy. [...] Bauer is supposed to be in N.Y. already, and probably definitively.

246

1939

We leave for the seaside in a few days—the French Riviera. Today, all over the world, one adds "if the Führer permits" to such projects. But one doesn't even have to, since it is a matter of course. People are very docile and easily bow their heads to the fist.

Oct. 2, 1939, Neuilly, to GALKA SCHEYER (Ger.):
[*Comparing Europe to America, where modern art was considered "crazy"*:] Here one may even go too far [*in the other direction*], if one considers many Surrealists and much of Picasso as sane. In my opinion, it often smells of decay. Even *Guernica*, for example, which you have promoted so warmheartedly. Frankly, it is incomprehensible to me what prompted you to saddle your compatriots with *Guernica*. Do you believe that such a painting could bring people to a clear understanding of and a reliable feeling for new art? Yes, I may be "partisan," but I have to admit that I hate the "deconstructive." In such cases, American and European attitudes coincide. With the difference, however, that the latter throws everything "constructive" and "deconstructive" into a basket labeled "crazy," but with the additional label "future." [...] Our descendants will say of us: "poor fellows," when they see Dalí's horse skull with flies glued to its eyes. Does this reflect our world? [...]

The French and English governments are correct in their assertion that peace can only be said to exist once the Nazis are eliminated, definitively and forever! Hopefully it will come soon.

Dec. 20, 1939, Neuilly, to OTTO NEBEL (Fr. [*due to censorship*]):
What about your plans for America? And your art? Your poetry? etc.? [...] On Sunday we will see Maurice Chevalier and Josephine Baker at the "Casino de Paris"! Voilà! I am drawing a lot, using the short time when there is enough daylight to paint. [...] I write this letter while listening to an opera at La Scala in Milan. And I like listening to the Austrian who speaks from various French stations. A mortal enemy of Hitler, he speaks with passion. Have you heard him? He always begins: "The truth is a means to defeat Hitler."

1940

Feb. 13, 1940, Neuilly, to OTTO NEBEL (Fr.):
It's always a good idea to occasionally leave your four walls and come back home happier. That's why I love our vacation trips so much.

So now you have 20 pictures in the Gugg. Collection. Bravo! [...] Overall the collection now has a better range, one can see a tendency to create a fair balance [*Hilla Rebay had hitherto privileged her lover Rudolf Bauer*]. There are about 100 of my paintings there, but very few purchased directly from me. Otherwise one might think that I'd become a millionaire! My wife recently discovered several of my paintings in the last catalog that had been bought from German museums and collectors. It would really only be fair if one got a small % of it. Otherwise it is nothing but additional competition for us. No, no legislation has any interest in us poor devils, artists.

That your friend Mr. R. B. [*Rudolf Bauer*] is now living in a luxurious residence with a private beach was interesting news to me. But I expected nothing else. [*And that he gave up painting for good after a quarrel with Guggenheim was also to be expected.*]

The day after tomorrow we meet Marc Chagall and his wife for coffee on the Champs Elysées. And tomorrow we're invited to dinner with friends. But such events are rare. We usually stay quietly at home, especially in the evenings.

Feb. 9, 1940, Neuilly, to HERMANN RUPF (Ger.):
I share your opinion that Germany prides itself on a strength "it no longer possesses." But that does not prevent it from producing a significant number of barbarians. For they are indeed barbarians, worse than the historical ones. Hitler's only real rival is Stalin with his atrocities in Finland. Another level on which the two leaders compete is in their lies. My wife sometimes listens to the Russian broadcasts from Moscow, and it is incredible how far their capacity for lying can go. [*On Nov. 11, 1939, Kandinsky had already written to his Swiss friend:* "My God, what horrible times! And all that because of a hysterical lunatic!"]

248

1940, 1941

Feb. 14, 1940, Jerusalem, EVSEI SHOR to KANDINSKY (Rus.):
[*Contact with Shor had never ceased (he left Moscow shortly after Kandinsky). He intended to write a book about Kandinsky and asked him in an undated letter (c. 1931) what his art could contribute to an understanding of the world's destiny. The artist's replies are in the archives of David and Evsei Shor, National Library of Israel, Jerusalem. See doc. 1914 below by David Shor. Regarding his plan to promote the arts in what was then Palestine, Evsei Shor writes:*]
Concerning my work, it is a pity that our paths—at least geographically—have taken different directions. But externally does not mean internally, and I would be very happy to serve your art (which is still totally unknown here) in the same way I did previously.

Mar. 5, 1940, Neuilly, to HERMANN RUPF (Ger.):
We too had hoped the Germans would end the war by taking internal political measures. The question of whether "there is one Germany or two" is being discussed more and more frequently in democratic countries. […] Here we can observe where dictatorships are leading. Will we see the end of these nightmares soon?

Apr. 21, 1940, Neuilly, to GALKA SCHEYER (Ger.):
All the atrocities that mankind suffers will eventually lead to a spiritual awakening. But when the final end will come is unknown to me. Perhaps towards the year 2000.

[*In May 1940, Germany invaded France and occupied the northern half of the country, including Paris. Kandinsky's work was exhibited at Neumann's gallery in New York as well as in Mexico City. His* Concerning the Spiritual in Art *was finally published in Italy. The death of Paul Klee profoundly saddened Kandinsky, and he wrote an homage to the artist.*]

Feb. 2, 1941, Neuilly, to PIERRE BRUGIÈRE (Fr.):
The absence of precise terminology for what one calls abstract art (what you call "real" and I call "concrete"), this absence is proof of

249

1942

the great vital force of this art, which is still in the process of developing and which has infinite new perspectives. A definite terminology is, in my eyes, proof of the end of development—"museum," a "perfect" classification. Our adversaries have been claiming for thirty years that the means of art called "abstract" are too limited for possible development in the future. That may be true for the blind.

May 1, 1941, Neuilly, to PIERRE BRUGIÈRE (Fr.):
The long absence of your news had worried us, now as we see not without reason. Please accept our sincere condolences, and to Madame Brugière as well on our behalf. We understand very well the severe heartache this loss has caused you. It is one of the greatest misfortunes in life to lose a child.

[*In 1941, Kandinsky had only one exhibition at Nierendorf's gallery in New York and a one-man show in Los Angeles.*]

Jan. 15, 1942, Neuilly, to HANS ARP (Fr.):
Everything is white outside our windows, and now and then large snowflakes fall from the sky. Instead of a sun, we have a good stove in my studio, and that's where we eat. The old dining room is now our bedroom, with a gas stove; so that's how one gets by.

Mar. 14, 1942, Neuilly, to PIERRE BRUGIÈRE (Fr.):
Generally, we don't have serious reason to complain. From our windows we had a perfect view of the bombardments on March 3, and for quite some time we were naive enough to think that it was a marvelous display of fireworks. My wife is a little worried seeing the mass of chimney stacks at Puteaux across from us, but I am sure the English will not drop bombs on a city where the rather small factories are closely surrounded on all sides by residential homes, but after a long "intermission" we hear the sirens again, a strange and disturbing music. None of this prevents me from working a lot, and I will show you my new paintings with the greatest of pleasure.

250

1942, 1943

Apr. 25, 1942, Neuilly, to CÉSAR DOMELA (Fr.):
[*Regarding the Album* 10 Origins, *edited by Max Bill with engravings by Arp, Bill, Sonia Delaunay, Domela, Magnelli, Kandinsky, etc.:*] Magnelli talked about a first edition of 100 copies. […] It was my great pleasure to show my most recent paintings to Mrs. Domela and to you, who are quite exceptional colleagues. Thank you for your telephone number, and we hope to have a safe trip [*to Domela's studio*].

May 9, 1942, Neuilly, to ALBERTO MAGNELLI (Fr.):
Our Boulevard de la Seine is a real poem: the chestnut trees are blooming.

July 28, 1942, Neuilly, to HANS ARP and
ALBERTO MAGNELLI (Fr.):
[*Both artists had left Paris for the "unoccupied" southern part of France.*] Since July 21 Jeanne Bucher is showing my paintings. I was very sad to have missed you at the opening. The exhibition is going well and is successful [*but no sales*].

Apr. 7, 1943, Neuilly, to PIERRE BRUGIÈRE (Fr.):
You will have just received my letter of Apr. 4 and therefore you already know […] the bombing spared us. In writing to you about theoretical matters, I completely forgot this event, which had, for a moment, made a violent impression on us. […] The warning siren was late, when two violent explosions broke all our windows. The explosions were on the racecourse where they left many victims, a little later from our windows we saw an immense fire in the direction of Saint-Cloud. […] After your visit I was sorry to have forgotten to show you my drawings, which you wanted to see. At the time, I had forgotten that I had quite a large quantity of finished drawings.

June 25, 1943, Neuilly, WILL GROHMANN (Ger.):
Last winter we had the possibility of heating my studio, which has

1943, 1944

now become our dining room as well. We sleep in what used to be the dining room, because there is a small gas stove there, which we heat very sparingly in the evening.

Dec. 6, 1943, Neuilly, WILL GROHMANN (Ger.):
Now, dear friend, you receive belated but no less heartfelt congratulations on your birthday from both of us. Good health, joy! [...] We too were shaken by Schlemmer's death. The news came so unexpectedly, and in fact his death came far too soon. Have you heard of the deaths of Delaunay and Marcoussis? Cancer took them both away. And Mrs. Arp died in Switzerland from coal gas [*carbon monoxide*] poisoning. Arp can't recover from the blow, I heard. — I don't need to ask you both not to forget us both.

[*In 1943, Kandinsky's work appeared in three different locations in New York, including Peggy Guggenheim's new gallery, Art of This Century, which had opened in October the previous year. In 1944 his work was featured in two exhibitions:* Konkrete Kunst, *organized by the Swiss artist Max Bill at the Kunsthalle in Basel; and* Peintures abstraites. Compositions de matières *at the Galerie l'Esquisse in Paris, alongside Domela, Magnelli, and Nicolas de Staël (the show closed prematurely in anticipation of the intervention of the Gestapo due to Domela's involvement in the French Resistance).*]

Apr. 20, 1944, Neuilly, to CÉSAR DOMELA (Fr.):
Thank you very much for your friendly help [*Domela had brought Kandinsky's paintings from the gallery L'Esquisse to Neuilly by bicycle*]. What do you think about these recent troubled nights? [*Heavy bombardments over two nights had left many dead.*] We hope you and your family are well, and we send our best.

Apr. 27, 1944, PIERRE BRUGIÈRE to KANDINSKY (Fr.):
I would have written to you much sooner if only to thank you for your long and interesting letter of February [*this means that Kandinsky had written a detailed letter to his jurist friend in February*]. The aim I have set

252

1944

for myself is: to learn to love, to understand, to know art, to know how to use it for a more expansive and healthier spiritual life.

[*The Allied forces liberated Paris from German occupation in August 1944. Kandinsky died of a stroke on Dec. 13, 1944. Olga de Hartmann told me that until the very end, he had planned to put on a stage production with Thomas de Hartmann— something on the theme of "Bacchantes," continuing their never-finished work on* The Yellow Sound, *but now using the new medium of film. Other than Nina Kandinsky, Thomas de Hartmann was the last person to see Kandinsky before his death (see his document below).*]

Supplementary Documents (chronological)

KANDINSKY, on seeing Claude Monet's *Haystack* in an exhibition in Moscow in 1891 (Rus.): For the first time, I saw a genuine painting. It seemed to me that, without the catalog, I wouldn't have been able to guess that this was a haystack. I found this lack of clarity unpleasant. [...] I felt vaguely that the object in this painting was missing.

IGOR GRABAR, c. 1900, in *Moia zhizn': Avtomonografiia* (Moscow: Iskusstvo, 1937), 141 (Rus.): [*Kandinsky*] painted small landscape studies using the palette knife, not the brush, and put several layers of bright color on the canvas (fig. 2). The result was multicolored studies, the colors of which were quite dissonant.

LOENGRIN (pseud.), "Exhibition of South Russian Artists," *Yuzhnoe Obozrenie,* Oct. 3, 1901 (Rus.): Mr. Kandinsky's paintings are full of such emotions that one, at a complete loss, can only shrug one's shoulders. [...] The jury bowed to the fashion, to "Secessionism," which is laughed at by all normal people in other countries as well. They are crazy paintings. Art should be generally comprehensible: the jury has sinned.

ALEXANDER BLOK, "Novoe obshchestvo khudozhnikov (Petersburg. Vystavka kartin v zalakh Akademii nauk)" (New Society of Artists [Petersburg. The Exhibition of Painting in the Halls of the Academy of Sciences]), *Vesy* 1, no. 3 (1904): 47 (Rus.). [Vesy *was a Russian symbolist magazine published in Moscow from 1904 to 1909, edited by the major*

symbolist writer Valery Bryusov. In this article, Blok, a well-known Symbolist poet, described two of Kandinsky's paintings and declared that he was looking forward to more of Kandinsky's work. The catalog lists three engravings and two tempera paintings: Poety (Poets), *no. 73, and* Vsadniki (Riders), *no. 74.*]

GUSTAV FREYTAG, from a manuscript, MES, Munich (Ger.): [*In his detailed written recollections of the artist, Freytag, a member of Phalanx and the NKVM and Kandinsky's close "hiking friend," reported that "Phalanx" (1902) was a protest*] against the jury system and the state of affairs within the "Secession," which in particular was accused of being elitist and intolerant towards new artistic currents. The "Neue Künstlervereinigung" [*1909*] was founded not only with the aim of giving disadvantaged artists an opportunity to show their works, but also of organizing group exhibitions of out-of-town and foreign artists whose work had, until then, rarely been seen in Munich. [...]

[*Kandinsky*] was fiercely opposed to all historical painting. [...] I already knew K. was quite far left politically. So he was certainly dissatisfied with conditions in Imperial Germany at the beginning of the century. [...] It is not impossible that after the war in Russia he was not a convinced communist, but simply hoped to find healthy, liberal views and conditions after the collapse of the Czarist regime. [...] People liked to listen to his stories because he always spoke animatedly and laughed heartily, had a sense of humor, and—what should be particularly emphasized, in view of some assumptions—never demonstrated a depressed or reclusive spirit, at least not when I knew him. He certainly appeared to be a positive, self-assured man with serious views. His manners were impeccable. Though his looks were slightly Asian, his behavior was European.

FRANZ MARC, writing about the first exhibition of the "Neue Künstlervereinigung München" at the Galerie Thannhauser in 1909; handwritten copy of Marc's text by Adolf Erbslöh, MES, Munich (Ger.): There is almost something absurd about the manner in which

the Munich public dismisses the exhibition. They act as if they see the excesses of sick brains; but in fact we are confronted with simple and rudimentary explorations of a yet undiscovered land. Did they disregard that all over Europe they can find the same spirit, exuberant, stubborn, and conscious? [...] One could imagine artists such as Matisse, Minne, Manguin, Puy, and others included in this small exhibition. Whoever has eyes enough to see will notice the same mighty movement of the new art here.

VLADIMIR BARANOV-ROSSINÉ to KANDINSKY, 1909–10? (Rus.): [*In 1910, Baranov-Rossiné moved from Russia to Paris, where he called himself Daniel Rossiné and belonged to the circle of "La Ruche" with Archipenko and Sonia Delaunay.*] I stayed in Bern [*Switzerland*]. Once I had a short talk with [*Hans*] Arp. [...] I agree with your theory that every color should correspond to a certain form (which is also true for musical notes). Your examples of cadmium yellow in a triangle, red in a square, and blue in a circle seem clear <u>to my feeling</u>. And as soon as I find better proof, the musical notes will be organized. But I have a question: what forms would correspond to orange, violet, and green? I forgot about that question when we met. I know how to mix colors, but how does one mix (geometric) forms? <u>Please be kind and answer</u>, then I will compare your judgment with mine. [...] I would be especially happy to work on that problem with a music expert. If Thomas de Hartmann could come to Switzerland, I would wait for him here. Perhaps I would also be able to come once more to Munich. Please let me know about his plans. [*The letter contains notes, charts, and descriptions*]. As I already told you, I have a system of noting forms and colors, but they don't match as a whole. Yet I am able to note down some of your pictures, the musicality of which I sense intuitively. [...] Greetings to your wife. Arp also sends his regards to you.

VLADIMIR BARANOV-ROSSINÉ to KANDINSKY, Aug. 1, 1910–11? (Rus.): Dear Vasily Vasilievich, I am now living in Sèvres [*close to Paris*] and intend to stay here for a while. I had to interrupt my work on notes.

257

Now I am starting once again. We did not discuss enough. [...] But I will get back to that project. I have been living here only 2 months and have already met an interesting sculptor, Archipenko, who is exhibiting in Berlin. How are your projects coming along? I would be happy if you could come and visit me here. — It would be a good idea to gather young Russian artists for an exhibition in Paris. Just look at the Italians! What do you think? — P.S. Chagall is a good painter.

Münchner Neueste Nachrichten, Sept. 10, 1910 (Ger.): [*Regarding the second exhibition of the NKVM, with Braque, Picasso, Derain, Rouault, etc.:*] There are only two possible ways of explaining this absurd exhibition: Either one assumes that the majority of the members and guests are incurably insane, or that they are shameless bluffers, who are not unaware of the need for sensationalism in our time.

The Russian avant-garde, 1910–11: The Cubo-Futurists of the Crimea (*Hylea*) with David and Vladimir Burliuk (as well as Elena Guro, Aleksei Kruchenykh, Vladimir Mayakovsky, Velimir Khlebnikov, Benedikt Livshits, etc.) in Moscow. "Knave of Diamonds" (*Bubnovyi valet*) opened its first exhibition on Dec. 10, 1910, where Kandinsky exhibited six works. Other participants from his Munich circle: Gabriele Münter, Vladimir Bekhteev, Alexei Jawlensky, Marianne Werefkin, Erma Barrera-Bossi, Adolf Erbslöh, and Alexander Kanoldt. In St. Petersburg, the "Union of the Youth" (*Soyuz Molodezhi*) was founded in 1910 and had its first exhibition on Feb. 16, 1911.

VLADIMIR IZDEBSKY, sculptor and friend of Kandinsky, opened his first *International Salon* exhibition in Odessa on Dec. 4, 1910. It traveled to Kiev, St. Petersburg, and Riga. Kandinsky was primarily responsible for the catalog of the second, even larger exhibition in 1911 and exhibited fifty-four paintings, including some abstract ones. Other participants included Münter, Werefkin, Jawlensky, Borissov-Musatov, Larionov, Lentulov, Mashkov, David and Vladimir Burliuk,

Mikhail Matyushin, and Alexandra Exter. Among the French contributors were Bonnard, Vuillard, Denis, Manguin, Rouault, Braque, Matisse, Marquet, Rousseau, Signac, Le Fauconnier, and De Vlaminck. The Dutch painter Kees van Dongen also participated.

David Burliuk, Crimea, to Nikolai Kulbin, St. Petersburg, 1911 (Rus.): Just back from the Salon exhibition in Odessa, together with Vladimir. A very interesting show—so many good French artists—excellent van Dongen, Braque, Rousseau, Vlaminck, Manguin, and many others.

Paul Klee on Kandinsky, 1911, in *The Diaries of Paul Klee 1898–1918*, ed. Felix Klee, trans. R. Y. Zachary and M. Knight (Berkeley: University of California Press, 1964), 264: Very curious paintings. Kandinsky wants to organize a new society of artists. Personal acquaintance has given me a somewhat deeper confidence in him. He is somebody and has an exceptionally fine, clean mind.

Franz Marc to Alexei Jawlensky, Feb. 13, 1911 (Ger.): [*Regarding Kandinsky:*] What a tremendous force, expressing things solely with purely painterly means: colors, lines, and spots—something that has so far never been realized in art. […] Who is going to keep him from going beyond those limits that, until now, have been the exclusive limits of painting, as long as he remains so artistic?

August Macke to Franz Marc, Aug. 11, 1911 (Ger.): I see Kandinsky very clearly as the spiritual stimulator of Münter's painting. I don't therefore agree with her claim that she works independently, just as I myself admit to a strong French influence upon my painting. […] I like Kandinsky better; from his pictures in our house, there is a constant flow of energy that is wonderful. He is a romantic, a dreamer, a teller of fairy tales. But what he is, in addition, is most important. He is full of boundless life.

NIKOLAI KULBIN read a shortened version of Kandinsky's *Concerning the Spiritual in Art* at the All-Russian Artists' Congress in St. Petersburg on Dec. 29, 1911. During the discussion, Prince Serge Wolkonsky spoke of his admiration for Kandinsky's courage, but admitted to having felt something strange, a limit between genius and madness. A. N. Kremlev commented: "Gentlemen, mercy! May one claim that the color yellow means joy?" But art historian Dmitry Aynalov and, of course, Nikolai Kulbin maintained that the high scientific value of the text demanded its publication in the *Works*, which only became possible in 1914. In addition to the text, an important color plate was included as a spectacular, full-page illustration on special paper (35 x 26 cm) (fig. 10). Since Malevich almost certainly saw this important publication, Kandinsky's "proto-Suprematist" chart may well have provided him with additional inspiration for the movement he founded in late 1915.

OTTO FISCHER, *Das Neue Bild. Veröffentlichung der Neuen Künstlervereinigung* (Munich: Delphin, 1912), 15 (Ger.): A picture without object is senseless. Half object, half soul is a cold madness. These are the aberrations of idle dreamers and swindlers. [...] A few spots and lines and points are not yet art.

ARNOLD SCHOENBERG to KANDINSKY, Mar. 8, 1912 (Ger.): You have such a rich personality that the slightest vibration always causes you to overflow ... I am very proud to have your respect, and I am tremendously glad of your friendship.

W. S. GHUTTMANN to GABRIELE MÜNTER, late April 1912 (Ger.): [*After having seen Kandinsky's paintings:*] May I ask you to excuse the disturbance I caused in your house earlier today as a result of my panic attack.

ALFRED KUBIN to GABRIELE MÜNTER, Aug. 3, 1912, MES, Munich (Ger.): I am pleased to hear that Kandinsky is now recovering properly. He really is a hero, when one considers all he takes upon himself—and how he handles it. I'm hearing many good things about Marc—and think he is destined to be the first to be recognized and understood. Kandinsky and I will probably not experience this—we have too many "foreign traits." […] Pass on my best and warmest wishes to Kandinsky, tell him I often suffer from inner quarrels and am often suicidal. […] He shouldn't forget me.

Announcement in *Odesskiy listok*, no. 44, 1912 (Rus.): In the near future V. A. Izdebsky shall publish an album with works by the famous Russian artist V. V. Kandinsky […] including works that were exhibited last year at the Paris Salon d'Automne and in Munich, Moscow, and Petersburg. The Odessa public is familiar with his paintings from the Salon exhibitions. [*This project never materialized because Izdebsky, after his two international exhibitions, was penniless.*]

DAVID BURLIUK, Moscow, to MIKHAIL MATYUSHIN, St. Petersburg, Dec. 17, 1912 (Rus.): The matter has been decided. We are sending material. Elena Guro's participation is essential. Yours as well. From our side—Velimir Khlebnikov, Benedikt Livshits, Mayakovsky, 2 Burliuk brothers. Possibly Kandinsky, Kruchenykh. […] Tomorrow 500 copies of "A Slap in the Face of Public Taste" will be ready. [*Other letters from Burliuk to Matyushin also mention Kandinsky.*]

DAVID BURLIUK et al., *Poshchochina obshchestvennomu vkusu* (A Slap in the Face of Public Taste) (Moscow: G. L. Kuzmin, 1912) (Rus.): [*Kandinsky was supposed to have taken part in the daring project, but as he learned more about this publication (bound in canvas instead of a normal cover), he was outraged by the brutal tone and content. All the old, still-revered writers such as Pushkin, Dostoevsky, and Tolstoy were to be jettisoned to make room for the new. The text was littered with strong language like "perfumed lechery" and "filthy*

slime." Four of Kandinsky's prose poems from Klänge *(Sounds) were included, although it is not entirely clear whether their publication occurred without his permission, or if he had initially agreed, not realizing the rebellious form the volume would take. Either way, he subsequently issued a public protest in two newspapers. He kept the book, and I was able to see it in Nina's library.*]

KANDINSKY, in two newspapers (Rus.): I warmly support every honest attempt at artistic creativity, and I am prepared to condone even a certain rashness and immaturity in young authors. With time and the correct development of talent both faults will disappear. But under no circumstances do I consider permissible the tone in which the prospectus was written. I condemn this tone categorically, no matter whose it is.

KURT KUECHLER, in *Hamburger Fremdenblatt*, Feb. 15, 1913, (Ger.): Yet another of those unfortunate monomaniacs who consider themselves the prophets of a new art of painting has just been exhibited at Louis Bock & Son. We have already campaigned several times with good reason against the nonsensical theories of these people and against all their bungling in the field, so we can certainly today get rid of this Russian Kandinsky quickly and without fuss. When one stands in front of the horrid mess of colors and muddled lines ... one doesn't know at first what one is supposed to admire more: the larger-than-life arrogance with which Mr. K. demands that his bungling be taken seriously, the unsympathetic impudence with which the journeymen of "Der Sturm" propagate this overgrown painting as a revelation of a new and future art, or the reprehensible hunger for sensation of the art dealer who hands over his rooms to this insanity of color and form. [...] At the same time, one feels the satisfaction that this kind of art has finally reached the point where it smoothly reveals itself to be the "ism" upon the shores of which it was bound to run aground, idiotism." [*Kandinsky was used to such insults, but it was becoming too much for his friends, and Herwarth Walden organized an international protest campaign in which many progressive artists, art historians, and others participated.*]

Wilhelm Hausenstein, "Für Kandinsky. Protest," *Der Sturm* 3, nos. 150–51 (March 1913): 278 (Ger.): When I met Kandinsky, nothing amazed me more than his unconditional tolerance. After all, I had imagined a radical: a principled one, a violent one. The first thing he said to me was the simple remark that he considered his art to be something highly relative. [...] The whole uproar about Kandinsky is doubly and triply absurd because he does not have the slightest trace of need for self-display. I have never met a more reserved artist. Kandinsky is also convinced that his method is not the one and only new principle. He sees himself as a conservative, just as Signac considered himself to be simply the guardian of the formal tradition of Delacroix.

Oskar Kokoschka, "Für Kandinsky. Protest," *Der Sturm* 3, nos. 150–51 (March 1913): 279 (Ger.): Kandinsky's book could open the eyes of those journalists who previously thought one should only write about counterpoint in painting.

Franz Marc, "Kandinsky," *Der Sturm* 4, nos. 186–87 (1913): 130 (Ger.): [...] And there is something else I feel when I think about Kandinsky's paintings: an unspeakable gratitude that once again there is a man who can move mountains. And with what a noble gesture he did it. It is an inexpressible relief to know this.

Hugo Ball, in a lecture on Kandinsky at the DADA gallery in Zurich on Apr. 7, 1917 (Ger.): Kandinsky was also the first poet to illustrate purely mental phenomena. In *Klänge* (Sounds) he shapes movements, growth, color, and sound through the simplest means. [...] Such a daring purification of language had never previously been attempted, not even by the Futurists. And Kandinsky went even further: in *Yellow Sound* [*a stage play*], he was the first to use a totally abstract idiom of meaningless vowels and consonants. [...]
Kandinsky is liberation, consolation, redemption, and reassurance. One should undertake pilgrimages to his paintings: they are a way

out of the turmoil, the defeats and despair of our time. They are a liberation from a collapsing millennium. K. is one of the great innovators, a purifier of life. The vitality of his intentions is just as striking and outrageous as Rembrandt's was for his time. [...] His activities also encompass music, dance, drama, and poetry. His significance is founded upon a practical and theoretical initiative. He is the critic of his own work and of his era. He is the poet of hitherto unheard verse, the creator of a new theater, author of some of the most spiritual books. [...] [*On Apr. 14, 1917, Ball performed four of Kandinsky's prose poems from* Klänge *(1913) at the Cabaret Voltaire in Zurich.*]

DAVID SHOR and GRIGORY ANGERT, Feb. 19, 1914 (Rus.): To the Beethoven of painting—Kandinsky. [*Dedication to the artist by Evsei Shor's famous father and by Angert as a sign of their esteem, in a copy of the book Angert had translated the year before, Paul Becker's* Beethoven *(Moscow: Studio Beethoven, 1913). The volume remained in Kandinsky's personal library.*]

ERICH GUTKIND to KANDINSKY, Feb. 17, 1916, MES, Munich (Ger.): I believe in a primal, mighty, metaphysical creative act, meaning the birth hour of Europe, and nowhere have I found, until now, more promise than in your art. More and more clearly, I am able to recognize there not just a "historical," but a cosmic step—the beginning of a new era. This statement is meant to be free of any exaltation. It is a good sign for the awakening that people finally begin to see your pictures. [...] Greetings to Mitrinović, we are often thinking of him.

NIKOLAY PUNIN, in *Iskusstvo kommuny* [*Russian arts magazine published by IZO-Narkompros*], no. 9 (1919) (Rus.): I protest in the strongest possible terms against Kandinsky's art. [...] All his emotions, all his colors are lonely, rootless, and reminiscent of deformities. No, no! Down with Kandinsky! Down with him!

Konstantin Umansky, "Kandinskys Rolle im russischen Kunstleben," *Der Ararat*, second special issue (May–June 1920): 29 (Ger.): In the war years, which for Russian art meant a critical reworking of foreign—especially French—influences due to many years of seclusion, Kandinsky's stimulation was still very noticeable. [...] Apart from the "Suprematists" and Kandinsky's immediate imitators (who are not worth mentioning), Kandinsky's work remains the sole and lonely revelation of Russian, Eastern radical abstraction. His stimulating power and influence on young Russian artists are visible to all those who do not divide the new art according to programs or into isolated factions, but can see an inner spiritual succession in the formally opposing directions. From this point of view, all young Russian art movements can be traced back to Kandinsky. [...] Kandinsky as an ideologue certainly remains the Russian art pope even today.

Dmitrii Melnikov, "Po povodu levoy zhivopisi" (About Leftist Painting), *Tvorchestvo* 7–10 (1920): 42–44 (Rus.): The physicalness of painted elements now becomes crucial, here abstract art is starting. Kandinsky is the ideologue and practitioner; he is one step away from Suprematism.

Dmitry Kardovsky to Petr Neradovsky, Nov. 9, 1920 (Rus.): Kandinsky who, as professor of the Art School, belongs to the so-called Leftists among the professors, along with Konchalovsky, Mashkov, and others. [*Later, perhaps to protect himself, he wrote in a volume edited by his wife:* "Kandinsky, in spite of all my respect for him as an educated person with a firm character, should not have been appointed professor at the Art School, because, as a painter, he is completely useless, and, as a non-objective artist, even a dangerous individual." *See* Kardovsky ob iskusstve. Vospominaniia, stat'i, pis'ma *(Kardovsky on Art. Memories, Articles, Letters), ed. E. D. Kardovskaya (Moscow: Academy of Arts USSR, 1960), 38.*]

KANDINSKY, in *Vestnik rabotnikov iskusstv* 4–5 (1921): 74 (Rus.): [*Regarding his "synthetic" works in Munich, 1909–10:*] I experimented with a young musician [*Thomas de Hartmann*] and a dancer [*Alexander Sakharoff*]. The musician selected, from a number of my paintings, the one that seemed "musically" the clearest to him. He improvised this painting on the piano in the dancer's absence. Then the dancer joined in, the music was played to him so he could "translate" this music into dance, and afterwards he had to guess which painting he had been dancing.

HANS CHRISTIANSEN, "Zur abstrakten Kandinsky-Kunst" (letter to the editor), *Neue Wiesbadener Zeitung*, Feb. 22, 1925 (Ger.): If, as an artist, I reject Kandinsky's paintings, I ask not to be simply equated with the public, which, in declaring these works insane, is guided more by sound instinct, while my rejection is the result of purely rational consideration.

I think these works are sick, decadent, because they are only conditional creations of a man. [...] He finds his audience only among the wrongly developing sexes, unconditionally feminine men and unconditionally masculine women. [...] A vertical artist standing firmly on his feet as a man, a <u>sane</u> Expressionist will always fight this type of painting. [...] Every healthy person, i.e., every man and woman of German origin who physically and morally unconditionally affirms the innate sex, should feel dread.

GABRIELE MÜNTER, litigation from 1923 to 1926: After many losses in Russia and Germany, Kandinsky sought to retrieve hundreds of his paintings that he had left behind in Munich in 1914. Münter resisted, and the process dragged on for three years until she finally returned Kandinsky's furniture and only fourteen of his works. The rest remained with the Gondrand forwarding agency until the early 1930s, when Münter, concerned about the uncertain political situation, took them into her house in Murnau. She protected the collection from the National Socialist regime and throughout World War II. In

1957, on her eightieth birthday, she donated the entire body of work, including manuscripts and letters, to the Städtische Galerie im Lenbachhaus, Munich.

CARL EINSTEIN, *Die Kunst des 20. Jahrhunderts* (Berlin: Propyläen, 1926), 240ff. (Ger.): He overlooks all too important forces, especially the design of space; his teaching is too poor and nothing more than the generalization of experience narrowed in self, whose simplicity and overly personal excitement turned into a theoretical justification, so that one could find peace with oneself.

HUGO BALL, "Prologue: A Backdrop [1927]," in *Flight out of Time: A Dada Diary*, ed. John Elderfield, trans. Ann Raimes (Berkeley: University of California Press, 1974), 7ff.: [...] When we said Kandinsky and Picasso, we meant not painters but priests; not craftsmen, but creators of new worlds and new paradises. [...]

At that time [*1913*], Munich was host to an artist who, by his mere presence, placed this city far above all other German cities in its modernity—Wassily Kandinsky. [...] He was concerned with the regeneration of society through the union of all artistic mediums and forces. There was no art form he had tried without taking completely new paths, undeterred by derision and scorn. In him, word, color, and sound worked in a rare harmony, and he knew how to make even the most disconcerting things appear plausible and quite natural. [...]

ERNST ARNOLD, Dresden, to LUDWIG JUSTI, Nationalgalerie, Berlin, Jan. 6, 1927 (Ger.): Based on a conversation with Prof. Kandinsky, whose commercial representation I have taken on, I would like to make you aware of two more pictures which he himself considers to be particularly important works: *Akzent in Rosa* (Accent in Pink), 1926; *Offenes Grün* (Open Green), 1923. I am probably not mistaken in assuming that you are considering acquiring a painting by K., who has just celebrated his sixtieth birthday and is so deeply involved in

German developments. [*On Dec. 10, 1927, Arnold followed this missive with a price list: "Zweierlei Rot* (Two Kinds of Red) 3500.–; *Offenes Grün* 2100.–; *Akzent in Rosa* 2800.–. *The artist has explicitly reduced his prices by 30%." On Jan. 7, 1928, he happily announced that the Nationalgalerie had acquired* Zweierlei Rot *(1916) for 3,000 marks.*]

WALTER GROPIUS to LUDWIG JUSTI, Sept. 26, 1927 (Ger.):

[*Denunciations against Kandinsky had already begun in 1922, at the same time that Alma Mahler had denounced him as being antisemitic; his own explanations and protests always proved unsuccessful, and he feared that the smears against him were impeding his application for German citizenship, which was granted only in 1928. As director of the Bauhaus, Gropius wrote on his behalf to the influential Justi, director of the Nationalgalerie in Berlin.*]

Confidential: Prof. Kandinsky, who has been working at the Bauhaus since 1922, has applied for German citizenship. In the process, quite unexpectedly, difficulties have arisen from an unknown source, which astonishes everyone who knows him personally. As you can see yourself in the enclosed letter from the Berlin chief of police, there was an unfavorable report from an undisclosed source about Kandinsky at the time; it is undoubtedly either an error or slander. Prof. K., whom I have known very well since 1921, breathed a sigh of relief when he arrived in Germany after leaving Russia and has consistently spoken out against what he experienced there. He even went so far as to avoid speaking about Russian affairs, and repeatedly emphasized in his public lectures on art and among his friends that art and politics must be kept separate under all circumstances.

In the five years of his tenure, he never spoke out in any way about political issues, so that the allegation of that confidential statement struck his colleagues as downright absurd.

Since such a note, which passes on to the states, naturally endangers Kandinsky's naturalization, and since it is hardly possible for him as a private person to determine the authorship of this message, I would like to ask you, dear Mr. Justi, to exert your significant influ-

ence. [...] Because it cannot be tolerated that Kandinsky's global standing in our country is so damaged by the personal statement of an evidently lone individual. [...]

Confidential attachment:

The Chief of Police, IA, Foreign Office, Log no. 2161, Berlin, Alexanderstraße 3–6, Aug. 9, 1927: According to a communication from the Reich Commissariat for the Supervision of Public Order from June 1922, based on a confidentially received statement at the time, the Russian citizen, the painter W. Kandinsky, was said to be very active in Bolshevik propaganda. He was supposedly exercising this activity mainly in circles of artists, actors, and journalists. However, the investigations carried out on this side at that time did not produce any evidence that he was politically active and engaged in Bolshevik propaganda. Otherwise, nothing adverse has become known about Kandinsky from a political point of view.

Signed by proxy Goehrke, certified: Krause, office assistant

HERMANN KLUMPP, Dec. 3, 1930, to KANDINSKY (Ger.): Your art and your teaching are like a law for my development [...] and I am persuaded that my coming to you has brought me considerably closer to the meaning and aim of my life.

ERNST ARNOLD, Dresden, to LUDWIG JUSTI, Nationalgalerie, Berlin, Mar. 25, 1931 (Ger.): Allow me to inform you that I have taken over, from the Ralfs collection, the most wonderful and priceless watercolors by Kandinsky, Klee, and Feininger. These works are currently on display in my rooms. [...] I would be happy to show you the sheets for inspection.

DIEGO RIVERA, "Hommage à Kandinsky," in *Wassily Kandinsky. Sélection. Chronique de la vie artistique.* vol. 14 (Antwerp: Éditions Sélection, 1933) (Fr.): I know nothing more real than the painting of Kandinsky—nor anything more true and nothing more beautiful. A

painting by Kandinsky gives no image of earthly life—it is life itself. If any painter deserves the name "creator," it is he. He organizes matter as matter was organized, otherwise the Universe would not exist. He opened a new window to look inside the Cosmos. One day Kandinsky will be the best known and the best loved of men.

ALFRED HENTZEN, on behalf of the director of the National-galerie, Berlin, to OTTO RALFS, Braunschweig, Aug. 18, 1933 (Ger.): Kandinsky's *Composition I*, which you placed here as a loan long ago, is insured for 40,000 Reichsmark. Since the painting will not be exhibited in the near future and we only want to insure at the state's expense those paintings that are absolutely necessary, the insurance will have to be canceled. In addition, according to Prof. Schardt, the work is insured far above its current value, which he estimates at only approximately 6,000 marks.

OTTO RALFS to ALFRED HENTZEN, Aug. 21, 1933 (Ger.): I am happy to come to an understanding on the insurance value. I am well aware that the value of this picture has fallen in recent times. [...] Kandinsky himself values this painting especially highly. It should be kept in mind that K. only painted eight *Compositions* during his rich creative period. Therefore *Comp. I* already has historical value and significance. [...] I would be content with insurance for the amount of 10,000. [*Hentzen's answer:* "Only uninsured storage possible." *The work was sent back to Ralfs on Sept. 7, 1933, and has since disappeared.*]

OTTO-ANDREAS SCHREIBER, "Worin zeigt sich das deutsche Wesen in der deutschen Kunst?" (Where does the German essence show itself in German art?), *Der Betrieb* 4, nos. 8–9 (1934): 10 (Ger.): But the differences become very clear if one compares the Germans [...] with a completely different race, for example the Semitic. [...] Kandinsky's oriental glow, Jankel Adler's pastiches were such typical testimonies of Jewish art. [...] That Germanic people must perceive

270

the Jewish formation of these things as their distortion is irrevocably based on the essential differences between the races: we consider every Jewish facial expression to be ugly. [*In* Der Betrieb *4, no. 10 (1934): 22:*] If the supremacy of Impressionism were to be broken, this could only be […] based on outstanding <u>talent and a national background</u>. Therefore <u>Barlach, Nolde, Schmidt-Rottluff, Marc, and Rohlfs</u> put forward their commitment to interiority as the strongest rejection of superficial art. […] The cordial, congratulatory telegram that Dr. Goebbels, the Minister of Interior of the Reich, sent to Edvard Munch, the Nordic founder of Expressionism, was a greeting from the new Germany to an essentially related art.

PAUL FERDINAND SCHMIDT, "Erinnerung an August Macke," *Kunst der Nation* 2, no. 19 (1934) (Ger.): The great impetus to intensify the color and create a flat surface came to him, as for all other artists, from KANDINSKY, the center and great inspiration of the "Blue Rider" in Munich. Their development was carried by a feverish enthusiasm for the outrageously new, which, in the creative years from 1910 to 14, anticipated the possibilities of half a century within an unbelievably compressed period. Macke's paintings and color sketches allow every change of the turbulent epoch to be clearly felt, his feelings follow all vibrations of the spiritual manometer with complete devotion, he goes up to the completely abstract color symphony, like Kandinsky, going almost further than Marc went.

ALOIS SCHARDT to KANDINSKY, Dec. 1, 1935 (Ger.): Your watercolors are still all hanging together in a room [*in the Kunstmuseum Moritzburg*] in Halle […] open to the public. [*What he doesn't mention is that it was a so-called* Schreckenskammer *or "chamber of horrors," which was common at the time and to which Schardt was forced to agree.*]

COUNT KLAUS VON BAUDISSIN, "Das Essener Folkwang-Museum stösst einen Fremdkörper ab" (The Essen Folkwang Museum repels a

foreign body), *Essener Nationalzeitung*, Aug. 8, 1936 (Ger.): [*The director of the museum had dared to sell Kandinsky's work, which was museum property:*] The Museum Folkwang has a rich inventory of works that were finally confiscated in the storeroom in 1933, in whose semidarkness they continue their ghostly existence and in their shrill dissonances accuse the shattered world from which they come. We cannot call it coincidence that an uprooted man, alienated from his homeland, started this idea [*abstract art*], which amounts to a game stripped of all sense for the mind that conceived it and that considers itself the ultimate intellect, a half-educated, undisciplined intellect, that is therefore opposed to life and suicidal. Only a Russian mind could have dreamt up such a thing.

Announcement, Nationalgalerie, Staatliche Museen zu Berlin, Bodestraße 1–3, c. 1937 (Ger.): Apart from the painting *Zweierlei Rot* [*1916*], another painting by Kandinsky, *Ruhe* (Quiet), 1929, has been transferred from the Nationalgalerie by the Prussian Minister for Science, Art, and Education. [*The picture may well be the watercolor* Quiet Assertion *(1929), now in the Solomon R. Guggenheim Collection. In July 1937,* Zweierlei Rot, *having been confiscated from the collections of the Nationalgalerie, appeared in the* Entartete Kunst *exhibition in Munich and soon afterward disappeared. A postwar notice from the Staatliche Museen zu Berlin reads:* "Our archive also has rich material of Kandinsky's works, some of which have been destroyed, are missing, or lost." *Further research on these sources is certainly recommended.*]

JEROME KLEIN, "Plenty of Duds Found in Abstract Art Show," *New York Post,* Feb. 19, 1938: These are the artists who are above imitating nature. But too many of them are not above imitating other artists in the most slavish manner. [*Is he referring to Rudolf Bauer? See the review by Emily Genauer below.*]

EMILY GENAUER, "Art of Tomorrow in Colorful Design," *New York World Telegram,* June 3, 1939: Kandinsky's [*works*] are complex, full of action, invested with subtle, sensitively balanced counterpoint, variations

in tone, shape and texture which are endlessly fascinating. They're like fireworks at the Fair or a sun-spangled fountain, or a passage of music, or a particularly brilliant length of fabric. — Some of Bauer's works have the same quality of excitement, though most are completely sterile, antiseptic creations with something of the appearance and about the same degree of excitement as the bubble design on a package of Wonderland, or a view through a child's kaleidoscope.

"Kandinsky, Leader in Modern Art, 78," *New York Times*, Dec. 1944, 21: [*Kandinsky's*] love for his work was demonstrated in Paris three years ago, under Nazi occupation, when he continued to paint although he had to wear gloves, a hat and an overcoat because of the lack of heat due to the rigor of war.

ANDRE LHOTE, "Kandinsky et ses jeunes censeurs: sur la liberté d'expression," *Les Lettres françaises*, Jan. 13, 1945, 3 (Fr.): I do not intend to defend here an aesthetic that never got my support; what interests me is the drama of this sick old man, insulted at the end of his life in a country he loved for its spiritual generosity. Young people came in droves [*in 1944*] to protest against this "barbaric, incomprehensible and decadent" painting (because it's always Nazi terminology that serves in such cases), and threatened to break the glass behind which these enigmatic canvases were displayed. To the director of the gallery who asked them to be more open-minded, the young misfits replied with these definitive words: "we would not have seen this during the Germans' time … "

CHRISTIAN ZERVOS, Jan. 13, 1945 (Fr.): After a happy life of 79 years, Kandinsky died on Dec. 13, 1944, having been paralyzed for six months. I say happy life because Kandinsky had never known illness, still less physical or moral suffering. He was a man who, in a most bewildering way, seemed to have lived apart from daily life. The war years and the Occupation in no way undermined his happiness …

And it did not keep him from painting … So at least this way he knew nothing of life's atrocities and lived in a state of complete beatitude. [*Zervos's letter to the sculptor Mary Callery, quoted by Christian Derouet in* Kandinsky. Correspondances avec Zervos et Kojève *(Paris: Éditions du Centre Georges Pompidou, 1992), 272 (Fr.):* "In striking him down, death destroyed a remarkable personality, part artist, part scholar and philosopher, at the same time cutting short the flight of a mind whose imagination anticipated the future … And yet, having known so well the attitudes of Kandinsky's everyday soul, I am convinced that he was as much in touch with the little things of life as with the greater."]

THOMAS DE HARTMANN, lecture in New York after Kandinsky's death, probably at a Sufi meeting where Hindu philosophy was well known: [*Describing Kandinsky's last days:*] His wife had asked me to cheer him up and had left the room. I was alone with Kandinsky, who was dying. He smiled at me, then went to sleep. I looked at him and his pictures on the wall, pictures he loved most. One was from the period of his first *Compositions*, the period of imaginary catastrophes and destructions, corresponding to that level which in Hindu philosophy is called the plane of suffering. They were painted during the years when no one could imagine that such catastrophes could take place. […] Some would see in these pictures a sort of foretelling. And then I looked at another picture, one from his last period—unearthly blue space, in it correct geometrical forms, and over the whole picture reigned peace, harmony, a kind of wonderful oneness in multiplicity [*possibly* Sky Blue *of 1940*]. A quite different, very high spiritual world. In Hindu philosophy, the enlightened world of high Reason. Perhaps here Kandinsky had foreseen the coming of a spiritual awakening, when the inner sound will be heard by everyone.

MELVILLE UPTON, "Kandinsky in Retrospect," *New York Sun*, Mar. 24, 1945, 6: The Wassily Kandinsky memorial exhibition is preeminently one of the things to be seen. […] It presents 227 paintings by the master who is credited with being the first artist to eliminate

objects from his paintings. If only those American modernists who have profited by the example attend it should prove an impressive tribute. From the moment you enter the galleries you are under the master's spell. […] And, in spite of those who can find nothing in non-objective art, you realize that these are things you could live with.

ALEXANDRE KOJÈVE, "The Personality of Kandinsky," July 21, 1945 (Rus.): [*Quoted from the English translation in Kojève,* Kandinsky: Incarnating Beauty *(New York: David Zwirner, 2022), 89ff.*] […] it is precisely the extreme richness of such a personality that determines its internal and manifest harmony. The equilibrium was there only because each point was balanced by its counterpoint. The feelings—familial, social, political— could therefore be deep and strong: they upset nothing, because they were in harmony with each other and with the whole. Reason thus could remain lucid and serene while contemplating the harmonious balance of a life, which was itself passionate and intense. […] Multi-faceted himself, he easily integrated all that was true, beautiful, and good. Only evil, in all its forms, was absolutely unacceptable to him.

GABRIELE MÜNTER, in her late diaries, 1948 (Ger.): In 1909, through no fault of my own, I became one of the founders of the "Neue Künstlervereinigung München." […] When the circle of the "Blue Rider" was formed in 1912, I was also among them from the start. With the works of the well-known masters, my works were represented by art dealers and made known far and wide in Germany and beyond—from Moscow to Chicago. I didn't have to do anything. […] [*Kandinsky*] loved, understood, protected, and furthered my talent.

GABRIELE MÜNTER to the psychiatrist POUL BJERRE, Apr. 7, 1949 (Ger.): My memories of Kandinsky are divided between my admiration for him as a great artist and my disappointment about the manner of his escape from our engagement. […] What could have happened to Lucie and Erich Gutkind (Volker), through whose mediation I found my way to you? I hope very much that they fled in time from

the catastrophe in Germany! I also found letters from Mitrinović, for whose "World Union League" Gutkind had won you over as well. How different the world would look, if spiritual people, reason, and kindness had been leaders of the people!

HANS ARP, "Kandinsky der Dichter," in *W. Kandinsky*, ed. Max Bill (Paris: Maeght, 1951), 89 (Ger.): What Kandinsky had to say was tender, rich, vivacious, and humorous [...] form and color merged and were transformed into fabulous unheard-of words such as no one had ever known before.

ALBERTO MAGNELLI, "Kandinsky le peintre," in *W. Kandinsky*, ed. Max Bill (Paris: Maeght, 1951), 17 (Fr.): [*Stressing Kandinsky's mastery of drawing:*] [...] how distinct each sign is, how each shape he conceived is perfectly clear; nothing was left to chance, nothing was unforeseen. [*Magnelli was one of Kandinsky's last visitors in 1944 and even then, he observed* "his youthful attitude, a natural cheerfulness, his joy of life [...] his constant readiness for enthusiasm."]

WILL GROHMANN, *Wassily Kandinsky: Life and Work* (New York: Harry N. Abrams, 1958), 9: The Italian artist Prampolini calls him "the Giotto of our time," the painter who brought painting back to life. His closest friends, Paul Klee and Franz Marc, were already on record that during the crucial years of the rebirth of European art, Kandinsky was far in the vanguard and supplied them with the courage to go on. His uncompromising attitude to life and art, his faith in the unconquerability of the human spirit, came with him from Russia. [...]

Although he was in contact with a very large number of his contemporaries [...] and was frank and informal in manner, most people know little about him beyond the fact that he was aristocratic in appearance, and possessed both integrity and amiability. [...] Only his closest friends and pupils knew how kind he was, let alone the full range of his spiritual and creative gifts.

Marcel Duchamp, "A propos of myself," Nov. 24, 1964, lecture at the St. Louis Museum, Missouri: My visit to Munich [*in 1912*] was the source of my complete liberation.

Hans Thiemann, explanatory note published alongside Kandinsky's letters to him in the *Wallraf-Richartz-Jahrbuch*, 1976 (Ger.): When I went to the Bauhaus in 1930, it wasn't just the Bauhaus that appealed to me, but rather the fact that Kandinsky taught there. […] About two years earlier, at a time when I was mainly preoccupied with Grosz, Dix, and Surrealism, I had seen his pictures for the first time. Although I didn't "understand" them, I was fascinated by them. […] I made up my mind to become his pupil and not his imitator. […] Thank God K. was an expert who was able to unleash himself when addressed humanely. […] Kandinsky used to spice up his corrections with stories and anecdotes that got to the heart of the matter. […] "Hungarian wedding feast" became shorthand for anything over-loaded. A major piece in this repertoire was the "voice of the deceased wife" [*in the words of Rousseau*], it served as a paraphrase for what K. understood by inner necessity. […] Although his letters were and could only be a modest substitute for the Dessau and Berlin studio conversations, for me they outgrew their content and became signs of freedom that encouraged perseverance. Occasionally, however, they also goaded me into committing imprudence that could have cost me my head and neck at the time. For example, in my reply to Kandinsky's comforting encouragement that resistance leads to concentration, I added that in Germany it even leads to a concentration camp.

Hannes Neuner, quoted in Nina Kandinsky, *Kandinsky und ich* (Munich: Kindler, 1976), 110 (Ger.): [*Regarding his time at the Bauhaus:*] Kandinsky could take criticism. He reacted to it in a mature way. He would reply patiently and impassively, answering even dumb questions, and he persisted until the questioner was happy. He liked to talk with us, his students, while Klee was glad to get away to collect

his own thoughts. Kandinsky used to spread his work out in front of us and discuss it with us. He explained why he had put red rather than green in a particular spot, etc. [*Neuner also spoke to me in glowing terms about his teacher, and visited him in Paris as often as he could.*]

ANNEGRET HOBERG, "Gabriele Münter in München," in *Gabriele Münter*, exh. cat., ed. A. Hoberg and H. Friedel (Munich: Prestel, 1992), 40 (Ger.): Unfortunately, the letters and other notes Münter left behind don't permit any impression other than one of an almost oppressive harshness and a noncommittal approach towards others, paired with insecurity and a propensity for self-isolation.

ARMIN ZWEITE, "Zur Geschichte des Blauen Reiters," in *Der Blaue Reiter im Lenbachhaus*, exh. cat., ed. Annegret Hoberg (Munich: Prestel, 1991), 51 (Ger.): [...] it cannot be overlooked that the idealism propagated by Kandinsky and, in a modified form, also by Marc, had to lead to a misjudgment of reality. [*See Marc's letter to Kandinsky from Nov. 16, 1914:* "My heart is not angry about the war ..."] [*Marc's*] errors, as can be seen in hindsight, were partly abetted by an ideology that Kandinsky also shared and which for him represented at least in part the theoretical precondition for abstraction.

ARMIN ZWEITE, "Der Blaue Reiter: Revolutionäres und Widersprüchliches eines ästhetischen Konzepts," in *Der Blaue Reiter und seine Künstler*, exh. cat., ed. Magdalena M. Moeller (Munich: Hirmer, 1998), 34, 38, 42 (Ger.): [*Regarding the Blue Rider:*] Absurd ideologies, based on occult sources (34).

[*Regarding Kandinsky's* Concerning the Spiritual in Art:] Escapism [...] harebrained verbiage [*Ger.* hanebüchenes Wortgeklingel] (38).

[*Kandinsky's motivation*] stems from a cloudy ideology, which today is only of historical interest (42).

EVA MAZUR-KEBLOVSKI, in *Apokalypse als Hoffnung. Die russischen Aspekte der Kunst V. Kandinskijs vor 1914* (Tübingen: Wasmuth &

Zohlen, 2000), 70 (Ger.): [*Citing Saint Basil the Great, Bishop of Caesarea in Cappadocia (330–379 AD), from the anthology* Patrologia Graeca *30, 380:*] A work of art should "not simply imitate the apparent, but rise to the spiritual sphere, of which nature is made." Evidently the Byzantines knew the difference between naturalistic and abstract art and disapproved of mimetic art. Basil of Caesarea puts the "spiritual image" in place of what the Hellenistic world had preferred as "sensually fathomable beauty."

[*During the era of the Soviet Union, Kandinsky as a non-person was rarely discussed, and if so, then usually in a derogatory manner. This attitude persisted even into the twenty-first century and is still apparent, for example, in the two luxurious volumes by Valery Turchin (2005 and 2008), which incidentally include non-authentic paintings.*]

IGOR B. YAKUSHEV, "Simptom otkrytosti. Viktor i Vasiliy Kandinskiye—patograficheskiy ocherk," *Medicinskaya psikhologiya v Rossii* 4, no. 5 (2010) (Rus.): [*Professor of psychiatry at the State University of Arkhangelsk, Yakushev examined Kandinsky in connection with his uncle, the famous psychiatrist Viktor Kandinsky, who experimented with hallucinations. He tried, as did Peg Weiss, to prove the influence of shamanism in connection with the family's roots in Siberia. He concluded that:*] no doubt is possible: Kandinsky's paintings are the hallucinations of a mentally ill person.

BORIS VON BRAUCHITSCH, *Gabriele Münter. Eine Biografie* (Berlin: Insel, 2017) (Ger.): Kandinsky's spiritualization stems from the desire to leave behind the imperfection of the physical sphere. The hostility towards the physical [...] found early expression in sexual inhibitions that stamped him as a "freak" for the rest of his life (67).

Last but not least, the rejection of nature suited Kandinsky from a practical point of view, because, in light of his lack of talent for drawing, the complete disconnection from all physical references was

almost ideal for him (68).

[*Regarding Münter in Stockholm:*] She was relieved to be able to discover the new surroundings for herself—without Kandinsky, the attachment-shy anchorite and hinderer, who preferred to bury himself in hotel rooms and avoid new social contacts (121). [*Literature on Münter too often tries to diminish Kandinsky in ways that are quite untrue and unfair— to say nothing of the "novels" written about the couple.*]

Biographies (chronological)

The following short biographies focus on the individuals' relationship to Kandinsky.

NIKOLAI ABRIKOSOV (1850–1935), son of Alexei Abrikosov, founder of a thriving confectionery company in Moscow. Related to Anna Kandinsky through her sister. The family's country estate was Vasilevskoe in Akhtyrka near Moscow, which Kandinsky often frequented. VLADIMIR ABRIKOSOV (1858–1922) ran a wholesale tea company, as did Kandinsky's father; he also presided over the Moscow Musical Association (see Igor Aronov, *Kandinskij*, 2010).

JOSEF ALBERS (1888–1976), German abstract artist and close friend of Kandinsky from their time together at the Bauhaus. After emigrating to the United States, he became an important figure at Black Mountain College. Their correspondence is published in full in a German/English edition.

ANNI ALBERS (Anneliese Fleischmann, 1899–1994), German textile artist at the Bauhaus. Married Josef Albers and emigrated with him to the United States in 1933 as the situation of Jews in Germany became increasingly dangerous.

GRIGORY ANGERT, Russian musician, theorist, and publisher. Together with Evsei Shor, he intended to publish *Concerning the Spiritual in Art* and other books by Kandinsky, but strikes and World War I put an end to their projects.

ALEXANDER ARCHIPENKO (1887–1964), Russian sculptor who embraced the innovations of Cubism. Emigrated to the United States in 1923.

HANS or JEAN ARP (1886–1966), German-French artist and poet. Cofounder of the DADA movement. Took part in the second exhibition of the Blue Rider and was involved with the artists' associations Cercle et Carré and Abstraction-Creation for the promotion of abstract art in Paris.

SOPHIE TAEUBER-ARP (1889–1943), German artist, married Hans Arp in 1921. After her early death in 1943, Kandinsky wrote her eulogy.

ANTON AŽBE (1862–1905), Slovenian artist and teacher at a popular progressive art school in Munich where Kandinsky, Jawlensky, Kardovsky, and others were enrolled.

HUGO BALL (1886–1927), German theater artist. After studying with Max Reinhardt in Berlin, he planned to stage Kandinsky's *The Yellow Sound* and parts of *Violet Curtain* in 1914 in Munich. Emigrated to Switzerland and cofounded DADA in Zurich in 1916.

VLADIMIR BARANOV-ROSSINÉ (Shulim Wolf Leib Baranov, 1888–1944), Ukrainian-Jewish artist, musician, and synesthetic experimenter. Studied art in Odessa and St. Petersburg and exhibited with the Cubo-Futurists in Moscow. Moved to France in 1910, where he called himself "Daniel Rossiné." Invented an optophonic piano comparable to Scriabin's color-sound instrument.

ALFRED BARR (1902–1981), American art historian. Visited the Bauhaus in early 1927, where Lyonel Feininger introduced him to Paul Klee but not to Kandinsky, who was ill at the time. During a trip through the Soviet Union in December 1927–January 1928, he became well acquainted with the late Russian avant-garde. This experience

later influenced his choices for the Museum of Modern Art in New York, of which he became the first director in 1929. Wrote *Cubism and Abstract Art* (1936), on which Kandinsky commented several times.

RUDOLF BAUER (1889–1953), German artist and close follower of Kandinsky in his abstract painting. Hilla Rebay promoted him energetically for the Guggenheim Foundation. Bauer emigrated to the United States in 1939.

WILLI BAUMEISTER (1889–1955), German artist, studied at the Bauhaus and later corresponded with Kandinsky.

KLAUS GRAF VON BAUDISSIN (1891–1961), director of the Museum Folkwang in Essen from 1934 to 1938 and SS-Obersturmführer. Sold Kandinsky's oil painting *Improvisation 28*, 1912, from the museum's inventory (the work is now in the Guggenheim Museum, New York).

VLADIMIR BEKHTEEV (1909–1971), Russian painter, lived in Munich 1902–5, member of the NKVM. His work was purchased early by museums. Expelled from Germany in 1914, he returned to Russia and was banished to Siberia by Stalin and forbidden to paint. He later became a successful book illustrator.

HANNES BECKMANN (1909–1977), German artist and photographer. Studied at the Bauhaus. Moved to Prague in 1933; Kandinsky tried in vain to help him emigrate to the United States.

ALEXANDRE BENOIS (1870–1960), Russian painter and art historian, averse to abstract art. Maintained a cordial relationship with Kandinsky, but did not help the artist either in Russia or in Paris.

POUL BJERRE (1876–1964), Swedish psychiatrist. Remained friendly with Kandinsky after the artist's stay in Stockholm in 1916.

BENEDIKTA (BENA) BOGAYEVSKAYA (1874–1930), Kandinsky's friend and mother of his goddaughter Ksenia. She burned his letters before her suicide in 1930. Her letters are now in the collection of the Gabriele Münter and Johannes Eichner Foundation in Munich.

ANDRÉ BRETON (1896–1966), French poet, cofounder of Surrealism. Bought two of Kandinsky's watercolors and invited him to participate in a Surrealist exhibition in 1933.

VALERY BRYUSOV (1873–1924), Russian Symbolist poet and theoretician.

PIERRE BRUGIÈRE, French jurist and art collector. Bought works from Kandinsky and had a serious interest in art theory.

JEANNE BUCHER (1871–1946), French owner of a small, progressive gallery in Paris. Exhibited Kandinsky's work several times between 1936 and 1944.

SERGEI BULGAKOV (1871–1944), friend of Kandinsky from university, married one of his cousins. Economist and religious philosopher.

FRITZ BURGER (1877–1916), German art historian, taught in Munich, wrote about Kandinsky several times and was invited by him to participate in the peace movement (see letter of July 7, 1914).

DAVID BURLIUK (1882–1967), Russian painter, poet, and primary leader of Cubo-Futurism. Studied with Ažbe in Munich. Friendly contact and exchanges with Kandinsky, exhibited with him in Munich and Moscow until 1913.

HEINRICH CAMPENDONK (1889–1957), German painter, young member of the NKVM.

Hans Christiansen (1866–1945), German artist famous for his modernist glass windows. Participated in a Phalanx exhibition in 1902. In 1925, he called Kandinsky's abstractions "decadent, unmanly," and "feminine."

Anna (Anya) Chimyakina (1860–?), Kandinsky's cousin and first wife. Studied literature and philosophy and owned a large collection of world literature. Remained friends with Kandinsky after their divorce (and even with Gabriele Münter until 1914). Anna's sister was married to the wealthy owners of the chocolate company "Abrikosov & Son" in Moscow.

Alexander Chuprov (1842–1908), Kandinsky's favorite professor in Moscow, a liberal Populist who had to leave Russia with his family. In Munich, he was welcomed by Kandinsky, who also helped his son and daughter.

Paul Citroen (1896–1983), studied at the Bauhaus and stayed in contact with Kandinsky.

Robert Delaunay (1885–1941), French artist and theater painter. Influenced by Cubism in 1909, founded Orphism with Sonia Terk. Wrote for the catalog of the NKVM and the *Blue Rider Almanac*.

Sonia Delaunay-Terk (1885–1979), Russian-Jewish artist, married to Robert Delaunay. Kandinsky wrote a tribute to her.

André de Ridder (1888–1961), Belgian economist, author, and art critic. Cofounder of the Belgian gallery and review *Sélection*, which devoted a special issue to Kandinsky in 1933.

NICOLAS DE STAËL (1914–1955), Russian-Baltic artist; lived in Belgium, then in France. Exhibited with Kandinsky in 1944. Famous for his late abstractions.

ANDRÉ DEZARROIS (1889–1979), French art historian and director of the Musée du Jeu de Paume. Exhibited Kandinsky's work and bought two of his paintings for the museum.

GUALTIERI DI SAN LAZZARO (1904–1974), Italian author and publisher. In Paris, he edited the periodical *Chroniques du Jour* from 1925 to 1931 and founded a publishing house of the same name. Launched the review *XXᵉ Siècle* in 1938.

NADEZHDA DOBYCHINA (1884–1949), Russian art dealer. Helped Kulbin, then opened her own gallery in St. Petersburg and exhibited Kandinsky's work several times as well as that of Chagall, Malevich, Goncharova, Popova, etc.

CÉSAR DOMELA (1900–1992), Dutch artist, key member of De Stijl. Left Berlin for Paris in 1933, where he befriended Kandinsky.

KATHERINE S. DREIER (1877–1952), German artist based in the United States, founder of the *Société Anonyme*, and friend of Kandinsky.

WERNER DREWES (1899–1985), German painter and graphic artist, studied at the Bauhaus. Emigrated to New York in 1930. Founding member of *American Abstract Artists*.

MARCEL DUCHAMP (1887–1968), French artist, visited Kandinsky in 1912 and translated *Concerning the Spiritual in Art* for himself and perhaps for his two brothers (which only became known in 1968).

ARTHUR JEROME EDDY (1859–1920), Chicago attorney and art collector. By 1914, he owned the largest private collection of Kandinsky's works. Helped the artist procure a commission to create four abstract panels for Edwin R. Campbell (founder of Chevrolet) in 1914.

BORIS EGIZ (1869–1946), Russian painter. Directed the Association of Southern Artists in Odessa, where Kandinsky exhibited frequently from 1898 on.

CARL EINSTEIN (1885–1940), German critic and author of *Die Kunst des 20. Jahrhunderts*, who did not like Kandinsky's art (see doc. 1926).

ELISABETH (ELIZAVETA, LISA) EPSTEIN (1879–1956), Ukrainian-Jewish painter, studied in Munich with Ažbe and privately with Kandinsky. Lifelong friendship with him.

ADOLF ERBSLOEH (1881–1947), German painter, cofounder of the NKVM. Became president of the association after it rejected Kandinsky's *Composition 5* for exhibition and half the members resigned in protest.

OTTO FREUNDLICH (1878–1943), German-Jewish sculptor and painter. Kandinsky helped him sell a painting to the Musée du Jeu de Paume in Paris and signed a petition urging the French government to support the struggling artist.

GUSTAV FREITAG (1876–1961), son of a famous German writer, close friend of Kandinsky, member of Phalanx and the NKVM (see doc. 1903).

PIERRE GIRIEUD (1876–1948), French painter, influenced by Sérusier and Gauguin, later became one of the Fauves. Member of the NKVM.

Hans Goltz (1873–1927), German art dealer and publisher, exhibited the work of the NKVM artists and hosted the second Blue Rider exhibition.

Natalia Goncharova (1881–1962), Russian avant-garde painter. Married Mikhail Larionov. Exhibited with the Knave of Diamonds in Moscow, among other groups. Emigrated to Paris in 1915. Kandinsky valued her art and owned several of her works.

Igor Grabar (1871–1960), Russian painter and art historian. Studied with Ažbe in Munich. Returning to Russia, he later became the first director of the Tretyakov Gallery.

Will Grohmann (1883–1969), German art historian. Wrote extensively and insightfully about Kandinsky and was friends with him, Klee, and other painters.

Walter Gropius (1883–1969), German architect, founder of the Bauhaus. Defended Kandinsky against the accusations of being a "Bolshevik agitator" that made the artist's life miserable in Germany, as well as the machinations of his own ex-wife Alma Mahler (see doc. 1927).

Ludwig Grote (1893–1974), German art historian, became director of the Anhaltische Gemäldegalerie in Dessau in 1927; a good friend of Kandinsky.

Peggy Guggenheim (1898–1979), niece of Solomon R. Guggenheim. Founded a gallery in London (Guggenheim Jeune), where she exhibited Kandinsky's work in 1938, purchasing *Dominant Curve* (1936).

Solomon R. Guggenheim (1861–1948), collector, founded his museum in New York. Hilla Rebay helped him collect abstract paintings, mainly by Rudolf Bauer but also by Kandinsky.

CARL GUMMESON (1869–1941), Swedish art dealer, staged an exhibition of Kandinsky's work in Stockholm in 1916 and published his book *Om Konstnaeren* in 1916. Organized two additional exhibitions and kept some paintings.

ERICH GUTKIND (pseud. Volker, 1877–1965), German philosopher and initiator of a pacificist movement of which Kandinsky was a part. Author of *Siderial Birth* (1910).

THOMAS DE HARTMANN (1885–1956), Russian composer and Kandinsky's lifelong best friend. Helped him with his stage experiments, including *The Yellow Sound*. Wrote about anarchy in music for the *Blue Rider Almanac*. Associated with Gurdijeff's Sufi group. Kandinsky's work, *Rose with Gray*, 1924, a gift to the Hartmanns from Nina after the artist's death, is now in the Nelson-Atkins Museum of Art, Kansas City.

OLGA DE HARTMANN (1886–1979), daughter of General Schumacher in St. Petersburg. Early marriage to Thomas de Hartmann. Studied singing, became a professional singer (soprano), and accompanied her husband.

HANS HILDEBRANDT (1878–1957), German jurist and art historian. Author of *Die Kunst des 19. und 20. Jahrhunderts* (1927).

VLADIMIR IZDEBSKY (1882–1965), Ukrainian sculptor, Kandinsky's close friend, member of the NKVM. Organized two international exhibitions in Odessa, where Kandinsky was a major participant with fifty-four paintings and several contributions to the catalog for the second show in 1911.

ALEXEI JAWLENSKY (1865–1941), Russian painter, lived in Munich from 1896 on, studied with Ažbe. Cofounder of the NKVM. Kandinsky helped him greatly when Jawlensky later became ill.

Erich Von Kahler (1882–1911), Czech painter, studied in Prague and Munich, exhibited with Phalanx and the Blue Rider. Kandinsky wrote a eulogy after Kahler's early death.

Vasily Silvestrovich Kandinsky (1832–1926), father of the artist, tea merchant, played the violin and painted. Traveled with his son and helped him financially until he received a large inheritance from an uncle.

Lydia Ivanovna Kandinsky (Tikheyeva, c. 1840–1921), Kandinsky's mother. After moving from Moscow to Odessa, she fell in love with Mikhail Kozhevnikov, whom she married and with whom she had four more children, one daughter and three sons. All the members of this large family were on good terms with each other, including her ex-husband.

Nina Kandinsky (Andreyevskaya) (1893–1980), daughter of a Russian army officer who died in 1905. Married Kandinsky in 1917. After his death, she promoted his art energetically, published *Kandinsky und ich* (1976), founded a society to help young abstract artists, and intended to fulfill Kandinsky's last will: to give his estate of around 400 paintings "to the Russian people." After hesitating, however, she ultimately wrote her own will in favor of France in 1980, where she had been living since 1934. In 1980, she was murdered in her summer house in Gstaad, Switzerland.

Dmitry Kardovsky (1866–1943), Russian painter, studied with Ažbe in Munich from 1896 on; a close friend of Kandinsky. His large portrait of a woman was sold to the Guggenheim Museum as a "Kandinsky" (see Hahl-Koch, *Kandinsky*, 1993, 39ff.). Returning to Russia, Kardovsky became an academic painter. Published *Ob iskusstve* (Moscow 1960), in which he criticized Kandinsky, perhaps as a means of self-preservation.

NIKOLAI KHARUZIN (1865–1910), Russian friend of Kandinsky from university and his main early correspondent. He wrote on ethnographic subjects.

PAUL KLEE (1879–1940), German-Swiss artist, close colleague and friend of Kandinsky in Munich and throughout their years of teaching together at the Bauhaus.

HERMANN KLUMPP (1902–1987), German architect. Earned a degree in law before joining the Bauhaus in 1929, where he was extremely impressed by Kandinsky's teaching.

ALEXANDRE KOJÈVE (1902–1968), son of Kandinsky's brother Vladimir Kozhevnikov. Studied philosophy in Heidelberg. In France he changed his name, wrote about Kandinsky's "Concrete Art," and remained in contact with his uncle.

PYOTR KONCHALOVSKY (1876–1956), Russian artist of the early avant-garde.

KSIDAS (Konstandinos Ksidas), Greek husband of Kandinsky's sister Elizaveta (Lisa), to whom the artist often refers. The couple had two daughters. Kandinsky was godfather to Lydia, their second daughter.

ALFRED KUBIN (1877–1959), Austrian graphic artist. Exhibited with Phalanx in 1904, member of the NKVM, later showed with the Blue Rider. Friend of Kandinsky.

NIKOLAI KULBIN (1868–1917), Russian doctor, artist, music specialist, organizer of progressive artists, and founder of the Association for the Synthesis of the Arts (ARS) and Triangle in St. Petersburg. Contributed a text on microtonic music to the *Blue Rider Almanac*. Read Kandinsky's *Concerning the Spiritual in Art* at the All-Russian Artists' Congress in St. Petersburg in late 1911 and afterwards in Moscow.

MIKHAIL LARIONOV (1881–1964), Russian artist and leader of the Cubo-Futurists. Creator of Rayonism in late 1912 and early 1913. Emigrated to Paris with his wife Natalia Goncharova in 1915. Close artistic contact with Kandinsky in Munich and Moscow.

HENRI LE FAUCONNIER (1881–1946), French painter, director of the academy La Palette in Paris. Member of the NKVM, wrote a catalog text and participated in the second Blue Rider exhibition.

ANATOLY LUNACHARSKY (1875–1933), Russian friend of Lenin, studied philosophy and natural sciences in Zurich. Became Russian Minister of Culture in 1917 and favored progressive art, including abstraction. Emigrated to France.

MAURICE MAETERLINCK (1862–1949), Belgian symbolist author and Nobel Prize winner. Kandinsky admired his pure, minimalistic style and owned several of his books. In 1891 he added tiny pencil drawings to Maeterlinck's *La Princesse Maleine* and gave it to the Kharuzin family in Moscow.

ALBERTO MAGNELLI (1888–1971), Italian artist. During their time together in Paris, Kandinsky saw Magnelli as a "friend and comrade-in-arms" in the battle for the recognition of abstract art in France.

SERGEI MAKOVSKY (1877–1962), Russian art critic and publisher of the review *Apollon*, where Kandinsky published his "Letters from Munich."

KASIMIR MALEVICH (1879–1935), Russian artist whose works Kandinsky exhibited in Munich and with whom he exchanged paintings. When Malevich created Suprematism at the end of 1915, their contact ended (see doc. 1911 and fig. 9).

292

FRANZ MARC (1880–1916), German painter, member of the NKVM, coeditor of the *Blue Rider Almanac* and Kandinsky's close friend.

FILIPPO TOMMASO MARINETTI (1876–1944), Italian author and founder of Futurism in 1909. Visited Russia and influenced the Cubo-Futurists. Interacted with Kandinsky and Herwarth Walden in Berlin. Later had close ties to the Italian Fascist regime.

ILYA MASHKOV (1881–1944), Russian artist of the early avant-garde.

HENRI MATISSE (1869–1954), French Fauve artist (after having studied law). Visited Munich in 1908 and 1910. Kandinsky reproduced one of his paintings in the *Blue Rider Almanac* and admitted to having been influenced by him.

VOLDEMĀRS MATVEJS (Vladimir Markov, 1877–1914), Latvian artist, theorist, and poet.

JULIUS MEIER-GRAEFE (1867–1935), German art historian, published three volumes on the art of the nineteenth and twentieth centuries (Stuttgart 1904).

VSEVOLOD MEYERHOLD (1874–1940), important progressive Russian dramatist and theater director who studied under Konstantin Stanislavski.

DIMITRIJE MITRINOVIĆ (1887–1953), Serbian art philosopher who admired Kandinsky and helped with Gutkind's pacificist initiative (see letters to Gutkind and Burger, 1914).

FERDINAND MÖLLER (1882–1956), German art dealer and gallery owner in Berlin. Exhibited Kandinsky's paintings and helped Solomon R. Guggenheim buy art during the Nazi period.

GABRIELE MÜNTER (1877–1962), German artist, Kandinsky's student and life partner until 1914. Despite her personal grief at the end of their relationship and her refusal to return the majority of his works to him, she took great care to protect his paintings and manuscripts from the Nazis and donated them to the city of Munich in 1957.

OTTO NEBEL (1892–1973), German artist, poet, and actor associated with the gallery Der Sturm in Berlin. Fled to Switzerland in 1933, where he corresponded with Kandinsky, who helped him sell his paintings.

ISRAEL BER NEUMANN (1887–1961), German art dealer in Berlin. Emigrated to New York in 1923, where he became Kandinsky's representative and friend.

WILHELM NIEMEYER (1874–1960), German art historian, whose judgment Kandinsky "did not understand."

KARL NIERENDORF (1889–1947), German art dealer in Berlin associated with Neumann. After his emigration to New York, he too exhibited Kandinsky's work from 1937 on. Nina Kandinsky claimed that he kept many paintings; Christian Derouet investigated and confirmed this charge.

ANDREI PAPPE (?–late 1920s), Russian engineer and friend of Kandinsky's family in Odessa. Became Kandinsky's first student (by correspondence) in 1898. Probably related to Alexander Pappe, who helped the artist with the transport of his work in Odessa.

ANTON PEVSNER (1884–1962), Russian avant-garde sculptor and painter; lived in Paris from 1923 on, where Kandinsky helped him with several exhibitions.

REINHARD PIPER (1879–1953), German publisher, printed Kandinsky's *Concerning the Spiritual in Art* as well as the *Blue Rider Almanac* and the artist's volume of prose poems and woodcuts entitled *Klänge* (Sounds).

VASILY POLENOV (1844–1927), Russian landscape painter, member of the Peredvizhniki ("itinerant") group of Realist artists.

OTTO RALFS (1892–1955), German art collector and patron from Braunschweig; created a foundation for young artists ("Friends of Young Art") in 1924, mainly to support Klee and Kandinsky.

HILLA REBAY (1890–1967), German baroness and artist. Energetically helped Solomon R. Guggenheim build his collection of non-figurative art, buying primarily from her lover Rudolf Bauer and to a much lesser extent from Kandinsky.

FEDOR RERBERG (1865–1938), Russian artist, cofounder of the Union of Moscow Artists (1893–1924); also organized annual exhibitions in St. Petersburg and the provinces. Exhibited Kandinsky's work several times, including twenty-two paintings in 1905.

ALEXANDER RODCHENKO (1874–1947), important Russian avant-garde artist, Constructivist. Lived in Kandinsky's tenement house in Moscow with his wife Varvara Stepanova.

NICHOLAS ROERICH (Nikolai Rerikh, 1874–1947), Russian Symbolist artist, also a jurist and philosopher. From 1920 on lived in America and India. Both Moscow and New York have a Roerich Museum.

HENRI ROUSSEAU (1844–1910), French naive painter. Kandinsky was particularly fond of his works and reproduced nine of them in the *Blue Rider Almanac*, more than by any other artist.

HERMANN RUPF (1844–1910), Swiss businessman and art collector, friend of Kandinsky and Klee.

MICHAEL SADLEIR (Michael Sadler, 1888–1957), English publisher and author. Bought *Improvisation 30 (Cannons)* from Kandinsky during a trip to Munich with his father in 1913. The visit led to him translating the artist's *Concerning the Spiritual in Art* into English (first published as *The Art of Spiritual Harmony* in 1914).

ALEXANDER SAKHAROFF (1886–1963), Russian expressionist dancer. First performed in Munich in 1910 and soon became famous worldwide. Member of the NKVM, friends with Kandinsky and Jawlensky. Thomas de Hartmann composed the music for his first dances.

ALOIS SCHARDT (1889–1955), German art historian. Exhibited the work of Die Brücke and the Munich circle and promoted abstract art as director of the Moritzburg Museum in Halle. During his brief tenure as Ludwig Justi's successor as director of the National Gallery in Berlin in 1933, he tried (in vain) to protect Kandinsky. After emigrating to the United States in 1939, he again emphasized Kandinsky's importance.

IVAN SHEIMAN, Kandinsky's "uncle" (through Anna's sister), magistrate and university professor in Moscow.

ALEXANDER SHENSHIN (1890–1944), Russian composer, theorist, and educator; Kandinsky's friend in Moscow, 1919–21.

MIKHAIL SHESTERKIN (1866–1908), Russian painter and secretary of the Union of Moscow Artists where Kandinsky frequently exhibited.

GALKA (EMMY) SCHEYER (1889–1945), German artist who became friends with Jawlensky in 1917. Moved to California in 1925, where she represented Kandinsky, Jawlensky, Klee, and Feininger as the Blue Four.

ARNOLD SCHOENBERG (1874–1951), progressive Austrian composer, founder of atonality and the twelve-tone technique (dodecaphony). Published his *Theory of Harmony* in 1911. A close friend and correspondent of Kandinsky (see Hahl-Koch, *Arnold Schoenberg, Wassily Kandinsky: Letters*, 1984).

NICOLAS SEDDELER (Nikolai Zeddeler, 1876–1937), Russian-Austrian artist, studied with Ažbe in Munich, belonged to Kandinsky's circle of friends.

SERGEI SHCHUKIN (1854–1936), businessman and Russia's greatest collector of modern art, who had his pick of works among dealers in Paris. His collection was appropriated by the state following the Revolution; Shchukin fled to Paris where he remained until his death.

EVSEI SHOR (1891–1974), Russian philosopher, publisher, and friend of Kandinsky, although none of their plans to publish the artist's writings (with Grigory Angert) came to fruition.

VARVARA STEPANOVA (1894–1958), Russian avant-garde artist, married to Alexander Rodchenko.

FRANZ STUCK (1863–1928), German modern artist; known as the "painter prince," a Munich celebrity and cofounder of the Munich Secession. Kandinsky, Klee, Albers, and many other artists studied with him.

E. TÉRIADE (Stratis Efteriadis, 1897–1983), Greek art critic, collector, and publisher; studied law in France. From 1926 on he wrote as a critic for Christian Zervos and his review *Cahiers d'Art*. Cofounder of the Surrealist review *Minotaure* in 1933 and the art magazine *Verve* in 1937.

BORIS TERNOVETS (1884–1941), critic and sculptor, in charge of the State Museum of Modern Western Painting in Moscow, 1919–37.

HEINRICH THANNHAUSER (1859–1934), progressive Munich art dealer, exhibited the Blue Rider group.

HANS THIEMANN (1910–1977), German artist who admired Kandinsky even before studying under him at the Bauhaus. Following Kandinsky's move to Paris in 1933, the two developed a frank and open correspondence.

FRITZ TSCHASCHNIG (1904–2005), German artist, studied with Klee and Kandinsky at the Bauhaus (J. Hahl-Fontaine, ed., *F. Tschaschnig. Retrospektive von 1919–1997* [Pulheim: Schuffelen, 1997]).

LETTE VALESKA (Heinemann, 1885–1985), German artist and photographer, friend and heir of Galka Scheyer, with whom she lived in Los Angeles from 1938 on. Her late naive paintings, along with Kandinsky's letters to Scheyer, are now in the Norton Simon Museum in Pasadena, California.

HERWARTH WALDEN (Georg Lewin, 1878–1941), German author, publisher, composer, and progressive art dealer in Berlin. Organized Kandinsky's first one-man show in 1912 and published his album *Kandinsky 1901–1913*, which included *Rückblicke,* the artist's short autobiography.

MARIANNE WEREFKIN (1860–1938), Russian artist, student of the Russian master Ilya Repin, and oldest founding member of the NKVM. She began a relationship with Jawlensky in 1892, traveling to Munich with him in 1896, where the two became key members of Kandinsky's circle. After World War I she lived in Ascona, Switzerland, where most of her paintings are now held.

KARL WOLFSKEHL (1869–1948), German poet, member of the famous circle of Stefan George in Munich.

CHRISTIAN ZERVOS (1889–1970), Greek-French editor and publisher of *Cahiers d'Art* in Paris; also ran a small gallery of the same name. Visited Kandinsky in 1927 and frequently helped the artist exhibit his work in Paris. Author of *Histoire de l'art contemporain* (Paris: Cahiers d'Art, 1938).

Literature

Andersen, Troels. "Some Unpublished Letters by Kandinsky." *Artes* 2 (October 1966): 90–110.

Aronov, Igor. *Kandinsky's Quest: A Study in the Artist's Personal Symbolism, 1866–1907*. New York: Peter Lang, 2006 [*letters to Nikolai Kharuzin, 9–14*].

Aronov, Igor. *Kandinskij. Istoki 1866–1907*. Jerusalem: Mosty kultury, 2010 [*twenty-five letters to Nikolai Kharuzin, 290–316*].

Avtonomova, Natalja. "Die Briefe Wassily Kandinskys an Dmitrij Kardovskij." In *Wassily Kandinsky. Die erste sowjetische Retrospektive*, exh. cat., edited by Sibylle Ebert-Schifferer, 47–54. Frankfurt: Schirn Kunsthalle, 1989.

Barnett, Vivian Endicott. *Kandinsky and Sweden*. Malmö: Malmö Konsthall, 1989.

Beutler, Christian. "Zwölf Briefe von Wassily Kandinsky an Hans Thiemann 1933–1939." *Wallraf-Richartz-Jahrbuch* 38 (1976): 155–66.

Bhattacharya-Stettler, Therese. "Kandinsky – Briefe an Otto Nebel 1926–1940." *Berner Kunstmitteilungen* 203–4 (January–February 1981): 1–19.

Biergel-Goodwin, Ulrike, and Wolfram Göbel, eds. *Reinhard Piper. Briefwechsel mit Autoren und Künstlern 1903–1953*. Munich: Piper, 1979.

Bilang, Karla, ed. *Wassily Kandinsky, Gabriele Münter, Herwarth Walden. Briefe und Schriften 1912–1914*. Bern: Benteli, 2012.

Boissel, Jessica, and Nicholas Fox Weber, eds. *Josef Albers and Wassily Kandinsky: Friends in Exile, A Decade of Correspondence, 1929–1940*. Manchester: Hudson Hills, 2010.

Bolt, John E. "Vasilii Kandinsky and Nikolai Kul'bin." *Experiment* 9, no. 1 (2003): 69–81.

Borkhardt, Sebastian. *"Der Russe Kandinsky." Zur Bedeutung der russischen Herkunft Vasilij Kandinskijs für seine Rezeption in Deutschland, 1912–1945.* Vienna: Böhlau, 2021.

Derouet, Christian. "Document I: 25 lettres de Kandinsky à Pierre Brugière." *Cahiers du Musée National d'Art Moderne* 9 (1982): 84–107.

Derouet, Christian, ed. *Vassily Kandinsky. Correspondances avec Zervos et Kojève.* Paris: Éditions du Centre Georges Pompidou, 1992.

Derouet, Christian, et al. *Kandinsky.* Paris: Éditions du Centre Pompidou, 2009.

Eddy, Arthur Jerome. *Cubists and Post-Impressionists.* Chicago: A. C. McClurg & Co., 1914 [*Kandinsky's letters, 125–37*].

"Five letters to Otto Hofmann." In *Otto Hofmann*, exh. cat., 48–57. Brussels: Goethe-Institut, 1993.

Grohmann, Will. *Wassily Kandinsky: Life and Work.* New York: Harry N. Abrams, 1958.

Hahl-Fontaine, Jelena, ed. *Kandinsky Forum I.* Fernelmont: Éditions Modulaires Européennes, 2006.

Hahl-Fontaine, Jelena, ed. *Kandinsky Forum II.* Fernelmont: Éditions Modulaires Européennes, 2007.

Hahl-Fontaine, Jelena, ed. *Kandinsky Forum III. Die Bühnenexperimente.* Fernelmont: Éditions Modulaires Européennes, 2010.

Hahl-Fontaine, Jelena, ed. *Kandinsky Forum IV. Neues über den frühen Kandinsky.* Fernelmont: Éditions Modulaires Européennes, 2015.

Hahl-Koch, Jelena, ed. *Arnold Schönberg, Wassily Kandinsky. Briefe, Bilder und Dokumente einer außergewöhnlichen Begegnung.* Salzburg: Residenz, 1980.

Hahl-Koch, Jelena, ed. *Arnold Schoenberg, Wassily Kandinsky: Letters, Pictures and Documents.* Translated by John C. Crawford. London: Faber and Faber, 1984.

Hahl-Koch, Jelena. *Kandinsky*. London: Thames & Hudson, 1993 [*with many documents pertaining to Russia*].

Hahn, Peter, ed. *Bauhaus Berlin. Auflösung Dessau 1932, Schließung Berlin 1933, Bauhäusler und Drittes Reich. Eine Dokumentation.* Weingarten: Kunstverlag Weingarten, 1985.

Hoberg, Annegret, ed. *Wassily Kandinsky und Gabriele Münter in München und Kochel 1902–1914*. Munich: Prestel, 1994.

Hoberg, Annegret. "Briefe Wassily Kandinsky – Albert Bloch 1936–1937." In *Albert Bloch: The American Blue Rider*, exh. cat., edited by Henry Adams, Margaret C. Conrads, and Annegret Hoberg, 185–91. Munich: Prestel, 1997.

Hoberg, Annegret. *Gabriele Münter*. Cologne: Wienand, 2017.

Kandinsky, Nina. *Kandinsky und ich*. Munich: Kindler, 1976.

Kandinsky, Wassily. *Kandinsky. Autobiographische Schriften*. Edited by Hans K. Röthel and Jelena Hahl-Fontaine. Bern: Benteli, 2004.

Kandinsky, Wassily. *Kandinsky: Complete Writings on Art*. Edited by Kenneth C. Lindsay and Peter Vergo. New York: Da Capo, 1994.

Kandinsky, Wassily. *Wassily Kandinsky. Gesammelte Schriften 1889–1916*. Edited by Helmut Friedel. Munich: Prestel, 2007.

Kangaslahti, Kate. "Nothing to do with Politics, only Art? On Wassily Kandinsky's Work in Paris, from 1934 until the Outbreak of the War." *Artl@s Bulletin* 6, no. 2 (Summer 2017): 62–80.

Kangaslahti, Kate. "The (French) Origins and Development of International Independent Art on Display at the Musée du Jeu de Paume in 1937." *MODOS: Revista de historia da arte* 2, no. 2 (May–August 2018): 9–31.

Kojève, Alexandre. *Kandinsky: Incarnating Beauty*. New York: David Zwirner, 2022.

Kovtun, Evgenii. "Pis'ma V. V. Kandinskogo k N. I. Kul'binu" (Letters by V. V. Kandinsky to N. I. Kulbin). In *Pamiatniki kul'tury. Novye otkrytiia, 1980*, edited by T. Alekseeva et al., 399–416. Leningrad: Nauka, 1981.

Kuthy, Sandor. "Kandinsky – Briefe an Hermann Rupf 1931–1943."

Berner Kunstmitteilungen 150–51 (May–July 1974): 1–19.

Kuthy, Sandor, and Stefan Frey. "Kandinsky und Klee. Aus dem Briefwechsel der beiden Künstler und ihrer Frauen 1912–1946." *Berner Kunstmitteilungen* 234–36 (December 1984–February 1985): 1–24.

Lankheit, Klaus, ed. *Wassily Kandinsky, Franz Marc, Briefwechsel: mit Briefen von und an Gabriele Münter und Maria Marc.* Munich: Piper, 1983.

Mazur-Keblowski, Eva. *Apokapypse als Hoffnung. Die russischen Aspekte der Kunst und Kunsttheorie Vassilij Kandinskijs vor 1914.* Tübingen: Wasmuth & Zohlen, 2000.

Meissner, Karl-Heinz. "Israel Ber Neumann. Kunsthändler – Verleger." In *Avantgarde und Publikum. Zur Rezeption avantgardistischer Kunst in Deutschland 1905–1933*, edited by Henrike Junge, 215–24. Cologne: Böhlau, 1992.

Misler, Nicoletta, ed. *Kandinsky tra Oriente e Occidente.* Florence: Artificio, 1993 [*letters to G. A. C. di Cesarò, 157–82*].

Rebay, Hilla, ed. *Wassily Kandinsky Memorial. In Memory of Wassily Kandinsky.* New York: Solomon R. Guggenheim Museum, 1945 [*Kandinsky's letters, 93–99*].

Rokytova, Bronislava. "'Lieber Herr Beckmann …' From Kandinsky's letters to Hannes Beckmann in Prague (1934–1939)." *Umění* 62, no. 1 (2014): 55–65.

Schlösser, Manfred, ed. *Karl Wolfskehl 1869–1969: Leben und Werk in Dokumenten.* Darmstadt: Agora, 1969 [*letters, 334–37*].

Simcik Arese, Marichia. "Vasilii Kandinsky and Giovanni Antonio Colonna di Cesarò." *Experiment* 1, no. 1 (1995): 73–139.

Turchin, Valery. *Kandinsky v Rossii.* Moscow: Obshchestvo Kandinskogo, 2005 [*six letters to Andrei Pappe, 416ff.*].

Von Gutbrod, Karl, ed. *"Lieber Freund …" Künstler schreiben an Will Grohmann. Eine Sammlung von Briefen aus fünf Jahrzehnten.* Cologne: DuMont, 1968.

Wörwag, Barbara, ed. *Wassily Kandinsky. Briefe an Will Grohmann*

1923–1943. Munich: Hirmer, 2015.

Wünsche, Isabel, ed. *Galka E. Scheyer and the Blue Four: Correspondence 1924–1945.* Bern: Benteli, 2006.

Wünsche, Isabel, ed. *Galka E. Scheyer und Die Blaue Vier. Briefwechsel 1924–1945.* Bern: Benteli, 2006.

Acknowledgements

First of all, I would like to honor all the significant individuals who have helped me and the memory of those to whom this publication pays tribute: Nina Kandinsky, Maria Jawlensky, Olga de Hartmann, Lette Valeska, Felix Klee, Fritz Tschaschnig, Hans Maria Wingler, Klaus Lankheit, and Hans-Konrad Roethel.

My special thanks go to my co-editor Kate Kangaslahti and the translators Amélie Lauve and Kira Croce, to Lissa Renaud, and to our reader Melissa M. Thorson. For their friendly assistance I thank Barbara Wörwag, Nicoletta Misler, Brigitte Salmen, Philippe Sers, and Igor Aronov. I am grateful to Hirmer Publishers and our project manager Karen Angne for her meticulous organization as well as the beautiful work of our gifted graphic designer Peter Grassinger. Without the help and support of my husband Marcel Fontaine, however, this project simply would not have been possible. For this reason, I dedicate the book to him.

For the rights and permissions to reproduce Kandinsky's correspondence, I am indebted to the following individuals and institutions: Angelica Jawlensky-Bianconi for the letters to Jawlensky (among them many unpublished ones); Therese Bhattacharya-Stettler of the Otto Nebel Archive, Bern; Matthias Mühling and Isabelle Jansen for letters to Gabriele Münter and Alfred Kubin as well as other documents, the Städtische Galerie im Lenbachhaus, and the Gabriele Münter and Johannes Eichner Foundation, Munich; Sina Walden, Karla Bilang,

and the Staatsbibliothek zu Berlin for the letters to Herwarth Walden; Barbara Wörwag and the Will Grohmann Archive at the Staatsgalerie Stuttgart for the letters to Grohmann as well as permission to reprint illustrations from the publication; Roland Krischel and the Wallraf-Richartz-Museum for the letters to Hans Thiemann; the Margit and Hermann Rupf Archive, Bern, for the letters to Hermann Rupf; the Staatliche Museen zu Berlin and the Piper publishing house for the letters to Franz Marc; Gloria Williams of the Norton Simon Museum, Pasadena, for the letters to Galka Scheyer; the Solomon R. Guggenheim Museum, New York, for the letters to Hilla Rebay and Katherine S. Dreier; the Yale Music Library for the unpublished letters to Thomas de Hartmann; the Getty Archives, Los Angeles, for the letters to André Dezarrois and Israel Ber Neumann; the Tate Archive, London, for the letters to Ben Nicholson; the Museum of Modern Art Archives, New York, for the letters to Alfred Barr; the University of Victoria Special Collections, Victoria, for the letters to Herbert Read; Nicoletta Misler for permission to reuse an illustration, since the museum in Odessa could not help in times of war; Igor Aronov, Israel, for the letters to Nikolai Kharuzin; and Bronislava Rokytova of the Literary Archive in Prague for the letters to Hannes Beckmann.

Index

Abrikosov (family) 21, 61, 102, 119, 281, 285
Abrikosov, Nikolai 281
Abrikosov, Vladimir 281
Aivazovsky, Ivan 17
Aynalov, Dmitry 260
Albers, Anni 237, 281
Albers, Josef 160, 172–73, 176, 182–83, 193, 223, 234, 237, 239, 243, 281, 297, 301
Andreyevskaya, Nina, see Kandinsky, Nina
Angert, Grigory 105, 264, 281, 297
Archipenko, Alexander 147, 257–58, 282
Arnold, Ernst 138–39, 267, 269
Arp, Hans 83, 90, 99, 101, 146, 162–63, 167, 178–79, 182, 193, 199, 215, 223, 226, 228, 237, 245, 250–52, 257, 276, 282
Arp, Sophie, see Taeuber-Arp, Sophie
Auslender, Serge 71
Ažbe, Anton 29–31, 33, 147, 229, 282, 284, 287–90, 297

Baker, Josephine 247
Ball, Hugo 91, 119, 215, 263–64, 267, 282
Balthus 176
Barr, Alfred 195, 197, 199–200, 202, 282, 307

Barrera-Bossi, Erma 258
Bauer, Rudolf 168, 207, 214, 218, 221–22, 232, 245, 246, 248, 272–73, 283, 288, 295
Baum, Julius 164
Baumeister, Willi 164, 283
Bekhteev, Vladimir 7, 134, 194, 258, 283
Beckett, Samuel 228
Beckmann, Hannes 180, 188, 210, 225, 239, 240, 243–44, 283, 304, 307
Beckmann, Matilda 180, 240, 244
Belling, Rudolf 188
Bena, see Bogayevskaya, Benedikta
Benois, Alexander 97, 126–27, 190, 208–9, 220, 283
Bertensson, Sergei 196
Bigot, Eugène 177
Bill, Max 251–52, 276
Bjerke-Petersen, Vilhelm 191
Bjerre, Poul 123–24, 127–29, 150, 275, 283
Bloch, Albert 106, 108, 303
Blok, Alexander 71, 255–56
Bogayevskaya, Benedikta (Bena) 11, 12, 37, 59, 60–61, 284
Bogayevsky, Petr 11, 17
Bonnard, Pierre 259
Bosch, Hieronymus 190
Brahms, Johannes 55

Braque, Georges 83, 175, 192, 217, 258–59
Braun, Otto 111
Breton, André 144, 228, 284
Breuer, Marcel 225
Breughel (Jan, Pieter) 190
Bryusov, Valery 125, 256, 284
Bryusova, Nadezhda 59, 75–76
Bruckner, Anton 55
Brugière, Pierre 237–38, 246, 249–52, 284, 302
Bucher, Jeanne 195, 214, 216, 237, 245, 251, 284
Bulgakov, Sergei 73, 284
Burchard, Irmgard 225
Burger, Fritz 110, 111, 284, 293
Burliuk, David 58, 66, 69, 71–74, 85, 87, 89–90, 92, 97, 99, 102, 118, 137, 258–59, 261, 284
Burliuk, Vladimir 58, 66, 71, 72, 102, 118, 258–59, 261

Campendonk, Heinrich 89, 147, 173, 284
Cézanne, Paul 56, 64, 109, 200, 215, 218–19, 243
Chagall, Marc 128, 162, 174, 220, 248, 258, 286
Chamberlain, Houston Stewart 111, 113
Chekhonin, Sergei 71
Chevalier, Maurice 247
Chimyakina, Anna, *see* Kandinsky, Anna
Christiansen, Hans 150–51, 266, 285
Chuprov, Alexander 25, 28, 45–46, 51–52, 285
Citroen, Paul 238, 285
Cuttoli, Marie 216

Däubler, Theodor 109, 111
Dalí, Salvador 176, 247
Danz, Louis 201–2
Degas, Edgar 64
Delaunay, Robert 7, 77, 81, 89, 105, 236, 252, 285
Delaunay-Terk, Sonia 251, 257, 285
Denis, Maurice 52, 259
Derain, André 258
Dezarrois, André 213–14, 216, 219, 240–42, 286, 307
di San Lazzaro, Gualtieri 242, 286
Dobychina, Nadezhda 88, 102, 103, 119–21, 125, 286
Doesburg, Theo van 245
Domela, César 195, 226, 236, 245, 251–52, 286
Dongen, Kees van 259
Dostoevsky, Fyodor 101, 261
Dreier, Katherine S. 131, 140–41, 144, 147, 163, 214, 286, 307
Drewes, Werner 153, 161, 163, 166, 175, 182, 196, 286
Duchamp, Marcel 144, 174, 215, 277, 286
Duvan, A. I. 51

Eddy, Arthur Jerome 104, 105, 111, 121, 158–59, 287, 302
Eggeling, Viktor 245
Egiz, Boris 44, 48, 51–53, 56, 287
Einstein, Carl 267, 287
Éluard, Paul 228
Ensor, James 57, 146
Epstein, Elisabeth 71–72, 75, 77, 81–82, 185, 221, 229, 235, 287
Erbslöh, Adolf 62, 256, 258
Ernst, Max 168
Evans, Myfanwy 183, 191
Evreinov, Nikolai 71, 90

Exter, Alexandra 69, 259
Eyck, Jan van 190

"Fanny" (housekeeper) 98–99, 104
Fauconnier, Henri Le 61, 69, 71, 73, 74, 77, 81, 259, 292
Feininger, Lyonel 133, 140–43, 151–52, 157, 167, 199, 269, 282, 296
Felixmüller, Conrad 109
Fokine, Mikhail 71
Frey, Karl 226
Freytag, Gustav 256

Gabo, Naum 207–8, 245
Gallen-Kallela, Akseli 35–36
Gauguin, Paul 52, 64, 74, 199, 287
Giacometti, Alberto 142
Giesler, Maria 73
Gimmi, Wilhelm 83
Giotto di Bondone 109, 276
Girieud, Pierre 56, 71, 74, 287
Gleizes, Albert 162, 236
Goebbels, Josef 236, 271
Gogh, Vincent van 64, 74, 82, 226
Gogol, Nikolai 46, 194
Goncharova, Natalia 60–61, 72, 81–83, 99, 102, 118, 286, 288, 292
González, Julio 180, 216
Gorodecky, Sergei 71
Gosebruch, Ernst 163
Grabar, Igor 34, 220, 288
Greco, El (Domínikos Theotokópoulos) 109
Grohmann, Will 134–38, 141, 143–45, 147–52, 159, 162, 166, 174, 176–77, 185, 192, 209,

221–22, 224, 226, 251–52, 276, 288, 302, 304, 307
Gropius, Walter 12, 132, 225, 268, 288
Grossmann, Ludwig Wilhelm 57
Grosz, George 277
Grote, Ludwig 153, 288
Grzhebin, Zinovii 126
Guggenheim, Peggy 228, 231, 252, 288
Guggenheim, Solomon R. 144, 168, 197, 206, 210, 214, 218, 228, 230–32, 237, 241, 246, 248, 272, 283, 288, 293, 295
Gummeson, Carl 118, 123–24, 127–29, 289
Guro, Elena 258, 261
Gutkind, Erich 93, 98, 108, 111, 113, 264, 275–76, 289, 293

Hartmann, Olga de 54, 58–61, 63–65, 72–73, 77, 82, 95, 97, 99, 100, 103, 117, 119, 123, 135, 170, 172, 174, 177–78, 182, 185, 189, 206, 217, 253, 289, 306
Hartmann, Thomas de 7, 54–55, 57–65, 72–75, 77, 79, 82–83, 85, 89–90, 92, 95, 96–97, 99–100, 103–4, 119, 123, 128, 149, 161–62, 165–66, 170, 172, 174, 177–78, 185, 189, 196, 206, 217, 253, 257, 266, 274, 289, 296, 307
Hartlaub, Gustav 164
Hausenstein, Wilhelm 113, 263
Hausmann, Raoul 245
Heckel, Erich 144, 166–67
Helbig, Walter 83
Hepworth, Barbara 183, 187
Hervé, Gustave 113
Herzen, Alexander 10
Hildebrandt, Hans 211, 289
Hodler, Ferdinand 87

Hofer, Karl 164
Hofmann, Otto 157, 220, 223, 302
Huggler, Max 213
Hugo, Victor 22

Izdebsky, Vladimir 54–55, 66, 68, 71–72, 79–80, 85, 101, 258, 261, 289

Jakovsky, Anatole 178
Jawlensky, Alexei 7, 33–34, 41, 46, 55, 62, 71, 110, 127, 133, 140, 142, 148, 151–53, 157, 159, 161–63, 172–74, 177–79, 184, 189, 193, 198, 205, 212–13, 220, 229, 232, 234, 240, 242, 258–59, 282, 289, 296, 298, 306
Justi, Ludwig 138, 167, 267–69, 296

Kahler, Eugen von 76–77, 290
Kandinsky, Anna (Anya) 10, 21–23, 25–27, 29–30, 34–35, 42–43, 48, 59, 64, 66, 69, 98, 116–17, 123, 281, 285, 296
Kandinsky, Elisaveta, see Ksidas, Lisa
Kandinsky, Lydia (mother) 38, 46, 48, 65, 95, 116
Kandinsky, Nina 8–12, 121, 123, 130, 133–34, 141–43, 146–47, 150–52, 178–81, 183, 187–88, 192–93, 204, 206, 209, 217, 224, 227, 231–32, 235, 238, 246, 250, 252, 262, 274, 289, 294, 303, 306
Kandinsky, Viktor 10, 279,
Kandinsky Vsevolod (son) 10, 12, 123, 125

Kandinsky, Vasily Silvestrovich (father) 20, 48–50, 53, 65, 95, 97, 103, 131, 139, 281, 290
Kandinsky, Vladimir, see Kozhevnikov, Vladimir
Karatygin, Vyacheslav 71
Kardovsky, Dmitry 33–35, 41, 50, 194, 220, 265, 290
Käsbach, Walter 163
Kirchner, Ernst Ludwig 110, 188
Kharuzin, Elena 20, 23
Kharuzin, Nikolai 17–28, 59, 291–92, 301, 307
Kharuzin, Vera 20
Khlebnikov, Viktor (Velimir) 89, 261
Khodasevich, Vladislav 45
Klee, Felix 7, 143, 259, 306
Klee, Lily 96, 113–14, 140, 146, 157, 176, 194, 213
Klee, Paul 11, 23, 34, 76, 89, 96, 104, 106, 108, 113–14, 127, 133, 136–43, 145–47, 149–52, 157, 159, 176, 188, 194, 212–13, 222, 225, 232, 242, 249, 259, 269, 276–77, 282, 288, 291, 295–98, 304
Kojève, Alexandre 137, 145–46, 150, 153, 155, 161, 163, 205, 274–75, 291, 302
Kokoschka, Oskar 76, 78, 81, 87, 142, 263
Konchalovsky, Pyotr 61, 62, 72, 90, 265, 291
Korovin, Konstantin 32
Kozhevnikov, Alexei (Alyosha) 153
Kozhevnikov, Alexandra 48, 116, 137, 153
Kozhevnikov, Mikhail 95, 146, 290

Kozhevnikov, Vladimir (brother) 21–22, 27, 46, 48,103, 116, 146, 291
Kremlev, Anatoly 260
Kropotkin, Pjotr 113
Kruchenykh, Aleksei 258, 261
Kryzhanovsky, Ivan 71
Ksidas, Konstandinos 47, 163, 291
Ksidas, Lisa 38, 146, 291
Ksidas, Lydia 38, 146, 291
Kubin, Alfred 55, 57, 70, 74, 77, 79, 81, 91, 105–6, 261, 291, 306
Küchler, Kurt 101
Kulbin, Nikolai 7, 57–58, 60, 69–71, 73, 75, 79–80, 82, 84, 86–88, 90–91, 96, 102, 259–60, 286, 291, 303
Kustodiev, Boris 70

Landauer, Gustav 113
Larionov, Mikhail 60–62, 64, 72, 81–83, 99, 102, 118, 258, 288, 292
Léger, Fernand 136, 140, 144, 162, 182, 217
Lenin, Vladimir Ilych 206, 292
Lentulov, Aristarkh 61–62, 64, 72, 99, 258
Levitan, Isaak Ilych 32
Liebermann, Max 164
Lilienthal, Erich 113
Lissitzky, El 211, 245
Livshits, Benedikt 258, 261
Loos, Adolf 81, 204
Lüthy, Oscar 83
Lunacharsky, Anatoly 126, 127, 292

Macke, August 72, 79, 88, 259, 271

Maeterlinck, Maurice 28, 61–62, 111, 292
Magnelli, Alberto 216–17, 226, 245, 251–52, 276, 292
Makovsky, Sergei 62–63, 292
Malevich, Kasimir 82–83, 118, 124, 197–99, 201, 211, 215, 245, 260, 286, 292
Man Ray 192
Manguin, Henri 257, 259
Marc, Franz 66, 69–77, 79, 81–83, 85–89, 100–101, 104, 106, 108, 113–14, 149, 151, 167, 169, 181, 198–99, 220, 256, 259, 261, 263, 271, 276, 278, 293, 304, 307
Marc, Maria 77, 114, 181, 220, 304
Marcoussis, Louis 252
Marinetti, Filippo Tommaso 158, 159, 174, 230, 293
Marquet, Albert 259
Mashkov, Ilya 61–62, 72, 258, 265, 293
Matveyev, Aleksandr 71
Matisse, Henri 56, 58, 62, 64, 74–76, 80, 86, 96, 106, 109, 162, 219, 257, 259, 293
Matvejs, Voldemārs (a.k.a. Vladimir Markov) 91, 92, 293
Mauthner, Fritz 111, 113
Mayakovsky, Vladimir 258, 261
Mayer, Alfred 91
Meier-Graefe, Julius 91, 101, 293
Melnikov, Dmitrii 265
Merezhkovsky, Dmitry 101, 111, 113
Mérodack-Jeaneau, Alexis 43
Meyerhold, Vsevolod 90, 91, 293
Michelangelo Buonarroti 109
Miró, Joan 162, 182, 199, 223

Mitrinović, Dimitrije 108, 110–12, 264, 276, 293
Moholy-Nagy, László 225
Möller, Ferdinand 115–16, 144, 146, 148, 153, 156, 167, 189, 218–19, 231, 293
Moillet, Louis 76
Mondrian, Piet 140, 162, 182, 245
Monet, Claude 28, 30, 64, 139, 200, 255
Muche, Georg 133–34
Münter, Gabriele 7–8, 10, 12, 14, 33, 36–50, 52–55, 57–66, 70–72, 77–79, 81, 86–88, 93, 95–99, 103–4, 106, 108, 113, 115–23, 128, 130, 135, 140, 144, 258–61, 266, 275, 278–80, 284–85, 294, 301, 303–4
Munch, Edvard 74, 87, 271
Mussorgsky, Modest 143

Narbut, Vladimir 71
Naumann, Emil 55
Nebel, Otto 167–68, 170, 176, 180, 188, 194, 206–7, 212, 214, 217–18, 221, 226, 230–32, 236–37, 242, 245–48, 294, 301, 306
Neradovsky, Petr 265
Neumann, Israel Ber 9, 137, 182, 186–89, 192, 195, 197, 198, 200, 204, 217, 249, 294, 304, 307
Nicholson, Ben 182–84, 187, 207, 307
Niemeyer, Wilhelm 73, 294
Nierendorf, Karl 133, 204, 212, 217, 250, 294
Nolde, Emil 57, 166–67, 222, 271
Nordstrom, Ernst 50

Ortner, Rudolf 7

Papini, Giovanni 111, 113

Pappe, Alexander 51, 53, 294, 304
Pappe, Andrei 18, 30–32, 294
Pavlova, Anna 194
Pechstein, Max 110
Pevsner, Anton 195, 215, 245, 294
Picasso, Pablo 58, 62, 64, 70, 74–75, 80, 83, 91–92, 96, 106, 109, 115, 140, 150, 162, 175, 182, 192, 194, 196, 217, 219, 247, 258, 267
Piper, Reinhard 70, 74, 96, 101, 108, 149, 295, 307
Pissarro, Camille 64
Polenov, Vasily 17, 295
Pölzig, Hans 164
Prampolini, Enrico 216, 276
Pratella, Francesco Ballila 73
Preis, Elena 125
Probst, Rudolf 189
Przybyszewski, Stanisław 111–12
Punin, Nikolay 264
Puvis de Chavannes, Pierre 34

Rachmaninoff, Sergei 55
Raphael Sanzio 109
Raffaëlli, Jean-François 64
Ralfs, Otto 137, 145, 221, 269–70, 295
Read, Herbert 169, 183, 229–30, 238, 307
Rebay, Hilla 144, 156, 173, 176, 183, 196, 206–7, 210, 214, 217–18, 221–22, 232, 236–37, 245, 248, 283, 288, 295, 304, 307
Repin, Ilya 34, 211, 298
Rerberg, Fedor 45, 50, 295
Ridder, André de 152, 163, 165, 168, 285
Rivera, Diego 153, 157, 191, 269
Rodchenko, Alexander 123–25, 295, 297
Roerich, Nicholas 70, 98, 295

Romanov, Alexei 52
Romanov, Boris 52
Romanov, Vladimir 52
Rosenberg, Paul 167, 192
Rouault, Georges 258–59
Rousseau, Henri 70, 76–77, 194, 259, 277, 295
Rubens, Peter Paul 210
Rupf, Hermann 178, 234, 245, 248–49, 296, 303, 307
Sabaneyev, Leonid 82
Sabashnikov, Ivan 10
Sakharoff, Alexander 266, 296
Sadler, Michael (a.k.a. Michael Sadleir) 79, 106, 110, 121, 296
Salzmann, Alexander 33
Schardt, Alois 151, 166–67, 170–71, 270–71, 296
Schawinsky, Alexander "Xanti" 176
Scheyer, Galka (Emmy) 7–8, 133, 137, 139, 140, 142–43, 147–49, 152–54, 156–59, 164, 166, 171–72, 175, 177, 179, 185, 187, 191, 195, 199, 200–201, 204–5, 217–18, 221, 224, 226, 232, 235, 240, 244, 247, 249, 296, 298, 305, 307
Schlemmer, Oskar 151, 164, 176, 252
Schmidt, Paul Ferdinand 271
Schmidt-Rottluff, Karl 166, 271
Schoenberg, Arnold 8, 14, 67–68, 72–74, 76–77, 83–85, 87, 89, 93, 96–98, 107, 109, 129, 131–32, 140, 179, 201–2, 260, 297, 302
Schreiber, Otto-Andreas 270
Schwitters, Kurt 245
Seddeler, Nicolas 33, 174, 297
Serov, Valentin 32
Shaw, George Bernhard 113

Shchukin, Sergei 64, 89, 95–96, 99, 193, 297
Sheiman, Ivan 22, 27, 296
Shenshin, Alexander 128, 130, 139, 296
Shesterkin, Mikhail 52, 54, 296
Shor, David 249, 264
Shor, Evsei 105, 143, 249, 264, 281, 297
Signac, Paul 11, 259, 263
Scriabin, Alexander 60, 76, 82, 84, 90, 118, 282
Smirnov, Nikolai 60
Soldenhoff, Alexander 142
Sologub, Leonid 64
Somov, Konstantin 70
Staël, Nicolas de 252, 286
Stalin, Josef 11, 248, 283
Stanislavski, Konstantin 61, 293
Stepanova, Varvara 123, 125, 295, 297
Stieglitz, Alfred 101–2
Stuck, Franz (von) 34, 54, 83, 297
Sudkovsky, Rufin 17
Surikov, Vasily 211
Szigeti, Joseph 150, 194

Taeuber-Arp, Sophie 178–79, 182, 223, 226, 245, 252, 282
Taneyev, Sergei 59, 76, 118
Tatlin, Vladimir 82, 118, 124, 215
Tériade, E. (a.k.a. Stratis Eleftheriades) 144, 214, 225, 297
Ternovets, Boris 138
Thannhauser, Heinrich 76, 81–82, 107, 256, 298
Thiemann, Hans 181, 190, 209, 220, 223, 228, 238, 277, 298, 301, 307
Tikheyeva, Maria 125, 290
Toulouse-Lautrec, Henri de 74
Tolstoy, Leonid 59, 65, 175, 261

315

Toporsky, V. V. 71
Toscanini, Arturo 182
Tschaschnig, Fritz 7, 298, 306
Tugendhold, Jakov 116

Valeska, Lette 7, 306
Vlaminck, Maurice de 83, 259
Vuillard, Éduard 259
Wagner, Richard 46, 177
Walden, Herwarth 87, 94–95, 98,
101–6, 108, 113, 119–21, 128–29,
262, 293, 301, 306, 307
Werefkin, Marianne 54, 61, 64,
71, 161, 220, 258
Wiechert, Fritz 163

Wiese, Erich 151
Wolfskehl, Karl 82, 299, 304
Wolkonsky, Serge 260

Yakovlev, M. N. 71
Yakulov, Georgiy 98, 105
Yavorsky, Boleslav 59, 61, 72, 76

Zak, Jadwiga 143–44
Zervos, Christian 140, 143–45,
148, 150, 152, 159–60, 162–63,
165, 174–77, 179, 182, 189, 216,
220, 231, 273–74, 297, 299, 302
Ziegler, Adolf 234

Image credits

Figs. 1, 16: Private archive, P. Sers.
Fig. 2: Odessa Fine Arts Museum, reproduced in *W. Kandinsky tra Oriente e Occidente*, ed. Nicoletta Misler (Florence: Artificio, 1993), 59.
Figs. 3, 5, 20–22, 24, back cover: Musée National d'Art Moderne, Centre Georges Pompidou, Paris; fig. 3, MNAM-CCI, Dist. RMN-Grand Palais / Georges Meguerditchian; fig. 20, photo by Lotte Jacobi; fig. 21, photo by Guy Carrard; fig. 22, photo by Hugo Erfurth © VG Bild-Kunst, Bonn 2023; fig. 24, photo © Georges Meguerditchian.
Figs. 4, 7, 13, front cover: Gabriele Münter- und Johannes Eichner-Stiftung, Munich, © VG Bild-Kunst, Bonn 2023.
Figs. 6, 8, 9, 11: Städtische Galerie im Lenbachhaus und Kunstbau, Gabriele Münter-Stiftung 1957, Munich.
Fig. 10: Illustration from the 1914 volume *Works of the All-Russian Artists' Congress*, from the copy in the editor's collection.
Fig. 12: Shalva Amiranashvili Museum of Fine Arts, Georgian National Museum, Tbilisi (photo by Igor Kozlov).
Fig. 14: State Tretyakov Gallery (Donation of Georges Costakis), Moscow.
Fig. 15: Photo by Igor Kozlov, Petr Aven Collection.

Fig. 16: Private archive.
Fig. 17: Städtische Galerie im Lenbachhaus und Kunstbau (purchased with funds from the Hypo-Bank, now UniCreditBank AG), Munich.
Fig. 19: The Solomon R. Guggenheim Museum, New York (previously in the Staatliche Gemäldegalerie, Dresden).
Fig. 23: Gilmore Music Library, Yale University, New Haven.

It has not always been possible to locate the copyright holders of the images. Justified claims will of course be settled within the framework of usual agreements.

Edited by
Jelena Hahl-Fontaine
in collaboration with
Kate Kangaslahti

Translations:
Kate Kangaslahti, Amélie Lauve,
Kira Croce

Project management,
Hirmer Publishers:
Karen Angne, Peter Grassinger

Copyediting:
Melissa M. Thorson

Graphic design:
Peter Grassinger

Prepress and repro:
Reproline Mediateam, Unterföhring

Paper:
Munken Premium Cream 90 g/qm,
Magno Satin 135 g/qm

Typefaces:
Adobe Garamond Pro

Printing and binding:
Friedrich Pustet, Regensburg

Printed in Germany

© 2023 Hirmer Verlag GmbH,
Munich, and the editor
For the work by Gabriele Münter
(Front cover): © VG Bild-Kunst,
Bonn 2023

Front cover: Kandinsky on a sofa at
Schnorrstraße 44, Dresden, summer
of 1905, photographed by Gabriele
Münter, Gabriele Münter- und
Johannes Eichner-Stiftung, Munich.
Postcard from Kandinsky to Poul
Bjerre, Stockholm, Mar. 11, 1922 (see
fig. 18). Back cover: Portrait photo of
Kandinsky by Hannes Beckmann,
1935 (see Kandinsky's letter of thanks
to Beckmann, Oct. 15, 1935), Musée
National d'Art Moderne, Centre
Georges Pompidou, Paris.

Bibliographic information published
by the Deutsche Nationalbibliothek
The Deutsche Nationalbibliothek lists
this publication in the Deutsche
Nationalbibliografie; detailed
bibliographic data is available on
the Internet at http://www.dnb.de

ISBN 978-3-7774-4036-1

www.hirmerpublishers.com